Un-American Psycho

Un-American Psycho:
Brian De Palma and the Political Invisible

Chris Dumas

intellect Bristol, UK / Chicago, USA

First published in the UK in 2012 by
Intellect, The Mill, Parnall Road, Fishponds, Bristol, BS16 3JG, UK

First published in the USA in 2012 by
Intellect, The University of Chicago Press, 1427 E. 60th Street,
Chicago, IL 60637, USA

A catalogue record for this book is available from the
British Library.

Cover Image: William Finley in "Phantom of the Paradise,"
©1974 Twentieth Century Fox. All rights reserved.

Cover designer: T.K
Copy-editor: MPS Technologies
Production manager: Jelena Stanovnik
Typesetting: Planman Technologies

ISBN 978-1-84150-554-1

COPYRIGHT ACKNOWLEDGMENTS: From *The New Biographical Dictionary of Film* by David Thomson, copyright ©1975,
1980, 1994, 2002 by David Thomson; used by permission of Alfred A. Knopf, a division of Random House, Inc.
From "Dreck to Kill" by Andrew Sarris, copyright ©1980 by Andrew Sarris and *The Village Voice*; used by permission of
Village Voice LLC.
From "Brian De Palma: The Movie Brute," copyright ©1984, 1987 by Martin Amis; used by permission of Penguin Group
and SSL/Sterling Lord Literistic Inc.
From *Easy Riders, Raging Bulls* by Peter Biskind, copyright ©1998 Peter Biskind; used by permission of Simon &
Schuster, Inc.
From "Brian De Palma Interviewed by Marcia Pally," copyright ©1984 by *Film Comment*/Marcia Pally; used by permission
of Marcia Pally.
From *American Psycho* by Bret Easton Ellis, copyright ©1991 by Bret Easton Ellis; used by permission of Bret Easton Ellis,
Vintage Books, Pan Books/Palgrave MacMillan, and International Creative Management.

Regarding the Author

Chris Dumas holds degrees from Oberlin College,
Columbia University, and Indiana University.
Born in Arkansas, he lives in San Francisco.

Table of Contents

List of Illustrations ix

Acknowledgments xi

Introduction: The Case of the Missing Disciplinary Object 1

Chapter 1: Shower Scene 19
 Hitchcock and the Murder of Marion Crane 26
 How to Blame De Palma 33
 How to Operate the Hitchcock Machine 47
 Everything You Ever Wanted to Know about Žižek
 (But Were Afraid to Ask De Palma) 71

Chapter 2: Get to Know Your Failure 83
 Death(s) of the Left: An Historical Cartoon 90
 Godard: The Holy Man 98
 Made in U.S.A. 108
 Cinema of Failed Revolt 128

Chapter 3: The Personal and The Political 145
 Bad Objects 147
 The Liberal Gaze 165
 The Political Invisible 178

Conclusion: Norman Bates and His Doubles 203

Reference List and Bibliography 217

Index of Film Titles and Selected Proper Names 229

List of Illustrations

1. *Body Double* (Brian De Palma 1984, Columbia Pictures). — ii
2. *Murder A La Mod* (Brian De Palma 1967, Sigma III). — 16
3. *Psycho* (Alfred Hitchcock 1960, Paramount Pictures). — 22
4. *Phantom of the Paradise* (Brian De Palma 1974, Harbor Productions). — 22
5. *Zabriskie Point* (Michelangelo Antonioni 1970, Warner Bros.). — 24
6. *The Fury* (Brian De Palma 1978, Frank Yablans Presentations). — 24
7. *Shadow of a Doubt* (Alfred Hitchcock 1943, Skirball Productions). — 47
8. *Dressed to Kill* (Brian De Palma 1980, Filmways). — 57
9. *Dressed to Kill.* — 60
10. *Vertigo* (Alfred Hitchcock 1957, Paramount Pictures). — 62
11. *Body Double.* — 62
12. *Dressed to Kill.* — 65
13. *Vertigo.* — 66
14. *The Birds* (Alfred Hitchcock 1963, Universal Pictures). — 66
15. *The Ladies Man* (Jerry Lewis 1961, Paramount Pictures). — 66
16. *Greetings* (Brian De Palma 1968, West End Films). — 68
17. *Phantom of the Paradise.* — 68
18. *Body Double.* — 68
19. *Body Double.* — 69
20. *Raising Cain* (Brian De Palma 1992, Universal Pictures). — 69
21. *Raising Cain.* — 69
22. *Raising Cain.* — 70
23. *Dressed to Kill.* — 79
24. *Dressed to Kill.* — 79
25. *Dressed to Kill.* — 79
26. *Body Double.* — 80
27. *Sauve Qui Peut (La Vie)* (Jean-Luc Godard 1980, Sara Films). — 100
28. *La Chinoise* (Jean-Luc Godard 1967, Anouchka Films). — 106
29. *Body Double.* — 106
30. *Murder A La Mod.* — 111
31. *Greetings.* — 113

32. *Greetings.* 113
33. *Greetings.* 113
34. *Greetings.* 115
35. *Greetings.* 115
36. *Dionysus in '69* (Brian De Palma 1970, Sigma III). 119
37. *Dionysus in '69.* 119
38. *Hi, Mom!* (Brian De Palma 1970, Sigma III). 123
39. *Hi, Mom!.* 123
40. *Hi, Mom!.* 123
41. *Hi, Mom!.* 129
42. *Get to Know Your Rabbit* (Brian De Palma 1970/72, Warner Bros.). 132
43. *Get to Know Your Rabbit.* 132
44. *Get to Know Your Rabbit.* 132
45. *Sisters* (Brian De Palma 1973, Pressman-Williams). 137
46. *Casualties of War* (Brian De Palma 1989, Paramount Pictures). 141
47. *Redacted* (Brian De Palma 2007, Film Farm). 141
48. *Body Double.* 142
49. *Casualties of War.* 142
50. *Home Movies* (Brian De Palma 1980, SLC Productions). 161
51. *Dressed to Kill.* 163
52. *Scarface* (Brian De Palma 1983, Universal Pictures). 169
53. *Dressed to Kill.* 171
54. *Dressed to Kill.* 171
55. *Dressed to Kill.* 171
56. *Imitation of Life* (Douglas Sirk 1959, Universal Pictures). 181
57. *Body Double* 186
58. *Body Double.* 187
59. *Body Double.* 187
60. *Body Double.* 187
61. *Body Double.* 190
62. *Blow Out* (Brian De Palma 1981, Filmways). 193
63. *Phantom of the Paradise.* 198
64. *Dressed to Kill.* 198
65. *Blow Out.* 198
66. *Casualties of War.* 199
67. *Mission: Impossible* (Brian De Palma 1995, Paramount Pictures). 199
68. *Redacted.* 199
69. *Casualties of War.* 200
70. *Sisters.* 215

Acknowledgments

Like most other first books in this field, the current volume began as a doctoral dissertation – written, in this case, under the auspices of the departments of Communication and Culture and American Studies at Indiana University at Bloomington, where it was supported by a Chancellor's Fellowship. I remain indebted to my doctoral committee, chaired by Joan Hawkins and comprising James Naremore, Eva Cherniavsky, and Jonathan Elmer, for their patience and their exacting criticisms during its completion. I extend a further thanks to Dr. Hawkins and her husband Skip for their hospitality, their humor, their graciousness, and their good taste in all things. Were it not for you, Joan, this book could never have been written.

Additionally, I wish to thank those other scholars and university colleagues of mine with whom I have had such memorable conversations (and for some of whom I have written papers) about Brian De Palma over the years. At Oberlin: Irene Chien, M. X. Cohen, Daupo, W. Patrick Day, Doug Dibbern, Susan Fischman, Josh Fox, Paul Francis, the inimitable Daniel J. Goulding, Lisa Jervis, Chris Labarthe, Mark Ozdoba, Robert Kirkpatrick, John Sloat (esq.), and Greg Travis. At Columbia: Mark Andrews, Michael Barrett, Seth Ellis, Dan Friedlander, Josh Lanthier-Welch, Will Luers, Elise MacAdam, Caroline MacKenzie, Dave McKenna, Ralph Rosenblum (RIP), James Schamus, and Shira-Lee Shalit. At Indiana: Chris Anderson, Nathan Carroll, Tonia Edwards, Darrel Enck-Wanzer, Suzanne Enck-Wanzer, Nicola Evans, Erik S. Fisk (esq.), Jonathan Haynes, Vanessa Kearney, Jim Kendrick, Claire Sisco King, Jon Kraszewski, the unforgettable Roopali Mukherjee, Jonathan Nichols-Pethick, and Bob Rehak. I am also grateful for conversations and/or correspondence I had about De Palma with Ethan de Seife, Scott Ferguson, Norman Gendelman, Zac Harmon, Todd Haynes, J. Hoberman, Lawrence Levi, Kenneth MacKinnon, James Moran, Marcia Pally, Amy Rust, David Weintraub, and Linda Williams. Each of these good people contributed to this project in ways that they might or might not wish to recognize.

Thanks, too, to Bonnie Clendenning and Nancy May-Scott at IU for preventing me from missing all the important deadlines. And an extra thanks to Amy Rust at Berkeley for throwing a fine conference ("Documentation, Demonstration, Dematerialization: American Art and Cinema of the late 1960's and 1970's," at which an early version of Chapter 2 of this book was presented). Thanks also to the conference board of the Society for Cinema and

Media Studies for providing a forum in which ideas from this book were aired on more than one occasion.

A deep bow of gratitude and humility to the editorial staff of *Critical Inquiry* and *Cinema Journal* for their willingness to give this material a chance. And the same deep bow to Jelena Stanovnik and the staff at Intellect Press.

Thanks to Geoff Songs, of the *De Palma A La Mod* website, and Ari Kahan, of the *Swan Archives* website, not only for their work (which is essential) but also for their extraordinarily generous help to the author in acquiring certain permissions; thanks also to Ethan de Seife for connecting me to them. Thanks to the great William Finley for his gracious consent to use his image on the front cover of this book. Thanks to Trinh Dang at Twentieth Century Fox for her assistance in securing a license for that image.

I extend special thanks to the great Mr. Steve Chack of the late and lamented Naked Eye Video (SF), as well as to Nathan Carroll, for help in locating some of the more difficult-to-find movies. Nathan gets a third thanks for his *real* commitment to the notion of the archive.

Many thanks to Don Marvel and Elke Pessl for providing a crashpad on so many occasions, and similar thanks to Bob Rehak and Katie Kenyon. Bob gets a third thank-you for countless hours of great film conversation.

Thanks to The Pine Box Boys (and associated musicians and friends) for providing something *really* worthwhile to do with my spare time during the writing of this manuscript. And thanks to everyone in the Department of Cell and Tissue Biology at the University of California, San Francisco for providing me with such an accommodating workplace during many stages of this process.

Thanks to Tabitha Lahr for processing the frame grabs (and for the cheese grits). And an extra thanks to John Sloat for a last-minute dissection of this manuscript, and to Dr. Kearney for her last-minute save.

Thanks to Greg Travis, my chief enabler and instructor, for twenty years of potential infinity (mainly embodied in his answering machine).

Jonathan Haynes watched me tunnel through this mountain from across the bay at Berkeley. As one of the three founding members of the San Francisco Brian De Palma Theory Collective, Jonathan has been a constant inspiration and an excellent respondent – especially on September 15th, 2006, the day that *The Black Dahlia* landed in theaters (aka Black Friday). This book would be incalculably less without him.

Chris Labarthe, the other founding member of the San Francisco Brian De Palma Theory Collective, has contributed to this project in hundreds of ways, not least reading the manuscript with a relentlessly cold eye on more than one occasion. He and I have been talking about movies in general, and De Palma in particular, for the length of our friendship – twenty years now! – and the completion of this book is a testament both to his enthusiasm and to his influence.

(We of the San Francisco Brian De Palma Theory Collective, by the way, hereby *demand* the immediate release of the original cut of *Snake Eyes*.)

Acknowledgments

Thanks to Walter Becker and Donald Fagen for their album *The Royal Scam*, the *Blow Out* of rock music, which could just have well been the subject of this book if it were not for certain, uh, *disciplinary* requirements. I definitely won't do it without the fez on.

A respectful wave across the gulf of irreconcilable time to the late, great Robin Wood, whom I never met but who more or less set me on this path.

Thanks to Brian De Palma, for the greatest laugh I have ever had at the movies ("You're gonna *kill* somebody with that sundial!").

Finally, I wish to thank Ernest and Elaine Dumas, without whose support, both material and spiritual, I could never have completed the task. It is to them that this project is dedicated.

Of course if I have forgotten anyone, let me state that – to paraphrase Swan – all those *excluded* shall be deemed *included*.

<p style="text-align:center">***</p>

Portions of this volume have been previously published. A condensed version of Chapter 1 appeared as "The Zizekian Thing: A Disciplinary Blind Spot" in the Winter 2011 issue of *Critical Inquiry* (37:2), and a different version of Chapter 2 appeared as "Cinema of Failed Revolt: Brian De Palma and the Death(s) of the Left" in the Spring 2012 issue of *Cinema Journal* (51:3). Thanks to the University of Chicago Press and the University of Texas Press, respectively, for their permission to reprint these materials.

Introduction

The Case of the Missing Disciplinary Object

At some point (perhaps during Reagan's second term), everybody in the anglophone wing of Film Studies started trying to "reinvent" the discipline. From David Bordwell and Noël Carroll to Linda Williams and Christine Gledhill (and their opposing anthologies, *Post-Theory: Reconstructing Film Studies* and *Reinventing Film Studies* in 1996 and 2000), from Robert Ray's fascinating *The Avant-Garde Finds Andy Hardy* in 1995 to the recent explosion of scholarly work on cinephilia, from the tussle of positions in Lee Grieveson and Haidee Wasson's recent (and essential) origin-narrative anthology *Inventing Film Studies* (2008) to the mutually problematizing state-of-the-discipline articles by Dudley Andrew and Gertrud Koch in a Summer 2009 issue of *Critical Inquiry*, the community of Film Studies scholars has been – and still is – riven by sharp disagreements regarding borders between territories, by new divisions and re-mappings both of the object of study and the methods of study in themselves. This millennial and transparently utopian impulse to revisit and reconsider the discipline's origins and boundaries arose, to judge by the rhetoric that still accompanies it, not only from a sense that the discipline no longer produces interesting criticism, but also from the idea that the nature of the object of study itself has changed under our very noses – that is, "the cinema is dead," having been effaced or deleted by new, invasive technologies of the image. The recent proliferation, on the one hand, of new media, new narrative forms, and new electronic modes of production and distribution – a dilation of the object of study in complicated and unforeseen ways – and, on the other hand, of different *modes* of film study (Bordwellite historicism vs. Žižekian psychoanalysis vs. "practical" auteurism vs. queer studies vs. reception studies vs. Deleuzian readings vs. subaltern and postcolonial emphases, and so on) have conspired to decenter the discipline, which is facing – let us not forget – additional pressures from the increasingly corporatized university environment in which we distressingly find ourselves. Robert Ray evidently sensed this in the early 1990s, since the "historical turn" of the Reagan-Bush years was already producing a tension between speculative criticism of the *Screen* variety and the facts-only, no-interpretation-allowed approach of the Wisconsin school – a tension that moved him to assert (in the most spectacular way possible) the continuing utility, if not the primacy, of speculative criticism. However, if by the year 2011 this tension has lessened, it is only because the Wisconsin model of cultural study is currently dominant; those who practice 1970s-style theory have taken something of a defensive posture. The Sokal hoax has certainly had its ripple effect on Film Studies.

No doubt it is reductive to cast the tension within the discipline to just two positions: if anything, the discipline is more multiplicitous in its discourses than ever. But there is no denying that a struggle for dominance continues in every aspect of the discipline: witness, for example, the number of mutually exclusive positions that Dudley Andrew had to corral – to use his recurrent cowboy metaphor – in order to provide an overview of the "state of the discipline" in 2009 (Dudley 879–915). On the one hand, the Bordwell contingent has tried to wrest the discipline away from speculative models and toward a specific set of empiricisms: thus (in *Post-Theory*) the attacks on Žižek, Brecht, and the "aggregate of doctrines derived from Lacanian psychoanalysis, Structuralist semiotics, Post-Structuralist literary theory, and variants of Althusserian Marxism," as well as the stated idea that "solid research can proceed without appeal to the doctrines once held to form the basis of all proper reflection about cinema" (Bordwell and Carroll 1996, xii). On the other hand, the pro-theory wing insists that the infusion of European models of textuality in the 1970s continues to pay dividends, that – despite a certain *excess of enthusiasm* in the 1980s that helped to produce a lot of questionable scholarship – cinema can still be productively approached through psychoanalytic, Marxist, feminist, and other models. So on the one hand, there is a desire for precision and a rejection of the speculative, and on the other, a reaffirmation of the speculative accompanied by a painted-into-a-corner acknowledgment of the necessity of both the empirical and the historical. What both positions want, though, is multiplicity and localization: theories instead of theory, research instead of cant, liveliness instead of boredom, usefulness instead of inutility – in short, *success* instead of *failure*.

But how, exactly, can we say that we have "reinvented" film studies? To this reader, it looks more or less the same. Despite the struggles over the status of the object (struggles that, despite their changing vocabularies, are hardly new), the discipline still operates by the model set out fifty years ago by the staff of *Cahiers du Cinéma* – an attention to repudiated genres (in 1955, the western; in 1995, pornography; in 2011, torture porn), the close attention to the grammar of specific texts, an emphasis on the historical dimension of the object. Increasingly left aside by both positions are *Cahiers*-style auteurism and the related impulse to address questions of comparative aesthetics, that is, *this* director is better than *that* one; the only real dispute is over the *Cahiers*-derived idea that theory is necessarily precedent to practice, and that dispute is really a quibble over the meaning of the word "theory." (I myself am not convinced, by the way, of the need to escape the *Cahiers* paradigm in any of its aspects.)

Despite the lopsided struggle between the Wisconsin school and the *Screen*-style theorists, however, the real openness of either position to new ways of considering the history and foundations of the discipline is far from clear. As we know, the institution of academic Film Studies in the United States has a long and complicated history of its own. Even setting aside the European discourses around film study (Eisenstein, Kracauer, *Cahiers*, &c.) that predate the advent of the discipline within the American academy, we have – as I write this, in 2011 – forty-odd years of increasingly sophisticated (and increasingly sedate) university-sponsored argument about the status and nature of a *quasi-object* – The Movies – which

remains, even in the age of Television Studies and New Media Studies, the privileged term in a constellation of discourses centered around moving images. And the tension regarding the future of Film Studies, in a certain way, is a contest over its history and foundations: what it has seen and what it has not seen, what it has produced and what remains unproduced, what it has theorized and what remains invisible to it.

The term *quasi-object* comes from Bruno Latour, who theorizes about the status of objects such as (for example) washing machines or parliamentary democracy, which are all at once *social* objects, *technical* objects, *discursive* objects, and *political* objects. If Latour's theorization is sound, then we could consider not only "the movies" but also "Film Studies" itself as quasi-objects: therefore Laura Mulvey's "Visual Pleasure and Narrative Cinema," to take a particularly focal example, would be an object of social and institutional pressures and knowledge, an object of technique (i.e. both a piece of machinery to be mobilized and a goal-directed product of theorization and experimentation), an object of discourse (being both a product of and an example of discourse, as well as *producing* discourse, i.e. thousands upon thousands of citations) *and* an object of politics (in the sense of defining politics as well as acting upon, and being acted upon by, politics). It makes sense, then, that Film Studies as a category of discourse or knowledge would also be a quasi-object: it comes into being as a result of dozens, hundreds, thousands of various pressures, movements, statements, experiments, premieres, and interventions – not only from within the academy, but also from journalistic treatments of film (from *Variety* to Roger Ebert), infinitely proliferating fan cultures on the internet and elsewhere, and – to be sure – the ineffable, unquantifiable personal tastes of each and every participant in the system, not to mention each participant's own way of theorizing his or her spectatorial affect (or lack thereof). Given these pressures and this recent history, are there any questions that the discipline is *not* asking?

One way to approach this question would be to ask another: what was the last film that started a real conversation across the entire discipline? Let's imagine what sort of hypothetical film would be able to precipitate a discussion that engaged *all* the multiple strands of Film Studies today. First, it would need to be a daring and experimental fusion of old and new media, mixing the analog and the digital, YouTube and cinema, fiction and documentary. In order to get the attention of auteurists (as well as scholars who track fan discourse) it would need to be the work of a "name" director – and yet it would also need to be a true transnational text, operating on post-Hollywood models of funding, production, and distribution. It would need to be *relevant*, and since one might say that the best marker of a film's relevance for Film Studies – especially after Todd Haynes's *Poison* – is whether the right wing has attacked it, we would therefore be looking for something that has been denounced by, say, Bill O'Reilly. And in order to engage feminism(s) and postcolonial scholarship, this hypothetical film would need to be about gender and violence, ethnicity and nationalism, power and resistance; in other words, it would need – to reference Judith Butler – to be about "bodies that matter."

And yet in 2007, when this exact film – Brian De Palma's *Redacted* – was released, there was no conversation, no argument; it did not register on Film Studies radar at all. No one even

went to see it, despite the fact that *Redacted* is about *everything* that we claim is important to us. Why might this be so? Could it have something to do with how Film Studies views its own history? Might it have something to do with a causal relationship between politics and taste?

* * *

In a way, this book is actually two books inextricably woven together. The first of them is an examination of Film Studies as a discipline, asking the kinds of questions outlined above. The second book is about a controversial American film director, and in certain crucial ways it resembles a traditional "auteurist" study. Let us introduce Mr. De Palma via a career profile in a canonical reference work – a book that claims to provide an authoritative, one-stop guide to the *basic facts about film for scholars of film.* The writer is David Thomson (admittedly, not precisely a dispassionate or clerical contributor to the discipline), and the entry is from *The New Biographical Dictionary of Film,* which was recently crowned (by a poll in *Sight & Sound*) the most important film book of the twentieth century:

> There is a self-conscious cunning in De Palma's work, ready to control everything except his own cruelty and indifference. He is the epitome of mindless style and excitement swamping taste for character. Of course, he was a brilliant kid. But his usefulness in an historical survey is to point out the dangers of movies falling into the hands of such narrow movie mania, such cold-blooded prettification. I daresay there are no "ugly" shots in De Palma's films – if you feel able to measure "beauty" merely in terms of graceful or hypnotic movement, vivid angles, lyrical color, and hysterical situation. But that is the set of criteria that makes Leni Riefenstahl a "great" director, rather than the victim of conflicting inspiration and decadence. De Palma's eye is cut off from conscience or compassion. He has contempt for his characters and his audience alike, and I suspect that he despises even his own immaculate skill. [...] De Palma is a cynic, and not a feeble one: there are depths of misanthropy there.
>
> De Palma was the son of a surgeon, and he has been heard to joke that that may account for his high tolerance of blood: the movie director as glib interviewee. [...] His films of the sixties were nearly underground: cheap, inventive works of cinema-verité, pulp satire, and comic-book essay form. They showed the mark of Godard [...]. Their originality is worth underlining, because the films were and are very little seen, and because their humor and their interest in the world has been replaced by a sardonic imitation of Hitchcock's engineering moves.
>
> De Palma wanted to make more popular pictures – a very American trait, but a good illustration of the choice between independence and commercialism that faces the film student. [...] De Palma absorbed Hitchcock's storyboard preparation, and his films are easily the closest screen approximation to the Master's grid system for anguished characters. The elegance of the pictures is in churlish opposition to the pain the people suffer.

Carrie is anything but turgid, but crazy with startling presence and sensational event. It was De Palma's greatest hit, and his most showy film. [...] But the cruelty of the plot, the poisoned sundae of humiliation, revivalist hysteria, and telekinetic effects are grotesque. It is a parody of a well-made film, as it keeps on battering you with its own style. Can a holocaust be tidy too? [...] *Carrie* is the work of a glittering, callous surgeon who left his knife in the body. [...]

De Palma has lost many of his old allies in the last decades – and he hasn't won me.

(Thomson 2004, 233–234)

Here, then, are *the facts* about Brian De Palma, as presented in the canonical film reference guide. He is vicious, empty, glib, a cynic, an exploiter, void of ideas or conscience, with depths of misanthropy in place of an authentic personality and, in the end, few admirers left to sob over the loss of what little promise he once had. De Palma has *some* talent of *some* kind, Thomson admits; he even prefers the new *Scarface* to the Hawks version, certainly a minority view among film critics of a certain generation. But Thomson is compelled to single out the director for a special kind of emphasis: De Palma has value to an historical survey of the art form precisely because he represents *the worst impulses that can be expressed in it.* Amazingly, given the book's claim to historical authority, Thomson does not mention the groundbreaking feminist boycott of several of De Palma's films in the early 1980s; perhaps this is because he has little or no sympathy for feminism in general. But Thomson scarcely needs to mobilize feminism to condemn De Palma; to do that, he can simply compare him to Leni Riefenstahl.

This is a fairly typical and representative example of the predominant rhetoric that De Palma inspired within the anglophone wing of Film Studies, as well as within film journalism, at the moment that Ronald Reagan occupied the White House. After the 1980 release of *Dressed to Kill*, De Palma symbolized – and, even now, continues to symbolize for many (if no longer the majority) of film academics, as well as mainstream film critics, in the United States – a certain excessiveness, a certain ferocity, a certain tastelessness that is too offensive *not* to identify, but also too *obvious* to discuss in any depth.[1] This dismissal was symptomatic of the 1980s, when what is often described as a national turn away from utopian politics and toward "the family" made De Palma's baroque style and larcenous approach to film history (not to mention his willingness to hyperbolize everything from intergender violence to racial discord) anathema to the very terms of the shared social project. It is my contention that "Brian De Palma" marked a uniquely *nervous* site in American culture of the Reagan 1980s – an intersection of pornography, history, authenticity, textuality, national identity, and the

[1] The rise of internet-based film criticism has begun to change all that (witness *Slate* Magazine's smart and thorough section on De Palma in the weeks before the release of *The Black Dahlia*). And of course De Palma has always had partisans, from Roger Ebert and Pauline Kael to Robin Wood and Kenneth MacKinnon. But even now, as A. O. Scott (2006) has pointed out, uttering the name "Brian De Palma" in a room full of film scholars is guaranteed to have an inflammatory effect on the gathering.

self-narratives of Left activism (not to mention the great triad of race, class, and gender). At the very least, "De Palma" marked the spot at which the notions of the author and the death of the author fundamentally recurse into one another – a recursion that Anglophone critics, both professional and lay, have never successfully navigated.

As of this writing (in 2011), De Palma has finally been recuperated (to an extent) by mainstream cinephiles; after all, *Blow Out* has its place in the Criterion Collection and *Scarface* has forced its way, guns blazing, into the canon of American popular masterpieces. Even so, academic Film Studies still has very little use for De Palma, either as an object of study or as a classroom tool. (Every undergraduate has seen *Scarface*, but how many of them have been told about the N.O.W. boycott?) Like every discipline Film Studies has its blind spots, and De Palma is one of them. I wish to suggest that, if we want to understand what the Reagan 1980s were really about – in other words, what has happened in Film Studies since the "death of the Sixties" – we cannot ignore films like *Phantom of the Paradise* or *Body Double* (or *Redacted*). What is so puzzling, in this context, is De Palma's continued invisibility to the very discourses that most need to encounter him. The notion alluded to in the book's subtitle – the "Political Invisible" – is that any system of representation (whether that be a textual formation, like "Hitchcock" or "Godard", or a social formation, like "academic Film Studies" or "feminism") is structured around a fundamental impasse, a singular unrepresentability – let us say "an Invisible" – that marks the system at its core and constitutes its primal scene. What is this impasse for Film Studies? I propose that De Palma can show us the answer.

In order to address this lacuna, *Un-American Psycho* poses a set of questions about contemporary American political and social culture, using the films of – and the discourses surrounding – De Palma as a foundation for this inquiry. It explores the representational logic of the "failure of the 1960s" as it was narrated in American films in the years between LBJ and Reagan, from Captain America's infamous "We blew it" in *Easy Rider* to the final moments of *Casualties of War*; it also concerns the roughly contemporaneous formation and consolidation of Film Studies as a discipline in the American academy, and the nature of the techno-political enterprise that has been its object. It discusses the "failed encounters" between De Palma and feminism, and between De Palma and Hitchcock Studies. Lastly, it places De Palma – or, rather, "De Palma" – in extended dialogue with other controversial figures in film authorship in order to provide a broader schematic for understanding the specific narrative, stylistic, and political gestures that gained De Palma so much notoriety during his career. In other words, "De Palma" is treated here as a quasi-object: what a representative baby boomer academic (or film journalist) can be assumed to think when he or she hears the words "Brian De Palma" is just as much a part of this object as, say, the DVD of *Casualties of War* that one sees marked down to $3.99 in the cutout bin at Wal-Mart.

* * *

One of the motivating reasons for this project is the paucity of serious critical writing on De Palma in English. (The French, in nearly all matters cinematic, are *way* ahead of the

rest of us.) As is often the case with controversial figures, one is either for De Palma or against him, since a neutral "middle ground" is simply impossible: either one directly or indirectly declares sympathy with his project as one understands it, or one repudiates his project (usually directly) – again, as one understands it. I will discuss the rhetoric of those who are "against" De Palma in Chapter 1, so we need not consider them in this introduction. But those scholars who see "something more going on" in (for example) *Body Double*, are few and far between, and it would be proper to address them now.

There have tended to be two kinds of "positive" or "sympathetic" approaches to De Palma. The first is that he is an *auteur*. In other words, his films have a set of common themes that express his personality, and these themes are neither banal nor self-contradictory nor corrupt; these themes, therefore, become the guarantee of the authenticity of his artistry. In this category we find works like Michael Bliss' *Brian De Palma* (1983), Laurent Bouzereau's *The De Palma Cut* (1988), John Ashbrook's *The Pocket Essential Brian De Palma* (2000), and Eval Peretz's *Becoming Visionary* (2006), all of which – given the defensive stance they tend to take in regard to the feminist reservations about *Dressed To Kill* or *Body Double* – choose to depoliticize the films.[2] The effect is sometimes one of shallowness and deracination, since all this approach delivers to the reader is the knowledge that the narratives of De Palma's films often concern *peeping* and that they occasionally feature sets of *matched doubles*. Further, the traditional auteurist route can only conceptualize De Palma's "use" of Hitchcock in terms of homage or tribute *a la* Bogdanovich, which is an insult both to the attentive viewer and probably to De Palma himself. What is more, how does one construct an old-style auteurist reading that could include both *Hi, Mom!* and *The Bonfire of the Vanities*, or both *Dionysus in '69* and *Wise Guys*? Even Peretz's book – which positions itself as a Stanley Cavell-style philosophical workout, trawling through *The Fury* and *Blow Out* for the ways in which De Palma figures "vision" and "perception" as constitutive of the Platonic subject – can only move De Palma into conversation with Film Studies by comparing him to Murnau, Dreyer, Bresson et al. There is a lot to say about De Palma, but comparing him to Dreyer is like praising Chantal Akerman for her skill with a car chase. If De Palma is a Great Director on the order of (say) Renoir or Kiarostami – and there are equally compelling arguments for *and* against this idea – it is not because he is a philosopher of subjectivity but, I think, because he is a satirist.[3]

After the old-style (and new-style) auteurists, the other type of "sympathetic" reading of De Palma is that which attempts to locate a political consciousness in his work. The most

[2] One might also mention several journal articles that treat De Palma exclusively in auteurist terms and thereby drain his films of their political content and context – see, for example, Hennelly, Jr. (1990); Robert E. Wood (1986); and Wayne Stengel (1985, 1987). These articles, all about *Body Double*, constitute a perfect object-study in how to use auteurism to evade political questions. There was, of course, a set of feminist counter-texts, many of which will be discussed in Chapter 3.

[3] As to the "great director" question, one might say that in general De Palma's worst movies are worse than the worst of, say, Welles or Mizoguchi, but are certainly not worse than the worst of, say, Chaplin or Bergman.

significant of these is without a doubt Kenneth MacKinnon's *Misogyny in the Movies: The De Palma Question*, which appeared in 1990 – six years after the furor over *Body Double* – and which attempts to "save" De Palma for feminism, or at least to clarify the terms of the debate, in much the same way that Robin Wood attempted to save Hitchcock in his *Hitchcock's Films Revisited*:

> It may be time to reopen the closed book, and in particular to reassess those De Palma movies which are now widely taken as self-evidently misogynistic, to be not so much about objectification and pornography as themselves objectificatory and pornographic. [...] The more detailed readings of these films are undertaken less to praise or blame De Palma the filmmaker, much less De Palma the man, than to suggest the complexity of the reading process, particularly when informed by feminist theory. The reopening of this closed book may result in the reopening of others taken to be "bad objects."
>
> (MacKinnon 1990, 20)

MacKinnon's analysis is theoretically solid and *extremely* carefully argued, although – mysteriously – he has very little to say about *Blow Out*, the closest thing to a *Lehrstück* that De Palma ever created. My argument in Chapter 1 will in many ways recapitulate MacKinnon's, especially in the presumption that De Palma represents a bad object for feminism. But it is also true that the attempt to find in De Palma an uncomplicated position of sympathy toward feminism, or identification with its goals, is bound to run aground. As I will argue, De Palma – like many other men within the New Left of the Nixon years – is able to identify with feminism largely insofar as its failure can map onto his own failure. MacKinnon's book, nonetheless, remains the standard book-length work on De Palma, and it is symptomatic (and illustrative of the conceptual lacuna we face when considering our subject) that it was ignored at the time of its release.[4]

Wood's work on De Palma has some assumptions in common with MacKinnon's, but moves past the antagonisms between feminism and De Palma toward a larger understanding of De Palma's political project. Wood finds *Sisters* to be deeply, even overtly feminist, and regarding *Blow Out*, he writes that

> the attitude to the American political system is characteristically pessimistic: the electorate can only choose between corrupt liberalism and corrupt conservatism, the corruption presented as all-pervading and irredeemable. One would scarcely wish to argue with such a view. The problem is, of course, the one I have already indicated in relation to progressive Hollywood cinema generally, but in De Palma's work (and this is both its major distinction and its major limitation) it reaches its most extreme expression: the blockage of thought arising from the taboo on imagining alternatives to a system that can

[4] Even after consultation with MacKinnon, I was able to locate only three reviews of the book in any English-language peer-reviewed journals, two of them hostile.

be exposed as monstrous, oppressive and unworkable but which must nevertheless not be constructively challenged. Cynicism and nihilism: the terms can no more be evaded in relation to De Palma than in relation to Altman. Obviously, De Palma's work suffers – as any body of work must – from an inability to believe, not necessarily in systems and norms that actually exist, but in any imaginable alternative to them. Yet it seems to me that his work is less vulnerable to attack along these lines than Altman's. At least he never hides behind the superior snigger, never treats his characters or his audience with contempt, and in his best films his thematic concerns achieve remarkably complete realization. Undoubtedly compromised from a purely feminist or purely radical viewpoint, his films offer themselves readily – one might say generously – to appropriation by the Left.

(Wood 1986, 159–160)

And yet the Left, like Film Studies, has not come around to De Palma. How could it, given the fact that De Palma, according to Wood, presents a world in which radical alternatives or solutions to injustice and suffering are unimaginable, that failure is inevitable, that the choice between Left and Right is a choice between two kinds of corruption? (Curiously, Film Studies has no problem with this worldview when it is presented by someone like Fassbinder.) Both MacKinnon and Wood address themselves, rhetorically, to an audience – feminists for MacKinnon, the Marxist Left for Wood – who have *misrecognized* what is "really there" in De Palma. But what both MacKinnon and Wood themselves misrecognize is that this "missed connection" between De Palma and feminism – or between De Palma and the Left – is not only endemic but constitutive. (Every utopian discourse needs a bad object.) Nevertheless, MacKinnon and Wood remain among the few film scholars writing in English who have placed De Palma in anything like a proper context.[5] And while the sphere of journalistic film criticism in the United States (helped along by the double pressures of European opinion and Tarantino-style fan discourses on the internet) is slowly beginning to rehabilitate De Palma's work, very few mainstream critics understand De Palma's project to be a political one. The most notable of these is certainly Armond White, and White is enough of an old-style auteurist to have attempted to locate, in the profoundly compromised *The Bonfire of the Vanities*, a pure expression of this project (White 1991).

Similarly, while certain De Palma films have been the object of many a productive critical gaze – the various feminist treatments of *Carrie* come immediately to mind (Carol Clover's and Barbara Creed's being the most canonical), as does the burst of articles on *Casualties of War* that appeared in the mid-1990s – there still has been no sustained attempt in the English-speaking branch of Film Studies to grapple with such nominally bizarre facts as the centrality of De Palma to the aesthetic of the editorial board of *Cahiers du Cinéma*,

[5] The single-most clear-thinking article on De Palma in English – even though it nominally is not about De Palma – would have to be Paul Ramaeker (2007), "Notes on the Split-Field Diopter," in *Film History: An International Journal*. Some others that particularly bear citing are Librach (1998); Steiner (1982); Cvetkovich (1991); Coykendall (2000); Bautista (1984); Straw (2007); Greven (2009).

which improbably named *Carlito's Way* the best film of the 1990s, or – most notoriously – the extraordinary rhetorical importance of *Scarface* to various minority cultures in the United States and across the world. (De Palma himself is the only person involved with the production of *Scarface* who does not seem surprised by the fact that it has become the single-most widely influential film of the last thirty years.) And, of course, there is *Redacted*, which caused a critical stir in Europe but which, in the United States, had the misfortune of having to compete for critical attention with such comment-worthy films as *Knocked Up* and *Hostel 2*.

What is missing from the field of Film Studies – or from the absent field of De Palma Studies – is any sort of attempt to draw together these different aspects of the system we would call "De Palma," nor a sense of how that system might once have been the site of so much cultural contestation.[6] This is because, in many ways, De Palma even today remains a blank spot in the history of American cinema. Originally, there was Brian De Palma, the improvisatory New York underground filmmaker whose draft-dodger comedy *Greetings* was the first feature film to address the resistance to Vietnam (and the first feature to earn an "X" rating from the Motion Picture Association of America); this is the De Palma who talked about "the revolution" during television interviews and who wanted to be, as he himself put it, "the American Godard" (see Gelmis 1970, 29). What is the relation between this forgotten De Palma – that is, the De Palma who was once shot by a cop (see Chapter 3) – and the De Palma who, twelve years later, would direct the notorious *Dressed to Kill*, object of a groundbreaking feminist boycott? Would this relation be a structural one (a tracing of common features across the films) or an historical one (a tracing of common features across the discourse *around* the films), or do these registers map onto one another – and if so, how so? In other words: what is, and what is not, an adequate approach to understanding the cultural role of filmmaking, and how would one apply it to this particular set of works?

De Palma's is a particularly interesting case in that the themes that accreted around him helped to obscure his movies and to make them, to a certain gaze, more or less invisible, especially once his Reagan-era notoriety had evaporated. (In terms of the ideal cultural climate for his work, De Palma could not have asked for a worse fate than the election of Bill Clinton.) This continued invisibility has meant that a certain set of issues, which intersected in and around De Palma's work during the 1970s and 1980s – and for those years, I argue, *only* in De Palma's work – have always been occulted with regard to one another. This is most noticeable around the intersection of authorship and misogyny: as I argue in Chapter 1, the appearance of *Dressed to Kill* at a precise historical moment could not help but fulfill a certain need within both feminism and traditionally auteurist Film Studies for a certain

[6] Eval Peretz, symptomatically enough, punts on this question. Comparing De Palma to a string of major film artists like Bresson and Minnelli, he writes, "That De Palma has not been viewed this way so far, and, even more than that, that he has been often derided and viewed with contempt, especially among American critics, is itself a fact raising highly interesting questions, but it is a matter for another study and is beyond the scope of this book" (Peretz 2006, 18). The present volume is that "other study."

kind of *bad object*. Can this collapse of registers have been anything but reactionary? This is not to second-guess the feminist response to both *Dressed to Kill* and *Body Double*; nor is it to contest the idea that De Palma's is a cinema of misogyny, even a cinema of sadism. The operational stance of this book, the *a priori* assumption about the most controversial aspect of De Palma's work, is this: *of course* De Palma is a misogynist; given the fact that he *is* – that the majority of the men of his generation are – I do not know how he could be expected *not* to be. At all times I operate on the assumption that De Palma's cinema is symptomatic, as many scholars have suggested. However, I also do not think that De Palma is any more misogynist or sadistic than any of the other ranking American directors of the 1970s; I would suggest, instead, that he is alone among his male peers in his troubled awareness of the problems toward which feminism mobilized itself during the era. (On the other hand I would also suggest that his *effectiveness* as a genre filmmaker, working with highly affective material such as murder and rape with nearly unlimited *technical* skill, has something to do with the kind of reactions his films provoke.) I propose that we acknowledge his misogyny in its proper context, that of male American film directors working in the post-Hays Code studio system; and then that we shift our perspective on the subject by asking how what we identify as his misogyny works rhetorically and, more to the point, how it generated, how it was meant to generate, a certain set of responses in a certain kind of audience. To put it in Lacanese: how did De Palma and Reagan-era feminism constitutively misrecognize each other?

Since I will be talking about various kinds of failure (failed communications, failed revolutions, failed films, &c.), what will be needed for this argument is a context for De Palma's films that takes into account the turbulence and interrelation among registers that marked the last half of the "American Century" – the relations, for example, between the aspirations of the New Left and the continually evolving struggle for women's rights, or the relations between the ideal of "personal" filmmaking and the quotidian reality of film finance. In this regard I have found it necessary to be mindful of what Reinhard Kosselleck tells us about historical knowledge, that it is not generated by the victorious but, rather, by the vanquished – that the primary question of historical inquiry, especially when it is conducted by the historical participants themselves, is inevitably "what went wrong?" After all, this would seem to be one of the primary preoccupations of De Palma and his cinema, since it is figured at the structural level in nearly every film he has directed, even those that he himself did not write.

Most importantly, this book will attempt to recognize that it is, at all points, an act of translation: not a translation between languages, like French to English (the process that created much of what we understand to be the intellectual wellspring of Film Studies in the last fifty years), but a translation between registers – most directly, between the register of the feature-length narrative film and the register of the peer-reviewed, tenure-packet-building scholarly publication. It has always seemed to me that Film Studies (in particular, as opposed to the Left academic project in general) constantly engages in this translation across registers while refusing to recognize that it does so. This is how dozens of scholars can every year publish excursuses on Hitchcock, his gaze, and his productive-theoretical

machinery – excursuses that are exclusively, often aggressively, aimed at a peer audience to the exclusion of those who, at least nominally, would most benefit from their insights (that is, "the public") – while simultaneously imagining that they are saying something that the films themselves do not already make explicit.

More often than not, we in the discipline operate from the assumption that Hollywood narratives do not, and cannot, directly express their theses – and that this is so because American filmmakers are not theoreticians (and Hollywood film, unless it looks exactly like *All That Heaven Allows*, is not theory). I think this assumption is a terrible mistake. Brian De Palma may not be able to index his decisions (narrative, structural, visual, political) by reference to the standard journals or the basic French theorists; he may be – he *is* – disastrously, perhaps willfully, inarticulate in interviews, often coming off as something of a grandiose adolescent. One might also choose to read De Palma as deliberately evasive, in the way that Hitchcock is understood to have been; or one might see De Palma as not having attempted to translate the cinematic product of his thought processes into the kind of discourse we would expect in a graduate seminar. (In other words, maybe he is cagey, or maybe he just has not done his homework.) But one must not imagine that De Palma – or, indeed, any filmmaker – *does not theorize*. I would suggest that *Body Double* is just as much a product of a process of theorization as *Men, Women, and Chain Saws*, and it should be understood as such. While De Palma may not know (for example) the work of Foucault, he certainly worries over – considers, theorizes, mobilizes – the interrelationship between power and resistance; similarly, one might say that De Palma's understanding of Brecht is incomplete, even undergraduate, but the influence is undeniable. Most importantly, De Palma may not have read Žižek (or even Rothman or Mulvey), but he certainly theorizes about Hitchcock as a system – and in more depth and with more acuity, I might add, than the bulk of what we might call Hitchcock Studies.

<p align="center">* * *</p>

This book is divided into three chapters and a conclusion. The first chapter, "Shower Scene," attempts to reposition De Palma in regard to Hitchcock, and thereby to Film Studies itself. The second chapter, "Get to Know Your Failure," discusses De Palma's relationship to Jean-Luc Godard and to the New Left. The third, "The Personal And The Political," discusses De Palma "in himself" – as a theoretician, as a political artist, and as an evidently reluctant cog in the industrial machine we call Hollywood. Finally, it is in the concluding chapter that the impatient reader will find an explication of this book's title. Be warned that I have elected to structure my argument in a kind of spiral fashion: the book does not move through the films in chronological order, and certain themes (the "screen–audience analogue," the problem of psychobiography, the idea of *père-version*) appear multiple times and in different contexts, hopefully gaining new meaning with each recurrence. I also depart from the scholarly template in *withholding* certain information until late in the game, as if this were a detective novel rather than a linear march through a set of theses. This is bound to strike some readers as a frustratingly inefficient and even *precious* way to do things; I can only beg the reader's indulgence.

Two further caveats are in order here. First: this is not intended to be a "definitive" book about De Palma. For example, I have chosen not to spend much time on certain important films – *Carrie*, *The Untouchables*, *Carlito's Way*, *Femme Fatale* – that would, if read in any detail, take us far afield from the central thesis. (Anyway, *Carrie* deserves its own book.) There are many other books to be written about De Palma: about the stylization of performance in his films (Al Pacino, William Finley, Michelle Pfeiffer, John Lithgow, Fiona Shaw, Sean Penn, Dennis Franz, Nancy Allen, Gregg Henry, the entire cast of *Redacted*); about his use of the split diopter or the widescreen frame or the split screen or the Steadicam or AutoCAD; about the way he mobilizes Kubrick or Polanski or Peckinpah or Anthony Mann – indeed, about De Palma's understanding of film history in general. Rather than attempting to be definitive in this regard, I have concentrated instead on a specific and narrow set of issues that run through De Palma's work and that circulate around it, at the expense of providing a real film-by-film overview. It is my hope that *Un-American Psycho* will help to lay the groundwork for future De Palma scholarship.

The second caveat has to do with the conclusions I draw about De Palma's cinema. De Palma, I argue, has a *position*, a logical and ethical one, in regard to that quasi-object that we on the Left call "the Political" and especially to feminism and the legacy of the 1960s. I want the reader to understand that I do not necessarily *agree* with this position, in particular the way that De Palma, as a former radical amongst so many, has conceptualized the notion of "failure." (My parents, for example, would take severe exception with De Palma in this respect.) The goal of this book, instead, is to provide a new context for the consideration of De Palma, and to "translate" his cinema into a technical language and for a discursive community – that of Film Studies – that previously has been unable to speak him.

The historical narrative does not, as narrative, dispel false beliefs about the past, human life, the nature of the community, and so on; what it does is test the capacity of a culture's fictions to endow real events with the kinds of meaning that literature displays to consciousness through its fashioning of patterns of "imaginary" events. Precisely insofar as the historical narrative endows sets of real events with the kinds of meaning found otherwise only in myth and literature, we are justified in regarding it as a product of *allegoresis*. Therefore, rather than regard every historical narrative as mythic or ideological in nature, we should regard it as allegorical, that is, saying one thing and meaning another.

– Hayden White, *The Content of the Form* (1987, 45)

Chapter 1

Shower Scene

I feel about Hitchcock the way I feel about Freud.

<div align="right">– Ann Cvetkovich (1991, 147)</div>

Let us begin with a sequence from *Phantom of the Paradise*, a film that Pauline Kael (1976, 367) described as "slapstick expressionism." Talentless rock chanteur Beef is in his dressing room, preparing for his debut on stage at the "ultimate Rock and Roll palace," the Paradise, a grand Gothic pile owned by the Mabusean rock entrepreneur Swan. The program tonight is a glam-rock musical version of *Faust* (and – as in *The Red Shoes* the performance-text at the center of the film structurally mirrors the movie that contains it). Beef has the opening-night jitters, and he has got them hard – how do we know? Leaving aside the fey, melodramatic tics of Gerrit Graham's jerky, eye-rolling performance, which are clearly overplayed for a properly Frank Tashlin/Charles Ludlam effect, we might cite the cigarette, pills, and cocaine that Beef ingests all at once, or perhaps the Sirk effect of Beef's reflection in the dressing-table mirror. We recognize the backstage cliché and think, perhaps, of Judy Garland or any of Jacqueline Susann's heroines, although at this point (1974? 2012?) there are any number of cinematic quotations that each of us, as viewers, might immediately recognize: so far, barely an hour into the film, there have been explicit references to *Rear Window*, *The Hunchback of Notre Dame*, *Touch of Evil*, *The Red Shoes*, *A Star is Born*, *The Devil and Daniel Webster* (among other permutations of *Faust*), *Citizen Kane*, *The Cabinet of Dr. Caligari*, and (of course) *Phantom of the Opera*, so from moment to moment, literally anything can happen – anything, that is, that has *already happened in another movie*.

Case in point: Beef gets up from his dressing table and walks into the bathroom, taking a moment to smile wanly at the surveillance camera that spins to watch him before slamming the door in its eye. Beef drops his bathrobe and enters the shower. He turns on the water and begins singing the opening number from the *Faust* cantata. As he sings, the camera tracks 180 degrees around Beef, through the cutaway wall of the shower and suddenly into a familiar perspective: a human figure in foreground, facing frame right into the stream of water from the shower head, with a translucent shower curtain behind. In the background left, the door. A "fright chord" has entered on the soundtrack (which is not how Bernard Herrmann did it, but no matter) and the door opens to reveal the Phantom, a figure in a red-and-black cape and exaggerated silver bird mask. The Phantom creeps toward the shower and then, in a brief spasm of montage, cuts open the shower curtain with a knife and – rather than committing the horrifying murder that is supposed to come next – seals

Beef's yelp with a toilet plunger. In his mangled electronic speech, the Phantom warns Beef never to sing his music again – or else. Beef fearfully nods his assent and then, released from the grip of the plunger, he slips downward out of frame, hitting the floor of the shower with a wet *thump*. Cut.

In one way, this is Brian De Palma's first "shower scene." In another way, it is not: structurally speaking, De Palma has already replayed *Psycho* in its entirety in the form of *Sisters*, and although in that film the structural gesture we might call The-Unexpected-Murder-of-the-Main-Character-One-Third-of-the-Way-into-the-Film does not take place in a shower, its appearance retains the narrative logic of its progenitor. (There is even a girl-showering-before-being-murdered passage in *Murder a la Mod*.) In *Phantom of the Paradise*, however, the scene appears in its "literal" rather than its structural form: shower, person in shower, shower curtain, figure behind curtain, knife, screaming, montage, aggressive musical score for strings (or low-budget electronic approximation thereto). Thus in *Sisters* and then in *Phantom*, the "shower scene from *Psycho*" has been

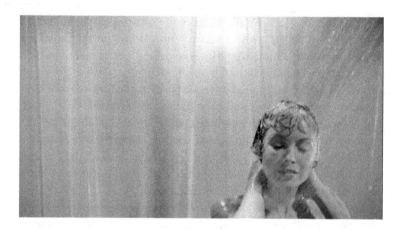

twice instrumentalized: once as an abstractly conceptualized link in a chain of narrative reasoning, and once as a purely literal and visual effect, a series of image-referents that add up to a "quotation."

After *Phantom of the Paradise* – which predated *The Rocky Horror Picture Show* by a year – De Palma would "engage" Hitchcock as a set of useful narrative, structural, and visual strategies in every single one of his movies, at both macro- (*Obsession* = *Vertigo*, *Dressed To Kill* = *Psycho*) and micro-registers (the "shower scene" in *Scarface*, the appearance of the massed umbrellas from *Foreign Correspondent* in *The Bonfire of the Vanities*, the "romantic" fireworks from *To Catch a Thief* in *Blow Out*, the *Rififi*-via-*Marnie* theft sequence at CIA headquarters in *Mission: Impossible*). Sometimes these deployments take the form of a "quotation," as a signal to a certain kind of viewer that a specific Hitchcock moment is being invoked; sometimes they are used invisibly, as dangerously sophisticated machinery for a specific affective goal, a set of grammatical cues designed to provoke a certain kind of audience response. *Dressed to Kill* is an ideal example of both types of use occurring at the same time.

Of course Hitchcock is not the only director on De Palma's mind; one could write a book about the other texts that De Palma "puts to work." Here one would include (for example) *Battleship Potemkin*, *The Discreet Charm of the Bourgeoisie*, *Céline et Julie vont en bateau*, *Last Tango in Paris*, *The Wild Bunch*, *Once Upon a Time in America*, *Model Shop*, *Zazie dans la Métro*, *La Nuit Américaine*, the Beatles films of Richard Lester, Nick Ray's *Party Girl*, the Maysles and Pennebaker ouevres, the films of Sam Fuller, and the work of the Italian modernists, particularly Antonioni – even (and especially) *Zabriskie Point*, evidently a pivotal film for De Palma. However, it is the relation to Hitchcock that has always occupied the center of most discourse about De Palma, even though few of his mainstream interlocutors have seen fit to think very carefully about the nature of this mobilization.

The point is not that De Palma is so often derided as a "technician" but that this focus on the technical – that is to say, on instrumentalization and directed experimentation – is not recognized as a highly developed strategy. Given that the emphasis in most of the canonical academic treatments of "postmodernism" (Jameson, Harvey, Lyotard) on an element of pastiche or quotation as a presumably new way of creating cultural meaning generally frames this tendency as reactionary or ahistorical, as a necessary structural component in the soul-destroying march toward global ultra-capitalism, it is surely no surprise that De Palma's engagement with Hitchcock – unlike, as we shall see, his engagement with other coherent directorial sign-systems such as those of Godard or Kubrick (or Peckinpah or Polanski, for that matter) – is the primary mechanism by which De Palma has so often been hoist with his own petard.

Why, exactly, is Hitchcock so "useful"? On the one hand, there is the fact that, more than any other film director living or dead, the movies *are* Hitchcock, and he they. Like Buñuel, another essential referent for De Palma, Hitchcock stands astride the development of cinema in the twentieth century from the late silent era through the collapse of the Hays code and beyond, and it is hardly controversial to claim that, along with Griffith, Welles, and Busby

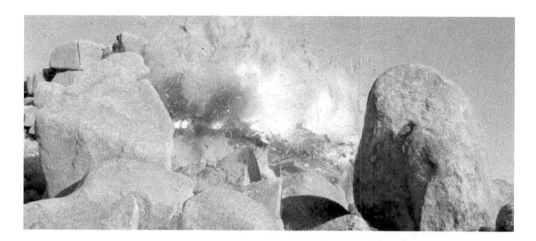

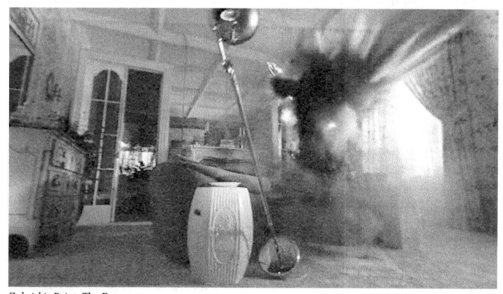

Zabriskie Point, The Fury.

Berkeley, he provided the visual grammar that defines the mainstream American cinema even today. ("He remains the seminal artist in this form," De Palma has said of him.[1]) On the other hand, there is the fact that Hitchcock bequeathed a set of concerns – murder, voyeurism, sadism, a certain kind of sexualized power struggle, the *technical* direction (or manipulation) of the viewer's affect – that still operate within mainstream cinema not

[1] In "De Palma: Les Années 60," a documentary by Luc Lagier and Amaury Voslion featured on a French DVD, *Brian De Palma: Les Années 60* (hereafter "Lagier and Voslion").

only as dominant narrative tropes but as visual and aural tropes as well. It is important to understand both of these points – the colossal influence that Hitchcock has had over the art form, as well as the specific nature and content of that influence – if we are to understand how the twentieth century might someday be called "the Hitchcock century." That is to say: it was the century in which the visual and narrative strategies we currently associate with "Hitchcock" came, long before the millenium, to provide the frame within which America, in some way, understood itself.

It is my contention that De Palma, or rather (more accurately) his cinema, "knows" this: movies like *Sisters*, *Blow Out*, and even *Snake Eyes* provide the only sustained investigation (whether "artistic" or "critical-discursive") of the political and personal implications of living in the "Hitchcock century" – that is to say, of living in a world where everyone, from the cashier at the nearest Arby's to the chair of Film Studies at your local state university or, for that matter, the chairperson of the Republican National Committee, inevitably imagine themselves to be Hitchcock protagonists. Further, that De Palma's movies perform, among other important gestures, an investigation of the social and technological conditions of their own possibility – and that they do so through an adaptation of "Hitchcock" as a set of narrative strategies and visual techniques – has to be understood, I think, not only as "the point" of De Palma's cinema but also as the primary reason why Film Studies, as well as the mainstream film culture in the United States, has at certain junctures been largely content to vilify, if not outright ignore, important works such as *Body Double* and *Raising Cain* – and, by extension, to misrecognize, in predictable and yet surprising ways, the logic of De Palma's system.[2]

I contend that those films of De Palma's most commonly called "Hitchcockian" constitute a series of logically complete, theoretically rigorous, and politically inflected "interventions" of a comparable (at least!) scale, complexity, and level of accomplishment as anything by William Rothman, Tania Modleski, or Robin Wood. When De Palma (in the Lagier and Voslion documentary *Brian De Palma: Les Années 60*) says, apropos of *Vertigo*, that "I've been thinking about it for almost forty years," why shouldn't we speculate that his thought is theoretically productive? Why can we not understand *Body Double* as a sort of doctoral thesis about Hitchcock? But in order to answer these questions, others must first appear: what conditions, at what theoretical or social register, allowed "De Palma's Hitchcock" to be "read" by Hitchcock scholars (and, indeed, by film scholars in general) only through certain prescribed frames? What were those frames, and how did they come to be dominant? What does it mean to watch De Palma (and to watch De Palma's Hitchcock) through these frames? Asking these questions will mean a lengthy, and narratively unearned, detour away from De Palma into the thickets of film history – a journey, perhaps, toward some kind of disciplinary primal scene.

[2] Or, to rephrase Jonathan Elmer on Poe: "why is it so hard to take De Palma seriously?" Cf. "The Cultural Logic of the Hoax" (1995, 174).

Hitchcock and the Murder of Marion Crane

[*Psycho*] – with its seminal shower scene – helped to usher in a cultural paradigm shift from the bland decade of the 1950's, with its emphasis on togetherness and family values, to the 1960's, that cataclysmic decade of political assassinations, student protests, free-speech conflicts, race riots, Vietnam protests, and, above all, violence – in our streets, in our political institutions, in our culture, and most vividly in our media, especially in our films, and in our music.

(Skerry 2009, 13)

It is surely the most famous scene in all of film history. At the least, it has generated more discourse – academic discourse, "public discourse," mainstream, underground, "official," "fan" – than any other moment in cinema; no other single scene can boast of having so many books devoted exclusively to it. Perhaps inevitably, the "meaning" of the scene changes with each interpretation, at least partially because its literal *boundaries* (where exactly does the "shower scene" begin, and where does it end?) also change with each interpretation – perhaps metonymically suggesting the idea that the scene, like the movie around it, cannot be contained, that it "seeps out" of its boundaries into the field that is supposedly "merely" its context. There is a sense in all writings about *Psycho* that the murder of Marion Crane "did" something to America – and something else to the rest of the globe, one presumes, not to mention what it did to "film form" itself. Pauline Kael (1984, 436) references the scene as the most "borderline immoral" moment she had ever experienced in a movie theater, a moment when Hitchcock had taken "the joke" too far; Peter Conrad, in his all-too-revealing *The Hitchcock Murders* (2000), spends nearly 300 pages dancing around what the scene "did" to him when he saw it as a youth in Australia. (He does not really broach that particular subject in any depth, but he makes two things clear, if only implicitly: first, that *Psycho* did not turn him into a homosexual, and second, that *Psycho* did not turn him into a feminist.)

By all accounts, Hitchcock's "shower scene" constitutes the greatest prank a major director has ever pulled on a film audience. The idea of *Psycho* as a joke or prank shows up everywhere – from James Naremore in *Filmguide to Psycho* (1973) to Robert Kolker in *Psycho: A Casebook* (2004) – but it is always understood as a mark of his genius, whereas De Palma's jokes are unfunny, sick, and literally harmful to the spectator, as one finds in Thomas Leitch's "How to Steal from Hitchcock" (2006). Needless to say, there is no way to determine what *Psycho* "did" to "real people" in "real time" – after all, how would we go about determining the answer? The film's effects in discourse are easier to identify, although, again, the problem of cause and effect effectively renders this line of inquiry tenuous, if not redundant. One thing is certain: after Alfred Hitchcock murdered Marion Crane, everything changed.

The slippage between author and character is nowhere more symptomatic than this point. Was this indeed, as Pauline Kael hints, the first time that a director had been held personally responsible for the murder of a fictional character? Certainly the idea that Hitchcock had blood on his hands is a sort of meme that has moved through both popular culture and

academic discourse for fifty years, with a particularly insistent appearance in feminist writings about film in the twenty years after the 1975 publication of Laura Mulvey's famous article. But of course Hitchcock can only have blood on his hands if he himself is in the movie wielding the knife, and so there has gradually appeared the notion that Hitchcock inscribes himself in the text in figures such as Norman Bates, or Uncle Charlie in *Shadow of a Doubt*. The idea of the "director-surrogate character" apparently originated with the Jean Douchet treatment of *Rear Window* – James Stewart at his window equals Alfred Hitchcock at his camera – but it assumes its most controversial articulation around the character of Norman Bates. William Rothman, for example, is able to read *Psycho* as a sort of punitive meditation on Hitchcock's own authorship by performing a rhetorical collapse between Janet Leigh and the figure of the spectator/critic (*You, the American male film critic and/or member of the Academy of Motion Picture Arts And Sciences, withhold from me the proper recognition of my artistry? Then I, Alfred Hitchcock, shall break into your bathroom and cut your beautiful naked female body!*). It is precisely this logic – albeit in a slightly less metaphoric form – that one sees in letters to Hitchcock from angry parents at the time of the film's release, complaining about its violence and perversity (see Rebello 1990). Hitchcock *murdered* that woman, *right in front of America's children*, and worse, he did it to her in the naughtiest place in the world – an anonymous motel toilet. And what caps the prank is the film's punch line, the mind-warping idea that that Norman Bates, screeching in the doorway with a butcher knife in his right hand, turns out *to be his own mother*. It is the most purely Surrealist moment in all of Hitchcock's cinema, so much so that it requires the immediate appearance of an emergency narrator – a forensic psychiatrist, no less – to explain away the wonderful sublimity of Norman's climactic entrance *in vestitu materno*.

Let us note a couple of things at this point. First, there is a deep structural connection between this pair of scenes/memes: the shower scene and the subsequent revelation of the psychotic "split personality" in its other-gendered form are linked not just causally (in the movement of the narrative) but at a deeper level – an *epistemological* level. To wax Žižekian: the burst of crazed, traumatic violence that shreds the screen and violates the hitherto-unbreakable contract between film and viewer creates a specific kind of problem, perhaps a problem of identification or engagement, but a problem that (presumably) is created in the viewer via the manipulation of the viewer's own sadism – a problem that in turn can only be solved by the appearance of a demonic object, the Mother-son-transvestite-knife-sign (accompanied, in *Psycho*, by the hollowed-out, grinning corpse of Mother) that brings the separate "threads" of Norman and Mother together. But the solving of this problem creates another problem: this is where the psychiatrist's speech appears. Hitchcock may or may not have had surplus "interest" in this scene (there is a certain amount of debate as to whether the scene was meant to have an "ironic" cast or whether Hitchcock regarded it as nothing more than a necessary narrative gesture), but the mere introduction of the psychiatric gaze – and the compulsion to narrate that it represents – allows the film's shell-game with audience identification to come to an uncertain end. It also introduces into discourse the figure of the character who murders on behalf of a malevolent force that – depending on

the viewpoint – either invades him from the outside without his knowledge or is absorbed, even called into being, by the repression of some unspeakable trauma. We can call that force "Mother," or we can call it "Hitchcock"; either way, it is clear that Norman kills Marion without knowing it, for reasons that are not available to him – on behalf of Mother, or on behalf of the godlike mastermind who sees all and, in doing so, creates, *in us*, that seeing.

So who *is* this Alfred Hitchcock? How did his "system" come into being in such a way that it can be understood to be "godlike"? Looking back over fifty-plus years of film theory and criticism from the vantage point of a new century, one sees how Hitchcock has been many people: the Jansenist moralist of Rohmer and Chabrol's pathbreaking studies, the towering humanist genius of Robin Wood (version 1.0), the obsessive sadist of Laura Mulvey's article, William Rothman's bizarre amalgam of Da Vinci and the punitive Jehovah of the Old Testament, and so on[3] – up through Slavoj Žižek's vision of Alfred Hitchcock as a kind of lay psychoanalyst and Lacanian theoretician. Indeed, the relationship of Film Studies in this country to the figure we call "Alfred Hitchcock" is an extremely complicated one, to say the very least. Fraught with half-submerged Oedipal trauma, both academic Film Studies (defined here as the sum of its published discourses) and the popular discourse of mainstream "film enjoyment" essentially perform – over a period of more than fifty years – a series of complex totemic negotiations with Hitchcock's corpse. That corpse – figured perhaps as the transdiscursive system we call "Hitchcock," or (at the level of the social Imaginary) as the vast enigma signified by Hitchcock's trademark profile in silhouette – has been, more or less, the primary battleground upon which all wars within the discipline have been fought. By the end of the twentieth century, his work and his name had generated more academic discourse in English (and probably more popular discourse) than that of any other film personality, and it is conceivable that this trend could continue indefinitely; in many cases, the tenor of that discourse has been more extreme than anywhere else in Film Studies – witness, for example, the wounded tone of William Rothman's "Some Thoughts On Hitchcock's Authorship" or the oracular flight of Laura Mulvey's landmark article, which responds to Hitchcock's sadistic patrilineage with a revolutionary injunction to destroy all visual pleasure.

Even with this wide range of different Hitchcocks on the theoretical market, there is a certain consensus about what he "was." Turning to Foster Hirsch, who offers a reasonably typical précis of the director's career, we see that Hitchcock – or, again, "Hitchcock" – is a godlike "mastermind," who "amuses" himself by devising "pre-ordained" and "catastrophic fates" for his protagonists, "awful things," which Hitchcock "watches dispassionately" with

[3] Each film scholar who confronts Hitchcock does so, it seems, in order to create his or her own particular "Hitchcock," and indeed each one is different – and yet no one can create a new "Hitchcock" without making certain *strategic alliances*. Even a volume as stubbornly associative and impressionistic as Peter Conrad's, with its smug invocation of the first viewing of *Psycho* as a terminal psychosexual event akin to the losing of one's virginity, more or less explicitly aligns itself with a phantom Andrew Sarris over and against a phantom Laura Mulvey while refusing to cite, or indeed name, either one.

"dry humor and unflappable detachment." In Hitchcock, "dark forces penetrate the most seemingly ordinary characters and settings," and these "average people are undone" by them – and yet Hitchcock believes "that we are all potential criminals, that lying in wait, beneath our civilized masks, is a dark, leering, other self." Because of this potential criminality and attendant self-awareness, Hitchcock is able to effect in his audience a "transference of guilt" – meaning that, in "more manipulative ways than in most crime films, we are made to root for the criminal"; indeed, "our response to the guilty characters reflects the criminal psychology that the film dramatizes" – indicating that, for the critic, the central relationship in Hitchcock's work is between the *criminal* and the *audience* upon whose secret desires the criminal acts (Hirsch 1981, 139–143).

The central issues here – Hitchcock's "Olympian" detachment, his overriding attention to technical matters, his insistence on (and apparent provocation of) the criminal desires of the audience, his attraction to "icy blondes" – coalesce into the multifaceted enigma of Hitchcock's authorship, an enigma that produces a seemingly endless supply of evaluative and interpretive discourse. Further, we know what it means to describe a certain address to the spectator's desires as "Hitchcockian," because it is that call – which is *always both narrative and technical* – that provides the hook upon which, in some way, the entire theoretical edifice of institutional Film Studies is hung. Whether this "hook" is understood as the universally operative process of suture[4] or (*a la* Bordwell) as a matter of local, social, describable and empirically verifiable viewing practices, it is what gives Hitchcock's films – to judge by the discourse around them – the most sustained erotic charge of anything released by Hollywood between the advent of sound and the collapse of the Hays code; it is also what makes them, in some way, "eternally" mysterious, ineffable, open to – and even, in the case of such provocatively obscure works as *Vertigo* and *The Birds*, forcefully eliciting – interpretive discourse.

It is hardly worth rehearsing the different historical stages in the evolution of the institutional understanding of that "call" or "hook," as it is understood in relation to Hitchcock. Interested scholars could hardly do better than to turn to Robert Kapsis's thorough (and, by now, canonical) *Hitchcock: The Making of a Reputation* (1990), which systematically moves through fifty years of both lay and academic writings about Hitchcock to show how Hitchcock's "reputation" – that is to say, "Hitchcock" as a *quasi-object* – undergoes several transformations and consolidations between the first rumblings of a Hitchcock cult in the 1960s to the appearance of *Vertigo* in the 1992 *Sight & Sound* poll of top ten films, culminating (after a brief account of Mulvey's paradoxical impact on Hitchcock studies) in an excellent chapter about De Palma's inheritance of certain aspects of Hitchcock's legacy. Kapsis recognizes that questions of Hitchcock's reputation hinge on how his *agency* is conceptualized from one historical moment to another; what Kapsis tracks – even though

[4] Let us not forget in this regard that Kaja Silverman, in introducing Oudart's theory of suture to English-speaking readers, used *Psycho* as her primary example. "The film terrorizes the viewing subject, refusing ever to let it off the hook. That hook is the system of suture." In *The Subject of Semiotics* (1983, 212). Is suture roughly equivalent, then, to the famed hook in *Texas Chainsaw Massacre*?

he does not use Lacanian terminology, or think in particularly Oedipal terms – is Hitchcock's ascent from mere signifier to *le nom-du-père* and, finally, to his final station as *le sujet supposé savoir*.[5] In this regard the best and most succinct proof we can offer is an offhand remark from the introductory chapter in Allen and Gonzalez's 1999 anthology *Alfred Hitchcock, Centenary Essays*: speaking of the progression of academic fashion "from textual analysis to apparatus theory to feminist-psychoanalysis to poststructuralism to the recent ascent of cultural studies," the authors suggest that "it is as though each methodological field must, at some point in its elaboration, turn its attention to [Hitchcock's] oeuvre, must test its precepts against or alongside the filmmaker's own" (viii).

The positioning of Hitchcock as a figure of authority against whom all theorists must wage battle in order to achieve some kind of legitimacy immediately recalls a number of stock psychoanalytic insights about fathers and children, and indeed Tania Modleski (1988) sounds a note on this theme by opening the introduction to her Hitchcock book with a discussion of Hitchcock's influence from beyond the grave – from the position of what Žižek (after Lacan) would call the Name-of-the-Father, the position of pure authority to which the "real" father ascends upon his death. One has only to consider the postscript to William Rothman's *Hitchcock: The Murderous Gaze* (1982), written immediately after Hitchcock's death, to see this ascension at work: from the figure of the all-too-present Father, with his uncomfortable, "murderous" demand for fealty and recognition, Hitchcock begins his transformation into the disembodied Signifier that stands in for an eternal mastery and, in doing so, guarantees the consistency of the subject as well as the entire Symbolic field. This transformation – from living enigma to eternal Sign – is the same transformation that overtook Lacan upon his death, and this lasting Signifier is the remnant of that figure that Lacan calls the *subject-supposed-to-know*; indeed, Rothman refers to "the knowing Hitchcock," the Hitchcock with whom it might be somehow possible to converse "about his 'secret places'" (342–344) – that is to say, the places from which he *enjoys*, the source of his power and evil. Of course, when Rothman writes these words, that revelatory, primal-scene conversation is no longer possible, since Hitchcock the man no longer exists; all that remains is "Hitchcock," the framed portrait of the master hanging over the proverbial fireplace, to be contemplated with wonder and anguish on those cold dark nights when one's own reality tends to unravel. (Let us not forget that questions of authorship are always questions about parenting, and therefore about God.)

One must point out here that the ongoing struggle over the status of Hitchcock was always coincident with the development of Film Studies as a discipline in the United States: the appearance of Robin Wood's *Hitchcock's Films* in 1965 might be said to be the first book-length cornerstone in a foundation whose other major elements would include

[5] Jonathan Haynes has provocatively suggested not only that the Truffaut book provides the *urtext* for everything we think we know about Hitchcock, but that the "Hitchbook" itself is best approached as a Truffaut film, one in which Hitchcock's themes become hopelessly entangled with those of Antoine Doinel. See the forthcoming "Hitchcock's Truffaut."

Al LaValley's *Focus on Hitchcock* (1972) and James Naremore's *Filmguide to Psycho* (1973), among others (not to mention the ultimate auteurist document, *Hitchcock/Truffaut*, which first appeared in English translation in 1968); these years are also the years when the institutionalization of Film Studies was at its peak – see, for example, Stephen Groening's disciplinary timeline (in Grieveson and Wasson 2008). Despite the enthusiasm with which *auteurist* discourse was adopted in the discipline's beginnings, however, the ease with which Hitchcock could be discussed in strictly evaluative and literary terms would be challenged almost immediately.

After these canonical texts (especially Truffaut's), the theoretical intervention that most irrevocably changed the field was doubtlessly the 1975 publication of Laura Mulvey's "Visual Pleasure" article, which can be said to have transformed the texture and tenor of Film Studies at a single stroke. Thus the locus of contestation changed from Hitchcock's "genius" to his pathology, from his artistry to his criminality, and the language of this contestation (and, as we shall see, recuperation) became that of psychoanalytically inflected feminism rather than (for example) a Leavisian attention to eternal verities. This is not to claim that political and/or semiotic interventions like the Marxist turn at *Cahiers du Cinéma* or the early writings of Peter Wollen or Stephen Heath were not important; it is that these interventions failed to capture the imaginations of the rank-and-file of the discipline in the way that the Mulvey article clearly did. Let us note that the previous major feminist gesture in Film Studies – Molly Haskell's *From Reverence to Rape* (1974) – preserved the tenets and the language of auteurism even as it attempted an overlay of not-quite-political rhetoric, and while it was warmly received (and caused its own share of controversy), it did not and could not have created the shock of recognition that Mulvey's article produced in film students and faculty across America. What remains fascinating about Mulvey's text, beyond its rhetorical power and pleasingly blunt aggression, is that – in aligning a familiar moral argument about the essential perversion of Hitchcock's work with a specifically political (one might say "revolutionary") line of reasoning – it too guaranteed itself (to paraphrase Gilberto Perez on Hitchcock) an existence "beyond the grave," an afterlife in citation far in excess of any other theoretician's fair share. Even Raymond Bellour, whose article on *Psycho* is, along with D. A. Miller's "Anal *Rope*," probably the greatest strictly academic treatment of Hitchcock ever written, often appears in citation as if he were an adjunct to Mulvey rather than an important corrective to her. Like the "Hitchcock" of Allen and Gonzalez (1999), it is as though each individual film scholar has had, at some point in his or her elaboration, to test his or her precepts alongside Mulvey's own. To connect two dangerous metaphors: one might say, and not without justification, that if Film Studies as a university discipline were to have a pair of "parents," they would be Hitchcock and "Visual Pleasure."[6]

[6] At the risk of career-jeopardizing frivolity, perhaps we might suggest in this context that, prior to Mulvey, every critic had been trying to mate with Hitchcock; Mulvey merely "took the Master from behind," so to speak, and thus one might say that Hitchcock Studies was the first academic discipline delivered via anal birth. (Of course it is usually De Palma who is accused of violating the Master.)

Let us consider a sequence of events in the solidification of "Hitchcock Studies," as Allen and Gonzalez have named it. Mulvey's article appeared in 1975, and important feminist reactions to her work began to surface in academic film publications almost immediately, from Jacqueline Rose's "Paranoia and the Film System" and the early focus of *Camera Obscura* on Hitchcock's *Marnie* (both 1976) to the famed exchange between Michelle Citron, Julia Lesage, B. Ruby Rich, and Anna Maria Taylor in *New German Critique* (1978) to the contributions of Janet Bergstrom (1979), Mary Ann Doane (1980), Tania Modleski (1982), and Mulvey's explicit sequel to her own article (1981).[7] That this theoretical meme – Mulvey's argument about Hitchcock's perversion of the gaze – might have been threatening to "Hitchcock Studies" in particular is evidenced by its conspicuous – if utterly unspoken – role as structuring Other in William Rothman's *Hitchcock: The Murderous Gaze* (1982), which positions itself as the ultimate auteurist gesture by literalizing (and therefore recuperating) Mulvey's argument – that is, the "murderous gaze" of the book's title is identified precisely as the sign of Hitchcock's genius, rather than as a site for feminist intervention. The content of this theoretical meme, a certain structural relation between the perversion inherent in the complex of eye-gaze-director and a more-or-less-hypothetical (and usually male) spectator, was built in such a way that it could, if necessary, reconnect with auteurism in a *practical* way: witness Tania Modleski's *The Women Who Knew Too Much* (1988), which seems to engage orthodox auteurism, or at least its emphasis on directorial agency and consistency, in direct or indirect ways on every page. But this most unorthodox marriage – of auteurism in its various levels of intensity and feminism in its multiplicity – could only happen if the system called "Hitchcock" were to be in some way evacuated of its most troubling aspect, the systematic nature of its cruelty and therefore its fascist potential. What is left behind is no longer misogyny but ambivalence, an oscillation toward and away from an empathy for the feminine: a new stage upon which the old totemic gestures of auteurism can be performed.

To wax Žižekian, let us assert that the process by which this *purification* of Hitchcock took place was the splitting of Hitch into two components: first, there is Hitchcock the "good father," whose works have elevated him to the position of Name-of-the-Father (the master-signifier, the *point de capiton*, the perfect empty sign); then there is the Father's shadowy double, whom Žižek variously calls the "obscene-knowing father," the "father of Enjoyment," or "*Père Jouissance*" (in other words, the Lacanian "anal Father," who steals the subject's enjoyment). The Name-of-the-Father fulfills the function that Žižek describes as "the ultimate guarantor of the 'neutral' stature of the Symbolic law within subjective economy" (Žižek 1992b, 156) – that is to say, the empty sign that, in standing in as the mark of a benevolent, all-knowing Authority, prevents the edifice of the Law from

[7] As Jane Gallop (1992, 10) points out, the early 1980s is also the moment at which feminist criticism was given a seat at the academic table – perhaps in compensation for the setbacks that the Reagan wave was beginning to deliver to "real" feminist goals.

becoming smeared with an excessive, horrifying enjoyment. The anal Father, by contrast, *is* that smear; he challenges the Name-of-the-Father by signaling a disturbance within or around it.[8]

The anal Father is always defeated, at least in Hollywood movies, but while his downfall signals the restoration of the paternal metaphor and guarantees the possibility of the sexual relationship, all of this cannot take place without the transmission of a certain forbidden knowledge to a subject who cannot, while the anal Father is around, assimilate it. Further, the anal Father always appears at a moment of disturbance in the paternal metaphor – a disturbance that might take the form of a buildup to war in Iraq, for example, or perhaps even the form of a serious contest over the ownership of a sign like "Hitchcock" (as was certainly the case in the academy in the late 1970s and early 1980s). Dare we take the next rhetorical step? Let us suggest that it was Brian De Palma who, with the release of *Dressed to Kill* and *Body Double*, assumed the position of the "anal Father" to Hitchcock's benevolent *nom-du-père* for a *number* of discourses and thereby prepared the route for the creation of Hitchcock Studies as a coherent field.

How to Blame De Palma

It is no accident that the two films of De Palma's that caused the most controversy were his most "blatant ripoffs" of Hitchcock; the fact that the violence in both films is contained within a specific kind of generic format – the ultra-popular, even *canonical* genre that we would have to call "the Hitchcockian voyeurism thriller" – is no doubt a significant reason why they generated a particular intensity of reaction. De Palma was not the first "Hitchcock imitator," either (after all, it was Billy Wilder who announced his intention, with *Double Indemnity*, to "out-Hitchcock Hitchcock"), nor was he the first to approach the problem of making a "Hitchcock picture" by remaking a *specific* film – one might point to any number of quasi-exploitation pictures with a more-than-family-resemblance to *Psycho* that appeared in the 1960s (such as Jack Hill's *Spider Baby*), not to mention Hitchcock's remake of his own *The Man Who Knew Too Much*. But it is the conjunction of two separate types or orders of negative reactions to *Dressed to Kill* – the feminist reaction to the film's violence and the Sarris-ist response to the film's obvious lineage – that enable De Palma's ascension in the 1980s to the level of something more than just a "bad object" (as Kenneth MacKinnon has it) for both the mainstream critical establishment as well as academic discourses, such as the multiple feminisms and various strains of film study in the United States, take cultural production as their object. Or, as Ann Cvetkovich puts it:

[8] For reference, Žižek's best example of the "anal Father" in Hitchcock is probably Uncle Charlie in *Shadow of a Doubt*, but another helpful example – particular to American sexual phobias – would be the all-CGI paedophiliac hydra of the Clinton-era *Lost in Space*. See the section called "Phallophany of the Anal Father" in Žižek (1992a, 124–140).

Aesthetic and political evaluation are closely linked in discussions of De Palma's work, such that the former serves as a cover for or displacement of the latter. De Palma can be scapegoated as a bad artist, thus taking the blame for a sexism that extends far beyond his films.

(1991, 148)

We have already seen (in the discussion of David Thomson) how the dominant rhetoric about De Palma functions. If we were to look for further examples of this positioning of De Palma as a "bad object," especially by writers without an explicit allegiance to feminism, we could find it in many places (the skeptical reader is invited to do his or her own random sampling of De Palma-related discourse, or just to check Kapsis' chapter on De Palma in *Hitchcock: The Making of a Reputation*). The signal moment, though, is probably the way that De Palma functioned as a contested site in the evolving aesthetic and rhetorical war between Pauline Kael and Andrew Sarris, especially in their respective reviews of *Dressed to Kill* in 1980. The well-publicized opposition between these two critics, even if their methods of critical evaluation are not as far apart as either one would have readers believe, can perhaps be used to epitomize the contestation of auteurism as a useful rubric for discussing film culture. Further, the specific rhetoric Sarris and Kael employ in articulating their positions on De Palma and Hitchcock (particularly in their opposition to one another) will echo not only in film journalism but also in academic Film Studies.

It is significant that one of Sarris's most often repeated complaints about Kael – along with her prose style and what Sarris perceived (probably correctly) as her gleeful attacks on his masculinity – is that she refused to recognize Hitchcock's genius. In a lengthy and unmistakably personally motivated cover-page article in the *Village Voice* one month before the release of *Dressed to Kill*, Sarris takes Kael to task for admitting to never having seen *Vertigo* (or *The Searchers*), and cites her embarrassment – which is nowhere in actual evidence in Kael's writings – that "Brian De Palma is an adulatory imitator" of Hitchcock (Sarris 1980a). This article, published seventeen years after Kael first took Sarris to task (and called Hitchcock a "prestidigitator") in her "Circles And Squares" (1965, 298), sets the stage for the amazing trio of reviews of *Dressed to Kill* –Sarris's, Kael's, and Sarris's rebuttal – that appeared in the late summer of 1980 in the *Village Voice* and *New Yorker* magazines. Sarris's first review (1980b) was published alongside a positive review of the film by J. Hoberman, who positions Hitchcock as the "remote spiritual father" of De Palma and, more incisively, compares De Palma's relationship with Hitchcock to Roy Lichtenstein's relationship with Franz Kline – a comparison that rings truer than almost anything else ever written about De Palma (Hoberman 1980). Sarris's review, by stark contrast, calls De Palma – not his film – "vulnerable and manipulative, sentimental and cynical, overwrought and flippant," and professes to have been utterly surprised to discover that the plot of *Dressed to Kill* is "a shamefully straight steal from *Psycho*" (Sarris 1980b). Sarris's review is riddled with questionable assumptions about the film and about De Palma, but it is in the Hitchcock comparisons that the piece reveals its logic. In contrast to Hoberman's review, which pays

deference to Sarris by identifying De Palma as an auteur, Sarris is at pains to mark De Palma as not just an imitator, but a thief. In the museum sequence, De Palma "borrows freely" from the (rather dissimilar) museum sequence in *Vertigo*, and this and other "flourishes" stolen from Hitchcock have "no depth of feeling" because "they do not mesh with De Palma's obtrusive facetiousness." De Palma also "cheats" by stealing from *Dead of Night* and *Echoes of Silence*, but it is the film's use of structural motifs from Hitchcock that mark the film as an act of thievery.

It is clear from this review – and from many of Sarris's writings on Hitchcock himself – that Sarris takes Hitchcock's own "flourishes" at face value, as if there were no trace of facetiousness or parody in (for example) *Psycho* or *The Birds*. Like Rohmer and Chabrol, Sarris reads Hitchcock not as a comedian or prankster but as an essentially serious (i.e. sincere) lecturer on fate and morality; it is because he is sincere that he is "inimitable" – his themes are his own and therefore no one else's, and through the repetition of those themes he offers an insight into man's eternal suffering. The postmodern idea that form and content are indissoluble has its antithesis here, since for Sarris there is an enormous gulf between the shallow titillation De Palma offers and the urtext, *Psycho*, upon whose structure De Palma hangs his "grotesque and unbelievable" "representations of urban life."

Pauline Kael's review of *Dressed to Kill* appeared a week after Sarris's, and where Sarris finds that the museum sequence (for example) is "achieved with an uneasy mixture of Hitchcock's lyrical mystification and [Peter] Goldman's obsessive carnality," Kael finds a more pleasing integration of De Palma's "ominous neo-Hitchcock lyricism with the shaggy comedy of his late-sixties *Greetings* days, when he used to let background jokes dominate the foreground" (1984, 39). Kael mentions Hitchcock several times, to be sure, but generally her tactic is to suggest (as she directly stated in her 1978 review of *The Fury*) that De Palma is better than Hitchcock, and she points out (as does David Denby in his review of *Dressed to Kill*) that De Palma has "learned" from Welles, Godard, Polanski, Scorsese, and Buñuel as much as from *Psycho*. Whereas Sarris cites De Palma's technical incompetence and "excessively tricky maneuvers," Kael observes that De Palma's "thriller technique, constantly refined, has become insidious, jeweled [...] he's probably the only American director who knows how to use jokiness to make horror more intense" (36, 38). Kael mentions the film's humor several times in the article, and it seems appropriate in this context to point out that Hitchcock himself apparently believed *Psycho* to be a comedy.[9] Unlike Sarris, who sees no contradiction within the claim that De Palma is both a thief and a parodist of Hitchcock, Kael reads De Palma's use of Hitchcockian motifs as a tool (as she said of *Phantom of the Paradise*) to create "a new Guignol, in a modern idiom, out of the movie Guignol of the past" (1976, 584) – in other words, to hyperbolize the already hyperbolic.

Unlike David Denby, Kael does not mention feminism directly: the only clue regarding her attitude toward the central issues mobilizing the anti-pornography movement's intervention against *Dressed to Kill* is her statement that "though [De Palma] draws the

[9] See Rebello, *Alfred Hitchcock and the Making of Psycho*.

audience in by the ironic use of sentimental conventions, when he explodes the tension (the shocks are delivered with surgical precision) those people in the audience who are most susceptible to romantic trickery sometimes feel hurt – betrayed – and can't understand why the rest of us are gasping and laughing" (38). The key phrase here is "those people" – *those* standing in for a range of possible gender-inflected identities from "girls" to "feminists" (or even "movie critics," by which she might in turn mean Sarris).

Kael's position toward feminism is by no means an uncontested area (and it is worth mentioning in this context that virtually the only film to which she ever applied the term "feminist" in a positive way is De Palma's *Casualties of War* [1991, 175]). It is exactly this omission or absence in Kael's review of *Dressed to Kill* that Sarris seizes upon in his noteworthy – and in certain ways unprecedented – second review of the film, published a month after Kael's review hit the streets. Here, Sarris is explicitly concerned with a feminist critical response to De Palma as well as with De Palma's thievery of Hitchcock, and let us note that this *mobilization of feminism against a female opponent* (that is, Kael) is, at this point, only the latest wrinkle in the ongoing scuffle between Kael and Sarris over the nature of the filmic object. It is worth quoting Sarris at length here:

Brian De Palma's *Dressed To Kill* contains many of the same ingredients found in a McDonald's hamburger: chopped meat (mostly Angie Dickinson's), sweet flavoring (primarily from Pino Donaggio's sugary score), and, of course, lots and lots of blood-red ketchup. To argue that such a concoction has its merits as flicky junk food is one thing; to confuse *Dressed To Kill* with cinematic *haute cuisine* is another. [...]

It strikes me [...] that De Palma does not so much "send up" Hitchcock as copy him as slavishly as Eve Harrington copies Margo Channing in *All About Eve*. Consequently, I find it a little obscene for critics like [David] Denby and Pauline Kael to punish Hitchcock posthumously for having once made films that show up De Palma's shot by shot replicas for the cheap, skimpy imitations they are. [...]

Nevertheless, despite Denby's reference to "more earnest writers" at the *Voice*, and to feminists generally, there has been remarkably little "feminist" frenzy in print over *Dressed To Kill* in the *Voice* or anywhere else. Women Against Pornography has belatedly staged demonstrations against *Dressed To Kill* in New York and San Francisco, but the WAP battlecries with their antilibertarian overtones seem to be losing favor even with feminists. Ellen Willis, the only licensed feminist columnist on the *Voice* staff, volunteered the observation that what was good enough for Pauline Kael was good enough for her. Since Kael has rhapsodized over *Dressed To Kill* as if it were a seamless masterpiece, this would seem that Willis has given *Dressed To Kill* a blank check. Denby may not read the *Voice* carefully enough these days to realize that feminism runs a distant second to Marxism. If the Angie Dickinson character in *Dressed To Kill* had been a gay, a black, a Hispanic, an American Indian, or a third world peasant instead of a grotesquely oversexed, middle-aged, bourgeois bitch with incriminating jewelry and apparel to match, there might have been more tears shed in print over her gruesome fate. [...]

What surprises me most about Denby's preventive maneuver against potentially opposing views is not his misreading of the editorial climate at the *Voice*, but the manner in which he tosses around the word "feminist" as a casual slur. Members of polite society are no longer allowed to use the word "communist" quite so carelessly. Hence, anyone who disapproves of *Dressed To Kill* on supposedly old-fashion moral grounds [sic] is automatically stigmatized as a loud-mouthed, bra-burning, shrewish activist with the "odious" abbreviation Ms. before her name. [...]

It is ironic [...] that Kael has completely enthroned the visual over the verbal as the much abused auteurists of old were alleged to have done. How we have come full circle! After all these years of denigrating Hitchcock, Kael is reduced to paraphrasing the most ancient texts of Chabrol, Rohmer, Douchet, Truffaut, Godard, and Wood on Hitchcock in order to describe De Palma's "art": "He underlines the fact that voyeurism is integral to the nature of movies." Hitch's *Rear Window* covered that subject so thoroughly that De Palma's minor variation in *Dressed To Kill* does not even deserve a footnote. [...]

That De Palma mucks about with soft-core porn and hard-edged horror – and *Dressed To Kill* is a mixture of both – does not mean in and of itself that he is a raunchy ghoul. Nor does the fact that he mutilates and murders women on screen necessarily mean that he hates women off-screen.

Indeed, it can be stated with the most rudimentary observation and documentation that De Palma expresses a much more hostile attitude toward the woman played by Angie Dickinson than he does toward the woman played by his wife Nancy Allen. De Palma's attitude toward Angie's Kate is revealed not so much by the violence he inflicts upon her as by the vapidity he imputes to her. Her brief life on the screen consists of nothing but her being ridiculed and humiliated before she is butchered.

After a lengthy excursus on the "gaping holes" in the plot and De Palma's stylistic contrivances to "conceal" those holes, Sarris concludes:

Hitchcock was not above such exasperating sleight-of-hand on occasion, but he never pretended to be superior to the problem. He worked hard on the very details disdained by De Palma. [...] De Palma is simply cashing in on the current market for "grunge," a term connoting the dispensing of blood and gore like popcorn to the very young.

(Sarris 1980c, 43–44)

The specificities of Sarris's rhetoric are worth exploring in detail, for it shares a set of concerns and structural moves that can be found in a wide variety of both academic and lay responses to De Palma throughout the 1980s. Leaving aside many inadvertently revealing phrasings and contradictions – such as the typically Sarrisian deployment of feminist rhetoric alongside bursts of misogyny – what is of concern here is the series of rhetorical moves Sarris makes to protect Hitchcock from De Palma. First, there is the clear collapse of De Palma the person into De Palma's films (or vice-versa). Sarris at first tries a forceful

separation between the two – witness his comment about how De Palma is not automatically a "raunchy ghoul" – only to merge the two a moment later with the problematic statement: "Nor does the fact that he mutilates and murders women on screen necessarily mean that he hates women off-screen." Unlike Hitchcock, there is no border between cinema and reality when De Palma is involved; *he* is the one murdering women on screen, the murders are *his*, he committed them and *owns* them, *even if he does not hate women*. Sarris is reaching for metaphor, but tellingly, he employs metonymy: after all, what is the definition of an *auteur* if not the person who is ultimately responsible for the deaths of his characters?

Was Hitchcock, too, a murderer? By way of contrast, Sarris does not even mention the fate of Janet Leigh in his 1960 review of *Psycho* in *The Village Voice*: he describes the film's "treatment of outrageous perversion as a parody of an orderly social existence" and alludes to "the hidden meanings and symbols lurking beneath the surface of the first American movie since *Touch of Evil* to stand in the same creative rank as the great European films" (Sarris 1960). But the closest he comes to describing the violence at the heart of *Psycho* – other than to mention that the film contains "the grisliest murder scenes ever filmed" – is to assert that the film is "overlaid with a richly symbolic commentary on the modern world as a public swamp in which human feelings and passions are flushed down the drain" (Sarris 1960). It is arguable whether Sarris is here referring to the blood of Marion Crane as it spirals into the shower drain, or to the literal "swamp" behind the Bates Motel into which Janet Leigh's shiny new car disappears; either way, Sarris seems to be describing a work of literary anti-humanist high modernism such as an Ionesco play or Bataille's *L'Histoire de l'Oeil* rather than the movie we call *Psycho*.

It is important here to recognize not only that the problem of Hitchcock's misogyny (which even Godard recognized) passes without mention in Sarris's original review but that, when *Dressed to Kill* arrives twenty years later, Sarris makes no attempt to re-read Hitchcock's original in these new terms. It seems that Hitchcock was never a misogynist – and if he was, then De Palma has absorbed that misogyny, and now it is *his* misogyny. (Or, more interestingly, perhaps misogyny *did not exist* until after 1960.) Hitchcock is guiltless, much like Professor Rupert Cadell in *Rope*, whose fascist ideas are stolen, literalized, and "perverted" in order to justify a murder; and if it is Hitchcock's movie (*Psycho*) that De Palma has mobilized to kill women, in the end it is no more Hitchcock's responsibility than the murder-by-rope is Cadell's. There is also the fact that De Palma must take the blame for Sarris' own misogyny: Sarris seems to indicate that, in cinematic terms, De Palma has called Angie Dickinson a "grotesquely oversexed, middle-aged, bourgeois bitch," whereas the fact is that her onscreen murder is a shock exactly because she is *not* drawn as a caricature, and therefore audience sympathies are with her, not against her. (The "bitch" remark belongs to no one but Sarris.)

Therefore, we have a whole set of displacements: misogyny and theft are handed off to De Palma so that a range of other locations – Sarris, Hitchcock, *Psycho* – can be free of these impurities. Given the amount of verbiage expended by the classic auteurists (including Sarris) on the theme of transference-of-guilt in Hitchcock's work, this lapse would seem to indicate a certain unrecognized *resistance*, a certain *blind spot* with regard to Hitchcock and what his

legacy finally "means," for what we have here is a classically Hitchcockian transference of guilt: De Palma has literally "followed Hitchcock's directions," as it were, and produced something *unspeakable*, something that must be repudiated in order for the Master to remain unstained. This mechanism of "calling to the father" – the subversive act of *literalizing* the Master's procedure in order to produce an unwanted, mutant result, thereby forcing the father to assert his function within the Law – Žižek calls, after Lacan, *père-version*,[10] and notes that this result is itself anticipated in Hitchcock's own narratives, which stage the situation we call *the transference of guilt* with an insistence that borders on the psychotic.

Another aspect of Sarris's second review of *Dressed to Kill* that bears further scrutiny is his attack on Pauline Kael (and several other critics), which unsurprisingly takes the shape of a protective gesture toward Hitchcock. According to Sarris, Kael is so buffaloed by De Palma's steals from Hitchcock that she is forced to fall back on an unannounced auteurist logic – the necessary (because structural) imbrication of cinema and voyeurism which, as Sarris points out, was articulated in *Rear Window* and discovered by Rohmer, Robin Wood, et al. This notion – cinema as voyeurism, voyeurism as cinema – belongs to Hitch just as The-Unexpected-Murder-of-the-Main-Character-One-Third-of-the-Way-into-the Film belongs to Hitch. It originated in *Rear Window* (if not in *Sabotage*) and finds its most extreme and logically rigorous expression there; therefore Hitchcock is the progenitor of this metaphoric collapse (cinema = voyeurism) and all subsequent iterations of it are, *by definition*, gestures toward the Master who gave us this knowledge in the first place. Perhaps there is no reason to claim for *Dressed to Kill* the kind of grand "theorizing about spectatorship" ascribed to *Rear Window* – De Palma's definitive meta-statement on that meta-issue would come four years later, with *Body Double* – but, then again, *Dressed to Kill* (like *Psycho*) is indeed a maze of spying, peeping, and surveillance, perhaps even more insistently than its urtext. Once she has pointed it out, Kael does not explore the voyeurism-surveillance-cinema theme:

> De Palma has perfected a near-surreal poetic voyeurism – the stylized expression of a blissfully dirty mind. He doesn't use art for voyeuristic purposes; he uses voyeurism as a strategy and a theme – to fuel his satiric art. He underlines the fact that voyeurism is integral to the nature of movies.
>
> (Kael 1984, 37)

[10] Bruce Fink defines "père-version" as a process in which "the pervert calls upon or appeals to the father, hoping to make the father fulfill the paternal function" (1997, 181). Note that I am not suggesting that De Palma is a "pervert" in the Lacanian structural sense; indeed, as Tim Dean (2008) points out, the idea of the actually existing structural pervert is the slipperiest, and potentially the most repressive, in the entire Lacanian canon. (Lacan says that all children, before they assume a structure in relation to the paternal metaphor, are perverse – see Seminar I, p. 214 – but actual adult perverts are allegedly rare, and the ones that choose analysis are rarer still; Dean points out that the concept is used in a normative fashion, despite the Lacanian claim that sexuality cannot be normalized.) Despite these reservations I find *père-version* to be a wonderfully suggestive idea, and if there is a single Hollywood film that reflects this idea as Fink defines it, it is *Body Double*.

Her analysis of this – the meta-filmic, voyeuristic aspect of the film – goes no further. Indeed Kael is not, in general, a rigorously theoretical writer[11], and her treatment of *Dressed to Kill* is typically impressionistic and evaluative. It would be wise here to point out that she, too, is guilty of a kind of double-standard when it comes to the violence in these films: in a neat reversal of Sarris's position, she once identified the central "joke" in *Psycho* as a "borderline case of immorality," whereas the repetition of this "joke" in *Dressed to Kill* is unproblematic, perhaps disturbing but also pleasurable and – no mistaking it – funny.

This may be one of the motivating factors behind the intensity of Sarris's attack on Kael: in her review of an imitation *Psycho*, she reproduces, in a single sentence ("He underlines the fact that voyeurism is integral to the nature of movies"), the entire breadth of the auteurist argument about Hitchcock and *Rear Window* in particular without a glance backward at the auteurist legacy – and, most egregiously, never once mentions *Psycho*. Whether the cinema-as-voyeurism idea is the exclusive discovery of *Cahiers du Cinema* is a matter for historians; what matters here is that, for Sarris, Kael and her ilk are guilty of "punishing" Hitchcock for inspiring (and being better than) De Palma.

Not surprisingly, this kind of rhetoric continued to appear throughout the 1980s, to the extent that the majority of the discourse about De Palma – both within the academy and within the sphere of mainstream film journalism – echoes tropes and phrases found in Sarris. I will use three typical examples to make my point. First, there is the Martin Amis essay "Brian De Palma: The Movie Brute" (1987), a bilious portrait of the director on the Los Angeles set of *Body Double*. Naturally, Amis's main concerns are problems of authenticity and "moral sickness." Amis does not push the Hitchcock issue with Sarris's fervor (perhaps because he seems to have no great love for Hitchcock in the first place), and clearly he is no feminist. But there is a Sarrisian obsession with De Palma's thievery, and the article takes the form of a jeremiad against De Palma on several different levels. The standard rhetorical trope here is to identify De Palma with an unwelcome social trend, for which De Palma becomes something like an avatar. Some examples:

> The illogicality, the reality-blurring, the media-borne cretinization of modern life is indeed a great theme, and all De Palma's major contemporaries are on to it. De Palma is on to it too, but in a different way. He abets and exemplifies it, passively.
>
> (Amis, 88)

Here, De Palma becomes the target of a critique straight out of Baudrillard (or Robert McChesney): he embodies ("exemplifies") dehumanization, derealization, the lies of big media, unlike all of his "major contemporaries" (who – Scorsese? Spielberg?), who are "on to it" in an *active*, rather than passive, way. But since De Palma is "on to it" and yet chooses to

[11] … at least not in the sense of "theoretical" that Hayden White implies when he claims that "the function of theory is to justify a notion of plausibility itself" (White 1987, 164).

remain passive, he is part of the problem. It is, indeed, De Palma's ethics that are in question (unlike his unnamed contemporaries). Another:

> Brian has style – a rare and volatile commodity. Style will always convince cinematic purists that the surfaces they admire contain depth, and that clear shortcomings are really subtle virtues in disguise. De Palma isn't logical, so he must be impressionistic. He isn't realistic, so he must be surrealistic. He isn't scrupulous, so he must be audacious. He isn't earnest, so he must be ironical. He isn't funny, so he must be *serious*.
>
> (Amis 84)

In other words: De Palma is the perfect director for movie fanatics who have no sense of depth, of human worth, of proportion: he is all surface, all shortcomings, like his fans. And in giving away his idea of what good filmmaking should be (logical, realistic, scrupulous, earnest, and funny – one assumes he means Jean Renoir), Amis stacks the deck against genre filmmaking, and especially what we might call "technical" filmmaking – that is, Hitchcock (who is rarely logical *or* realistic *or* scrupulous *or* earnest, although usually he *is* funny). In discussing the making of *Carrie* in 1976, Amis says that

> by now Brian's contemporaries, his Warner brothers, were all drowning in riches and esteem, and he was "more than ready" for a smash of his own. "I pleaded, *pleaded* to do *Carrie.*" And so began De Palma's assimilation into the Hollywood machine, his extended stay in "the land of the devil." The Sixties radical package was merely the set of values that got to him first, and he had wearied of a "revolution" he found ever more commercialized. De Palma now wanted the other kind of independence, the "dignity" that comes from power and success within the establishment. He is honest – or at any rate brazen – about the reversal. "I too became a capitalist," he has said. "By even dealing with the devil you become devilish. There's no clean money. There I was, worrying about *Carrie* not doing forty million. That's how deranged your perspectives get." Nowadays his politics are cautious and pragmatic: "capitalism tempered with compassion, do unto others – stuff like that." The liberal minimum.
>
> (Amis 83)

Here, De Palma not only enacts but *becomes* "the liberal minimum" – a "brazen" stance that Amis presumably finds morally bankrupt, either for De Palma's having given up his "guerrilla"-hood, or for his having once been a guerrilla in the first place. He embodies, therefore, something "brazen" about capitalism itself – a rhetorical gesture that Amis can only make because of the particularities of De Palma's noxious "vision." (Could one imagine Amis suggesting that the "brilliant" Scorsese, for example, has a metonymous relationship to capitalism?) Indeed, it is De Palma's "reversal" that Amis finds hypocritical; one would not – and Amis would not – expect to find Scorsese or the "bright and articulate" Spielberg

having the perspective or self-knowledge to express their personal development in terms of an inevitable capitulation to political and economic necessity (as De Palma does), but it is precisely this "honesty" (or "brazenness") that disgusts Amis. It is as if De Palma, with his revolutionary ideals, should have joined the Peace Corps rather than making *Carrie*, while Spielberg or Scorsese, never having been politically idealistic, are in no danger of being "brazen." As it turns out, the "liberal minimum" is not even the minimum.

By 1988, critical consensus had condensed into a single "thought" about De Palma, meaning that, as Laclau and Mouffe might put it, his signifier had become fixed. We find a perfect example of this solidification in the wonderful one-sentence dismissal of De Palma in Robert Philip Kolker's study of the new American *auteurs* in *A Cinema of Loneliness* (1988): "Brian De Palma has made a career of the most superficial imitations of the most superficial aspects of Hitchcock's style, worked through with a misogyny and violence that manifest a contempt for the audience exploited by his films (though in *Scarface* and *The Untouchables* he has shown a talent for a somewhat more grandiloquent allusiveness)" (Kolker 1988, 161). This single sentence – in a chapter on Martin Scorsese that goes on to characterize, positively and at some length, *Taxi Driver* as an homage to *Psycho* – deserves to be unpacked. First, there is the repetition of the word "superficial." De Palma imitates Hitchcock's most obvious and depthless qualities, and does so in an obvious and depthless way; the obvious implication is that there are *deeper*, more subtle aspects to Hitchcock's work that could be reappropriated in a *deeper, subtler* way – as if Hitchcock's "message" or his "depth" could be separated from his style in any productive, meaningful sense. (One imagines *Vertigo* directed by Stanley Kramer.) Then there is De Palma's "contempt" for the audience that he "exploits" – unlike Hitchcock, who naturally always felt warmly toward his audience and never, ever deceived or manipulated them for a commercial end. (Let us recall here David Lynch's *Blue Velvet* and the "contempt" that the director, according to Robin Wood, felt for his characters.) De Palma's contempt for his audience becomes "manifest" in violence and misogyny, in precisely those qualities that would elevate Martin Scorsese, for example, to the forefront of the canon of American cinema artists. The key difference between De Palma and someone like Scorsese would then be the twinned oppositions of contempt/respect and surface/depth.

These oppositions – contempt vs. respect, surface vs. depth – define Steven Prince's view of the matter in *A New Pot of Gold: Hollywood Under the Electronic Rainbow, 1980–1989*, otherwise known as Volume 10 in the Scribners' series "History of the American Cinema." In this text, with its quasi-authoritative status as a part of a research-standard reference work, Prince offers an overview of the De Palma controversies some fifteen years on, long after the most extreme era of the director's Hitchcock-related notoriety had faded – and yet, as Prince has it, "to date, De Palma's work has not fully recovered from this tarnishing" (Prince 2000, 232). Perhaps because of his historical perspective on the events, Prince is the first among our examples to voice the idea that "the nation's moral climate shifted in the 1980s" (232) – meaning, presumably, that in the 1970s a different national consciousness

was in operation, a consciousness that did not read De Palma's provocations as reactionary or dangerous. Prince understands the furor surrounding *Dressed To Kill* and *Body Double* to be at least partially a function of a national *shift in perspective* that roughly coincides – although he does not directly make this connection – with the advent of the Reagan era. We will speculate about the nature of this shift in Chapter 2, but for now let us note that Prince recognizes that De Palma's status as bad object has been historically mediated – and let us also note that Prince, in spite of this recognition, actively reinforces this bad-object status.

De Palma primarily appears in two sections in Prince's book: as an entry in a set of brief historical essays about 1980s directors (sandwiched between Francis Ford Coppola and Arthur Penn), and as the primary antagonist in a section entitled "The Pornography of Horror," which attempts to supply a dispassionate account of the feminist interventions both into literal "pornography" as well as into what we might call, at least for the moment, "the pornographic." Among the rhetorical themes we find repeated here is the notion that De Palma himself is a murderer (Prince notes that "impaling [women] with power drills and slashing at them with razors damaged [De Palma's] reputation among critics and in the industry itself" [232]). Prince also dismisses *Body Double* as "a retread of Hitchcock's *Rear Window* and *Vertigo* set in the world of pornographic filmmaking," noting that "the impalement of a woman with a power drill was the film's most incendiary scene, though the picture as a whole was widely condemned for its tawdriness" [231].

We also find an interesting division of labor: in speaking of *Scarface*, Prince assigns the film's politics to another director ("With a script by Oliver Stone, the film indicts American capitalism") while, in the very next paragraph, holding De Palma responsible for everything else ("Awash with blood and cruelty, De Palma's *Scarface* is unremittingly savage and cold" [230]). Note that Prince admits that the infamous "shower scene" in *Scarface*, with its roaring chainsaw and spurts of blood, works largely "by suggestion and implication, lodged in the viewer's imagination with terrible clarity by images that are not graphically detailed" [230]; when a similar tension between on-screen and off-screen, between the *shown* and *not shown*, is utilized for a literal rape scene in *Casualties of War* rather than a metaphorical, male-targeted one as in *Scarface*, Prince can suddenly no longer "see" – that is to say, he can no longer *remember* – the film's actual technique, which he describes as "almost pornographic in its fixation" [232]. Prince grants De Palma his "florid visual stylishness," but the key adjective here – "florid" – draws yet another line between what is acceptable and what is De Palma. By contrast, if we peek at Prince's similar essay on Oliver Stone (260–263), we find a consistent valorizing of that director and his politics, even when (as in *Born on the Fourth of July*) his style is "bombastic and operatic" – or, for that matter, when it is "aggressively cinematic" (*Talk Radio*) – because Prince understands Stone (in contradistinction to De Palma) to be a political, specifically Leftist, even "compassionate" director. Thus the sequence in *Platoon* in which a Vietnamese village is slaughtered can be understood in the following terms – "few scenes of violence in contemporary cinema have been as disturbing to watch, as morally

discomfiting, or as closely rooted in harrowing historical experience" – whereas the rape scene in *Casualties of War* is merely exploitative.[12]

Elsewhere in the volume, the essay "The Pornography of Horror" sketches a narrative that, given the volume's putative "official" standing, seems to present itself as a diachronic reference or even master narrative of the intersection of feminism, mainstream "exploitation" filmmaking, industry economic practice, and the nation's "changing moral climate" in the early 1980s. Of its six pages, four are devoted almost exclusively to *Dressed to Kill* and *Body Double*. Prince begins by citing a "particularly troubling [...] stylistic feature" of violent movies of the era, "the use of a subjective camera to represent the killer's point of view as he stalked his victims." This "optical device," as Prince terms it, "first appeared in Michael Powell's *Peeping Tom* and in Hitchcock's *Psycho* before John Carpenter elaborated it throughout *Halloween* and established its effectiveness in the slasher cycle." This device "made the viewer share the killer's visual perspective," and this was "morally objectionable" in its "appeal to pruriently sadistic impulses." Detailing first the objections of mainstream sources like Roger Ebert and the staff of the *Chicago Tribune* and then the objections of feminist organizations such as Women Against Pornography and Women Against Violence in Pornography and Media to the "violent misogyny that seemed to proliferate through eighties horror," a trend that De Palma "epitomized," Prince draws an explicit connection between "low-budget quickies like *Maniac*" and De Palma's "high-visibility" *Dressed to Kill*, with its "very respectable box office" (Prince 355), in terms of the appearance of pornographic values and gestures inside mainstream Hollywood product.

Hitchcock, naturally, appears as a priori to the narrative, and Prince negatively contrasts *Dressed to Kill*, which "punishes" its (first) female lead for her sexuality, with *Psycho*, which presumably does not: therefore De Palma is critiqued for discovering and literalizing that sadistic aspect of Hitchcock that must be papered over in order for Hitchcock to maintain his canonical status.[13] Whereas the original shower scene "is clinical and dispassionate (and terrifies because of this)," De Palma's "*Dressed To Kill* is more graphically violent and more explicitly sexual than *Psycho*, and it conjoins the violence and the sex more intensively and punitively than Hitchcock, who had, by contrast, merely pointed to both conditions" (353).[14] The implication is that De Palma – who has often been called both "clinical" and "dispassionate," especially in regard to this film – is actually, in this instance, neither: he is invested in the murder, it is a *heated* event for him, and his desire for this murder causes him to really *let loose*, to lose his "clinical" distance and become "passionate." After all, as Prince

[12] Of course *Casualties of War* has a basis in a specific historical incident while *Platoon* is a fantasia about Vietnam movies, but this is by the by.

[13] There is a similar double-vision in Prince's writings on Sam Peckinpah: like David Thomson with Hitchcock, Prince finds a progressive and even visionary stance in Peckinpah's technical approach to violence that, at least in his own terms, he would also find in De Palma if he bothered to look. See *Savage Cinema: Sam Peckinpah and the Rise of Ultraviolent Movies* (1998).

[14] In response to Prince, one might imagine what would have happened if Hitchcock's *Frenzy* had appeared in 1984 – or, for that matter, if *Body Double* had appeared in 1972.

points out, "the attack in the elevator is more graphic, more prolonged, and more attentive to the anxiety and struggles of its victim to survive." Further, and "of key importance, the graphic violence is visited upon a character whose intimate sexual desires we have just witnessed" – again, quite unlike *Psycho*, or at least Prince's understanding of it.

By this logic, the violence that is visited upon Angie Dickinson's character – unlike, by implication, that in *Psycho* – is excessive precisely because she has been individuated. If the character had been anonymous – a secondary or tertiary character, like the victims in *Halloween*, rather than a lead character, like Janet Leigh – then the sadism would not be so pronounced. But of course this is exactly the point: the sadism inherent in Hitchcock's narrative is, as Pauline Kael pointed out, directed *at the audience*, and the overlap between this originary, narrative violence (the unexpected murder of the audience's main point of identification) and the "elevator scene" is too much for Prince, whose own memory of the scene is, like everyone else's, framed by its affective immediacy. The causal relationship between sexual activity (or even desire) and immediate, random retribution that apparently informs films like *Friday the 13th* – which is mentioned in this essay exactly once – is proposed to inform *Dressed to Kill* as well, and indeed it does, just as it also informs Hitchcock's films in varying degrees, from the murder of Janet Leigh (which Donald Spoto [1983] describes as having had a liberating effect on Hitchcock's most sadistic tendencies) through to the rape-murder that would have opened *The Short Night*. In De Palma's hands, however, this causal relationship cannot be read as anything but a desperate expression of the director's most uncontrollable personal fantasies – as if the scene in the elevator were something like a date rape, a burst of deeply personal violence erupting without preparation in the middle of a character-driven idyll.

One could argue that the extreme reactions to *Body Double* in many critical quarters were perhaps a consequence, at least in some sense, of Spoto's portrait of Hitch (in *The Dark Side of Genius*, 1983) as a sadistic, enjoyment-stealing monster, which appeared the year before *Body Double* and which directly caused both feminist scholars and auteurists to reconsider the "sadism" question. More importantly for Stephen Prince, there is the roughly current re-release of several "withdrawn" Hitchcock films, including *Rear Window*. For example, Prince describes the plot of *Body Double* as "modeled on Hitchcock's *Rear Window* and *Vertigo*, but [lacking] their sophistication and elegance" (353). Ignoring the near-constant Brechtian gags and continuity-jolting explorations of *mise-en-abyme* that continually interrupt the meta-Hitchcockian narrative of *Body Double*, Prince takes the film literally, describing Deborah Shelton's attraction to Jake Scully as "improbable" and the size of the film's murder weapon as "patently absurd." (Recall here Hitchcock's oft-cited gripe about those members of the audience that he dubbed "the Plausibles.") Comparing the death of Deborah Shelton's character to the shower murder in *Scarface*, Prince attempts to draw a distinction by claiming that "the gangland killing was sadistic but nonsexual," while "Gloria's death is sexually sadistic." Additionally, Prince writes that "De Palma's inclusion of the porn industry in the film's narrative seemed gratuitous and without structural foundation or requirement" (much, we would point out, like everything else in the film, from the "patently absurd" proliferation of Hitchcockian memes, to the "improbable" Frankie Goes

To Hollywood music video that interrupts the action shortly after the central murder scene, to the final diegesis-shattering gag of the "body double" under the closing credits). Thus, Prince concludes, "as a male filmmaker who had choreographed and orchestrated Gloria's end, there was no way for De Palma to evade the charges of feminists that it was a scene redolent of misogyny," despite De Palma's "inadequate" attempts to "stand behind First Amendment rights as a filmmaker" (356).

And so it goes. Across these texts, all written at the height of De Palma's notoriety – and the astute reader will have noticed that they were all male writers, in some cases speaking *on behalf of* feminism – there is a consistent collapse and dilation of certain issues around these films and their director, as well as an attendant set of contradictory rhetorical impulses.[15] So, just as there are many Hitchcocks, there are many De Palmas: there is De Palma the thief, who takes Hitchcock's imagery and narratives and perverts them; there is De Palma the rapist/murderer, who reaches through the screen and drills women to the floor; there is De Palma the capitalist, who makes movies for profit and panders to the lowest common denominator; there is De Palma the failed radical, who exemplifies everything trashy and "wrong" about his generation. There is De Palma the pornographer, who hates women and punishes them for their sexuality; there is De Palma the "black sheep" of the 1970s auteurs, who unlike his contemporaries is bilious and hateful (and a failure); there is De Palma the "intellectual," who cannot feel; there is De Palma the moron, who cannot think.

One might understand this profusion of contradictions as the proper definition of the position of the anal Father, who, like Uncle Charlie in *Shadow of a Doubt*, must be both cultivated and savage, warm and yet ice-cold, impulsive but calculating, a social impostor and yet genuinely, coherently psychotic. A certain ambiguity and unfixedness is part and parcel of this social function, since it confers solidity and canonicity (if you will) onto the signifier that it vampirically abuts. Thus the "anal" Father fulfills his function: he appears, affords a consolidation of terms, and *drops away* – defeated like Uncle Charlie, who appears as if by magic, reaffirms for his horrified niece the tenuous but necessary opposition between social constraint and antisocial madness and, once defeated, falls from a moving train. In becoming the "anal" Father for a variety of discourses, what function does De Palma fulfill? He draws the sticky charge of implacable gynophobia from Hitchcock, and in doing so allows Hitch to ascend to a sacred place – a canonical place? – where his animus against the female body can be re-read as (to use Tania Modleski's term) "ambivalence" and even "sympathy" toward the feminine, and where his gender-directed violence – such as the rape of Melanie Daniels in the attic at the end of *The Birds* – can be read as pure metaphor (as opposed to De Palma's metonymic, directly authorial violence); further, he "steals" from Hitchcock, marking Hitchcock as original, as a valuable quantity to be protected. Further, he becomes a capitalist and even a figure of capitalism's deepest

[15] For an all-too-brief discussion of scholarly writings on De Palma by women, especially those that self-identify as feminist, see Chapter 3. I hope that the segregation of men from women, in this context, is understood as an argumentative strategy and not as some other kind of symptom.

contradiction (the "liberal minimum") while Hitchcock becomes a relic, an historical document, catalogued and therefore no longer an object of exchange. Even as late as 2006, after De Palma has more or less "dropped away," a scholar as thorough as Thomas Leitch can (in his essay "How to Steal from Hitchcock") reduce De Palma's work to a set of operational principles rooted in criminality: "Steal Everything That Isn't Nailed Down," "Flaunt Your Thefts," "Start By Stealing From Hitchcock, End by Stealing from Yourself" (Leitch 2006, 253–267).

In this context, might we not suggest that, in creating or fulminating a split within itself – a split between the auteurist project, with its originary emphasis on the director as smuggler of meaning, and the post-structuralist project, with its political freight and its anti-pleasure, anti-populist ethos – that Film Studies was preparing itself, all through the 1970s, for the appearance of a certain kind of bad object, and that this bad object would necessarily take a certain kind of shape? And, finally, might one not say (with or without irony) that *Dressed to Kill* – for it is, indeed, *Dressed to Kill* that "did it" – represents, in its assumption of the place of this bad object, the moment of De Palma's greatest triumph?

How to Operate the Hitchcock Machine

De Palma [...] is the auteur whose authorship is secured precisely by his thefts; the meaning of each of his thefts is inseparable from the fact that it is to be recognized as a theft.

(Leitch, "How to Steal from Hitchcock," 2006, 260)

So how, exactly, do De Palma's films address themselves to the problem of "Hitchcock" – or, in other words, how is it, on a *literal* level, that De Palma "uses" Hitchcock? If we look at the five De Palma pictures that most explicitly mobilize Hitchcockian structures and other narrative

"traces" – *Sisters* (1973), *Obsession* (1976), *Dressed to Kill* (1980), *Body Double* (1984), and *Raising Cain* (1992) – we can see how, over the course of twenty years, De Palma's theoretical understanding of the "Hitchcock machine" (understood here as the sum of Hitchcock's appropriable narrative and technical gestures) develops as a central theoretical strategy.

Each film in the series permutates a canonical Hitchcock text, sometimes with a central scene or development descended from another; thus, *Sisters* replays *Psycho* and *Rear Window*, *Obsession* replays *Vertigo*, *Dressed to Kill* replays *Psycho*, and *Body Double* replays *Rear Window* and *Vertigo*. (*Raising Cain* is a special case, replaying *Psycho* inside *The Discreet Charm of the Bourgeoisie*.) In addition there are the specific grammatical techniques that De Palma has "learned" from Hitch – a set of techniques that are put to work by dozens if not hundreds of other filmmakers, usually without critical incident – and upon which De Palma has elaborated a complex set of new and unique gestures.

At the risk of being slightly remedial, let us take an extended look at *Dressed to Kill*, which – like *Sisters* – puts *Psycho* to work in an extraordinarily complex way, and which achieves a level of purely formal, even *classical* technical perfection that Hitchcock himself rarely equaled. There are two main types of mobilizations here, narrative and technical, and it might be useful to list them, even if the list is only partial. First, there are the structural/narrative mechanisms De Palma lifts from *Psycho*:

The dreamlike, sexualized opening, with the god's-eye camera moving unbidden into an illicit coital space. In *Psycho*, the camera floats through downtown Phoenix and, through a series of cuts and dissolves (apparently a compromise, as Hitchcock could not solve the technical problems inherent in his original conception), passes through the window of the hotel bedroom where Marion Crane and her lover Sam Loomis have just had sex; in *Dressed to Kill*, the camera dollies with Kubrickian slowness through a dimly lit middle-class bedroom and into a pastel bathroom where a married couple are going through their morning toilette, a scenario that visually recapitulates the opening "shower scene" in *Carrie* before veering into a surreal, masochistic fantasy of rape in the shower (impossibly, a man appears out of the steam and sodomizes the wife while her husband impassively continues to shave). *Psycho*, of course, was made under the regime of the Hays code, which even in 1960 forced directors (the perverted ones, naturally) to "suggest" sexual conduct through highly developed visual codes; by contrast, *Dressed to Kill* (released thirteen years after the gigantic assault on Hollywood codes of representation that was *Bonnie and Clyde*) features a full-length view of the nude body of Angie Dickinson in the very first shot, and within thirty seconds moves on to pubic hair, swollen nipples, masturbation, and (suggested) sodomy. We must also mention, however, the fact that – more than the opening of *Psycho* – the first scene of *Dressed to Kill* recalls the coachman-rape-fantasy that opens Buñuel's *Belle de Jour*, and in fact De Palma was quick to point out in interviews that *Dressed to Kill* owes more to Buñuel than Hitchcock; we will return to this point later, but it is important to recognize here, however briefly, that while the structural machinery of the film is descended from *Psycho*, there is in the film's tone a genealogical link to Buñuel's surrealist view of sexual desire that, while similar to that of Hitchcock, remains distinct from it.

The sharply drawn regional American milieu as a background to murder and poisoned sexualities. *Psycho* famously takes place in the American southwest, and with its flat focal planes and television-style high-contrast black-and-white photography, it has the stylistic effect of accentuating the class status and blighted, no-future lives of all of its characters, from the grotesque businessman who propositions Marion Crane at the film's beginning to the stalled-out economics of the Bates Motel and its surrounding area. Hitchcock's choice in this regard has helped to position *Psycho* as "something more" than just a horror film: because of the general hopelessness that permeates every shot, *Psycho* can be read as (for example) an allegory of human nature after the fact of the Nazi camps, or as a satire on the illusory nature of the American dream. De Palma, on the other hand, restages *Psycho* in the New York City metropolitan area and chooses a desaturated, fogged-out color palette that, like the cinematography in *Obsession*, recalls Vilmos Zsigmond's celebrated work in Altman's *McCabe and Mrs. Miller*. Moreover, *Dressed to Kill* takes place in a slowed-down, repressive world of money and leisure; Kate Miller's comfortable suburban life (expensive couture, sessions with a therapist, mornings spent lingering at the museum) mirrors that of the well-paid Manhattan shrink whose time she buys, and the upscale prostitute who witnesses Kate Miller's demise invests in art and plays the stock market. De Palma's decision to stage *Dressed to Kill* in a fantasy of shallow white-person self-absorption always goes unremarked. The darkness-at-the-heart-of-the-American-dream interpretation that has always been *Psycho*'s birthright, therefore, is not available to *Dressed to Kill*; its satirical quality, when it is noticed, is read not as social satire but as superficiality and "mere" formal game-playing.

The use of a socially transgressive female as the main character, and the use of that character as a kind of lure for audience identification. In *Psycho*, Marion Crane is forced by her desire for a "normal" life with her lover Sam to steal $40,000 from her boss and to flee Phoenix for California; in *Dressed to Kill*, Kate Miller is fed up with her inattentive husband and his dreadful performance in bed, and finds herself engaged in a random flirtation and pickup in the Metropolitan Museum. It is notable that in each instance the "wronged" man clearly deserves this transgression: in *Psycho*, the boss and the oilman are boastful, unpleasant men, while in *Dressed to Kill*, the husband is so disconnected from his wife that he barely appears in the movie at all. In both films, the audience is positioned through basic film grammar to align with this woman as the point of strongest identification; each film goes to some lengths to give us this character's thought processes – in *Psycho*, we hear Marion's inner monologue as she imagines the reactions of her boss and friends at work to her theft and disappearance, while in *Dressed to Kill* we literally "see" Kate's thoughts as split-screen superimpositions. Each film uses basic point-of-view camerawork (often with a mobile camera) and shot/reverse-shot constructions to enforce this positioning and identification, and – most importantly – each film gives this character a moment of realization, of reckoning, just before someone or something (another character in the movie, God, Fate, the director, society) punishes her for her transgressions. Marion Crane decides to "make things right," adding up her expenses (she subtracts the price of her getaway car

from the $40,000) and taking a purgative shower; Kate Miller, on the other hand, discovers that she may have contracted a venereal disease from her pickup and flees his apartment in a panic, forgetting her wedding ring in the process. It is at this point in each narrative that audience identification with this character – whatever "audience" we mean, and whatever we mean by "identification" – is presumably strongest. Note also that *Dressed to Kill*, unlike *Psycho*, is released to theaters at an historical moment, when the idea of sexual and social self-empowerment for women is an important subject not only for feminists themselves, but for Hollywood cinema as well. Needless to say, it is important to remember that any Hollywood mobilization of this theme – or any social theme – is primarily motivated not by political idealism but by the profit motive, and that this is potentially one of the targets of De Palma's satire.

The sympathetic male character who shares a kind, quiet moment with the female lead, and whose own female "split" turns out to be a murderer. In *Psycho*, it is Norman Bates; in *Dressed to Kill*, it is Dr. Elliott. Andrew Sarris, in his first review of *Dressed to Kill*, claims to have immediately recognized the brief scene between Kate Miller and her psychiatrist as a structural analogue to the extended dialogue between Marion Crane and Norman Bates. In *Psycho* this scene takes place long after Marion has fled Phoenix and undergone a series of paranoid trials that would help to explain why her encounter with Bates, in any other film, would be a decisive moment of sympathetic human contact; in *Dressed to Kill*, the scene is much shorter, much less foreboding (the psychiatrist's office contains no stuffed animal heads, for instance, and there are no looming low-angle shots of the characters), and takes place much earlier in the narrative. (Moreover, Dr. Elliott will seemingly take on a supplementary detective role in the narrative, attempting to contact "Bobbi," the transvestite murderer, through her answering service – but of course Dr. Elliott *is* Bobbi, and is merely not returning his own calls to himself.) We should also point out that, in *Psycho*, Marion Crane does not actually describe the "trap" she has walked into; her "therapeutic" conversation with Norman Bates remains at the level of metaphor, which is how she can "see herself" – recognize her own truth – in Norman's hopelessly dead-end situation. In *Dressed To Kill*, however, the conversation is literally therapeutic: in a familiar trope in mainstream feminist cinema of the late 1970s, Kate Miller complains about her husband's lack of sexual prowess and his insensitivity to her needs, and it is Dr. Elliott's job to offer "neutral" therapeutic discourse – to advise her to "think of where [her] anger is going." Later, Kate Miller will have an extraordinary sexual encounter with a tall, dark stranger, an encounter that – for a brief moment – leaves her renewed, empowered, and possibly endowed with the courage she needs to transform, or even end, her marriage.

The redemptive choice, thwarted. After her therapeutic conversation with Norman, Marion Crane decides to right her wrongs, to take responsibility for her actions: she will return to Phoenix, give back what remains of the money, and accept the punishment she deserves. When she steps into the shower, she will be cleansed of her sins. Kate Miller, by contrast, is only briefly fulfilled. After the (presumably) spectacular coitus in the stranger's apartment, she glows with happiness and pride; she has taken control of her desires and, for

once, acted in accord with them; she has stepped out from under her husband and made her own choice, had her own defining experience. Three nasty surprises await her, however: first, the disclosure that her partner has a venereal disease; second, the realization that she has left her wedding ring behind; and third, the towering figure who will trap her in the elevator. What is the nature of the "joke" being played on the protagonist in the two films? Marion Crane does not die "in the flower of her sin," but in the cleansing light of redemption, while Kate Miller is struck down in the moment of supreme defeat – as she returns to the stranger's apartment to retrieve the wedding ring, the symbol of a captivity that she cannot really escape. Note that the canonical scholarship on *Psycho* usually assumes that Hitchcock is "calling" to the innate anti-social impulses of the viewer – impulses that are activated and indulged, almost redeemed, and then finally attacked. However, this "call" in *Dressed to Kill* is not understood in similar terms: instead, it is De Palma who is anti-social, not the audience.

The murder of the main character in an enclosed space – a.k.a. "the shower scene." In order for this gesture to function properly, it must occur roughly a third of the way into the film, at the point at which audience identification with the character is presumably strongest – and therefore the point at which this character's death would be most unexpected and jarring. Additionally, the murderer must be seen indistinctly, since the "woman" who performs the killing will turn out to be the sympathetic male in drag. The elevator scene in *Dressed to Kill* is probably the most intense and intimate (which is not necessarily to say *personal*) murder in all of De Palma's work – although let us recall that, for sheer sadism, it is certainly topped by the necktie-strangulation in *Frenzy*. However, in both *Psycho* and *Dressed to Kill*, the intensity of the violence is in direct proportion to the strength of the audience's identification with the character. Hitchcock apparently wanted the shower murder to be understood as an attack on the audience (cf. his famous notation that the scene should leave the impression of a knife slashing through the celluloid, ripping the fabric of the movie screen itself) and therefore the murder is played for an absence of comic effect. By contrast, in *Dressed to Kill* the scene itself is played for comedy of a not-so-subtle variety: the exaggerated sound effects (the palm-slashing is accompanied by what sounds like ripped silk) and the intercutting between the murder and the insipid conversation of the couple waiting for the elevator two floors below help to achieve a hyperbolized, ambiguously comic Polanski (or Ken Russell) effect.

The substitution of a new female lead, and the sexless pairing of this new character with a sympathetic male who will, in partnership with her, take on the job of detection. The sympathetic male must be of some relation to the now-deceased female lead: thus in *Psycho*, Marion Crane's lover Sam Loomis reappears in the narrative in partnership with Marion's sister Lila, while in *Dressed to Kill* it is Kate Miller's son, Peter, who partners up with Liz Blake, the "high-class hooker" who witnesses the murder's immediate aftermath. The object of detection is of course different in each case: in *Psycho*, Marion has disappeared, and Sam and Lila must attempt to discover her fate, while in *Dressed to Kill*, Kate Miller's dead body is left in plain sight, so that the object of detection is the identity of the "blond

woman" Liz saw in the elevator. The sexlessness of the couple is necessarily unmarked in *Psycho*, while in *Dressed to Kill* the relationship between the high-school-aged Peter Miller and the worldly prostitute Liz Blake is, as Pauline Kael said, "hilariously innocent" – in direct contrast to the creamy, eroticized atmosphere of the rest of the film, which is, as Kael said, "permeated with the distilled essence of impure thoughts" (Kael 1984).

The policeman who "doesn't get it." In *Psycho*, the figure of Arbogast enters the narrative in a most sinister way and is dispatched appropriately, while in *Dressed to Kill*, Detective Marino – and perhaps this says everything – is played by Dennis Franz. It should be pointed out here that both Hitchcock and De Palma habitually populate their films with policemen that are at least clueless and often threatening; *Psycho* in particular introduces two policemen – the one who stalks Marion Crane, and Arbogast – whose appearances in the narrative visually operate in the most self-consciously threatening manner possible. However, De Palma's relationship to "the Law" is different from Hitchcock's; there is never a point in any of De Palma's work where a policeman "works" in the narrative in quite the way that Marion Crane's highway stalker does, as a nearly mute, masked threat. By contrast, policemen in De Palma are always cogs in a larger machine, either corrupt (as in *Scarface* or *The Untouchables*) or merely *structurally convenient* (as in *Dressed to Kill* or *Raising Cain*).

The climactic confrontation between the new female lead and the murderer-in-drag. In both instances, the female lead unknowingly enters the spider's lair: Lila Crane wants to talk to "Mother" about whether she saw Marion the night she disappeared, and her exploration of the house is surely *Psycho*'s most visually perverse sequence (the praying hands, the copy of the "Eroica" symphony on the turntable, the indentation in the pillow, the fright of Lila's reflection in the mirror); Liz Blake, by contrast, wants to discover the identity of Dr. Elliott's last patient (a blond woman photographed by Peter Miller via his improvised bicycle-cam), and her attempt to seduce Dr. Elliott in his office (in order to gain access to his appointment book) is again staged in a strictly hyperbolic fashion, complete with flashes of lightning and a preposterously overstated dream-monologue rape fantasy. In both instances, the male lead comes to the rescue, although in *Dressed to Kill* it is the deus-ex-machina of the blond policewoman who provides the real "rescue" by shooting Dr. Elliott/ Bobbi through the office window.

The psychiatrist's explanation. Pauline Kael calls this "arguably Hitchcock's worst scene" (1984, 40), although there was always a hint of parody about it in the first place; De Palma's treatment of it, on the other hand, is unambiguously played for parodic effect (one only needs to cite Detective Marino's facial expression at the moment of Dr. Levy's line, "Dr. Elliott's penis became erect"). Whether a 1960 audience would really require an "emergency narrator" to provide such a detailed and verbose explanation of the events is still a matter of debate, but in any event, Hitchcock's scene permits the narrative suddenly to arrive in the realm of the clinical, a transition which could be said to serve as the film's real "punch line." *Dressed to Kill* has been operating in this realm since the first act, with the appearance of a psychotherapist as a primary character; however, the difference between

Psycho's use of forensic psychiatry and the use of American ego psychology in *Dressed to Kill* maps neatly onto the difference between the Hitchcock film's desert landscapes and the De Palma film's Manhattan setting. Thus, the chronologically earlier appearance of the psychiatrist in *Dressed to Kill* immediately places the film's narrative in a world of bourgeois privilege and leisure far removed from the economic desperation and hopeless lives of *Psycho*, into which the appearance of the psychiatrist serves as a fairly severe epistemological intrusion. On the same register, we should consider here the weight each film gives to the figure of the transvestite: in *Psycho*, the word is spoken with the same relish that the word "virgin" is spoken in *The Moon Is Blue* (and rebuffed with similar intensity: let us recall the inflection that the psychiatrist gives the line "Transvestite? – not *exactly*"). In *Dressed to Kill*, however, the film's most visually overloaded sequence involves the telecast of a Phil Donahue show featuring a post-op transsexual (and her memorable pronunciation of the word "heterosexual"), automatically placing us in a different discursive era, and we are clued in to the murderer's gender confusion early on, when "Bobbi" confesses the crime into Dr. Elliott's answering machine with the line, "I'm a girl trapped inside this man's body!" What serves as the shocking final plot twist in *Psycho* – that Norman Bates is his own mother – is therefore *a priori* to the narrative of *Dressed to Kill*, which foregrounds the fact that the murderer is a psychotic transvestite from the very first scene after the murder. The psychiatrist's explanation in *Dressed to Kill*, therefore, has no structural purpose other than to call attention to itself as a reference to its analogue in *Psycho*.

What is more, De Palma chooses to split Hitchcock's original five-minute scene into two parts – first in a police station, and then an outrageous postscript in a restaurant in which an aging diner overhears Nancy Allen's elaborate description of the steps involved in a clinical sex-change procedure and nearly faints from disgust, hereby allowing De Palma to literalize the anticipated reaction of some segments of his audience within the film frame itself. This scene serves the narrative function of setting up the film's "stinger" ending, but it also allows the psychiatrist's speech to continue through the voice of what we might call "the Vera Miles function," as if that character were having to re-explain the mechanics of Norman Bates's psychopathology to John Gavin. That "impossible" scene – like the opening sex act between John Gavin and Janet Leigh – is here literalized by De Palma, who consistently chooses to include everything that Hitchcock either could not (because of the requirements of the production code) or would not (because Hitchcock was not a Godardian). It is this scene that Kael called "hilariously innocent," and the distance between the "innocence" of the two characters – their apparent *healthiness* – and the outrageous clinical detail in which vaginoplasty is discussed between them maps perfectly onto the distance between the two films' conception of psychiatry itself.

The disturbing, ambiguous coda. *Psycho* famously ends with a scene that, for Raymond Bellour (2000), serves to frustrate the Hollywood convention that a film's ending should reply to its beginning. This is the moment at which Norman/Mother, who would not harm a fly, gazes directly into the camera as a skull is superimposed over his face, which then dissolves to the reappearance of Marion's car as it is dragged from the swamp. Earlier in the

film – before the psychiatrist scene – we have been treated to the double revelation of the mummified corpse of Mother and the fact of Norman's not-exactly-transvestitism. *Dressed to Kill* provides no mummy, nor does it stop after the psychiatrist's explanation; rather than providing an analogue to Norman/Mother's final direct address to the audience (with its death's-head superimposition and the butt of Marion's car emerging from the swamp) and thereby allowing the audience to peek behind the "psychotic mask" of the murderer, the film heads straight into another "pure cinema" sequence, ending with a second literal "shower scene" (the film is bookended by them) that outdoes *Psycho* for pure surrealist *frisson*, with a disembodied hand reaching out of a medicine cabinet and cutting Liz Blake's throat with a straight razor. It is notable that both of these "shower scenes" are also dream sequences, and true to form, neither of them is initially announced as such. The second of them ends with Liz Blake waking up in Kate Miller's bed – the same bed that the first shower scene/dream sequence ends in – thus providing exactly the kind of circularity or closure that, as Raymond Bellour points out, *Psycho* goes to extraordinary lengths to refuse. It is also important to note that, just as the film's opening explicitly recalls the beginning of *Carrie*, this final shot recapitulates *Carrie*'s ending, with the camera pulling back from a distraught woman in bed as she wakes up from a nightmare that will presumably haunt her for the rest of her life.

Those gestures from *Psycho* that are notably missing from *Dressed to Kill* (the appearance, for example, of the mummified body of Mrs. Bates at the film's conclusion) are precisely those gestures that, as we shall see, cannot be produced by De Palma's system, which (like Hitchcock's) has definable parameters and epistemological rules. De Palma's horror, after all, is not familial, but social, historical, institutional; as Žižek might put it, there is no psychotic kernel at the core of De Palma's universe, since any attempt to mobilize familial pressures as a source of horror (such as *Raising Cain*) results in the evacuation of the political content that normally fills that function. That is to say, no De Palma film could produce a dreadful object such as the hollowed skull of Mother, an excremental remainder of unspeakable Oedipal trauma that, once it is produced, stops the film dead in its tracks. That corpse, not Marion Crane's, is *Psycho*'s true object, and its appearance sets up the film's punch line and serves as its ultimate guarantee of meaning (or, more precisely, non-meaning). *Dresssed to Kill*, on the other hand, takes place in a world in which everyone has already seen *Psycho*, and therefore the psychiatrist's speech about psychosis and gender is unnecessary; it explains nothing and appears merely to announce itself as a kind of punctuation before the final – and, strictly speaking, utterly gratuitous – slide back into pure cinema, which is after all only possible, structurally speaking, because of the lack or irrelevance of the maternal remnant.

This list of narrative cues, while highly abstracted, gives an adequate impression of the ways in which *Psycho* – which was, let us not forget, entirely *sui generis* at the time of its release – becomes, in De Palma's hands, a set of familiar narrative gestures that can be technologized for a specific purpose. What of the second type of mobilization, those reappropriated gestures from *Psycho* that we might understand as technical rather than

narrative? First, there is the matter of the musical score. Bernard Herrmann's score for *Psycho* is perhaps the most widely imitated of the second half of the twentieth century, not for its general sweep or its strings-only instrumentation, but for a single passage – the shrieking chords during the shower murder – that in the intervening fifty years has appeared, in one mutation or another, in probably a thousand movies. Pino Donaggio's score for *Dressed to Kill* quotes this passage, to be sure, but expands the instrumentation (woodwinds, piano) and surrounds this privileged moment with a lushly romantic score that would not seem out of place under the opening credits of any daytime soap opera – or in a larger-budgeted porn movie (the moaning female vocals would certainly point to a kind of auditory mobilization of audience ideas about "the pornographic"). It is, in fact, not dissimilar to any standard "romantic" score of the era (that of *The Turning Point*, for example), and in general Donaggio – who also scored *Carrie, Home Movies, Blow Out, Body Double*, and *Raising Cain* for De Palma – provides a deadpan pastiche of utterly generic "film score" cues. Pure cinema, as Hitchcock conceptualized it, is dependent on orchestral music for its affect, and De Palma – again like Hitchcock – relies on familiar musical tropes to achieve certain affective goals. In this instance, what is important technically is the use of music to complement long sequences without dialogue, such as Marion Crane's drive from Phoenix to the Bates Motel or Kate Miller's assignation in the Metropolitan Museum of Art.

We have already mentioned De Palma's use of basic Hitchcockian film grammar, such as point-of-view camerawork, the perverse God's-eye-view shot (in through the window of a hotel room, for example, or into a married couple's bathroom), and the tracking-backwards-pulling-expectant-character-alternating-with-approached-object construction so provocatively analyzed by Žižek,[16] such as Lila Crane's approach to the Bates house or Kate Miller's approach to the taxicab outside the museum. We could mention here another type of Hitchcockian shot – the pull-out-push-in geography shot, moving from tiny detail to master shot and back to tiny detail (i.e. the shot in *Vertigo* that begins on Jimmy Stewart, pulls back to provide a wide view of Ernie's pub, and then pushes in to find Kim Novak's green dress in the crowd) – that De Palma utilizes with particular care in *Dressed to Kill*, such as the memorably elegant shot that begins on a wedding ring on a shelf in a so-far-unnamed man's bedroom, pulls Angie Dickinson down a long hallway as she sleepily dresses herself, and then reverses direction to bring a telephone into the foreground. This is a variant on the perverse God's-eye-view shot mentioned above, and its use here – and elsewhere in both *Dressed to Kill* and De Palma's subsequent work – demonstrates, as do so many other details in so many movies, De Palma's attention to not only the theory but the detail of Hitchcock's grammar. De Palma has clearly studied this grammar at both macro- and microscopic levels – in a manner that might be compared to what Raymond Bellour has achieved – and has

[16] "In Hitchcockian montage, two kinds of shots are thus permitted and two forbidden." In *Looking Awry* (1991, 117).

reached a level of operational fluency with it that Hitchcock himself never attained.[17] One good indication of this is that De Palma's refinement of any particular Hitchcockian technique often takes the form of an adjustment in *speed*: thus the aforementioned pull-out-push-in shot in Lockman's apartment is staged with breathtaking – even Kubrickian – languor, while the slow-motion spatial triangulation around the falling baby at the end of *Raising Cain* seems to marry *North by Northwest* with *L'Eclisse* or *Zabriskie Point*. Certainly Hitchcock *always* played games with the elasticity of cinematic time (from the little boy unwittingly carrying a bomb onto a London bus in *Sabotage* to the deaf charwoman mopping the hall during a robbery in *Marnie*); this might be said to be a major piece, perhaps the central piece, in Hitchcock's discovery and technologization of the gaze. What De Palma does, in effect, is to choose to act upon Hitchcock's theoretical conclusions, and this procedure might be called "scientific."

For example, let us address the technique that we might call **The Traumatic Burst of Montage**: we have already cited Hitchcock's famous conceptualization of the shower scene as a meta-cinematic moment (the knife puncturing the screen and therefore the spectator's eye), and we would do well to cite also the fact that Saul Bass was brought in to "design" the visuals for that sequence – lending credence to the idea that the scene operates at a level of abstraction and graphic design heretofore unprecedented in Hitchcock's cinema. De Palma, in the elevator scene in *Dressed to Kill*, goes for the same effect – an explosion of rapid cutting around the victim's body that is nearly Cubist in its abstraction, coupled with a precision of composition and framing that would seem to exceed the scene's formal requirements. De Palma experiments with the rhythm of the scene as well, stopping and restarting the violence twice to accommodate, as mentioned earlier, comically insipid cutaways to a couple waiting for the elevator two stories below – not to mention the shift to slow motion, a technique that, in general, De Palma has arguably used with more fluency than any other Amerian director, even Peckinpah. There is also the fact that De Palma signals the murder before it happens, which Hitchcock does not do: the murderer is pointedly visible, lurking in the stairwell, in the background of the shot that pulls Kate Miller into the hallway and places her at the elevator (and there is a tracking shot, approximating the POV of the murderer, out of the stairwell and into the hallway as the elevator doors close). Once Kate is safely in the elevator, De Palma toys with the audience by confronting Kate with the creepy, accusatory gaze of a young girl who enters the elevator a couple of stories below before sending Kate back upstairs in the elevator to retrieve her wedding ring. Additionally, in Hitchcock's original scene, the violence is famously suggested rather than

[17] By way of contrast, one only needs to compare Truffaut's *The Bride Wore Black* to see what happens when a director studies Hitchcock's narratives and not his technical style. Herrmann's score, for example, is insulting; it is used, as Hitchcock *never* used music, to "paper over" dead spots in the visual track – always the mark of laziness and/or poor planning. It is often pointed out that Truffaut was here attempting to marry Renoir and Hitchcock; this is a disingenuous way to put it, but perhaps Renoir's humanism and Hitchcockian technique are fundamentally, epistemologically incompatible.

literalized, so that the cutting of Marion's flesh is replaced by the cutting between shots; De Palma, naturally, "shows everything" – the slash of the razor through skin is presented without metaphor or substitution, so that the montage accentuates, rather than masks or sublimates, the violence.

All of this essentially boils down to the ways in which De Palma picks up Hitchcock's interest in "pure cinema" and refines it. What often – but not always – goes unremarked in discussions of De Palma as thief-of-Hitchcock is the range of formal devices that Hitchcock himself never used and which De Palma perfects: the split screen, of course, but also the canted-low-angle shot/reverse-shot construction (which appears in *Dressed to Kill* in the conversation between Dr. Elliott and Dr. Levy in the mental-hospital stairwell), the use of the split diopter as a distanciation device, dissolves into and out of split screen, cleverly integrated jump cuts, and even anti-naturalistic manipulations of the anamorphic lens (as in the taxicab chase). Some of these devices are Godardian, and indeed we will discuss Godard and his technical influence on De Palma in Chapter 2; others are particular to De Palma, whose display of virtuosity in *Dressed to Kill* is at least partially dependent on his ability to subsume experimental visual effects seamlessly into a strictly generic narrative. Hitchcock, let us recall, imagined that the essence of "pure cinema" was purely visual – imagemaking without dialogue – and it is inarguable that great stretches of *Dressed to Kill* represent the culmination, within Hitchcock's own generic parameters, of that ambition.

Compare the technical perfection of *Dressed to Kill* with De Palma's *Sisters*, a preliminary experiment with Hitchcockian memes and grammar wherein De Palma subversively fills the Janet Leigh role with an African-American male actor and Norman Bates role with a Caucasian female. In *Sisters*, the split subjectivity of the Norman Bates figure remains sexual in nature, but here it is framed as an institutional, rather than familial, trauma: the twins of the film's title are not positioned in regard to a family structure (their parents are never mentioned) but rather in their relationship to the medical gaze, which is inevitably both parental and sexual. Thus the

psychiatrist who narrates the Bates pathology for the viewer in Hitchcock's text here becomes not an objective, neutral observer (the medical gaze ratifies the transparency of Law) but rather becomes the guardian, lover, and accomplice of the psychotic murderer. Therefore this figure takes his position as part of the narrative's "problem" in that he appears on the scene not in order to offer closure, but as part of that which must be closed. Indeed, as Robin Wood obviously relishes pointing out, the doctor is castrated at the film's end – stabbed in the crotch in more or less the same way as the film's Janet Leigh figure, an upwardly mobile African-American man. The intrusive Mother figure is repositioned so that her presence is a "problem" not for the narrative itself but rather for the "amateur detective" character, who appears here, as in *Dressed To Kill*, in the position of "witness": a white female reporter who lives in the Staten Island apartment complex in which the murder takes place and, indeed, witnesses the event through her "rear window." Her insistent search for "the black man's body" – his name, like his corpse, vanishes from the film immediately after the murder – is of a piece with the left-wing "muckraking" reportage pinned to the walls of her apartment, and this strange evocation of "political commitment" is matched by the figure of her traditionally minded, bourgeois mother, who routinely identifies her daughter's outrage at society as "just a phase." *Sisters* ends with the reporter, now brainwashed into believing that the murder never took place, in the protective arms of her mother while the Arbogast figure, a private detective, impotently monitors the body-concealing sofa from atop a telephone pole in Nova Scotia.

We will have much more to say about *Sisters* in Chapter 2, specifically as regards the potential significance of the choice to build a Hitchcockian narrative around a missing black body (especially in 1973), but let us merely foreshadow that argument by suggesting here – as a kind of placeholder – that *Sisters* might be seen as De Palma's first attempt to mobilize *Psycho* (and other Hitchcockian modules) toward a specifically *political* end. By way of contrast, let us then describe *Obsession*, with its mangled script by Paul Schrader, as De Palma's impossible attempt to behave like Andrew Sarris – that is to say, to regard Hitchcock from the position of slave in relation to his master; here we find De Palma attempting to recreate the "masterpiece effect" of *Vertigo* by carefully emulating its tone, structure, sound, and *mise-en-scéne*. Like *Vertigo*, it involves a haunted woman who disappears and then "comes back" in another body; there is also the soft, sentimental male hero, whose repeated wounding gives the film its "tragic" dimension. The mysterious "other" city and its own ghostly double, between which the template narrative oscillates – elaborated in *Vertigo* as San Francisco and its colonial past – here appears as New Orleans and Florence, Italy, a transposition of a temporal difference onto a geographical one. There is the replication of *Vertigo*'s own narrative bifurcation: two movies, a detective story and then a story of a man's sexual obsession with a ghost that is not a ghost, staged as the "before" and "after" of a central tragedy, which at the moment of its occurrence is misread and which therefore replicates itself at the end of the film. There is the fogged-out evocation of that strange quality of light that typifies San Francisco, replicated by Vilmos Zsigmond by "flashing" the film negative (again, as in *McCabe and Mrs. Miller*). And then there is the presence of Bernard Herrmann, who provides a Theremin-driven pastiche of his legendary score for *Vertigo*, right down to the chromatic clusters in the brass and organ.

Why and how does *Obsession* "not work"? After all, it achieves the curious effect of bringing into ghostly presence another movie, a putatively *better* movie, that runs directly behind it, and indeed this is how *Obsession*, of all of De Palma's films, is closest in its effects to Gus van Sant's zombified shot-for-shot reanimation of *Psycho*. It is notoriously difficult to speak critically of humor and its role in positioning an ideal spectator, but it should be noted here that of all De Palma's films, there are only two that may be said to be without humor: *Obsession* and *Casualties of War*. *Obsession* – with its aggressively swooning Panavision camerawork, its attendant sublimation of the Maysles-Godardian verité style that was until that point De Palma's primary heritage, and its reverential ochre-and-graveyard-white production design – is certainly evidence of a certain transferential relationship, and perhaps the ghostly presence of the already-uncanny *Vertigo* (which upon its release was, like *Psycho* after it, *sui generis*) helps to defeat De Palma's Guignol impulses, which are, it becomes apparent in their absence here, precisely what brings him into alignment into Hitchcock in the first place. Andrew Sarris wrote that *Obsession* was more of "a critical *essay on Vertigo* than a film in its own right" (Sarris 1976), and if we are to take Sarris at his word – that *Obsession*, in contradistinction to *Dressed to Kill*, is an academic paper on Hitchcock – then it is probably not a very good paper, but this evaluation is of little consequence here. Its attempt to elaborate *Vertigo*'s system operates in several registers at once (structural, grammatical, tonal); and while De Palma cannot be said, with *Obsession*, to have located the central theoretical issue in *Vertigo* (that *la femme n'existe pas*), he – or his cinema – had certainly figured it out by the time he made *Body Double*.

If *Sisters* (as we will see in Chapter 2) might be a political act built on a Hitchcockian skeleton and if *Obsession* represents an attempt at mastery, both of *Vertigo* in its specificity and of Hitchcock's film grammar in general, then how are we to conceive of the project of *Dressed to Kill*? Let us note again what is missing in that film's "adaptation" of *Psycho*: the familial as the source of horror; the alienated "inner landscape" of rural America as a place of murderous psychopathology; the low-budget, vaguely documentary quality; and the pressures of the Hays code, which always manifested as collapses and substitutions. What does De Palma substitute for these elements? There is pure (i.e. narratively unmotivated) cinematic form as the source of horror; there is the soap-opera landscape of anonymous upper-middle-class New York as the stage for that horror; there is the diffused Panavision cinematography and aggressively self-referential camera movement he retained from *Obsession*; and, as a potentiality rather than a restraint, there is the world of American cinema after the sexual revolution (and before AIDS), in which a mainstream motion picture could reasonably begin with a graphic masturbation-and-rape fantasy in a glass-walled shower.

Most notoriously, even with these differences of context and content, *Dressed to Kill* and *Psycho* share a central conceit: the strategic mobilization of audience sympathies for a transgressive female character, who is then jettisoned from the narrative in a moment of ferocious, traumatic violence. *Dressed to Kill* stages the central "prank" of *Psycho* within the specifically Hollywood world of "adult femininity" (*Alice Doesn't Live Here Anymore*, *An Unmarried Woman*, &c.), and in doing so occasions a flood of sexualized fantasy and

Interiority as lure.

sadistic violence into what was already a highly contested generic space. The effect is not quite parodic: the film is filled with gags, all of them deadpan and each operating at a different register (visual, aural, narrative/structural, linguistic, even the strictly generic), but it is clear that the mobilization of the central "prank" of *Psycho* is the motivating operation. This use of a quasi-sophisticated, modern suburban woman as a kind of "lure" to lead the audience into the (presumably pleasurable) trap of the prank would result, of course, in social controversy, bitter division between opposed sides, and a surplus of argumentation about thievery, authorship, and capitalist motivation.

The film's project, though, is purely formal – in that its "content" is, in a way, entirely beside the point. One cannot say that this is true of *Psycho*, which circles around a set of issues about gender with an insistence quite above and beyond their functionality as elements in a shocking thriller: this is how queer readings of Hitchcock are far more productive than queer readings of De Palma. Even though it has a surplus of highly charged content (transvestitism, sexual freedom and punishment, prostitution) and a surplus of autobiographical material from De Palma's life (the Keith Gordon character, as we will see in Chapter 3, operates as a clear stand-in for De Palma himself), *Dressed to Kill* is clinically detached from the implications of its gender politics, and this is perhaps what drove both auteurists and feminists away from the film with such force. Indeed, the film's ideational content – the character arc of Kate Miller, like the character arc of Marion Crane – is a kind of carrot-on-a-stick for the viewer's affective response, and although *Dressed to Kill* goes to some lengths to properly procure its "effects" (i.e. delivering scares, keeping the viewer guessing and engaged, &c.), it does so with one eye (as it were) on the viewer's pleasure and another on the process of distancing him or her from that pleasure.

On the other hand, there is also *Body Double*, which is as insistent upon its use of Hitchcock to produce a specific kind of *unpleasure* as *Dressed to Kill* is the opposite. It was widely noted that *Body Double* seemed to have been made out of spite, in order to provoke the critics who

had accused him of "ripping off Hitchcock" four years before, and indeed that seems to be an integral part of the film's conception: incorporating shards of Hitchcockian "business" from *The Lady Vanishes, Young And Innocent, Rebecca, Foreign Correspondent, Rope, Strangers on a Train, Dial "M" For Murder, Rear Window, The Man Who Knew Too Much, Vertigo, North by Northwest, Psycho,* and *Marnie* (and probably others), it is paradoxically De Palma's purest and most intense film, and probably the most daringly self-reflexive Hollywood film of the Reagan era. There is a measure of self-reflexivity built into any De Palma film, to be sure, but *Body Double* – unlike any of Hitchcock's films, for example – is set in Hollywood and takes filmmaking, specifically genre filmmaking, as its subject. The narrative itself is an amalgam of two main Hitchcock texts: from *Rear Window*, we have the trope of a man witnessing – or at least detecting – a murder in an adjoining dwelling, with a movie-screen-shaped window (or a series of them) in between; the narrative presumably then becomes an allegorical meditation on cinema spectatorship. From *Vertigo* we have a more complicated string: a man is "set up" to spy on a woman who is not really the person he thinks she is; the "real" woman is murdered and he is unable to save her; the man sinks into a narcissistic obsession with the dead woman (he has failed to stop the murder or apparent suicide, and this failure crashes his entire psychic economy); at the end, the man realizes that in fact there was a substitution of one woman for another, and that his heretofore-unknowable private sexual economy was mobilized for this "witnessing" by another man, a husband, who needed an "objective" guarantee of his own innocence in order to murder his wife. This string, in turn, would seem to cast the narrative into an allegory of male desire, or (as Žižek, after Lacan, would put it) the impossibility of the sexual relationship – after all, what makes this narrative quintessentially Hitchcockian is, like the traumatic movement from Marion's story to Norman's in *Psycho*, the transition from a simple surveillance-and-detection story to another type of narrative, the narrative of loss, madness, and object substitution.

These two films – *Rear Window, Vertigo* – are, along with *Psycho*, the cornerstones of Hitchcock studies; they are generally taken to be his most personal films, the purest and most transcendent expressions of his philosophy or worldview, or whatever abstract noun one privileges here. (Had he not made them, Hitchcock's total oeuvre would be considerably less coherent – he might be *merely* the "master of suspense" they once claimed him to be, and in that light perhaps he would be remembered no more fondly or widely than, say, Otto Preminger.) In *Body Double*, however, these epochal film texts are reduced to a kind of narrative-structural toilet paper.[18] This deliberate vulgarization – which one is almost *required* to read as an affront to *some* discursive community with *some* protective relationship to Hitchcock (film critics? Hollywood executives? Andrew Sarris? Martin Scorsese?) – is most tellingly expressed in a

[18] J. Hoberman mentions the reaction of a friend, who during a screening of *Body Double* leaned over and whispered, "He's gotten so reflexive, he's disappeared up his own asshole." This is not the place to attempt an "anal" reading of De Palma or *Body Double*, but there is no doubt that the film – especially its more aggressively smutty parts – has the gleeful tone of someone smearing excrement on the Mona Lisa. In "Double Is My Business," reprinted in *Vulgar Modernism* (1991, 204).

single moment from the film, De Palma's recreation of the "flower shop/Madeleine in the mirror" shot from *Vertigo*. In *Body Double*, the enraptured face of Jimmy Stewart as he spies on the remote, glacial Kim Novak is replaced by the bespectacled and argyle-sweater-vested Craig Wasson, whose vapid come-on line to Melanie Griffith (who appears in the mirror gyrating slowly and wearing a buttless leather *bustier*) is delivered with a perfectly blank, even wooden lack of inflection – a shocking parody of Jimmy Stewart's endearingly quizzical sweetness. Indeed, what is missing in *Body Double* (and, indeed, from De Palma's work in general) is precisely that which is most Hitchcockian: the aspect of *l'amour fou*, the Surrealist obsession with Woman-as-Object that is taken as a sign of the subject's interiority, depth, or capacity for feeling. Interiority, depth, capacity for feeling: these are not the qualities one associates with the airbrushed ciphers that, in *Body Double*, stand in for what even in Hitchcock we would call "characters," and indeed the film's project would seem to be an elaboration of the idea that there are no human beings in Los Angeles. This is not an earth-shattering idea – Nathanael West can be said to have delivered the definitive elaboration of the Hollywood-as-wasteland trope in *The Day of the Locust*, and one might even read the Schwarzenegger disaster *The*

Last Action Hero as a quasi-subversive vehicle for its expression – but in *Body Double* the yoking of this idea to an ultraviolent Hitchcock pastiche would necessarily, given what Steven Prince terms the "shifting of the moral climate," produce an explosion of misrecognition from all quarters. The evacuation of "character" (and "depth" and "interiority") from *Body Double* is of a piece with its shift of its Surrealist energies from the aspect of *l'amour fou* to cinematic spectatorship in general: rather than the hypnotic and inescapably Buñuelian lure of Angie Dickinson's "depth" and "interiority," we get a Godardian slippage between cinematic registers, from *Vampire's Kiss* (the supremely evacuated generic gorefest inside which *Body Double* opens) to *Rear Window* and *Vertigo* via *Holly Does Hollywood*, and back again (twice). The film floods itself with intimations of "the pornographic," and while this argument will be further elaborated in Chapter 3, when *Body Double* is discussed in tandem with *Blow Out* and *Scarface*, it should be noted here that Hitchcock – unlike Michael Powell, and unlike De Palma – never made the choice to set an exploration of "the scopic regime" within the industrial film apparatus– much less the world of pornographic film. (Of course there is the matter of Hitchcock's never-completed *Kaleidoscope*, but about that there can be only speculation.)

The last of De Palma's explicitly Hitchcockian essays, *Raising Cain*, is inescapably of a certain kinship to the earlier entries in the series. Again, a canonical Hitchcock text – *Psycho* – is interrogated in terms of its structure and grammar. The film might be usefully put in the form of a question (and let us not forget Godard's dictum that "a good film is a matter of questions properly put"): how does one remake *Psycho* in a world where not only is it common knowledge that Norman Bates is his own mother, but also where everybody knows in advance that any Brian De Palma film is automatically a remake of *Psycho*? De Palma's solution is to move the last-act revelation that the Sympathetic Male is a split personality to the film's opening scene, so that the narrative adopts as an *a priori* the idea that the point of identification (as Žižek might say) is always-already compromised. What happens as a consequence of this move is a radical shuffling of the narrative elements: the Psychiatrist Who Knows is introduced (spectacularly) in the second act, the malign parental remnant becomes an actual character (although it is not clear that the crazed Dr. Nix is not one of Carter's splits until the film's climax), and – most significantly – the "shower scene," the traumatic burst of violence that breaks the narrative in half and constitutes its defining split, disappears – subsumed into and across the structure in such a way that it appears as a kind of constant *formal* violence, an inexorable fracturing both of the narrative and of spectatorial identification. The formal severity of this fracturing is worth noting. In a sense, *Raising Cain* is De Palma's most avant-garde film, even surpassing the radical split-screen experiment *Dionysus in '69*: the second act, for example, is a flurry of Buñuelian temporal reversals, so that one character wakes up out of a dream three times in a row (almost certainly a nod to *The Discreet Charm of the Bourgeoisie*); elsewhere the action is daringly surreal – from the dislocated hand that snaps up into frame to cut John Lithgow's wrist with a scalpel to the outrageous climactic action sequence, in which a dozen elements (pickup truck, baby carriage, bag of groceries, drunk hotel guests, gunman, falling infant, two separate

John Lithgows, etc.) interact in protracted slow motion in a multi-leveled motel courtyard. The most astonishing technical feat in the film – and one of the most forceful stylistic gestures in all of American cinema – is surely the appearance of the Psychiatrist's Explanation, which coincides with a magnificent traveling master shot that alternately pulls and follows three figures through a four-story police station and into the basement morgue, where the camera abruptly meets the accusing gaze of a corpse. (It is worth noting that this, the most amazing moment in *Raising Cain* and possibly the funniest traveling master shot yet made, was more or less directed by Corky McConkey, De Palma's go-to Steadicam operator – a good example of De Palma's approach to collaboration.) There is also a surfeit of other specific gestures from *Psycho*: the sinking of a body-laden car into a swamp, complete with a moment of panic (both for the murderer and for his accomplices, the audience) as the car stops sinking halfway; the last-moment revelation of the murderer in drag; even a nearly unmotivated use of the word "transvestite," far in advance of the moment at which the actual appearance of a man in drag becomes a narrative possibility.

This radical reorganization – dare we call it a "deconstruction?" – of structural elements from *Psycho* demonstrates, more than any other De Palma film, the level at which "Hitchcock" can be thought abstractly. (Conceptually, the film it resembles most is Raoul Ruiz's great *Treasure Island*.) Of course by this point, De Palma is referencing his own work on Hitchcock even more than he's referencing Hitchcock himself, like a film scholar building off his own past research; this is how we can get echoes of earlier moments like the empty-shoes-in-the-closet in *Dressed to Kill*, which reappears almost verbatim (if you will) in *Raising Cain*, or a certain kind of triangulation of point-of-view around objects, which appears as an editing methodology in De Palma's work for the first time in the car-crash sequence in *The Fury* and which is put to work here in nearly half a dozen scenes. However, the deliberate mobilization of "the pornographic" and "the ultraviolent" in *Body Double* and, to a certain extent, in *Dressed to Kill* is entirely absent in *Raising Cain*, which is extraordinarily chaste in terms both of its sexuality and of its bloodletting. (Compare, for example, Paul Verhoeven's controversial Hitchcock pastiche *Basic Instinct*, which opened the year before *Raising Cain* and which certainly raised the bar both for explicit sexuality and for graphic violence far past what De Palma has ever attempted.) The subtraction of these elements allows for a level of abstraction hitherto unseen in De Palma (and, indeed, in Hitchcock), so that by comparison to the other films in the Hitchcock series – *Sisters, Obsession, Dressed to Kill, Body Double* – *Raising Cain* emerges as a kind of terminal meditation on Hitchcock's machinery, very nearly divorced from the narrative content that the machinery normally supports.

It will be helpful here to look at a particular stylistic gesture that should serve to delineate more precisely some of the differences between the two directors' systems. This is what we might call *the return of the camera's gaze* – those privileged moments when a character is allowed to "see" the camera and to return its look, to gaze directly into the lens in a highly charged moment of "recognition." Aside from Norman's gaze into the camera at the end of *Psycho*, the most famous of these in Hitchcock is probably the moment in *Vertigo* when Kim Novak, as Judy Barton, slowly turns from the door through which Jimmy Stewart has just

The empty shoes in the closet.

exited and comes to face the camera, a look of profound terror on her face. Her gaze triggers a flashback to the "primal scene" of the real Madeleine Elster's murder, giving the audience the "truth" of that event for the first time, and once the flashback is over, a dissolve returns us to Judy Barton's anguished face as she winces and "breaks contact" with the spectator. The peculiar, inexplicable power of this moment is entirely due to the fact that she seems to "see us" – that for an instant the character meets the gaze of some kind of indefinable supernatural agency that can only exist within the frame of a Hitchcock picture. (William Rothman would tell us that, at that moment, the character sees Hitchcock.) It is, indeed, a gaze into the face of Death, and the spectator for that instant occupies a position that literally does not exist and cannot be articulated. It is the single most powerful moment in all of Hitchcock's work, which is not to say that moments like this one do not occur in many of his films: another example of it occurs late in *The Birds*, when Melanie Daniels awakens on a couch after her attic "rape" by the birds and looks directly into the lens, swatting it away with her hands in wordless terror. The gesture of allowing a character to "see" the camera works differently in Hitchcock than it does in any other director or genre[19]; consider, for example, the way in which characters in Werner Herzog or Ingmar Bergman films habitually "address" the camera at privileged moments. This is a modernist gesture *par excellence*, and it finds its American corollary in Jerry Lewis's double-take at the camera at moments of sexual distress (i.e. every three minutes or so in his classic *The Ladies Man*) or in Charlie Chaplin's glance at the audience at moments of surprise – in modernist drama, as in

[19] The most truly Hitchcockian use of the gesture outside Hitchcock's own work occurs – unsurprisingly – in Powell and Pressburger, whose films together are profoundly similar to Hitchcock's, even to the point of probably having had a determining influence on them. Think, for example, of Moira Shearer's terrified gaze into the camera at the conclusion of *The Red Shoes* – where, following Rothman, we might say that she "sees" the film audience right before she hurls herself off a balcony to her death.

slapstick comedy, the moment of "character sees the audience" is a purely *generic* moment. In Hitchcock, however, one might assert that these moments are the crux of his filmmaking; all of *Psycho* leads up to the moment at which Norman/Mother looks up, smiling vacantly, and returns the gaze of the audience before metamorphosing into a skull (and it is often suggested that the mummified body of Mother in the cellar of the Bates house is gazing at the audience). Rothman's entire reading of Hitchcock's system depends upon these returned gazes; he interprets them – correctly, I think – as the hinges upon which Hitchcock's work turns. It is no accident that Hitch himself is allowed to meet the camera's gaze in his cameo in *Marnie*, his last great film: after that moment, his art turned to ashes.[20]

In De Palma, by contrast, the "Return of the Gaze" is much closer to that of Jerry Lewis: a moment of comic rupture. The opening shot of *Body Double*, for example, brings us face-to-face with a vampire lying dead in his coffin; accompanied by a burst of "fright music" he springs up and, snarling, bares his fangs directly at the lens – then freezes in terror. It turns out that he is literally "locking up" in anxiety in front of a 35mm film camera, which the film's first cut brings into view. In *Phantom of the Paradise*, Winslow Leach is pronounced "guilty" of drug possession by a judge positioned in front of an enormous American flag; Winslow spins around and, waving his arms directly into the lens, proclaims that he has been framed. (The next cut takes us to Sing-Sing.) We might also mention the outrageous moment in *Greetings* when a JFK conspiracy buff, in the midst of tracing bullet trajectories on his girlfriend's naked body, spins to face the camera and explains the logic by which he has just disproved the single-assassin theory.

In these examples, the use of the gesture might be called Brechtian, forcing a "break" in the film's illusion of continuity that (at least theoretically) throws the audience from the diegesis; De Palma alludes to Brecht in several interviews from the early 1970s and proclaims the importance of distanciation as a technical tool.[21] Only once does De Palma use the gesture in a Hitchcockian way, and even then it doubles as a Brechtian gag: in a marvelous scene late in *Raising Cain*, John Lithgow is under hypnosis and one of his "multiples," a little boy named Josh, has come to the forefront. His interrogator (a psychiatrist, naturally) asks him about another multiple, Margot, which makes Josh nervous, since Margot is the "keeper" of the multiples and presumably knows "where the babies are" (the plot revolves around some kidnapped infants who are to be used as a control group in a child-psychology experiment: one is immediately reminded of *Peeping Tom*). Suddenly, Josh "sees" the camera – which is positioned behind the psychiatrist's left shoulder – and whispers "she heard me!", his face contorted in terror. The "she," of course, is Margot, and as Josh panics and "spills the goods" to the psychiatrist, the camera tracks elegantly around the table to land behind Josh's right shoulder, where Josh spots "us" again – and, eyes rolling back, passes out. In this shot, the spectator occupies the place of an impossibility – a floating fragment of "split personality," a malignant agency somewhere between a "character" and a director surrogate – that has no

[20] Compare Spielberg after *Schindler's List*.

[21] Brecht is also invoked in several of De Palma's promotional interviews for *Redacted*.

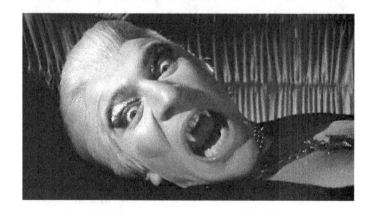

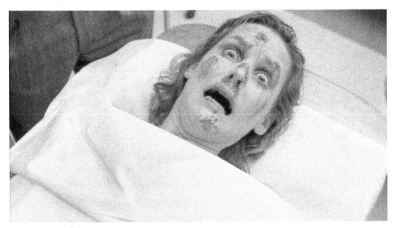

The return of the gaze.

Diana Vreeland drag.

dialogue and, until the film's last shot, no body to occupy. (The "punch line" of *Raising Cain* is the embodiment of this impossibility: John Lithgow in Diana Vreeland drag.) A similar moment, earlier in the same film, brings the camera face-to-face with a corpse in a morgue; when the sheet covering the body is whipped back, the dead woman's eyes – frozen open in a scream of terror – are staring directly, accusingly, at "us." Again, the returned gaze is an absurdist punch line: we are confronted with the body at the end of the previously described four-minute traveling master shot, during which we get that film's deadpan replay of the Psychiatrist's Explanation – so that the appearance of the corpse is roughly analogous, in structural terms, to Norman/Mother's final gaze at the camera in *Psycho*. Another example of this gesture, again in a medical environment, occurs during one of the film's numerous narrative-jolting, unmotivated flashbacks: Lolita Davidovich, in the role of a doctor, kisses Steven Bauer at the stroke of midnight on New Year's Eve and, in doing so, kills his wife – who wakes up from her coma, sees the infidelity, and dies. The visual shock of the death is given through a burst of room-spanning montage, which brings the camera directly into the dead woman's face, her sightless, accusing eyes locked directly into the gaze of the lens.

Should we attempt to describe an overall strategy here? As we have seen, all of De Palma's most explicitly "Hitchcockian" movies are centered around the canonical trio: *Rear Window, Vertigo, Psycho*. This is an important fact to note, for while De Palma has clearly seen and absorbed most, if not all of Hitchcock, it is only what one might describe, after Sarris, as the "sick" Hitchcock – the Hitchcock of objectification, split motives, and obsessive, sexualized surveillance – that appears as a primary structural element in De Palma's work. Bits from other Hitchcock films may show up as references – the strangulation from *Dial "M" for*

Murder in *Body Double*, for example – but always and only as support machinery for the interrogation of the three canonical texts. And even *Rear Window* can only appear, in a certain way, as support machinery – suggesting that its central motif (the witness who sees and yet does not see) is only of interest insofar as it can provide a bridge between the split narratives inherited from *Vertigo* or *Psycho*. Note that De Palma never recycles Hitchcockian narratives about couples tied together by accident, who fall helplessly in love (as in *The 39 Steps*), or stories about helpless women caught between two men (as in *Notorious*): his Hitchcock essays are focused relentlessly elsewhere.

Therefore, De Palma's own "Hitchcock," as an object with boundaries, dovetails neatly with that of psychoanalytic Film Studies, especially that which takes an explicitly feminist stance: he isolates Hitchcock in his sickness and, in doing so, elaborates Hitchcock's perversion as a structural motif. Thereby the structure of these films becomes evidence, perhaps proof, of what we might (after Žižek) call Hitchcock's *agalma*: that which is in him more than himself, the hidden place from which he stages his enjoyment. Given the particular way in which Hitchcock built his narratives around transgression and punishment, it is inevitable that his phantasmatic elaborations of the rule of Law become, in some way, the basis for his own ascension to the level of the Law; Hitchcock's ascent to the figure of *nom-du-père* is paradoxically both the condition of possibility for, and the consequence of, the transposition of his narrative logic onto the level of the social imaginary. This is how *Body Double* can be an essay about the ways in which the critical gaze imagines itself to "own" Hitchcock's legendary procedure; and since De Palma's address to that critical gaze – from the continual *trompe-l'oeil* games that De Palma plays with the film frame to the gleeful provocation of the deadly rape-and-murder-by-electric-drill – is at all moments articulated through Hitchcockian grammar, it might be said to constitute a *parricidal act*.

Everything You Ever Wanted to Know about Žižek (But Were Afraid to Ask De Palma)

It is worth noting at this point that, while Hitchcock may have ascended to the level of master signifier, he remains – more than ever – somehow "perverse," a director whose filmic concerns are defiantly rooted in the third term of Lacan's trio of subject positions – neurosis, psychosis, perversion. It seems that almost every article of Hitchcock scholarship written from a certain hermeneutic perspective is concerned with his perversion: Hitchcock's suspense is "a kind of perversion" (Bonitzer 1992, 153), his cinema is "the very institution of perversion" (Bellour 2000, 254), and so on. The theorist to get the most mileage out of this idea is doubtlessly Slavoj Žižek, whose "use" of Hitchcock, like De Palma's, is entirely instrumental: Hitchcock appears at key points in Žižek's free-associative writings on Lacanian dialectics as a kind of primary support, providing "proof" of such difficult concepts as "woman does not exist" and "the letter always returns to its sender in its true, inverted form" in isolated scenes from a range of his films, from *Blackmail* to *Marnie*. Žižek

is on record with his typically hyperbolic claim that Shakespeare read Lacan, and while he never explicitly claims the same for Hitchcock, the idea nevertheless resonates everywhere in Žižek's writing that Hitchcock is *un Lacaniste*, that Hitch – more than any other filmmaker – illustrates a profoundly Lacanian view of intersubjective relations as determined by fantasy and the *che vuoi?* of desire.

Since Žižek's intervention might be called the last major theoretical breakthrough in "Hitchcock Studies" of the twentieth century, let us assume that, for the moment, Žižek's Hitchcock is currently the dominant one; it is certainly the primary "Hitchcock" in regard to which, at this moment, a discussant must position him- or herself in order to be current. Žižek is a relatively recent arrival on the Hitchcock scene; his first book in English arrived nine years after the appearance of *Dressed to Kill*. Therefore, the Hitchcock paradigm into which Žižek "intervened" was already marked forever by De Palma's own intervention. The question then becomes: to what extent could Žižek's "Hitchcock" and De Palma's "Hitchcock" be said to be the same system? What are their differences and their similarities? In order to delineate how Žižek's Hitchcock "works," we would want to look specifically for constructions of Hitchcock's agency. Given that Hitchcock shows up in every single one of Žižek's books, let us, for the sake of brevity and clarity, concentrate on two of Žižek's extended meditations on Hitchcock "in himself": first, the three pieces authored by Žižek in his anthology *Everything You Always Wanted to Know about Lacan (But Were Afraid to Ask Hitchcock)*, and then the three chapters in *Looking Awry: An Introduction to Jacques Lacan through Popular Culture* grouped together under the section heading "One Can Never Know Too Much about Hitchcock."

Let us begin by noting a certain rhetorical trope that Žižek uses with uncanny frequency. This might be called his *logic of the total system*, a logic that he inherits from Hegel via Lacan. For example, Žižek claims to have located "the elementary cell, the basic matrix of the Hitchcockian procedure" in the use of the phallic "thing that sticks out" (the reversed windmill in *Foreign Correspondent*, for example), which Žižek aligns with the Lacanian *point de capiton*, the empty signifier that knits together both individual subjectivity and the social order (Žižek 1994, 87–89); this "spot" or "stain" is "the fundamental constituent of the Hitchcockian universe," and in order to create and mobilize this stain, Hitchcock uses a certain pattern of editing – a grammatical tic that "is, so to speak, the elementary procedure, the zero degree of Hitchcockian montage" (Žižek 1994, 116–117). Elsewhere, Žižek identifies Hitchcock's "elementary strategy," a more abstract movement whereby "the viewer becomes aware of how this gaze of his/hers is always-already partial, 'ideological,' stigmatized by a 'pathological' desire" (Žižek 1992b, 225). What is more, Norman Bates has a certain "awareness of our complicity" (and thus his haunted gaze into the camera at the end of *Psycho*), and thus Hitchcock offers a "Hegelian lesson" in the idea that "the place of absolute transcendence, of the Unrepresentable which eludes diegetic space, coincides with the absolute immanence of the viewer reduced to pure gaze" (Žižek 1992b, 244). Žižek locates "the quintessence of Hitchcock" in a similar moment, the God's-eye-view from the top of the staircase in the Bates house, for it is the next cut, the cut into the POV of Norman/

Mother as he/she kills Arbogast, that "accomplishes, in Hegelese, the reflection-into-self of the objective gaze into the gaze of the object itself; as such, it designates the precise point of passing over into perversion" (Žižek 1992b, 249).

The system is indeed total; in dividing Hitchcock's films into periods, Žižek identifies a stage ("from *Marnie* onwards") that he names "'post'-films, films of disintegration," in which the "breaking apart of Hitchcock's universe into its particular ingredients" enables "us to isolate these ingredients and grasp them clearly" – implying that in previous stages Hitchcock's universe was coherent, systematic, even rigid (Žižek 1992b, 5). The logic of this total system, naturally, requires that the system have a "psychotic core," which is "the ultimate Hitchcockian dream" of manipulating the viewer "directly, bypassing together the *Vorstellungs-Repräsentanz* (the intermediate level of representation and its reflective redoubling in the representative)" – a "dream of a drive that could function without its representative in the psychic apparatus" (1992b, 240–241).[22] Further proof of the coherence of this system resides in the fact that Žižek is able to find *sinthomes* there, elements of hardened, pure enjoyment that signal the bedrock of the subject's desire – in this instance, those "characteristic details" in Hitchcock that "persist and repeat themselves" without implying a common meaning – the glowing glass of white fluid that recurs in several films, for example (1992b, 125–127). However, Žižek is careful to distance this notion of system from "psychological reductionism"; that is Hitchcock criticism that attempts to isolate or even posit the existence of an "original experience" in Hitchcock's life that forms the traumatic kernel around which his films circulate (1992b, 217). Therefore, Hitchcock himself disappears; Žižek knows that his presence is a trap, and so Hitchcock is subsumed into the set of effects that Žižek calls "Hitchcock."

Let us note at this point that this total system is simultaneously operating at two levels. It operates like a subject, a subject that uncannily resembles what we assume we know about the man Alfred Hitchcock, divided between technical expertise and uncontrolled personal obsessions and therefore split, diseased, even specifically perverse; it also operates like a god, in that it – unlike any person or system – understands itself in its entirety, is capable of metalanguage (perhaps even itself constitutes a metalanguage), understands and has access to its own desire and, most importantly, understands and has access to *our* desire. (Hitchcock, like Bob Dylan, can *see through our eyes* and *see through our brain*, like he sees through the water, which – in what we might call a "*Psycho* reference" – rolls down his drain.[23]) This magnificent being would be capable of existing simultaneously on two incompatible registers of existence – one of knowledge, and one of non-knowledge – and although he never explicitly makes this connection, Žižek essentially understands Hitchcock to be a Lacanian analyst, the object of transference for the entire discursive community we call Film Studies. The Lacanian analyst, as we may or may not remember, does his or her job by filling out the hole in the Big Other – that is to say, he tries to assume the place, for the patient,

[22] The example cited is Hitchcock's famed conversation with Ernest Lehman about wiring the audience with electrodes and playing their emotions like an organ.

[23] "Masters of War," on *The Freewheelin' Bob Dylan*.

of a figure of perfect and mysterious knowledge, who magically understands the nature of the patient's enjoyment and yet refuses to impart this information. This, then, would be the nature of the massive transference that, according to Žižek, Film Studies has affixed to Hitchcock: the various struggles to define what and how Hitchcock "means" something are instances of this transference, which in the strictly therapeutic relationship necessarily involves a kind of paranoia about (and desire for) the analyst on the part of the patient. Thus the analyst's inscrutability becomes the object of interpretation, and this – according to the strictest Lacanian doctrine – becomes the mechanism by which the "cure" is effected.

Naturally, since for Žižek Lacanian psychoanalysis is a theoretically revolutionary program, it follows that he will understand Hitchcock to be threatening to the status quo in some irreconcilable way. How does he do this? It suffices to note that, for Žižek, Hitchcock is indeed a "subversive." For example, Žižek locates a certain "ideologico-critical potential" in the films, a potential that resides in their "allegorical nature." This allegorical level – which Žižek, citing Jameson, identifies as a specifically "modernist" type of allegory, in which the diegetic content allegorizes its own enunciation (as opposed to classical allegory, in which characters personify abstractions) – is mobilized in order to counter "the classical Marxist reproach," which "would be, of course, that the ultimate function of such an allegorical procedure, by means of which the product reflects its own formal process, is to render invisible its social mediation and thereby neutralize its sociocritical potential" (Žižek 1992b, 217–218). In anticipating this hypothetical classical Marxist critic, who would presumably "reproach" Hitchcock for his unproblematic position as regards the ideological status quo of industrial capitalism, Žižek conceptualizes a Hitchcock who is at work, like an analyst, to undo the force of the "ideological call" by forcing the viewer to identify "with a pure gaze" – "the illusion involved" in which is "far more cunning."

This logic is the mechanism by which Žižek can describe "Hitchcock's elementary strategy" thusly:

> By means of a reflexive inclusion of his/her own gaze, the viewer becomes aware of how this gaze of his/hers is always-already partial, ideological, stigmatized by a pathological desire. The crucial fact is that this desire is experienced as a transgression of what is socially permitted, as the desire for a moment when one is, so to speak, allowed to break the Law in the name of the Law itself [...] Precisely when Hitchcock appears at his most conformist, praising the rule of Law, and so on, the ideological-critical mole has already done its work, the fundamental identification with the transgressive mode of enjoyment which holds a community together – in short, the stuff of which the ideological dream is effectively made – is contaminated beyond cure.
>
> (Žižek 1992b, 225–226)

In other words, Hitchcock tricks us by confronting us with our darkest desires – desires that he always-already knew to be there – and, what is more, he knows that he is doing it, and he knows that we do not know he is doing it. The idea that Hitchcock acts on the

darkest desires of the audience goes back to the critics at *Cahiers du Cinema*, but in Žižek it is coupled with the idea (an idea, let us not forget, conceived in response to an anticipated "Marxist reproach") that this procedure is ideologically subversive, that it produces some kind of political change in the viewer's consciousness – although Žižek is not very explicit about this point, probably deliberately so.

It is not too much of a leap here to see a certain resemblance to the popular notion – at least amongst leftist critics of a bygone era – that the use of certain kinds of Brechtian strategies, distanciation and so on, could or would produce something like revolutionary consciousness in an audience. We will return to this idea, but for the moment let us simply note that Žižek's own variant on this theme is to claim for Hitchcock an impulse to destroy the ideological work of narrative closure, especially in a film like *Psycho*, which, as Raymond Bellour pointed out, has a bifurcated structure in which the film's end in no way replies to its beginning – violating a structural necessity of the so-called classical Hollywood film.

The foundation of this logic, again, is the status of Hitchcock's self-knowledge. How is it that we know that Hitchcock is not just accidentally producing these effects – assuming these effects can be said to occur in the first place? Because of what Žižek, after Jameson, calls the "allegorical dimension" of Hitchcock's work – that is to say, the extent to which the "filmic enunciated indexes its process of enunciation." Meaning: Hitchcock's films are allegories of themselves. Not only does Hitchcock inscribe his own position as author-God-father-analyst into the diegetic content of the films, he inscribes our position as viewers into the films as well, so that *Psycho*, like *Rear Window*, is ultimately an allegory about Hitchcock's relationship with the audience. Žižek's entire theoretical edifice, like Rothman's, hangs on this assumption; everything else follows from and depends upon it.

But what if it were not true? What if the "allegorical dimension" in Hitchcock's work were simply, as Žižek says in Hegelese of a certain edit in *Psycho*, "the reflection-into-self of the objective gaze into the gaze of the object itself" – so that the critical apparatus brought to bear on Hitchcock's work chooses Hitchcock as its object in the first place simply because his narratives can be refracted back onto themselves in such a way that the critical gaze can find itself mirrored there? In other words, what if *Rear Window* is not a film about the cinema, but merely a film about voyeurism?

It seems to me that the nearly fifty-year-old assumption that *Rear Window* is "about the cinema" is perhaps the founding mistake of Film Studies. If we were to remove the assumption that Hitchcock's cinema constitutes a kind of metalanguage – that the system contains elements that describe the system itself, or that Hitchcock understands himself in the same terms that we understand "Hitchcock" – then we find ourselves in the curious position of having to paraphrase Lacan's infamous dictum that "woman does not exist" – namely, that Hitchcock does not exist. Or, to put it in a slightly different, equally Lacanian way: in the way that "Woman is a *symptom* of man," Hitchcock is a symptom of Film Studies.

I am, of course, proposing just that. What is more, let me suggest here that when Žižek looks for a certain intentional technologizing of Hitchcock's own grammar, or when he searches for those moments in Hitchcock when the narrative indexes the relationship of the

film object to the audience that consumes it, or when he finds a certain subversive effect in the refusal of closure and the attendant exposure of the workings of the apparatus – in other words, when he looks for metalanguage about Hitchcock's cinema in Hitchcock's cinema – in all those instances, when Žižek says "Hitchcock," he really means "De Palma." For what else is De Palma but a certain position both outside *and* inside Hitchcock that guarantees "the reflection-into-self of the objective gaze into the gaze of the object itself"? In other words, what else is *Body Double* but a rigorous theoretical investigation into the critical idea that *Rear Window* is a film about the cinema? It is not *Rear Window* that indexes its own relationship to the viewer, but *Body Double* – or *Sisters*, or *Raising Cain*, or what have you. Žižek mentions in the introduction to *Everything You Always Wanted to Know about Lacan (But Were Afraid to Ask Hitchcock)* that what distinguishes classical representation from whatever comes after – modernism? – is the idea that interpretation is inherent to its object, and Žižek goes on to discuss how this is true in relation to Hitchcock's own work. But it is De Palma's films, not Hitchcock's, that square this particular interpretive circle, by literally subsuming Hitchcock and therefore obviating the need for the critical gesture of interpretation. Thus the critical gesture of attempting to prove that *Psycho* contains something like a doctoral thesis about itself is not helped by the critical misrecognition of *Body Double*, which *is* a doctoral thesis about Hitchcock. (*Pace* Rothman, we might call *Raising Cain* "Some Thoughts on Hitchcock's Authorship.") So if the great flow of discourse about Hitchcock is at least partially driven by the idea that Hitchcock understood his own system, then it is driven by what we might (imprecisely) call an *optical illusion* – the appearance of the critic's own gaze as a force in the film frame. That optical illusion is of Hitchcock's own self-reflexivity, and the fact is that when we look for Hitchcock's self-reflexivity, we find it not in Hitchcock, but in De Palma.[24]

A single set of examples will hopefully make our point. Let us examine a gesture that recurs in both Hitchcock and De Palma: the moment of the *screen-audience analogue*. In Hitchcock, of course, there is a near-constant element of theatricality and performance, from the onstage denouement of *The 39 Steps* to the society ball full of Nazis in *Saboteur* to the entirety of *Stage Fright*, and so on; there are even a couple of appearances of "the movies" as a social fact, most famously the *Who Killed Cock Robin?* sequence in *Sabotage*, in which Sylvia Sidney "realizes" the truth of her husband's behavior while watching the screen in the movie house she manages. Then there is *Rear Window*, the film in which, as Jean Douchet puts it, "Hitchcock elaborates his very concept of cinema (that is to say of cinema in cinema), reveals his secrets, unveils his intentions" (in Deutelbaum and Poague 1986, 7). There is no need to

[24] To this end, one should perhaps think of the system called "Hitchcock" as Lacan thought of the system called "Freud": "With Freud the analytic experience represents uniqueness carried to its limit, from the fact that he was in the process of building and verifying analysis itself. We cannot obliterate the fact that it was the first time that an analysis was undertaken. Doubtless the method is derived from it, but *it is only method for other people. Freud, for his part, did not apply a method.* If we overlook the unique and inaugural character of his endeavour, we will be committing a serious error" (Lacan 1991, 21; italics mine).

rehearse the entire line of argument, which has a clear lineage all the way from Douchet's original article to Lee Edelman's deliciously outrageous "*Rear Window*'s Glasshole," but at least let us note that this is the film around which nearly the entire cluster of ideas about Hitchcock's self-reflexivity are built; it is here that Hitchcock most notoriously ruminated on his own "procedure," creating a situation in which the film narrative, like an audience member in a theater, never leaves a single location. The lone voyeur in the wheelchair watches the apartments across – he *peeps* – and constructs narratives while doing so. Moreover, he ignores the beautiful woman who puts herself at his service, only springing to attention when she "crosses over" into the visual field of the apartments across. Here is Douchet's thesis: "Stewart is like the projector; the building opposite like the screen; then the distance which separates them, the intellectual world, would be occupied by the beam of light. If the reader also remembers that Stewart is first the spectator, he can conclude that the hero 'invents his own cinema'" (Douchet 1986, 10). Additionally, depending on which particular article on *Rear Window* one reads, there is sometimes an element of speculation about Hitchcock's judgment: is the film a righteous condemnation of voyeurism, as Rohmer and Chabrol suggest, or is the film evidence of Hitchcock's "moral sickness"? Clearly the need to invoke this issue and then to make a decision about it would reflect any given critic's position on such matters (just as Douchet's claim that Hitchcock is offering his viewers a form of psychotherapy might reflect a certain desire for reassurance on the part of the critic).

How is it, exactly, that we know that *Rear Window* is "about" Hitchcock's own procedure? It is certainly a film "about" voyeurism, and perhaps it might be said to be about the nature of fantasy (in the Lacanian sense of the word). And of course the cinema itself involves seeing and not being seen, and certainly voyeurism is about the *hope* of seeing without being seen. Jimmy Stewart and the opposite wing of the building are a metaphor for the cinematographic procedure itself (Stewart = camera, projector, spectator; windows = locations, screens, objects of the gaze); he is apparatus, participant, and fetishist, and he is also the director, a point of identification for Hitchcock, the audience, Stewart himself. It does not seem too bold a distillation to suggest that this idea – that the movie *Rear Window* is about the movie *Rear Window* – is one of the foundational assumptions of the discipline of Film Studies, not to mention of auteurism in both its strict and popular forms. The chicken-and-egg problem in this instance is the attempt to determine whether *Rear Window* is read as an allegory of itself because it was directed by Alfred Hitchcock, or whether one can describe Alfred Hitchcock as being able to "elaborate his concept of cinema" because of *Rear Window*. After all, it is not Ted Tetzlaff's *The Window*, which appears in every introduction-to-film class as a director's "testament" to his own procedure, even though it too is built around the intersection of witnessing, voyeurism, and interpretation; nor is that role filled by (for example) Hitchcock's own *Stage Fright* or *The Man Who Knew Too Much*, both of which could reasonably be argued to represent a sort of metaphorical exploration of *directing* in its most abstract sense.

What *Rear Window* represents, then, is the clearest moment of what Žižek, after Jameson (after Rothman), calls the *allegorical dimension* of Hitchcock's work, the movement by which the filmic enunciated (the diegetic content) indexes its own process of enunciation (its formal

structure or perhaps, more abstractly, Hitchcock's "relationship to his public"). Let us recall in this context that Žižek claims, in response to a hypothetical Marxist reproach, that "the strongest 'ideologico-critical' potential of Hitchcock's films is contained precisely in their allegorical nature." The film arouses a certain desire in the viewer, then fulfills it, and this movement "confronts the viewer with the contradictory, divided nature of his/her desire" (Žižek 1992b, 218–219). The elaboration of this idea would be that "the viewer," identifying with Jimmy Stewart in his wheelchair, comes to recognize that Stewart's behavior is in some way problematic, and that this problem is roughly analogous to the viewer's own behavior; in this moment, a sort of Brechtian "full consciousness" arises in the viewer, who learns that his relationship to the fantasy-space of the movie screen is both *unhealthy* and *ultimately contingent*.[25]

Let us compare this standard trope with its expression in De Palma. We might go as far back as the connections between voyeurism, super-8 filmmaking, and social disconnection drawn in De Palma's early, "guerilla" efforts (not least of which would be the devastating end of *Greetings*, which stages the entirety of *Casualties of War* in a single visual joke); or we might choose to begin with *Sisters*, which opens its narrative inside a voyeuristic TV game show entitled "Peeping Toms" and goes on to stage its own (rather literal) interpretation of *Rear Window*'s central narrative turn. We might equally cite the opening of *Carrie*, with its reflexively porno-slow tracking movement through a girls' locker room, or *Home Movies*, which is overwhelmed throughout its entire length by the collision between filming and peeping. We might mention the amazing moment in *Dressed to Kill* when Dr. Elliott, having strangled a nurse, removes her clothing while the gathered asylum inmates cheer him on (the high-angle shot zooms out until the screen is perfectly split between Elliott and his crazed, libidinous "audience"): the movie we are watching is on the left, and we are on the right. Or we could mention the continual demonstrations of the mechanics of sync-sound in *Blow Out*, or the Cannes sequence of *Femme Fatale*, or the entirety of *Snake Eyes*. However, the central place to look – if you are looking for a film that, unlike the movie *Rear Window*, is about the movie *Rear Window* – is *Body Double*, which stages the screen–spectator relationship at both literal and allegorical levels and frames that relationship within both an industrial and a narrative context. (We might even say that *Body Double* is not just about *Rear Window* – it is about *Body Double* being about *Rear Window*.) We will return to *Body Double* and the specificities of its *trompe-l'oeil* games in the third chapter of this book, but if we wished simply to locate an "ideologico-critical potential" in a moment of confrontation between "the viewer" and his or her onscreen analogue, we would need to go no further than *Body Double*'s dizzying final minutes – the passage that begins with Craig Wasson standing over Melanie Griffith, imploring her to emerge from the darkened, cavernous "theater" of the

[25] One might speculate that one of the primary errors in Hitchcock criticism is the unconscious tendency to ascribe to Hitchcock in *Rear Window* the kind of modernist use of the film frame that Antonioni introduced six years later, in *L'Avventura* (1960); this kind of framing would not enter Hitchcock's vocabulary until *The Birds*, in 1963.

open grave where she sits ("Are you gonna stay in there the rest of your life?") and concludes with a diegesis-bending demonstration of the illusionist powers of montage (in which we watch as one actress's head is magically placed on another's naked body). *Body Double* is aswarm with movies within movies, screens within screens, and narratives within narratives, and the extraordinary measures it takes to problematize and analogize the spectatorship as a contingent process (beginning with its opening shot) is in no way matched by *Rear Window*, which – I would argue – may constitute a meditation on voyeurism but does *not* necessarily constitute a meditation on its own process of enunciation.

Let us be more specific: perhaps we might suggest that if, for Hitchcock, cinema is a type of voyeurism, then for De Palma the reverse is true: that *voyeurism is a type of cinema*. This reversal of direction from the general to the particular could have been a foundational moment for Film Studies, and what is curious is that the discipline papers over or renders invisible this reversal by claiming De Palma's position for Hitchcock: it attempts to track, through this "allegorical dimension," the ways in which Hitchcock's project is self-descriptive and, in doing so, occults the actual instance in which Hitchcock's project is "objectively" described.

This allegorical dimension is fundamental to Žižek's "Hitchcock," and one would assume that its actual elaboration in De Palma would be a source of endless fascination for Žižek. However, what amazes is that, in all of Žižek's writings, De Palma is never mentioned. Of course it is Žižek's prerogative to write about whom he chooses; if he writes about Hitchcock, why should he necessarily have to address De Palma? But it would seem that, given the specific kinds of uses to which Žižek puts film texts and especially Hitchcock's, Žižek would have something to say about the positioning of De Palma in relationship to Hitchcock,

especially since Žižek is interested in the ways in which certain Lacanian ideas "appear" in certain kinds of texts. I would hazard a guess that Žižek literally cannot "see" De Palma – that for Žižek, just as for a generation of film scholars and critics, De Palma is almost literally "invisible." We could hypothesize that this would have something to do with the standard way that Hitchcock is "consolidated" as a system.

But there is something more as well. Žižek presents himself as the ultimate Hitchcock scholar, the one who can shift perspective and move out from the object on so many levels that even the most macro of patterns can be placed in a global context. Anyone who reads Žižek closely, however, will eventually notice two things: first, that Žižek does not know anything about movies – it sometimes seems as if he has seen less than forty or fifty of them[26] – and, second, that everything that Žižek says about Hitchcock, especially in his earlier works like *Everything You Always Wanted to Know about Hitchcock*, is essentially an adaptation of a single source: Fredric Jameson's *Signatures of the Visible* (1990). This book – edited and published right on the cusp of Jameson's adoption of Lyotard's term "postmodernism" – exemplifies Jameson's peculiar mixture of "resigned" Marxism and ersatz psychoanalysis, and it contains almost the entire breadth of Žižek's knowledge about authors and film form, including Jameson's spectacularly Žižekian-*avant-la-lettre* read of Rothman's book. Žižek couples parts of *Signatures of the Visible* with Jameson's model of the realism-modernism-postmodernism triad and starts from the idea that there are a series of historical breaks, distinct or indistinct, that separate groups of films from one another; these categories are necessary if we are to understand that film, as fantasy, develops in tandem with historical developments in late capitalism.

Naturally – for reasons that are both metaphysical and quotidian – Hitchcock cannot be placed in any of these three categories, so Žižek more or less proposes that he is all three. But the modernist gesture is still understood to be the moment at which film form begins to recognize itself and to deny the grammatical and political rules of realism. Jameson identifies De Palma as the first American postmodernist director (Jameson 1990, 55), but he himself never actually says anything about De Palma other than that he is a postmodernist. (He also cites *Blow Out* as a paradigmatic pomo text, but saves his read of its politics for his essay on paranoia films in *The Geopolitical Aesthetic* [1992], which Žižek appears not to have read.) Žižek, I think, assumes that, past the gesture of "pointing to" De Palma, there is not anything more to say, perhaps having accepted the received wisdom that De Palma is not worth discussing. And perhaps Žižek has not even *seen* any De Palma movies.

[26] In recent years, this casual unfamiliarity with the scope of cinema as a form has broadened slightly (for example, Žižek seems to have finally discovered High Modernism, such as the work of Bergman and Tarkovsky); however, his interest in film continues to be purely instrumental, and largely consists of the "usual suspects" – *Brazil, Blade Runner, The Matrix*, et al.

But if we recognize that De Palma is as much about Godard as he is about De Palma, then we immediately see the real reason why Žižek cannot "see" him – because Žižek cannot see Godard, either. This is because film work that actually does perform the critical gesture within itself is *per se* resistant to a certain kind of interpretive reading – the kind of interpretive reading that must perform a critical gesture *on behalf of* a film. And this is also because film that actually constitutes itself as political – as Godard's does, and as I think De Palma's does too – in a way forces a blind spot in a critic like Žižek, who sees direct political gestures as always-already doomed to failure, like gestures toward actual political revolution.[27] Of course one would point out that De Palma is of the same opinion – that is to say, there is no revolutionary or political gesture that cannot be absorbed and neutralized by capitalism. De Palma has said these exact words in interviews countless times. But perhaps this is exactly why Žižek cannot see De Palma: he instead finds traces of radical self-reflexive potential in the subversive procedures of Hitchcock without having any idea what those traces would look like if they were actually present in a so-called Hitchcockian text.

In the end, what makes De Palma's version of "Hitchcock" so invisible is rooted in the historical era that Hitchcock himself inaugurated. As we will explore in the next two chapters, we live in a world forever marked by the movie *Psycho* and the various memes that it introduced into American consciousness. One might say that, for the Left, the American public *is* Norman Bates – of two minds, hopelessly divided against itself, with no self-knowledge and a deep, murderous psychosis born of something nasty and primal and ultimately familial. (The discourse surrounding the Obama presidency reminds us how relevant this idea remains.) And *Blow Out* demonstrates that, for De Palma, the murder of Marion Crane and the assassination of John F. Kennedy are inextricably linked – so that, in a way, De Palma's entire career is a series of permutations on the theme of the Zapruder film as a kind of "shower scene." One might point out that this collapse of the fictional into the historic is not exclusive to De Palma, but then again without De Palma we cannot approach the central fact that *Psycho* is fundamentally *a priori* to the American social contract as it is currently understood.

[27] Note that the W. Somerset Maugham anecdote (from the play *Sheppy*) about Death in the desert – the source of John O'Hara's *Appointment in Samarra*, said to be De Palma's favorite novel – is also a crucial text for Žižek insofar as it illustrates certain Lacanian ideas about repetition compulsion and the ultimate path of the Letter (for example, see Žižek 1989, 58). These are also De Palma's themes: note the literal appearance of the Maugham anecdote in *Redacted*, both at a structural and at a diegetic level. Perhaps one might say that De Palma has already had his appointment in Samarra, and that Žižek, never having encountered De Palma, has not yet had his.

Chapter 2

Get to Know Your Failure

Since she's been gone, it's been about three days... uh, get back to the real stuff now – masturbation – I mean, uh, sex is sex... Uh, it's never quite like Norman Mailer writes, but, uh, masturbation, you got, uh you got the, you got – [affecting authoritarian voice] *you got your contemplation this generation sadly lacks* – uh – contemplation – you got masturbation... I mean, you got control. You got the widow thumb and the four daughters – uh – I mean, the, like, you can – you got thoughts, you can think of anything. You can think of, uh, pigs... you can think of trains going in tunnels, think of, uh, bagels – uh, you're not limited to women – I mean, uh, when you do, when you do come back to thinking about women, now – ahh, ah, you should see [...] You should see some of the women I think about.

– David Holzman

In this monologue – from the 1967 "underground" film *David Holzman's Diary* – the main character, speaking directly to the camera (in the founding instance of what would become a common trope of "underground" cinema of the era, he is "filming his life"), laments the consequences of his recent breakup with his girlfriend, Penny, who has left him because he would not stop filming her. The moment that shatters the relationship is, of course, captured on film: David wakes up in the middle of the night and, entranced (his word is "touched") by his sleeping girlfriend's naked form, grabs his trusty Eclair and "takes the shot" – a long, lingering mobile shot, moving slowly around her naked body, that allows the spectator (as Mulvey would say) to visually feast upon her nudity without her knowledge. Naturally, she wakes up, and (to say the least) reacts badly: she leaves him. This event occurs relatively early in the film; the rest of the narrative charts David's ultimately unsuccessful attempts to win Penny back – without turning off the camera, of course. (Given the choice between his girlfriend and the camera – or, perhaps, between his "direct experience" of his girlfriend and the *mediated* experience of her offered by the technology at his disposal – he chooses the camera.) Needless to say, this is offered up as a *bad* choice; as a consequence, David nearly disintegrates in front of us – stalking his girlfriend, indulging in long defensive monologues in direct address, addressing the camera as if it had its own agency ("what the fuck do you want from me?") – until, at the film's formally adventurous climax, David appears as a still photograph from a souvenir booth, accompanied by an acetate transcription of his own voice. His equipment has been stolen, as well as – presumably – the raw footage we have been watching for the last seventy minutes. The film itself ends with a whimper of defeat: David is alone, abandoned by his girl, his equipment, and his checking account.

The monologue about masturbation is interesting for several reasons, but the most relevant in this instance has to do with the nature of the pornographic fantasy David describes. One does not need to think about *women*, necessarily; his alternative is not to fantasize about men, but rather to fantasize about *metaphors* for the sex act. One can think about policemen and the potential for violence they represent, unless we are to assume that by "pigs" David literally means farm animals; one can think about trains going into tunnels (let us assume that this constitutes a "Hitchcock reference"); one can think about bagels – that is, holes. Consider the range of potential classifications here – sex-as-violence, sex-as-unrepresentable-punch line, sex-as-mechanism – as well as the moment at the end of the monologue when David advises the camera that it "should see some of the women I think about." To wax Žižekian: does not this confession – of the functionality of metaphor in fantasy, of the essentially idealist nature of the Imaginary – provide an appropriate definition of the cinematic enterprise itself, especially as it was understood in New York City in 1967?

Clearly, with this confession, we find ourselves under the sign of Jean-Luc Godard, the epochal Swiss director who famously suggested that cinema, at its purest, required nothing more than a girl and a gun. Indeed, Godard is referenced by name in the opening shot of *David Holzman's Diary*, a film shot on a close-to-zero budget at a time when the very act of making an "underground" movie meant, almost by definition, that you were making a movie in Godard's shadow (and, to an extent, any movie made in Godard's shadow is *about* Godard, in exactly the same way that all of Godard's own movies are about the American cinema).[1] Of course Godard was just one of the francophone directors who stormed the proverbial gates at the beginning of the 1960s, many of whom – Resnais, Truffaut, Rivette, Varda, Demy, Chabrol, etc. – each had their own significant impact on various American filmmakers. But Godard's innovation, coupled with his wild career trajectory and (especially during the Anna Karina years) his force as a media personality, helped to make him the central figure in world cinema during that decade. Much has been written about the shadow that Godard cast over the entire filmmaking enterprise through the 1960s; Pauline Kael put it most succinctly in her review of *Week End*:

> When it comes to Godard you can only follow and be destroyed. Other filmmakers see the rashness and speed and flamboyance of his complexity; they're conscious of it all the

[1] Of course it would be foolish – and imprecise – to suggest that Godard and the other members of the *Nouvelle Vague* were the only important influence on the horizon for this generation of American filmmakers. In addition to the wealth of example presented by the products of the studio system, there is also the cinema-*verité* contribution of the free-jazz documentarians, such as Pennebaker and the Maysles brothers (specifically cited by De Palma on more than one occasion), as well as the slightly-not-*verité* anti-documentaries of directors such as Shirley Clarke and the Newsreel collective. There is also grindhouse cinema, which *must* have touched other young American directors besides De Palma. And of course there is John Cassavetes, a debt to whom De Palma repays (spectacularly) in the closing seconds of *The Fury*. But it seems likely that the Godardian sense of the immediate – and the liberatory potential of the quotidian as film subject – had its *own* influence on these figures.

time, and they love it, and, of course, they're right to love it. But they can't walk behind him. They've got to find other ways, because he's burned up the ground.

(1970, 143–144)

By the end of the 1960s, of course, "Godard" meant a great deal more than the mere innovations that Godard himself brought to the language of the feature film (including, but not limited to, the strategies he shared with the other filmmakers in the *Nouvelle Vague*): the jump-cutting, the location shooting, the attention to the urban and to the quotidian, the explosion of "unmotivated" text onto the screen and into the diegesis, the stylized use of sound and color, the anti-naturalistic camera movements (distanciation by way of Ophüls), the structurally independent *plan-séquence* (a lengthy scene taken in an unbroken, mobile master shot) as a basic unit of grammar, the tidal wave of cinematic quotation, the illusion-shattering direct-to-camera interviews of actors *qua* actors, and so on. Nor was Godard simply the sum of his characteristic narrative obsessions: treacherous women, violent men with intimations of gangster grandeur, the journey out of (or into) the city and back again, the use of prostitution as global metaphor, the pressures of pop culture, the opposition between society and nature, the enormous fact of American cinema as a cultural frame, and so on. By the time of De Palma's first widely released film (*Greetings* in 1968), "Godard" also meant *politics*, or at least a structuring awareness of Vietnam and of American imperialism (topics that "entered" Godard's discourse in a decisive fashion in *Pierrot le Fou*) and a surface engagement with the ideas of Marx (the fact of the class struggle) and Sartre (the artist's moral imperative to engage with that struggle both in and apart from his art); a few years later, after his break with "the movies" (i.e. America), the system we call "Godard" would also mean Althusser, and therefore Mao.

In order to set the Hitchcock question into better relief, I wish to take the measure of Godard's early influence on De Palma, who began his career with a series of "underground" films in the "Godardian style" – even if, unlike Jim McBride's *David Holzman's Diary*, none of them mention him by name. Indeed, I will argue that De Palma's entire career has transpired under the sign of Godard, and that De Palma's "use" of Hitchcock (or Polanski or Kubrick) can only be understood if that use, that mobilization, is understood in a Godardian context. (De Palma, like Sirk, also works under the sign of "Brecht," although his understanding of what that means might differ from that of a professional Brecht expert.) How is it, exactly, that film history has forgotten that De Palma was once prone to making statements like "my films deal with the obscenity of the white middle class" and "if I could be the American Godard, that would be great – I think there are more interesting social and political things going on here in the United States than in France"?[2] What would happen if we were, instead, to take De Palma at his word?

[2] From an interview conducted in the spring of 1969, on the first day of shooting for *Hi, Mom!*, a film that was going to be, in De Palma's words, "much more radical than *Greetings* – it deals with the obscenity of the white middle class […] it's a film that says that the only way to deal with the white middle class is to blow it up" (Gelmis 1970, 29).

If we can pull off the formidable trick of re-aligning De Palma with Godard and with Brecht (as against the thief-and-rapist trope of Chapter 1), what might some of the potential consequences of this action be? We have seen some of the complications, across different discursive registers, of the alignment of De Palma with (or against) Hitchcock: a slippage between author and murderer, the marking of the author as the ultimate embodiment of social contradiction, the appearance of patriarchal metaphors (which of course only appear in response to social crisis), the consolidation of an auratic original against a copy (or against thieves). But if we attempt to construct a new historical context for De Palma's work – a trajectory which has been, for all intents and purposes, invisible – then the appearance of Godard allows us to make new alignments and thus new metaphors.

If we are to align De Palma with Godard, we will also need to sketch a different kind of institutional history than that which we drew upon to understand the relationship of De Palma to Hitchcock. As we have seen, the discourse of academic Film Studies has changed and consolidated over time. First there is a movement from auteurism to politicization (and the advent of what Bordwell and Carroll pejoratively call "Grand Theory" is the moment at which, for those scholars, the discipline collapses), then there is the "historical turn" and the movement into disciplinary multiplicity, a double reorientation that corrects the discipline's arc. Of course there is the equally defensible position that Grand Theory is what *saved* Film Studies, and while most of those who still practice Grand Theory do not quite state that conclusion, there is still the distinct sense that Marxism and psychoanalysis took the discipline to a level of rigor and relevance that it would not have otherwise achieved. (Dudley Andrew makes a point of this claim in his particularly well-judged essay "On the Core and Flow of Film Studies" [Andrew 2009].) Either way, the centrality of Hitchcock to the project of Film Studies remains unchanged, no matter how hard some of the post-theory scholars try to dislodge him. But just as Hitchcock's own status, tracked historically, shifts and morphs in response to changes in the needs of the discipline (and De Palma shifts, too, in response to both sets of changes), one might say that the discipline itself has also shifted and morphed in response to (or merely alongside) changes in another figure – that is to say, Godard.

After a paradigm-setting ten-year career as a member of the editorial board of *Cahiers du Cinéma* – during which he helped to create most of the conceptual apparatus that governs the discipline even today – Godard made his likewise paradigm-setting debut as a feature-film director in 1960, with *Breathless*, and over the next ten years followed a long and complicated trajectory that led him from insouciance to militancy. Once that trajectory was over – once Godard had made the leap from the jazzy, impromptu *Breathless* to the ghastly firestorm of *Week End* – a new trajectory began, one that was marked, as we are given to understand, by the failure of the revolutionary project: the attempt, in the films of the Dziga Vertov Group, to create cinema without recourse to the mechanisms of identification inherent to Hollywood grammar – that is to say, to create Marxist-Leninist cinema – failed miserably, for reasons that change depending on the account one reads (the failure of the working class spectator, Godard and Gorin's willed obscurity, the inadequacy of the extant system of

distribution, the impossibility or preposterousness of the project itself), and Godard's career since that point has been that of a lone prophet in the desert, heeded by few and followed by none, leaving "unwatchable" films behind him like indecipherable stone tablets. It is possible that this reading of Godard's trajectory is inaugurated, at least in English, by Pauline Kael, whose review of *Week End* is one of the signal moments of her work and who intensely disliked all of his subsequent films (uncannily, she understood that Godard had gone as far as it was possible to go); certainly most of the rhetoric in anglophone film scholarship on Godard's work from 1967 onward comes from this review, as well as from from her review of *La Chinoise*, which appeared just a few months earlier. De Palma, who includes a shot of Kael's book *I Lost It at the Movies* in *Greetings*, is sure to have read these reviews, and it is a good bet that most readers of this book will have read them as well.

How does this narrative of Godard's trajectory – however attenuated and broad – resemble that of Film Studies, at least as it is understood in the United States? Let us first point out that the discipline comes into being, at the institutional level, at more or less the same historical moment that Godard is experiencing this "failure" (and, as Jonathan Haynes points out, at the same moment that Truffaut's "Hitchbook" appears in English[3]). To be sure, Film Studies has its own trajectory from insouciance to militancy, although the moment at which auteurism takes root in the university setting is already one of turbulence, historically speaking. At this moment, one can still imagine auteurism to be a revolutionary project, or at least compatible with radical impulses (in February 1968, for example, *l'affaire Langlois*, with its dramatic confrontation between film critics and riot police, pits the sanctity of the movie theater as archive/temple against the repressive forces of state power). At the same time, however, *Cahiers* is making its hard swing Leftward into Maoism, and with similar trajectories taking place in the British film magazines, an emphasis on the cinematic apparatus itself appears. Once these new theories begin trickling into English-language film journals, it is only a matter of time before the discipline receives an electrifying new manifesto; the luck of the draw falls to Laura Mulvey. This is the moment at which, for Bordwell and Carroll, the discipline is lost: Lacan plus Althusser equals a new academic hegemony. After this point, Film Studies, like Godard, is a lone wanderer in the desert, leaving behind impenetrable essays (in runes, on stone tablets) about scopophilia in *Gilda* and castration anxiety in *Rio Bravo* – a circumstance that brings Bordwell and Carroll to demand the banishment of interpretation itself. Does this nearly discipline-wide turn to Marxist-psychoanalytic feminism – like the project of the Dziga Vertov Group, like the auteurist experiment of the so-called New Hollywood, like the student-led attempt to create a Leftist revolution in the United States – in some way constitute, or signify, a "failure"? And if so, for whom?

To be sure, this is a question about a specific moment in history, a moment recent enough to have been personally experienced by virtually the entire founding membership of the discipline of Film Studies. Since we are investigating De Palma, we might designate this stretch of time as being roughly coterminous with his early career: if we isolate the period of

[3] "Hitchcock's Truffaut," forthcoming.

time from the release of *Greetings* in 1968 through the telekinetic revenge fantasies of *Carrie* in 1976 and *The Fury* in 1978, we have a ten-year range in which, as they say, *everything happens*. How would we go about framing these different narratives – that of De Palma, that of Godard, that of Film Studies – in such a way that we can understand, through them, larger narratives about what was happening in the United States? In other words, how would we connect the quasi-object we are calling "De Palma" to that other quasi-object, the "New Left?"

If our aim is to frame De Palma's early career – that is to say, his career (or careers) before the controversial *Dressed to Kill*, which inaugurates the era of De Palma The Murderous Pornographic Thief – in such a way as to illuminate the pressures, social and political, that impacted upon that career, then we will have to come to terms with a central idea: that of *failure*. Naturally we will have to deal with what Hayden White calls "historical narratives," and as White points out, these documents are always allegorical, "saying one thing and meaning another" (White 1987, 45). Perhaps, following Reinhard Kosselleck, we might assert that all historical documents are at some level about failure, since it is those who understand themselves to be "vanquished," not the ones whose economic interests are ultimately protected, that must theorize the "how" and the "why" of their own experience (Kosselleck 2002, 45–83). But if we were to begin with some historical narratives – all examples of a certain type of retroactive narrative about a certain span of history, all of which we might identify preliminarily as having been composed *in the shadow of disappointment* – then we would want to try to connect movements in Film Studies, movements in film production, and movements in the larger social narrative at this particular suturing point, the idea of failure, without losing sight of what failure implies: that is to say, a *before* and an *after*, a time of possibility followed by a traumatic break.

Death(s) of the Left: An Historical Cartoon

> This is to be my last book of film criticism [...] The relentless, seemingly inevitable "progress" of capitalism in its "advanced" stage – the connotations of those words taking on a hideous irony – is destroying on all levels of society every possibility of a creative response to life [...] The "liberal" position – that capitalism is capable of reform – has become merely derisory, a mask of illusion and self-deceit with which people shield themselves from their own despair.
>
> (Wood 1998, 6)

How many times have the sixties died? Given that so many discourses – personal accounts of the New Left, studies of the critical apparatus of the university, histories of the New Hollywood, &c. – seem to have an investment in asking "what went wrong" with the spirit of 1968, it seems imperative to recognize the ubiquity of this theme, and to ask whether it might have created a certain truth effect in these discourses. For example: writing about a

decade that he defines as stretching from 1965 to 1977, Peter Starr sketches a narrative about that massive heterodox corpus that we in the United States know as "French theory" – that is to say, specifically French theory, in its specifically national context, through the time span beginning "with a resurgence of leftist activism in 1965 and ending with the massive abandonment of Marxist models exemplified by the 'New Philosophy' debates of 1976 and 1977" (Starr 1995, 2–3). This stretch of time is marked by a traumatic historical moment, which provides both the "before" and the "after" of Starr's narrative, as the provocative title of his book, *Logics of Failed Revolt: French Theory after May '68*, suggests. That traumatic moment, the primal scene of Starr's narrative, is not only the events of May but the so-called betrayal elections that followed, in which De Gaulle's government enjoyed a massive landslide in a popular referendum: the nascent "revolution" of students, workers, and professional intellectuals was betrayed by the French people, betrayed by De Gaulle's government, and perhaps even betrayed by their own revolutionary desires. One might say, as Starr does, that this double movement – toward revolution and then into backlash – is the moment with which all of French theory defines its own movement both toward and away from political commitment. Here is Starr's précis of the "logics of failed revolt" referenced in his title:

> The modern fascination with revolution as the agent of historical repetition habitually expresses itself through one of three broad genetic scenarios. According to the first, or what I call the "logic of specular doubling," revolutionary action is doomed to repetition because revolutionaries invariably construct themselves as mirror images of their rivals. Derived from Lacan's work on narcissistic aggressivity in the mirror stage, and with significant roots in nineteenth-century anarchist polemics, this logic is commonly conflated with a second logic, a "logic of structural repetition" […] Roland Barthes gives voice to this logic when he speaks, in a passage from *The Pleasure of the Text*, of a "structural agreement between the contesting and the contested forms." Complementing these logics of structural repetition and specular doubling, one often finds various "logics of recuperation," whereby specified forms of revolutionary action are said to reinforce, and thus to be co-opted by, established structures of power.
>
> (Starr 2–3)

To translate this into a certain vernacular: the revolution will fail because the militant is doomed to be the mirror or exact obverse of the evil father he replaces ("the logic of specular doubling"); or because the social forms exchanged in the revolutionary moment will turn out to be precisely the same as one another ("the logic of structural repetition"); or because revolutionary action will always end up assisting, and therefore operating at the exclusive benefit of, the Man ("the logic of recuperation"). Let us note that, in all three logics, it is unclear whether it is the revolutionary project or the revolutionary himself that is to blame: it is not the reactionary corporate-statist opposition, even though in all instances they turn out to be *much more clever* than the naïve revolutionary; and it is not necessarily "the people" who mistakenly reject the revolutionary moment (and who only come into existence as an object

of Left discourse in the first place). This slippage is nowhere more apparent than in the specter of the Gulag, the Stalinist narrative that (as Starr, among many others, points out) the French Communist Party (and, for that matter, much of the American Left) ignored throughout the 1970s: whether we lay the blame at the foot of History or at the foot of individual pathologies (Stalinism, or Stalin?), we must *blame* – even though in the final analysis the specific object of blame does not matter, since at the end of all revolutionary roads lie the camps.

In tracing these logics, Starr identifies a set of narratives that recur in virtually all of the post-1968 production of what we in the American academy refer to as "French theory," the "classics" of which were mostly produced in the twelve-year period that Starr describes: a decade in which the utopian aspirations of French intellectuals on the Left were raised to an unprecedented level of expectation and then hopelessly dashed. Starr suggests that this double movement – the reaching of a critical mass of revolution (barricades, tear gas, &c.) and the popular rejection of the possibilities of the moment – provides the (often unspoken) subtext for such disparate thinkers as Althusser (in his 1970 "Ideology and Ideological State Apparatuses") and Kristeva (in the 1974 *Revolution in Poetic Language*), as well as Cixous, Barthes, Jambet, Lardreau, and so on. The "father" of these types of discourse, naturally, is Jacques Lacan, and Starr traces a lineage of thinking about *revolution as repetition* that returns from Lacan's notion of the "Fort/Da" game as the operative paradigm for the revolutionary impulse and arrives – retroactively, of course – at the profusion of explanatory discourse following the original, disastrous French Revolution, from whence we inherit our still-current notions of "left" and "right." Unlike the New Philosophers such as Bernard Henri-Levy or Alain Finkielkraut, Starr does not identify these logics or their Left-intellectual context as symptoms of a creeping Stalinism. In fact, Starr clearly wants the spirit of *les événements* to return – thus his question, "how might a new status of the modern community depend upon the salutary contagion of *exemplary actions*, such as one finds at work in that revolutionary spectacle that was May '68?" (Starr 11). Starr does not go so far as to address what the consequences of these invisible "logics" might be for the English-speaking academy in particular, which imported French theory *en bloc* in the 1970s and which had its *own* narrative of revolution and failure, repetition and backlash; but the implication is clear: if the academic Left has inherited these tropes, then their use is sure to cause effects.

In his book *French Theory*, François Cusset offers a similar thesis, elaborately tracing a direct relationship between the moment that "the political impetus of the 1960's stopped cold" (Cusset 2008, 57) and the advent of high theory in the anglophone academy. As Cusset points out, these "problems" are generally taken up not by Left academics, but by those on the Right – those who, for whatever reasons, choose to resist (for example) Marxism or psychoanalysis or, more insidiously, feminism. Thus in addition to French turncoats like Alain Finkielkraut or Bernard Henri-Levy, we have American efforts such as (to choose one example among so many) *The Rise and Fall of the American Left*, which its author, John Patrick Diggins, published twice – once in 1973, and once in 1992. The difference in the two historical frames is precisely as one would expect: the preface to the revised edition identifies

the energies of the New Left as having disappeared from the streets and re-materialized in the academy, and claims that, "having lost the class war in the factories and the fields, the American Left continues the battle for cultural hegemony in the classroom" (Diggins 1992, 15–16) – a battle fought with the reactionary tools of "nihilists" like Foucault, Derrida, and Lacan. Certainly Diggins is no Leftist: he identifies himself as occupying an essentially "Niebuhrian position," "to the right of the Left and to the left of the Right" (19). But his narrative precisely mirrors that of Todd Gitlin in *The Sixties: Years of Hope, Days of Rage*, who sees in the influx of French theory a certain nihilism, perhaps even a structural co-optation. "Looking forward in fear," Diggins writes of the current position of the radical Left in the academy, "it looks backward to hope." Thus the great classic American Left of the labor movement, of Eugene V. Debs and the Socialist option, finally runs aground in the discursive logorrhea that typifies the academic Left of the post-Vietnam era. The question he poses in this context is especially interesting: "why study the American Left if it is little more than a record of foibles and frustration?" His answer is startling: "The Left's saving remnant is the tension between its promises and its failures [...] It may be that the failures are inherent in its promises, particularly if one sees the goals of the Left are impossible to realize" (22–23). In other words, the anti-productive revolution – without which the eschatology of the Left is nothing – is impossible; but this is why it is *useful to study*.

Similarly, Fredric Jameson places the eschatological failure of the Left in a certain narrative context:

> [T]he last few years have been marked by an inverted millenarianism in which premonitions of the future, catastrophic or redemptive, have been replaced by senses of the end of this or that (the end of ideology, art, or social class; the "crisis" of Leninism, social democracy, or the welfare state, etc., etc.); taken together, all of these constitute what is increasingly called postmodernism.
>
> (Jameson 1991, 1)

Jameson's version of this narrative places "some radical break or *coupure*" at the end of the 1950s or the beginning of the 1960s (around the time of *Psycho*). But when did the rest of the world, leading or following the academy, enter the land of after-the-failure, and what possibilities did we lose? Here is the opening sentence of a book by Irwin Unger entitled *The Movement: A History of the American New Left 1959–1972*: "The Phenomenon we called The New Left is over." It goes on: "Obviously the political left has not ceased to exist entirely [...] Yet, as a distinct phase of the radical assault on Western Establishments, the New Left has dwindled away and in the United States, at least, has ended" (Unger 1974, v). The relevant span of time, as Unger defines it, begins with the appearance of the University of Wisconsin journal *Studies on the Left* in 1959 and ends "sometime between 1969 and 1972 with the conquest of SDS by hard-line, orthodox Leninism" (Unger v). The traumatic core of Unger's narrative, like Gitlin's later effort, is therefore the formation of the Weathermen – the evolution of the popular (and anti-populist) student movement from nonviolent,

democratic protest into domestic terrorism. The primal scene in this instance, depending on which book you read, is either the disastrous SDS convention in the summer of 1969 or the accidental explosion at the New York townhouse in March 1970, when three members of the Weathermen were killed while making bombs. Other sources about the era will necessarily have different primal traumas: there is the bombing at the University of Wisconsin and all the bombs that followed; there is Chicago in 1968, both the riots and the disastrous convention itself; there is the fracturing of SDS at its 1969 convention (perhaps the most convincing of the various "death moments"); there is Kent State in 1970; and of course there are the symbolic values of the big assassinations (Bobby Kennedy, Dr. King), the various courtroom dramas, Jackie Kennedy's second marriage – all of what Jules Feiffer called the "little murders." (There is also the drug narrative: before, there was *pot* and all was golden; then came *speed*.)

In this or any of these narratives, there is a moment of bifurcation: the traumatic moment is a passage, a rupture, before which is a state of possibility and after which everything has always-already failed – a state that, as it turns out, has always-already been foretold. This is the passage from King to Malcolm X, from nonviolence to violence, from idealism to nihilism, from hope to despair. The rest of the 1970s, then, are a slow and painful rollback of cultural and social gains as the New Left endures its death throes, ending in the triumphant advent of Ronald Reagan in the fall of 1980: one California-borne social movement is exchanged for another. The definition of the phrase "New Left" is not without its ambiguities, either; Irwin Unger makes a point of separating the civil rights movement, which he sees as primarily driven by African-Americans and their own organizing, from the "New Left," which he understands to be the *student* Left of the SDS era (white, moneyed, threatened by the Draft but otherwise bored); Todd Gitlin (1988) is more inclusive, but unsurprisingly the students are the center of his narrative as well. A decade separates these two books and their original dates of publication, but the narrative is surprisingly similar: internal pressures destroyed the movement; the move away from Gandhi and Dr. King and toward Leninism and terrorist action was a fatal misjudgment; the system retrenched and won the war. Or, as Peter Clecak put it in 1973: "Viewed from every serious radical perspective, the historical situation itself has enforced the paradox of powerlessness on Leftists of every ideological cast" (Clecak 6).

How far can one trust these narratives – especially given the emotional baggage that accompanies every one of them? The question is particularly vexing when one considers many of the accounts of the leaders of the movement – folks who were *there* but who "moved on" in practice, if not in thought (Todd Gitlin [1988], Bill Ayers [2003], Mark Rudd [2009]) as well as the accounts of those who "broke" with the Left entirely (David Horowitz [1998], Ron Radosh [2001]) and those who simply, neurotically reverted to a pre-political state (Jerry Rubin [1976], Jane Fonda [2006]). While some of these narrators are transparently unreliable or symptomatically unaware of their constitutive blind spots (especially David Horowitz, whose *Radical Son* is a blizzard of undigested Oedipal insinuation, or Bill Ayers, whose political impulses are invariably triggered by his habit of "falling in love"

with every female who enters his orbit), they all come to a certain set of conclusions: the revolution almost happened, but it did not – in fact, it failed; it failed because of pressures internal to the movement and perhaps even inherent to the revolutionary project itself; and the social reversal against the movement was in any event decisive, so that any hope for future effort along these lines is best downscaled to a local, personal scale, if not completely abandoned.

Indeed, that story that we might call "the death of the New Left" is in many ways inextricable from a larger story, a story about a moment in the American experience that we call "the death of the sixties." In the American version of this narrative (the Robert Crumb version, one might say), the Summer of Love gives way to the bad dream of Watergate, and the traumatic scenes in this narrative are legion – the LaBianca-Tate murders, the stabbing at Altamont, or any of a number of rock-star asphyxiations, not to mention Nixon's rise, fall, and subsequent pardon. The kids are not free – they are evil, nihilistic death-swingers; and the system is not fixable – it is eternally corrupt. Thus the liberatory potential of youth culture, in its newly deregulated infancy, burns itself out in a disaster of permissiveness that was always-already the movement's inevitable end, framed by the machinations of a State that simply cannot brook any threat to its coherence. In seemingly all instances of this narrative, we read this stretch of history as Hunter Thompson does: as a wave that roars in, reaches its height, collapses, and recedes, leaving wreckage and despair in its wake (Thompson 1971, 63). Afterward, all is like that chilling and clearly allegorical shot at the end of *Gimme Shelter*, with the silhouetted concertgoers stumbling away from the arena, dazed and still too stoned to understand what has happened.

Now that we have moved into a specifically cinematic register, let us add one more familiar narrative about a similarly defined time span. Here is a good condensation of it:

> The thirteen years between *Bonnie and Clyde* in 1967 and *Heaven's Gate* in 1980 marked the last time it was really exciting to make movies in Hollywood, the last time people could be consistently proud of the pictures they made, the last time the community as a whole encouraged good work, the last time there was an audience to sustain it.
>
> (Biskind 1998, 17)

This passage – from Peter Biskind's *Easy Riders, Raging Bulls* – exemplifies the dominant history of Hollywood filmmaking of the period. The film industry was in crisis, a crisis at least partially produced by the enormous gulf or time lag between what was "going on" in the culture and what was "going on" in Hollywood filmmaking[4]; *Bonnie and Clyde* and *Easy Rider* opened the door to youth and therefore to countercultural values in their "authenticity." For a brief time (eight years or so) the movies reflected social reality in all its

[4] The products of this crisis – best exemplified by the aggressive schizophrenia of movies like Ted Flicker's 1967 surrealist masterpiece *The President's Analyst* or Preminger's cortex-melting *Skidoo* in 1968 – surely deserve their own book.

ambiguity, violence, and affect; then the industry, like the social imaginary itself, retreated once more into fantasy. Biskind's traumatic moment is the ascension of what we might call "the Spielberg-industrial complex"[5]: in this narrative, the patterns set by the release of *Jaws* in 1975 and by that of *Star Wars* in 1977 destroy the brief moment of opportunity and hope and freedom epitomized by the "personal" filmmaking of Ashby and Scorsese and Altman. For a brief moment, the wave rises; then it recedes, leaving detritus like Scorsese's *New York, New York*, Friedkin's *Sorcerer*, and Altman's *H.E.A.L.T.H.* beached like whales behind it. But of course the fatal problems are inherent in the revolutionary program from the start: the irony, one is given to understand, is that it is the success of *The Godfather* that prepares the way for the massive advertising onslaught and wide release pattern that typifies the Spielberg-Lucas way of conceiving, producing, and selling a movie, and it is precisely the freedom from old-fashioned studio-driven filmmaking – the *permissiveness* of the new system – that, in the end, brings the moment of the counterculture auteur to a disastrous close. "There was a counterrevolution at the beginning of the 1980s," writes Biskind, "but *Heaven's Gate* was merely an excuse, a shorthand way of designating changes that had been in the works since *The Godfather* had transformed the way the studios did business eight years earlier" (Biskind 401). So it is precisely the opening up of a space for a counter-industrial cinema that allows for the apotheosis of its structural opposite, a cinema of the industry and for, one understands, the American public: a public imagined by the film industry as by the Left (and probably by the Right as well) to be 250 million Norman Bateses.

Elsewhere Biskind finds ample evidence to support the idea that the American auteurists of the 1970s – Altman, Coppola, Friedkin, Schrader, Scorsese, et al. – not only destroyed themselves, but that this self-destruction was foretold, even inherent in the program from its inception. "At the end of *Easy Rider*, when Wyatt tells Billy, 'We blew it,' he would be proved correct, although it would take over a decade to see it," Biskind writes. "Dennis Hopper and Peter Fonda had created an anthem for a generation, but they had also imagined its apocalyptic destruction, which many of the decade's directors did their best to emulate" (Biskind 408). Whether it was too much power, too much money, too many drugs, too many women, too much hypocrisy – the failure of the revolution is to be blamed on the revolutionaries. Biskind quotes John Milius to this effect ("The stuff that brought it all to an end came from within" [Biskind 401]) and, like so many others, points to Lucas and Spielberg as the Judases of the revolution, making the anti-revolutionary movies that would, like the martyrs of Stalinism, betray the movement from within. In the end, Biskind asks:

> Could another group of directors have done it differently, broken the back of studio power, created little islands of self-sufficiency that would have supported them in the work they wanted to do? Could a hundred flowers ever have bloomed? Probably not. The strength of the economic forces arrayed against them was too great. "We had the naïve notion that it was the equipment that would give us the means of production," said Coppola.

[5] My thanks to Bob Rehak for this term.

"Of course, we learned much later that it wasn't the equipment, it was the money." Because the fact of the matter is that although individual revolutionaries succeeded, the revolution failed.[6]

(Biskind 434)

If we were to speak structurally, then, we might note a certain convergence across all of these narratives – from Starr's story of French theory in its historical context to the varied accounts of the American New Left through Hunter S. Thompson. To wit: the defeat signaled by *Star Wars* is the same defeat signaled by the election of Reagan, and it is the same defeat because in each instance the same forces, operating at different registers, were pitted against one another – although really the world was ready for revolution, and if it did not happen, it is only because we were fighting ourselves.

The effects of this type of rhetorical *massif* can be seen even in something as distant as Robin Wood's self-professed final book (1998), which begins with a mournful jeremiad about the failure of the liberal project – which is, of course, synonymous with the death of cinema. Perhaps at that moment Robin Wood was in the minority in figuring film criticism as a necessarily political act, but we should not forget that, at one point, politicization was the only possible response to the social turbulence of the era – both in film theory and, for most (if not all) of the important directors of the 1970s, in film practice. This position can be seen most clearly – and most poignantly – in Laura Mulvey's most recent work. Mulvey, one of a mere handful of people who can claim to have single-handedly effected a positive structural change in the discipline, has also begun to sound the baby boomer's lament for *a time before*, when the future was possible. "Over the past few years," she wrote in 2004, "I have been thinking about the way that a break or fissure in the continuities of history has come to separate a 'then' of the 1970's, the moment of origin, at least in Britain, of feminist film theory and practice, and a 'now'" (Mulvey 2004, 1286). Identifying feminist film theory as a "last wave," Mulvey goes to great lengths to impress upon the reader a sense of loss, of nostalgia and regret, claiming that "any sense that the utopian aspiration could be realized as a political program and have a transformative effect within the social world came to an end quite suddenly in the early 1980's" (1287). Moreover, this eclipse "marked a watershed, a gap in the continuity of history that created a 'before' and an 'after', a 'then' and a 'now'" (1288). Whatever can be said about the cinema today, the truth is that all is loss and death; *possibility*, if it ever was, is no more.

So from Gitlin to Horowitz, from Coppola and Biskind to Mulvey and the late Robin Wood, the same themes resound – almost always expressed with a wounded regret, a general disappointment in the commitment of oneself and others, and an intense preoccupation with missed chances and misled choices. It is disturbing that all of these registers collapse into one another so easily; perhaps this is because the quasi-object that

[6] Compare with the following: "Money was the solvent that dissolved the tissue of the '70s like acid on flesh" (Biskind 422).

we call "the Zeitgeist" is a type of "God concept" – that is to say, it absorbs all metaphors into itself, and indeed its touch turns all *facts* into *metaphors* as well; ultimately, it is measurable only through the effects that it, in its absence, produces. The "wave" described in these accounts, as operational metaphor, surely has its own discursive history; irrespective of its provenance, what fascinates in this instance is the way in which this metaphor – the wave – is mirrored from register to register, always figured as a kind of limit: this high, and no higher. The wave crested, yet did not reach its goal – because *we* were that wave, and we *failed*.

Godard: The Holy Man

Of those unfortunate souls who were left high and dry, there is perhaps no figure more central to the Grand Theory wing of Film Studies than Godard, who even today – when he is increasingly subject to charges of anti-semitism – remains the closest thing that the discipline has to a holy man. There is no need to rehearse too many of the specifics of Godard's history here, given that he rivals Hitchcock in the amount of discourse he has generated within the discipline (and it should be said that, in languages other than English, he appears to have Hitchcock decisively beat in that regard); it is no surprise that his trajectory, like that of De Palma, mirrors the narratives that we have been sketching for the last few pages. In the dominant narrative of Godard's career – which, for readers of English at this moment, might as well be that of Colin MacCabe – Godard's move into explicitly political, if not yet Maoist, filmmaking coincided with the dissolution of his marriage to Anna Karina, and the first sign that the naively self-reflexive world of *Breathless* and *Une Femme Est Une Femme* was in eclipse was the 1965 release of *Masculine-Feminine*, with its dialectical formal combination of fiction and essay and its nascent inquiry into the fact of Vietnam. From *Masculine-Feminine*, it is only a few steps to the apocalyptic fury of *Week End*, after which Godard is in some way "spent": once one has declared the end of cinema, where can one go? As it turns out, one can only head into the ultra-modernism of films like the outrageous *Vladimir et Rosa*, which serves as a testament to the idea that the only place in American film one can turn to find assistance with the arduous task of *conceptualizing a militant cinema* is the work of Jerry Lewis.[7] And once that failure is in place – the Dziga Vertov Group experiment burns out like the Weathermen – the only available option is to collapse back into a frantic re-evaluation of language itself, in a move that might be said to anticipate that of the tenured nihilists of the Semiotics Department at Yale.

[7] The ultra-distanced, essentially surrealist films directed by Lewis (themselves a kind of abstraction of Frank Tashlin's visual language) are first operationalized by Godard (and/or Gorin) in the late Dziga-Vertov films; this strange but appealing influence continues to appear through the 1980s – most memorably in *Prenom: Carmen*, which consciously owes as much to De Palma as it does to Lewis.

Naturally, there is a traumatic moment for this narrative as well. For Godard, it is almost certainly May 1968, although it is often said that Godard had been preparing for *les événements* for years[8]; and of course there is also the popular conception that Godard helped to *create* that (inter-) national trauma in the first place, such as the contemporary as well as historical accounts that pinpoint the release of Godard's *La Chinoise* in 1967 as a harbinger, if not a determining cause, of the events of May[9] – not only for its specificities (the students of Nanterre, early contact with Dany le Rouge, and the fact of Mao) but also for its generalized ambiguity: what *does* Godard think of these kids? And there is Godard's participation in *l'affaire Langlois*, which – according to commentators like Louis Menand as well as filmmakers like Bernardo Bertolucci – helps to put The Cinema at the very center of *les événements*. However, May 1968 – as both event and failure – torqued Godard's work in an unforeseen direction, and while mainstream French cinema followed in the footsteps of Hollywood and gradually developed toward the Americanized kitsch of *Diva* and *Three Men and a Cradle*, Godard headed off into the no-man's-land of total opposition – opposition to "the cinematic," to the industry, and perhaps even to the specialized, urban film audience that Godard once courted. Indeed, one might see early 1970s films like *Ici et Ailleurs* and *Numéro Deux* as hymns to failure – not only the failure of May 1968 and the specific failures of the French and Palestinian student revolutions, but also the failure of the Dziga Vertov group (and especially the failure of the glorious folly that is *Tout Va Bien*) to position itself in a productive way in regard to the overthrow of the semiotic regime of capitalism. After all, the stretch of cinema from *Week End* up to *Sauve Qui Peut (La Vie)* is as resolutely difficult as any ever made, and – like that of much post-Left academic criticism – this obscurity, willed or not, is essentially anti-populist.

The question to ask of Godard's "red period" *qua* cinema is this: what does it want, and from whom does it want it? Colin MacCabe describes the Godard/Gorin films, with their "grotesque, if not offensive" politics, as having been "made for an audience that didn't exist at the time, and it is hard to imagine them finding a real one now" (MacCabe 2004, 237). We know how this cinema is "political": it is political at the level of content (i.e. Sheila Rowbotham reading her own feminist texts in *British Sounds*) and at the level of the form (i.e. the fact that Rowbotham is off-camera – not to mention what we *do* see while Rowbotham reads, which is a different woman, entirely naked, pacing aimlessly around a stair landing). Indeed the rhetorical logic of the Dziga Vertov Group films, as MacCabe points out, is best expressed in a line from *British Sounds*: "if you make a million prints of a Marxist-Leninist film, you get *Gone with the Wind*." But exactly *how*, again, is the disjunctive mobilization of content and form in something like *Pravda* political? How does it operate? What political effects does it intend to produce, and in whom? If it has no audience, then what *is* it?

[8] Or it might be, as it was for Dylan, a near-fatal motorcycle accident.

[9] See, for example, Margaret Atack's *May 68 in French Fiction and Film: Rethinking Society, Rethinking Representation* (2000), which points out that one of the primary sources – if not *the* primary source – for journalists attempting to understand *les événements du Mai* was *La Chinoise* – "the May '68 film par excellence" (Atack 9).

For the post-*Week End* Godard, in thrall both to Althusser and to Barthes, the Sartrean problem (of humanism, the State, and inaction) was best approached through the ultra-dehumanization of Mao, as well as through the now-you-see-it-now-you-do-not logic of Situationist *détournement*; exactly how productive this alliance would be is best summarized by the wounded, acidic snarl of *Sauve Qui Peut (la vie)*, Godard's "return to cinema" – which can be said, after J. Hoberman, to be the film in which Godard finally disappeared up *his* own asshole. Afterwards, from films like *Passion* and *King Lear* to the late video essays like *Histoire(s) du Cinéma* and *Film Socialisme*, all is lost and all is melancholy, film and life and politics are all a maze of mirrors, and the only place (outside Mozart) that human joy is to be found is in the contemplation of green landscapes, the surfaces of lakes, and the abstract patterns of jet vapor-trails in the sky.

This legacy of innovation, commitment, and failure – understood as a string of causes and effects, ordered, determinant, and inevitable – is what Godard shares with the narratives we have been sketching. (For many commentators, such as Gorin, Godard's failure is total.) Nonetheless, the fact remains that Godard is, above all others and to this day, *the revolutionary filmmaker, and his inscription into the discourse of Film Studies as the ur-cineaste* as well as the embodiment of counter-Hollywood practice is so pervasive that it is perhaps more foundational to the discipline's constitution (or at least its collective sense of self) than Hitchcock. Peter Wollen's writings on Godard (1982, 79–91) might stand as a prime example of the way in which the director takes this position: breaking Godard's essential contributions into a set of structuralist binaries (narrative transitivity vs. narrative

intransitivity, identification vs. estrangement, closure vs. aperture, &c.), Wollen judges Godard's "break with tradition" to be the first steps on the road to a truly revolutionary cinema, and indeed the coupling of Godard's break with tradition with his enormous revolutionary potential is a theme of almost every word written about Godard during the Vietnam era.[10] Even as late as 1975, James Roy MacBean could state without too much hyperbole that Godard was the only filmmaker to whom one could turn to see authentic revolutionary practice in action, and twenty years later Kaja Silverman and Harun Farocki would use essentially the same language to describe him, even as the triumph of multinational entertainment conglomerates (or however one figures the current Blockage to Revolution) made Brechtian gestures, as political strategy, unrecognizable and perhaps obsolete. In other words: Godard *is* opposition, *even after the impossibility of opposition*; within this logic, he is all the more heroic for having refused to submit to the logic of the mainstream film industry even as this refusal has left us with anti-popular and sometimes aggressively unwatchable cinema. And if Godard has been happy to play the character of the stubborn, even senile adherent to the gestures of the past, incapable of adaptation or compromise (as in *Soigne Ta Droite*), he still represents the last remnant of that broken holy thing called modernism – that is, as long as we understand postmodernism to signify *that which, in the moment of greatest crisis, has always-already given up its ideals*.

If, in contradiction to every bit of received wisdom about De Palma (including his fan discourse), we are to place him not under the sign of Hitchcock but under the sign of Godard, what aspects of Godard's system – that is, "Godard" – will need to be in place? First, there was the generalized importance of Godard (for example, as operational aesthetic, as common point of reference) for a certain *bloc* of American filmmakers in the 1960s and 1970s. By 1968, when De Palma released *Greetings*, Anglophone filmmakers like John Schlesinger and Richard Lester had already made certain Godardian tactics part of mainstream English-language film grammar. Hollywood, though – being a certain kind of industry with a certain kind of history – was more resistant to jump cutting and essayistic digressions, although in the confusion of the turn of the decade, it looked as if anything could happen; of the young American directors who rose to prominence in the wake of *Easy Rider* and its sloppy perversion of the Godardian aesthetic, only Steven Spielberg has never cited Godard as a pivotal influence. (Even Lucas was "set free" by Godard: could *Star Wars* exist without *Band of Outsiders*?) Even so, while one might productively track the appearance or mobilization of Godardian cinematic logic in specific films of the New Hollywood – the Alka-Seltzer shot in *Taxi Driver*, for example, or the repetition of certain tracking shots in Harry Caul's workspace in *The Conversation* – these appearances or mobilizations are generally merely that, decorative frills. Scorsese, for example, did not follow Godard into Mao; he followed

[10] Even the occasional disagreements with Godard – as when he cites Godard's "confusion over the series of terms, fiction / mystification / ideology / lies / deception / illusion / representation" (Wollen 1982, 79) – are couched in the kind of rhetoric that typifies the adulatory student's combative relationship to a favored teacher.

Visconti into self-abnegating class hatred, and even at his most splintered (*Raging Bull*) he is more Resnais than Godard. Similarly, Schrader – the only one of the New Hollywood auteurs to have actually written a book of auteurist criticism – kept Godard, as a technology, at arm's length even as he used him as a legitimizing reference by citing him in interviews. But Godard – far more than Cassavetes, whose movies were never *fun* – towered over independent filmmaking practice all the way through the cresting of The Wave and, in some ways, remains the patron saint of that era.

Second, there is the idea that, because of his links to critical practice – both his previous life as a critic for *Cahiers du Cinéma* and his proximity to, and interest in, Althusserian Maoism – Godard might be said to be a major point of – dare I say it? – *imaginary* identification for Film Studies as a discipline in the English-speaking world. (Obviously this will become more problematic if Godard's new reputation as an anti-Semite continues to gather steam.) At the very least we might say that if Film Studies has a coherent orientation toward an object of study, then whether by intent or circumstance that orientation (and that object) is roughly coterminous with that of Godard, since it is Godard's evolving conceptualization of American cinema that, in many ways, has provided the template for the discipline's conceptualization of the same object — and also since he, as much as anyone else on the *Cahiers* staff, can lay claim to being an important progenitor of the discipline's own discourse. One might be literal here and point out the number of ways in which the *Cahiers* model of film study is still the dominant mode of film study in the academy: films depend on other films (and on contemporary politics, arts, and technology) for context and meaning; films can and should be closely analyzed, like paintings or literature; while debate is necessary, there *is* an establishable canon of great films, and disreputable works, such as Hollywood genre pieces, have as much claim to membership within that canon as any deliberately "artistic" effort; theorizing about film necessarily precedes film practice. (The crowning figure of *l'auteur* is the only "officially" exiled portion of this epitheme.)

This question – what is the imaginary relation of the discipline of Film Studies in the United States to that quasi-object we call "Godard"? – is largely the same question we asked of "Hitchcock," although the historical fact of Godard's "first life" as a critic writing in theoretical-evaluative terms about the cinema makes the question immeasurably more complicated: for it is the curse of writing about Godard that one must write about Godard writing, and Godard filming, and how Godard's writing and Godard's filming are, if not coterminous, at least mutually imbricated. If Hitchcock is the original *object* of the discourse of English-language Film Studies, then Godard is in some uncanny way the original *subject* of that discourse; his essayistic cathexis-approach to Hollywood cinema, both in his written criticism and his filmed criticism, mirrors – and perhaps inaugurates – the early institutional history of Film Studies in both French and English, and his subsequent shift to a political, anti-populist critical practice mirrors, and perhaps again inaugurates, a similar shift in the discourse of the institution (a shift that the discipline's Federalist wing, exemplified by the Bordwell contingent, has seemingly reversed). One might say that the

remainder of the discipline that still insists on theory sees Hitchcock as it understands Godard to have seen Hitchcock, and even that we see ourselves as we understand Godard to have seen himself.

This has, of course, largely to do with the way that the subject is expected to prove his or her own coherence – that is to say, the practice of self-disclosure. Unlike Hitchcock, who is understood to be deliberately reticent about his methods because (like Lacan) he is wary of his interlocutors' power to disseminate and therefore dilute his knowledge, Godard is and has always been happy to explicate, to generate text – both written and verbal – about his films, his tactics, his intentions, and the varied contexts (political, industrial, sexual) in which his work is formed and in which it generates meaning. This is one of the ways in which it is possible to see a continuity between his work at *Cahiers du Cinéma* and his films; indeed, one might say that all of the *Cahiers* critics who became important directors (Truffaut, Rivette, Rohmer) are typified by a similar continuity, although only Godard made the shift toward anti-populism that typified much of the academic Left in the period after *les événements*. It is one of the great contradictions of Film Studies that the qualitative importance of an author's intent is precisely correlated to his or her unwillingness to self-disclose; this is how the discourse around Kubrick's *2001: A Space Odyssey* and Hitchcock's *Vertigo*, precisely because of their directors' incapacity – or unwillingness – to "go all the way" (i.e. to provide, preferably over a notarized signature, political or Lacanian justifications for a text's specificity), are always marked by questions of intent, whereas no one asks what Godard was "trying to do" or "meant to do" in (for example) cruelly interrogating Hanna Schygulla about her sex life in *Passion*. Criticism is all about completing the equation: even the most admiring criticism, such as Robin Wood's first article on *Vertigo*, implicitly assumes that the "work of art" requires translation in order to be effective.

How lucky, then, that Godard is so helpful in this regard: the more narratively opaque his films get (the middle third of *Made in U.S.A.*, the entirety of *Nouvelle Vague*), the less the critic is concerned with explicating them, because Godard, even when he does not actually say anything helpful (as in his recent interviews), is always assumed to know *exactly* what he is doing, even (perhaps especially) when on set he submits, in an methodically aleatory fashion, to the laws of chance. This is different from the way in which Hitchcock becomes *le sujet supposé savoir*: Godard is the ultimate authority on his own films, is possessed of an impossible transparent self-knowledge, while Hitchcock is the ultimate authority about the film going on inside the spectator's head. In other words: Godard, being a critic, knows everything about representation (which is to say, *movies*), while Hitchcock, being God, knows everything about desire (which is to say, *spectatorship*): the viewer's desire, the critic's desire, Norman Bates' desire.

If Film Studies *is* Godard, then what aspects of Godard – keeping in mind the Lacanian paradox that *the truth is outside*, that the truth of the subject is extimate to the subject – have traditionally been unavailable to Film Studies, especially in the English-speaking academy? First, there is the problem of *tone*: humor, for example, or the use of what is most easily called "irony." With respect to Godard, most of his classic interlocutors in English – from Susan

Sontag to David Sterritt to Richard Brody – fall into the trap of reading his comic moments literally, so that gestures of purely conceptual humor such as the admixture of Bogart and Walt Disney in *Made in U.S.A.* are exclusively read as political gestures; this is why a more complicated artifact like *Vladimir et Rosa*, with its Ed Wood *mise-en-scène* and its weirdly protracted and unfunny "comedy" routines (like the stuttering tennis-match conversation about revolutionary practice), is usually bewildering to both lay and scholarly writers. (To this day Film Studies has never come close to an adequate theory of tone: the closest it gets is in its treatment of Douglas Sirk.[11]) For example, James Roy MacBean, one of the last hardcore Marxist-Leninists to write for a non-specialized film magazine (*Film Comment*), seems to live in a world in which Godard never tells a joke. After all, the revolution is *no laughing matter*, which is why something like *Vladimir et Rosa*, is utterly bewildering to him. One can feel MacBean's interpretive desperation in passages like this one, which appears after two pages elaborating the progression of the film's humor from "political" to "vulgar":

> In spite of the rough spots, however, the comic tone of *Vladimir and Rosa* is refreshing. (As Brecht wrote, "A theater that can't be laughed in is a theater to be laughed at.") For one thing, it indicates that far from losing his sense of humor in the process of becoming radicalized, Godard has just as keen a wit as ever. Moreover, far from relegating humor to some private area of his life where revolutionary firmness might momentarily be relaxed, Godard clearly has a healthy recognition that humor can be an effective weapon in the revolutionary struggle. And that's a lesson not every would-be revolutionary has learned, I'm afraid.
>
> (MacBean 1975, 165)

Has MacBean, like the less fortunate of the "would-be revolutionaries," learned the efficacy of humor? The answer is self-evident, and it would be pointless to simply ascribe MacBean's bewilderment to a typically Marxist blindness to the sublimity of Jerry Lewis. To be sure, not every Film Studies participant writing in English about Godard perpetuates this blind spot (and let us not forget that the academy traditionally has trouble conceptualizing humor in the first place, so at some level this is a *global* weakness, rather than local to the discipline). But if a significant part of the delight in encountering Godard is his humor, then its absence in the discipline's conceptualization of Godard means that there is a similar absence in the discipline's conceptualization of itself.

It is not just that comedy, being a body genre (since it is imagined to produce laughter in the same way that pornography produces arousal), has only recently entered the discipline's field of vision in its proper form: Steven Shaviro and others have attempted to address

[11] One can find multiple ways in which the ironic, stylized Sirk described by Mulvey or Paul Willemen maps onto the ironic, stylized De Palma, whose films, like Sirk's, confront the viewer "with a deliberate and systematic use (i.e. a mechanization) of a stylistic procedure" of a particular genre — the melodrama with Sirk, the Hitchcockian voyeurism thriller in De Palma — coupled with "strong parodic elements" and the "deliberate use of cliché" (Willemen 66). These two filmmakers, nevertheless, do not enjoy the same kind of status.

comedy in the same terms that Film Studies (after Linda Williams) has learned to use to address pornography and horror – that is, as a matter of *affect*; but then again the affective aspect of film humor is not necessarily what defines it. (Is my laughter at the Christmas-tree-ornament-shooting sequence in *The Thin Man* – or, for that matter, my laughter at Richard Burton uttering the word "fascinating" in *Exorcist II* – the same as my laughter at the bank robbery in *Prénom: Carmen*?) There is also the overarching philosophical idea that bodily affect and intellectual response are different from one another, an idea that (needless to say) is Cartesian in origin; but if any human experience begs the question of this separation, it is film spectatorship, and it is a measure of the failure of Film Studies as it is currently constituted that it, as a discipline, is unimaginable without a dialectical separation between (as Steven Shaviro would put it) the cinematic body and the spectator's gaze.[12]

After tone, there is the related issue of *pastiche*. Even as the average baby-boomer Film Studies academic characterizes De Palma as a "rip-off artist," s/he inevitably understands Godard's use of reference to be a legitimate cinematic strategy – even when it reappears, in a depoliticized and presumably debased form, in someone like Tarantino. But one cannot accuse a director of plagiarizing Godard in the way that one can accuse a director of plagiarizing Hitchcock because, in a way, Godard himself is the first and greatest cinematic plagiarist. Jean-Pierre Gorin has spoken of Godard's career as a continual assault on notions of intellectual property, and the overlap between the referencing or rewriting of cinema history and what we call "critical practice" is nowhere more evident than in films like *Made in U.S.A.* or *Histoire(s) du Cinéma*[13]; one might then argue that De Palma's entire career is also a continual assault on notions of intellectual property, and that this orientation toward the history of cinematic form is merely one of the ways in which De Palma is "marked" by Godard. And yet there is a blindness within the academy regarding this strategy as well, and it has to do with the way in which cinematic self-reflexivity is defined: in Godard, referencing *Johnny Guitar* or showing Raoul Coutard at the camera is a form of *écriture*, whereas in De Palma, referencing *Sunset Boulevard* or showing Stephen Burum at the camera (both in *Body Double*) is no more than crass slapstick. Why? Because Godard is self-evidently *literary*, and De Palma is not. This is how a scholar as putatively thorough as Robert Stam can write a book with a title as totalizing as *Reflexivity in Film and Literature* and never mention De Palma: Godard is understood to be a reader, and because he reads, he theorizes reflexivity in the manner of Borges. De Palma, by contrast — since he is not commonly understood to be literary — does not theorize; therefore, and in contrast to (say) Sirk, the manifest narrative is taken to be the sum of the film's resources.

[12] Of course I do not pretend to offer a solution to this dilemma; I therefore share this failure as my own.

[13] Godard, unsurprisingly, has little good to say about De Palma, even though he prominently features *The Fury* in *Histoire(s) du Cinéma*. Of the "film school generation" Godard once wrote, "the most disgusting, though I liked him at the beginning, is De Palma" (*"le plus dégoûtant, et pourtant je l'ai aimé à ses débuts, c'est De Palma"*). From "ABCD … JLG," in *Le Nouvel Observateur*, no. 1206, December 12–24, 1987. Thanks to Jonathan Haynes for the translation.

Raoul Coutard: *écriture*; Stephen Burum: not *écriture*.

There is a third issue that bears elaboration, and that is the issue of provocation. If one lists the directors that have traditionally been revered by Film Studies precisely for their most provocative aspects – Buñuel, Fassbinder, Renoir (in *La Règle du Jeu*), Sirk, Todd Haynes – it becomes apparent that this list is held together not by the targets of their provocation, but by the *seriousness* of their gestures. Consider, for example, that Buñuel and Fassbinder see all social structures, including liberal humanism, to be identical in their ability to destroy actual persons, while Renoir and Sirk might be said to uphold liberal humanism over and against bourgeois, Victorian morality. What these directors have in common is a certain gravity, signifying an *adult* understanding of what is at stake: the struggle is always, at some level, antifascist. Godard, or at least the "classic" Godard, is in this group. Against this category one might group those directors who, due to the extremity of their stylistic presentation and their grotesque humor, would be understood to be *adolescent* and therefore not serious: here one would put Ken Russell, the Louis C.K. of *Pootie Tang*, and Brian De Palma. (Kubrick and Sam Fuller straddle these categories, to interesting disciplinary effect.) De Palma's provocations, although conceptually identical to those of Buñuel and Fassbinder, cannot be recuperated by Film Studies precisely because of this adolescent quality, which in most of these directors manifests as gleeful scatology or the "reckless" deployment of violence. (As I will argue in Chapter 3, De Palma's "comic" admixture of generic and political dissonance – such as handling of racial dischord in *Hi, Mom!* and *Scarface*, or humor and sexual violence in *Blow Out* and *Body Double* – helped to cement his rejection by, and subsequent invisibility to, the discipline.) One might speculate at length about the reasons for this disciplinary resistance, which might have something to do with the specific kind of personality type that is drawn to Film Studies as a discipline and especially to positions of leadership within it – but, short of an expensive ethnographic survey of every member of SCMS, this sort of speculation cannot be very productive. What can be asserted, however, is that – despite its multiplicity – Film Studies has an aesthetic, and that this aesthetic renders certain kinds of gestures unreadable. This is how films like *Body Double* or the incomparable *Lisztomania* (or, indeed, *Vladimir et Rosa*) remain opaque to the discipline as it is currently constituted: without a supple understanding of cinematic tone (which, like Pauline Kael's idea of "movie sense," perhaps cannot be taught), scholars simply cannot parse dissonant filmmaking.[14]

[14] This isn't limited to unreadable gestures that are assumed to have intent (however adolescent) behind them; it also applies to accidentally aphasiac texts like *Robot Monster* or *Strange Hostel of Forbidden Pleasures*. Scholars like Jeffrey Sconce and Joan Hawkins are blazing important new paths into the study of psychotronic cinema, but unfortunately it remains a marginal field of study. De Palma, of course, has many historical links to the paracinematic, from his association with Paul Bartel to his evocation of grindhouse cinema in the opening shot of *Blow Out*.

Made in U.S.A.

> A voyeur is always outside. But once he gets in, he becomes revolutionized. And he's in the front ranks when the revolution comes.
>
> –Brian De Palma (quoted in Gelmis, 31–32)

Given the fact that Godard's shadow was terrifyingly long for filmmakers all over the globe long before he dumped Nicholas Ray for Mao, it is hardly surprising that De Palma, who shot his first feature (*The Wedding Party*) in 1965 and who lived in New York City through the decade, might have encountered Godard's cinema and been marked deeply by it. It is also hardly surprising that De Palma's cinema, like Godard's, evolves historically from film to film and makes radical shifts –aesthetic, political, industrial – through the 1960s and 1970s, tracing a narrative similar to those we have been outlining in the previous section. Of course, we have seen how by the 1980s De Palma's cinema would no longer be easily recognized as "Godardian" – although, as I hope I have made clear, this would have less to do with De Palma's cinema in itself and more to do with the dominant positioning of De Palma as (let us say it) a scapegoat. But if we retrace De Palma's development as *un Godardiste* through the 1960s and into the 1970s, perhaps we will find ourselves in a position to recognize that *all* of De Palma's cinema is fundamentally Godardian: that is to say, it is irreducibly of the moment, politically Brechtian, formally rigorous, and committed – whether by design or habit – to the use of allegory to explore social and ethical issues.

We will later consider how *un Godardiste* would necessarily make movies within the changing power structures of post-Spielberg Hollywood. First, let us recall that Godard's cinema, as it is generally understood, itself underwent a series of shifts throughout the 1960s in order to come to the end of its "early" phase: from the epochal *Breathless*, with its nascent self-reflexivity and generic playfulness, through the "cool" formalism of *Une Femme Mariée* and *Masculine-Feminine* to the pre-radical "endgame" of *La Chinoise* and *Week End*, Godard's cinema begins as a double reflection – not, let us point out, as a "critique" as it is now understood – on Hollywood cinema and French society and evolves into precisely the sort of impersonal "critique" that we would associate with filmmaking that has moved past, or is about to move past, liberal sentiment. There is a similar logic to De Palma's early filmmaking, which evolves from the juvenilia of *Woton's Wake* and *Murder a la Mod* (1961 and 1966, respectively) into a "socially conscious" (i.e. observational but pre-radical) revue-sketch-style essay form in *Greetings* (released in 1968) and finally into something far more violent and apocalyptic in *Hi, Mom!*, released two years later. Our objective here is not to track how De Palma "does" Godard – after all, one does not and cannot "do Godard" in *quite* the same way that one can "do Hitchcock" – but rather to see how Godard serves as the determining condition of possibility for De Palma's cinema, both as formal system and as social artifact.

One very good reason for the relative invisibility of De Palma's history as *un Godardiste* is, quite simply, that much of his earliest work has been unavailable for years. Two of his early

features, *Murder a la Mod* (1966) and *Dionysus in '69* (1970), were screened very rarely after their first appearances, and only appeared on home video for the first time in 2004 and 2006 (respectively). At the moment of this writing, only one of his fictional shorts (the award-winning *Woton's Wake*, from 1962) and one of his documentary shorts (*The Responsive Eye*, a 1966 essay-film on an exhibition of Optical Art at MOMA) have been legitimately released on home video; and while his feature debut *The Wedding Party* (co-directed with a professor at Sarah Lawrence, who handled the actors, and with a fellow student, who supplied the production capital) has been intermittently available to the consumer since VHS first appeared, it remains impossible to see such potentially fascinating material as De Palma's documentary for the NAACP (*Bridge That Gap*, 1965) or his work for the Treasury Department (*Show Me a Strong Town and I'll Show You a Strong Bank*, 1966). This means that, unlike Godard's pre-*Breathless* work (or Scorsese's short films), the sum of De Palma's cinematic origins has been, and remains, shrouded in obscurity.

While *Woton's Wake* is clearly the work of a film student, a proto-Godardian melding of dozens of cinematic references (*The Seventh Seal, La Dolce Vita, Phantom of the Opera, The Red Shoes, Citizen Kane*, and so on) and – most typically of the era – featuring a climactic mushroom cloud, *The Wedding Party* is thoroughly Godardian – that is to say, it is marked irrevocably by the allusive, technical Godard of *Breathless, Une Femme Est Une Femme*, and *Vivre Sa Vie* (as well as by Malle, via the technical playfulness of *Zazie dans le metro*, and by Truffaut via the jazzbo melancholy of *Jules et Jim*). Although packed with jump cuts, *plan-séquence* construction, deliberate *faux raccords*, discontinuous sound editing, and various other typically Godardian devices (not to mention a casual approach to sexuality and social mores), *The Wedding Party* features what might best be described as De Palma's most thoroughly innocuous narrative scenario: the weekend-long wedding celebration of a moneyed white couple, narratively situated within the vantage point of the groom and his two groomsmen (one of whom is Robert DeNiro in his first film appearance). Given that this is clearly an apprentice-work made in the moment before the collapse of the production code, it is hardly surprising that the film continually seems to be straining against its subject matter. On the other hand, the technical devices, unlike their appearance in any Godard film, do not arise from a theoretical engagement with the narrative or a genre. If there is a trace of what Andrew Sarris might call "the sicko De Palma," it is in a sequence in which, during a rainstorm, the night before his wedding, the groom gets drunk on the balcony of a tower room of his bride's parents' Long Island mansion, and is soon joined there by his bride: as they lie on the floor together and converse (in a clear dislocation of the sex act), the struts of a window-frame, dripping with rain, are optically matted over the image – as if the camera is peeping through a window into someone's bedroom. The effect is poor enough that, especially when read retroactively, the scene appears to be the genesis of the willed artificiality of the back projection in *Body Double*: in other words, given what we know about De Palma's use of "the fake" throughout his career, perhaps we can read this moment as the first instance in which De Palma mobilizes artificiality, rather than simply achieving it.

If in *The Wedding Party* we find evidence of a nascent Godardian approach to narrative and a thoroughly Godardian approach to montage and sound, the legendarily rare *Murder A La Mod* puts Godard to a double use – not just by picking up on Godard's trademark fracturing of classical technique, but by attempting to mobilize the entire history of cinema in a *comparative* fashion. The structure couples *Psycho* with *Rashomon*: the quasi-sex-murder at its center is framed within three different narratives, each one of which plays out according to a different set of visual-structural generic requirements (romantic melodrama, silent-film comedy, suspense thriller). De Palma kept the film out of circulation for more than thirty years, presumably because of its technical shortcomings (poor sound recording, a clumsy management of narrative information), and so it has until very recently been an object of curiosity and intense speculation on the part of De Palma's fan base. And, indeed, since *Murder A La Mod* is De Palma's first attempt to take a Godardian position toward the Hitchcockian object, it stands in precisely the same relation to later films such as *Blow Out* and *Body Double* as Cronenberg's *Crimes of the Future* does to *Videodrome* and *Dead Ringers*: that is to say, *Murder A La Mod*, as William Rothman claims on behalf of *The Lodger*, contains *in nuce* all the major structural and epistemological gestures that will eventually return as the director's mature "system."

It would perhaps be giving the game away to point out that the film opens with a series of screen-tests, explicitly framed as a barely disguised attempt to get the women in front of the lens to take their clothes off – a situation that is echoed, to different effect, in *Greetings, Hi, Mom!*, *Sisters*, *Phantom of the Paradise*, *Home Movies*, *Dressed to Kill*, *Blow Out*, *Body Double* and, most memorably, *The Black Dahlia* and *Redacted*, both of which (as in *Murder A La Mod*) feature De Palma's own voice as that of the off-screen cameraman. In an epistemological turn that looks forward to the ending of *Blow Out*, *Murder A La Mod* closes with a character (the eternal William Finley) staring at footage from a snuff film and abjectly moaning, "He killed the lady... and he put her in the picture!" In between, there is a range of effects and gestures to which De Palma would return throughout his career: William Finley hurtling through dark hallways and up a staircase, the undercranked camera in hot pursuit (*Phantom of the Paradise*); a series of close encounters in a cramped elevator (*Dressed to Kill*); split foreground-background compositions, with an action in one register going crucially unnoticed in the other (*Dressed to Kill*, *The Black Dahlia*); the Rashomon structure (*Snake Eyes*). While the film is crudely made – and, for this reason, garbled and sometimes difficult to parse – it still reads as a catalog of De Palma themes, however nascent and undeveloped, from the blurring of lines between the diegetic fiction and the production of that fiction, to surveillance and the ubiquity – perhaps even the social inevitability – of voyeurism. This is the first place where De Palma equates filmmaking with violence, and violence with filmmaking; De Palma goes so far in this respect that it is difficult to determine, at any given point in the narrative, which acts of violence are "real" and which are stage business. (In a proto-Argento moment, the offscreen director in the opening scene reaches into the frame and cuts his model's throat.) *Murder A La Mod* also offers the first real evidence of what would later be identified as De Palma's misogyny, not only in the punitive violence it enacts

against women (one woman is stabbed in the hand and then – referencing Buñuel – in the eye) but also in the unreflectively masculinist way De Palma positions the two central female characters as, respectively, a dumb blonde and her castrating, tightly wound best friend. It is hardly worth noting that the men are portrayed as dishonest, libidinal, and violent, except insofar as this gender binary repeats itself throughout De Palma's work up until *Raising Cain*: men exploit women, and women accede to it. (Starting with *Cain*, they do not accede.)

Murder A La Mod can barely be said to have been "released" (it played for one week on one screen in New York City, on a bill with Paul Bartel's extended short film *The Secret Cinema*, a kind of ür-*Truman Show*); De Palma's next feature, *Greetings*, made possible everything that followed. Set in a recognizably Godardian milieu – the world of disaffected urban youth, the East Village instead of Paris – and offering a highly episodic narrative with three separate protagonists and a central issue (the Draft) that, in 1968, could not have been more topical, *Greetings* was a huge hit with the "youth audience," earning box-office receipts twenty-five times its original budget (a million-dollar return on a $40,000 investment – of which, naturally, De Palma himself got almost nothing). It was also the first film to receive the MPAA's brand-new "X" rating (for a generous helping of nudity, swearing, smoking of joints, and not-too-explicit coitus), and it predates *Easy Rider* by a year – making it something more than a footnote in the development of

the "alternative" cinema of the time.[15] Like that of *The Wedding Party*, the narrative of *Greetings* is a series of blackout sketches organized around three male characters, all white; in this case, each is in the middle of the draft-induction process, and each may or may not have to go to Vietnam. One sees Godard operating, as a principle, in the first shot – a news report (shot directly off a black-and-white television) praising a speech by Lyndon B. Johnson (LBJ); the film ends with a clip of that same speech ("I'm not saying you never *had* it so good, but that *is* the truth, isn't it?"), so that the film is bookended, ironically, by the official voice of America. (At the time De Palma was shooting *Greetings*, LBJ had not yet shocked the nation by declining, in advance, the party's nomination for re-election.) Sandwiched between LBJ's twin appearances and built around the draft-induction narrative are a cluster of other narratives: one character tries computer-arranged dating (in a subplot that provides most of the film's sexual content); another character becomes obsessed with the Kennedy assassination (and – this is unclear – is himself assassinated); a third (Robert DeNiro) reads a psychoanalytic essay about the traumatic roots of voyeurism out loud to the camera and, intrigued, decides he would like to try it out – voyeurism, that is. He buys a film camera and tries to create his own porn film, starring himself as a peeper who, at the appropriate moment, jumps into the frame and makes it with the woman on screen: like David Holzman, he has to have the frame before he can have desire.

The film is packed with references to its cultural moment: a hardbound copy (with original black dust jacket!) of *Hitchcock/Truffaut* is displayed for the camera (as well as *The Boston Strangler* and Pauline Kael's *I Lost It at the Movies* – also in hardback); a poster of Malcolm X makes a long cameo appearance, as does a framed poster proclaiming "Abolish HUAC!". A Vietnam veteran – apparently a "real one" – makes an appearance with a McCarthy button on his lapel and delivers a long monologue about the atrocities he witnessed. One character spends time chatting with the street vendor of a new Village newspaper called *Rat! Subterranean News* – a broadside that alters magazine advertisements to bring out what is repressed in them (i.e. pasting a rifle-carrying black revolutionary into an ad for cologne) in a timely reprise of Situationist processes. The film ends with a pair of scenes labeled "Two Views From Vietnam": the first features a film journalist – apparently, again, a "real one" – monologuing woodenly about his recent trip to North Vietnam while his 16mm footage is projected on the wall behind him; the second places the amateur peeper – having *failed to fail* his induction exam – actually *in* Vietnam, combat raging in the background. After LBJ makes his stinger appearance, an American flag fills the screen: *THE END!*

[15] *Greetings* is, however, almost never mentioned in surveys of the cinema of the era. It barely rates a mention (one citation in the index) in Julian Smith's groundbreaking (and similarly forgotten) *Looking Away: Hollywood and Vietnam*, perhaps because its existence belies Smith's central thesis (that American film had not addressed Vietnam). Austen and Quart, in their *Cineaste* article "The American Cinema of the Sixties," fail to cite the film. Nor does J. Hoberman in *The Dream Life*. The list goes on. One can only guess that the invisibility – or dismissal – of De Palma's early, Godardian cinema might have something to do with his later positioning as a thief and a rapist – except, of course, for the very real (and unspoken) alternate possibility that none of the authors mentioned above (except, significantly, for Hoberman) actually *likes* Godard or his processes.

Godardian framing in *Greetings*.

In a clear theoretical advance on *The Wedding Party*, *Greetings* includes such Godardian devices as direct-to-camera address, speculation about American imperialism, casual nudity, the unmotivated appearance of written text on the screen, the use of unpredictable, sex-obsessed youths as protagonists, and the inclusion of such up-to-the-moment concerns as birth control, rock music, and computer dating. What sets De Palma apart from Godard, however, is what relates him to Buñuel: the deep, determinant, motivating force behind *Greetings* – and, to a greater or lesser extent, every film he has made since – is the old *épater les bourgeois*, the desire to shock the hell out of one's elders and one's peers. This is not to denigrate this motivation, which is – let us be honest – as noble and potentially productive as any aim in cultural production: it is, rather, to point out that Godard, even at his most outrageous (doubtlessly *Week End*), positions himself relative to the targets of his criticism differently than De Palma. This is at least nominally due to a difference in national context, but it is also due to a different conceptualization of what "Godard" means. Like Hitchcock in relation to "Hitchcock," Godard has access to "Godard" only in the form of the return of his own letter: he has no access to the truth of his system, because he *is* the system. But De Palma puts "Godard" into operation to a specific purpose, just as he would "Hitchcock," and that purpose is *local*: it is New York City in the ferment of 1967–1968, and the various potentialities of that place in that moment would necessarily appear as elements deserving of an "X" rating.[16]

If we are to treat *Greetings* (like *Murder A La Mod*) as a kind of *ur*text for De Palma, we would need to pay close attention to a pair of tropes. The first is the Kennedy assassination; the second is Vietnam. The attention to the first of the Great Assassinations of the 1960s is remarkable in certain ways (*Greetings* is, to my knowledge, the first American film to address the JFK assassination in any literal fashion) but not so surprising in others, given that De Palma was twenty-three years old in November 1963 and twenty-six when he made *Greetings*. What *is* interesting – and typically De Palma – is how the enormous social fact of Kennedy's death and the confusion around the Warren Report appear in the narrative: that is, in relation to film and to the female body. Early in the film, the conspiracy theorist – played by Gerrit Graham, the singer who would later confront the Phantom's toilet plunger in the dressing-room shower – brings a photographic negative taken at the Grassy Knoll moments after the shooting (the *original* negative, one assumes) to a friend who works in a photo lab; he wants her to enlarge it so he can prove that a certain police officer mentioned in the Warren Report is visible behind a fence. (Every time it is used, the officer's name is rudely beeped out on the soundtrack.) Her response is classic: "Oh, I saw that movie, *Blow Up*. I know how this turns out; you can't see a thing." Nevertheless, she takes the negative and walks off screen. Graham is then seen from the back, holding up his previous attempt at

[16] From the vantage point of the twenty-first century, it is hard to reconstruct how shocking *Greetings* might have been at that time, but let us not forget that, like John Waters at the same moment, De Palma was staging the sort of almost-politicized outrage that would, in short order, become a different kind of social energy entirely.

an enlargement while he waits for the new one; after a moment, he lowers the enlargement – revealing the previously hidden sight of a fashion photographer and his subject, chatting excitedly while he snaps pictures of her, in an elaboration on *Blow Up*'s most infamous sequence. When the new enlargement arrives, Graham eyes it for a couple of seconds, then spins to address the camera, and therefore the audience, with a long, incoherent monologue about Officer [Beep], pointing excitedly at the enlargement the whole time: "See? See? See?" The image freezes, and an optical effect zooms in toward the enlargement in his hands – already indistinct and blurry – until it fills the frame. True to form, you cannot see a thing. Later in the film, a cut brings us to a photo of one of the bullets that killed the President; as an optical effect zooms us out of the photo, we realize that the photo is on a magazine cover, and that the magazine cover is itself covering the hips and pubis of a naked woman sprawled out on a bed, surrounded by magazine articles and various "reference materials" about the assassination. The camera looms over her from directly overhead. Kneeling beside her is the conspiracy theorist, who is using measuring tape and printed statistics to map JFK's wounds onto his girlfriend's body with a black felt pen. Once he is done, he spins to face the camera

again, and delivers another incoherent direct-address monologue about the government cover-up ("For the bullet to have exited at this angle, the President would have to have been standing on his head!"). When he holds up a copy of a book called *Whitewash*, the screen wipes to white.

Let us note here two transpositions. The first is superficially interesting: the mapping of JFK's wounds onto a woman's naked body. (As we will discover in Chapter 3, the connection it signifies will reach its apotheosis in *Blow Out*, where it is far more rigorously theorized.) The second, the connection to Antonioni, complicates matters. *Blow Up* was recently in theaters when *Greetings* was in production; its specific presence here – like *Une Femme Est Une Femme* in Bertolucci's *Before the Revolution* – signifies that the film's logic was, as they say, a topic of conversation. (The importance of *Blow Up* to De Palma's understanding of cinema and politics would best be demonstrated by citing its return as a structuring principle in *Blow Out*; there is also the importance of the film to Hitchcock, who legendarily regarded Antonioni's achievement with intense jealousy.) Additionally, we know from interviews with De Palma that his emotional and logical relationship to the assassination of JFK *as a thought-event* is very different from, say, Oliver Stone's. For example:

> When something's investigated by so many people, and there are so many versions of what possibly could have happened, there are so many witnesses, so many points of view [...] The Zapruder film is something we have that seems concrete, but what you get is ambiguity and you get a bunch of truths, and consequently you get no truth. And the more you investigate, the more your investigation affects the people you are investigating, and the more the truth is slipping away, and is elusive.
>
> (Quoted in Lagier and Voslion, 2003)

It is clear De Palma made a connection, however vague, between the epistemological "problem" of the JFK assassination and the similar "problems" of the missing corpse and invisible tennis ball in *Blow Up*. Thus the traumatic undecidability of the assassination – through the twin texts of the Zapruder film and the Warren Report, both central to De Palma's understanding of "truth" and "evidence" – gets mapped onto what is for many the ultimate example of cinematic high modernism, with its climactic game of Conceptual Tennis: if there is no ball (no object, no truth), then what is the object of the game, and what would it mean to participate in it? This connection will be wildly amplified first by *Blow Out* and then by *Snake Eyes*, but it appears here in *Greetings* in a pure, unadulterated form. Unlike Oliver Stone – who tries to get at "the truth" even though it is as elusive as that tennis ball – De Palma recognizes as early as 1967 that any attempt to understand "what really happened" is bound to fail or, worse, to destroy the very people one is intending to help. When Gerrit Graham, the assassination buff, is gunned down – rather abstractly, it must be said – toward the end of *Greetings*, it both is and is not a flip joke about the phantasmatic pervasiveness of the JFK conspiracy. Over a decade later, De Palma would point out – in an interview promoting *Blow Out* – that

when you have a truth that does not fit in with what people want to accept, you are an odd man out and you will be driven crazy or totally ignored or killed. I really believe that. If you read about the Kennedy assassination and the witnesses that vanished you realize there's all kinds of paranoia.

(Amata 78)

The other central De Palma trope here – and of course it is of a piece with the JFK material – is Vietnam. It enters the narrative here in a Godardian way, through the literal imposition of material alien to the form (i.e. a news broadcast, shot right off the TV) and lingers around the narrative at every moment. At the film's opening, one of the three characters has just met with the draft board, one is about to meet with them, and the third is scheduled to meet with them soon; none of them knows yet whether he will have to go. The film's first fifteen minutes is an extended sequence in which the three brainstorm for several days about how to get out of the draft. Should they pretend to be gay? Pretend to be crazy? Pretend to be physically unfit? Pretend to be a zealot, either on the left or the right? At the film's end, the peeper (Robert DeNiro) finds himself in Vietnam, accompanying an American news crew as they "film the action"; he sees a Vietnamese woman through the brush and approaches her, rifle in hand – only to use the film crew to recreate, in the film's outrageous punch line, exactly the same peeper-joins-the-action porn film that he had tried to create earlier ("Window? You understand *window*? Okay, okay, you're at home, you're relaxing – take off your shoes").

As regards both of these tropes, JFK and Vietnam, the viewer will note the use of the female body, in relation to these issues, to figure a certain *abstraction* – an abstraction, or set of abstractions, that changes according to context. There is the woman's body as screen, as mannequin, as model (photographic model, production model, heuristic model); there is the woman "herself" as object of desire, with her body as the object of projection (not necessarily of knowledge). The mapping of JFK's wounds onto the body of a sleeping, naked woman, for example, telescopes several different registers – political, sexual, economic, historical, visual – onto the only shape ready-made to fit any assigned meaning. Would we say that this *a priori* conceptualization of woman as object or screen is any different, in type or intensity, than the same conceptualization in the contemporaneous New Left? We could make the obvious comparisons (*David Holzman's Diary*, for example, or *Easy Rider*) but let us merely bookmark the idea that women's liberation – as feminism was understood at that point, and usually evidenced in films directed by men as a certain *insistent display of sensitivity* to the gender/power dynamic – was not yet an issue for De Palma. In fact, let us momentarily take for granted the idea that – even considering the references to feminism in *Sisters* and the menstrual apocalypse at the heart of *Carrie* – this problem, the arbitrary (yet, under capitalism, structurally inevitable) social oppression of women, will not appear as a primary rhetorical subject until *Blow Out*.

After the success of *Greetings*, De Palma next released *Dionysus in '69*, a two-camera cinema-verité record of a controversial performance by The Performance Group, originally directed for the stage by New York underground theater legend Richard Schechner. The original performance, based on Euripides' *The Bacchae*, was aggressively "environmental" in

that, as was frequent at the time, there was no spatial distinction between the audience area and the stage – so that performers and members of the audience (especially during the play's more *orgiastic* moments) are indistinguishable. De Palma's legendary film – "legendary" because, until 2003, totally unavailable – takes Godardian distanciation tactics one step further by virtue of being presented entirely in split-screen. Like *Greetings*, the film received an X-rating, and again, its formal innovations predate their appearance in a commercially more successful film – in this case, *Woodstock* – by a year.[17] *Dionysus in '69* more or less uses its two screens to run two parallel angles on the event: at any given moment, one frame focuses on the performers, and the other on the audience (who, during the pivotal Bacchanalia at the heart of the film, join in the action – dancing, taking off their clothes, making out, &c.). The movie is full of full frontal nudity of both sexes, and the split-screen technique adds a frantic, dislocating effect to the spectacle of the production, which – more than anything – is incredibly *loud*. (In order to understand the dialogue while auditioning the film in a home-video environment, one has to crank the volume considerably.) At one point, one performer nearly rapes a girl in the audience, pulling her out from her friends and climbing on top of her as she struggles underneath him for an unconscionably long length of time; the camera records this event impassively. When Dionysus (the god, played by William Finley, aka Winslow Leach) makes out with Pentheus, the kiss of the two male performers fills both screens, mirror images of one another – the only moment of its kind in the film. At the end, when Pentheus has been torn to pieces, the entire cast – except for William Finley – is *covered* with blood, and Finley suddenly appears in a suit with a bullhorn to announce his candidacy for President of the United States. "A vote for Finley in '68 means Dionysus in '69!," he shouts as the mob carries him onto the street, camera trailing behind. The last image is an optical freeze of William Finley giving something quite similar to a Nazi salute, borne aloft on a tide of NYC hipsters, as he exhorts the crowd to prepare itself for an apocalyptic social revolt.

Like *Greetings*, *Dionysus in '69* is built to shock. However, this is not the Utopian, anti-parental "Sixties" of the Summer of Love anymore (which appears in *Greetings* expressed almost exclusively in terms of sexuality): this is the dark and bloody ground of what both Peter Biskind and David Thomson would call "the Orgy," the cry for freedom from all constraint that accompanied the counterculture's drop into the nihilistic, death-swinging apocalypse of Manson and Altamont. And indeed the potential for violence – not

[17] Of course the technology of the split-screen was first utilized in the early silent era and had had its use as a piece of Hollywood vocabulary (Doris Day and Rock Hudson on the phone, for example), but De Palma's utilization of it – to splinter the film frame into different conceptual angles – seems ontologically related, somehow, to the Kennedy assassination and the multiplicity of narratives that can be constructed around a given event. (The apotheosis of this technique in De Palma's hands would be the split-screen sequence in *Snake Eyes*.) As regards *Woodstock*, on which project Scorsese was one of six (credited) editors and one of two assistant directors, let us note that, since De Palma and Scorsese knew one another by this time (as friends, colleagues, and competitors), it is entirely possible that Scorsese actually watched De Palma editing *Dionysus* in split-screen and simply ported these methods to Michael Wadleigh's film. The historical record is, however, unclear.

only revolutionary violence, but the violence of sexual release, of letting go, of death – was in the air: it was Vietnam, it was JFK, and it would soon be De Palma's main subject, as it was already Godard's.

If *Greetings* and *Dionysus in '69* can be said to have been built upon a certain understanding (if a naïve one) of the possibilities of the medium opened up by Godard – specifically the essayistic, scientist-of-the-quotidian Godard of *Masculine-Feminine* – then *Hi, Mom!* is the film in which De Palma enters his *Week End* phase. Rife with political violence, intimations of uncompromising socialist revolt, and images of race warfare, as well as the ubiquitous sexual innuendo which was still a hallmark of the New Left, *Hi, Mom!* charts the evolution of the peeper from *Greetings*, now a Vietnam veteran, from his attempts at super-8 strictly-voyeur porno filmmaking ("peep art") through his encounter with confrontational political theater and then into domestic terrorism. In almost every way this is De Palma's most extreme film: *Scarface* has more bloodletting and *Body Double* is far more reflexive (and more thoroughly theorized), but *Hi, Mom!* starts with porn and ends with the bombing of a Manhattan co-op apartment building, with presumably dozens if not hundreds dead, and in between shuffles through styles, textures, and narratives like a Vegas croupier. At this point De Palma has clearly seen *La Chinoise* and *Week End* (both of which opened in New York in 1968), but *Hi, Mom!* makes no attempt to mobilize Godard's more invasive cinematic techniques, such as screens filled with blinking, repetitive text, robotic camera movements (lateral tracking, unmotivated architectural shots), or harshly disjunctive sound editing. What De Palma takes from *Week End*, rather, is revolutionary violence and a severe, even incapacitating ambiguity about that violence, and indeed there are sequences from *Hi, Mom!* that will echo through the rest of his work as models of how to allegorize social turbulence.

Hi, Mom! went into production as *Son of Greetings*, and so the film opens with Robert DeNiro, the peeper from *Greetings*, just returned from Vietnam, looking at an ultra-grungy Manhattan apartment offered by an ultra-grungy landlord (the film debut of Charles Durning). The place looks awful until we – and the peeper – see the view from one window: a bank of apartment windows across the street, *ripe* for peeping. DeNiro – the character's name is Jon Rubin – immediately agrees to take the place, and then De Palma plunges us into the first of his trademark demonstrations of cinema technology (a trope that would return with particular intensity in *Blow Out*). Starting with the title credits, which roll over Jon's view of the apartment building across the street (a still frame of a brutalist apartment block with little "scenes" optically printed into each window), De Palma takes the audience on a half-hour-long tour through the varied functions and purposes of the cinematic gaze – in a long preparatory buildup for the film's centerpiece, the infamous "Be Black, Baby!" sequence.

In order to properly set the audience up for this, the most incendiary piece of American filmmaking of the decade, De Palma needs that audience to understand what filmmaking is, and what the gaze might be. To that end, he begins with porn: first, a visit to the office of a porn entrepreneur – Allen Garfield, in a reprise of his role from *Greetings* – where we encounter a row of whirring projectors, with a row of porn loops playing on the wall in the background. From here, we move to a porn theater, where Garfield lectures DeNiro on how to properly address a porn-theater audience (while watching what looks like hardcore

porn, presumably – like that in *Greetings* and *Body Double* – shot by De Palma himself), and from there to a sauna, where – in a reminder to the audience that *Blow Up* is a point of reference – DeNiro uses enormous frame blowups of shuttered windows to sell Garfield on the idea of amateur, candid-camera porn as "peep art." From here, a tumble of short scenes about filmmaking and the operation of the gaze fly by: a film-equipment salesman's demonstration, clearly shot in 8mm, of focal length and aperture width and microphone placement, with the camera in the hands of a housewife who is (like David Holzman) filming her diary; DeNiro filming the lives of the people in the apartment block across the street, in De Palma's first explicit reference to *Rear Window*; the housewife filming her dreary apartment block and encountering a recalcitrant neighbor; DeNiro passing a TV store on the street and stopping to watch (at which point we slip into 16mm, black-and-white "broadcast" mode, complete with inset TV-shaped screen, for several minutes). There are frequent titles and scrolling text, *a la* Godard; the colors are bright and primary, again like Godard; De Palma frequently turns to *plan-séquence* construction; and so on.

The buildup to "Be Black, Baby!" ends with a long sequence in which DeNiro decides to seduce the film's equivalent of *Rear Window*'s "Miss Lonelyhearts," a young woman (Jennifer Salt) who lives in the opposite building: he attempts to engineer a situation in which he and she will have sex at a *specific moment* so that the 8mm camera in his apartment, pointed at her window and set to "go off" at a specific time, will catch the act. The fantasy goes wrong from the start: he has planned out the pre-coital conversation to the smallest detail – that is, he has *overtheorized* it – and when he arrives, Salt is ready to hit the sack immediately. He stalls her with his planned conversation as best he can, then finds that he must go out to purchase a contraceptive. As it turns out, he has no idea how to use one: the store clerk – Peter Maloney, the JFK witness in *Greetings* – has to explain how to unroll a condom, and it is here that the audience is cued to realize that *this guy is a virgin*. (This moment – with this particular actor playing this particular type of severely alienated character – will return to haunt *Taxi Driver*, which circulates around the question of Travis Bickle's virginity with a less satirical eye.) When he returns to her apartment, they immediately go at it; at this moment, the 8mm camera in his apartment slips on its tripod and, succumbing to gravity, tilts down. We cut to DeNiro and Garfield watching the result: the guy and the girl are getting it on, it is *great stuff, very hot*, and then suddenly the frame tilts down to reveal the apartment below, where Gerrit Graham, the JFK nut from *Greetings* (and Beef from *Phantom*), is painting his own naked body black. Garfield (outraged at what he perceives to be – as we may recognize – a Godardian or avant-garde gesture) begins shouting invective, calling DeNiro a pervert and a Commie, while on the projected film loop, Graham – now totally black, except for his garishly white penis – flexes his muscles and gives the Black Power salute to a camera on a tripod. In a perfect image of the narcissism of the male student Left, he is taking heroic pictures of himself in blackface.

We have encountered Graham previously in *Hi, Mom!* We first see him as DeNiro sees him, through the lens of his 8mm camera: we "peep" on him through his apartment window as he rips down his Monet posters and replaces them with huge posters of Che and Malcolm X. As the film begins, then, he is a recent convert to the Left: is he doing it to *score with chicks*? In addition

to seeing him through *this* POV, we have also encountered him on another kind of screen. *Hi, Mom!* is interrupted three times by "television programming" – that is to say, by a sudden cut to black-and-white frame-inset 16mm footage – and each of these three interruptions is presented as an episode of "National Intellectual Television" (a barely disguised exaggeration of National Educational Television, still current in 1969). Graham appears in all three of these episodes. In the first, he and a pair of black militants harangue people on the street about their racism – white passersby, black passersby, Asian passersby. (The puzzled responses of some of the interviewees convinces me that most of these sequences are indeed "candid," although the uncredited Mary Davenport – who plays the nagging mother in *Sisters* – is one of these "unrehearsed" strangers.) The insistent righteousness of Graham's performance – familiar to anyone who has ever hung out with a brand-new "true believer" (usually a college sophomore) – further clues us in to a certain ambiguity with which De Palma might want us to view this character. The second of Graham's television appearances is labeled "The Theater Of Revolt," and it is preceded by a theatrical audition. DeNiro sees a poster, on which is a woman with exposed breasts and a rifle; he eyes the breasts and then reads the sign, which is a notice announcing an open audition for a theatrical performance called "Be Black, Baby!" The troupe, clearly seeking something like authenticity, is looking for Caucasian males who can play cops. DeNiro, we immediately realize, is clearly the man for the job, and we get to witness his successful audition, in full "New York's Finest" drag (with nightstick in hand). In the very first appearance of the patented DeNiro Psychopath, he brutalizes a trashcan, two doors, a ladder, and a mop as if they were all wise-ass hippies – the first explosion of intense macho rage that DeNiro is allowed on a cinema screen. (In this moment we are allowed to see DeNiro's entire future career, condensed into three brief static shots.)

And then, with Robert DeNiro installed as a member of an avant-garde theater group, De Palma plunges us into "Be Black, Baby!," a staged cinema-*verité* record of a performance piece (in inset black-and-white 16mm) that manages to compress most of the themes of *La Chinoise* and *Week End* into eighteen grainy, high-contrast minutes of escalating violence and wild, screaming panic. After a title card reading "The Theater of Revolt," we watch as a group of white bourgeois theater-goers are invited to experience "what it means to be black in America"; to this end, they are "blacked up" with makeup, then systematically beaten, humiliated, robbed, and perhaps even raped (it is unclear) by the black actors, who are themselves in whiteface. The audience can see what is coming long before the theater patrons, who are blissfully ignorant of what they are about to experience, but even with expectations raised, the sequence is unbearably grim and horrifying. After the screaming, the blasts of gunfire, and various forms of battery (including DeNiro's appearance as a racist cop, who calls an aging Jewish accountant "nigger" before beating him with his club and then deputizing all the actors in whiteface), the theater patrons – weeping, bleeding, and terrified – are ejected onto the street, where they are welcomed by smiling actors chanting "Be Black, Baby!" The punch line arrives with each of the patrons enthusing for the documentary camera about the experience they have just had. "Clive Barnes was really right," one of them says. "This was quite a show. I'm going to tell all my friends they have to come see it."

On the one hand this is simply an extended and especially cruel conceptual gag about radical chic: once they are cued to do so, each of these well-meaning readers of the *New York Times* will recuperate what they have just experienced as having been "good for them" – that is, it has made them *better liberals*. (Compare, by contrast, the humiliatingly sour detour-through-the-Bronx sequence of *The Bonfire of the Vanities*, which resembles a Ron Howard version of the idea.) The white-liberal-guilt theme is familiar enough, and it certainly did not start with De Palma; there is also the possibility – perhaps the certainty – that De Palma was thinking of Joseph Tuotti's "Big Time Buck White," a confrontative off-Broadway piece about race that had a brief national tour before its transformation (co-optation?) into a full-on Broadway musical starring Muhammad Ali. Whatever the specific inspiration for the sequence – or wherever we assign its authorship – what makes "Be Black, Baby!" so astonishing is the intensity of the sequence, which wants to *put the viewer through it* just like the theater patrons on-screen: everything from the precision of the *verité* technique (courtesy of a specialty cameraman) to the force of the performances works to emphasize the violence and to add to the sense of tumult and confusion. In terms of the theatrical situation, this is clearly an elaboration on *Dionysus in '69*; the idea of performance-as-revolution/revolution-as-performance is taken one step further toward its logical conclusion – that is, actual revolutionary violence – and the issue of audience participation becomes something very much like the active suppression of the middle class by a revolutionary vanguard. It is, indeed, terrifying. But if the sequence "puts the viewer through it," just as the theater patrons have been put through it, then is *Hi, Mom!* – like "Be Black, Baby" – therefore *good for you* as well? That is, does it make you a *better liberal*?

For the most part the critics, unlike the theater patrons inside the film, did not think so, but it was not just the "Be Black, Baby!" segment that they disliked; critics in Britain in particular worried that *Hi, Mom!* would inspire terrorist bombings. This would be because of the film's concluding section, in which DeNiro – after watching the third of Graham's television appearances, in which he and his black brethren and sistren attempt to "bring the revolution" to a Manhattan apartment block and are all shot to death (on TV) by a white nuclear family with a machine gun – decides to blow up the building into which he has been peeping, killing everyone inside. Earlier, we have seen DeNiro reading out loud from *The Urban Terrorist*, which urges its readers to infiltrate the bourgeois culture by looking just like a typical bourgeois, adopting his tastes and social routines, before moving to destroy it from the inside. Now, we see that he is living with girl-in-the-camera Jennifer Salt – is he *married* to her? – who complains about the utility of the household appliances and the color of the kitchen walls. DeNiro harrumphs around his pipe like a proper husband, then plants a bomb in the laundry room and runs: the building explodes and (presumably) collapses. *Hi, Mom!* ends with another television segment – this one a news broadcast from the site of the bombing – in which DeNiro appears anonymously, arguing with a black psychiatrist named Dr. King that all this violence and bloodshed is *not* necessarily a direct result of America's involvement with Vietnam – that all the hippies and the other Leftists are trash and scum, and this is a great country, dammit! The film's final line supplies its title, as DeNiro cheerily turns to address the news camera with *a personal message to someone at home.*

Believe it or not, *Hi, Mom!* is a comedy, but then again it must have been hard to see that at the time, since the film had the misfortune of appearing in theaters just days after the Weathermen blew themselves up in a New York City brownstone. Perhaps because of this coincidence, the film was a critical and financial disaster in the United States; mainstream critics were puzzled by its shifts in tone and, like Godard's *La Chinoise*, could not figure out exactly what message De Palma intended to communicate to them. *Hi, Mom!* usually goes unmentioned in critical discussions of radical cinema of the era; Michael Ryan and Douglas Kellner, for example, have nothing to say about De Palma's early cinema in *Camera Politica*, although they have plenty to say about the misogyny of De Palma's Hitchcock period. From a historical distance, this is probably because of the events of the 1980s and the critical paradigm through which De Palma was subsequently understood. But there is an ambiguity to De Palma's stance in relation to the aspirations and motivations of the Left – unlike that of, say, Arthur Penn, whose trajectory from the paranoiac *The Chase* (1965) to the sub-Antonioni card trick of *Night Games* (1975) is consistently marked by a less-than-self-reflective attitude toward its "tragic" political content – that marks something like *Hi, Mom!* as more difficult to fix and, therefore, less "coherent."

Of course for Film Studies in its American context this same ambiguity marks Godard as complex, rather than incoherent: a kind of critical double-vision that automatically understands *literariness* as a signifier of *commitment*. But unlike Godard, the De Palma of *Hi Mom!* is dispassionate, even scientific: he theorizes, but his theorization has a different relation to its object – as well as a different object. Godard appears, in the midst of all this, as a useful cinematic tool, a kind of conceptual strategy for change: but of those American filmmakers of De Palma's generation, only De Palma himself understood that Godard's ambiguity is inseparable from that strategy.

That ambiguity – especially in and around Godard's hazy relationship to violence, with *La Chinoise* being only the most notorious example – is a central point of comparison with De Palma. Peter Conrad once wrote a book called *The Hitchcock Murders*; who will write *The Godard Murders*? Of Godard's features up through *Week End*, only three (*Une Femme Est Une Femme*, *Une Femme Mariée*, and *Deux Ou Trois Choses Que Je Sais D'Elle*) are free of violent death, while some of them – such as *Alphaville* or, especially, *Week End* – are positively swimming in corpses. In Godard, the distribution and intensity of the violence plays out along the same gender lines as it would in John Ford or Sam Fuller; it comes to him as a set of generic practices, with its own way of making meaning. (Thus the use of red paint and casually arranged "dead" extras in *Pierrot le Fou*, the movie of Godard's that most insistently underlines its adherence to generic requirements.)

Are there, however, *sex-killings* in Godard, as there are in De Palma? Or did the fact that Godard never essayed the Hitchcockian thriller – as he essayed the detective film, the youth-on-the-run film, the domestic melodrama, science-fiction, and so on – automatically preclude a certain sexual emphasis in the staging of violent death? Certainly women die in Godard: for example, there is Anna Karina's death in *Vivre Sa Vie*, with the aleatory tolling of the church bell in the background. Would we say that she is being punished – and if so,

is it because she is a woman, or because she is a prostitute? And if punished, then by whom – Godard? If *Vivre Sa Vie* is satiric – and it seems not to be – is her death satiric? There is the death of Brigitte Bardot in *Contempt*: she and Jack Palance lie motionless in the front of his photogenically crashed Fiat, with brilliant red coloring painted delicately on their foreheads, as Coutard dollies slowly around them. Does her death, in this instance, signify allegorically? If so, is it easier because we do not see – *pornographically* see – her death? If she figures an abstraction at this moment, is she "Anna Karina" – or could she be "consumerism"? There is the pointedly off-screen rape of Mireille Darc in *Week End*: is that moment a satire of consumerism? Or is it satirical at all? Darc is certainly used allegorically in *Week End*, even more so than Bardot in *Contempt*; what, then, does *her* rape allegorize?

Since these questions open up onto a different book altogether – the use of violence against women as an allegorical device in "Left" cinema of the 1960s[18] – perhaps we should approach this juncture of issues in a different manner. How was Godard's violence traditionally framed by critical discourse? Susan Sontag, for example, only mentions Godard's violence *qua* violence in the last two pages of her lengthy excursus from February 1968. Speaking of a certain anti-dramatic quality, Sontag writes, "this coolness is a pervasive quality of Godard's work. For all their violence of incident and sexual matter-of-factness, the films have a muted, detached relation to the grotesque and painful as well as to the seriously erotic. People are sometimes tortured and often die in Godard's films, but almost casually" (Sontag 1983, 261).[19] This detachment, this coolness, is best defined – especially in our context – as the absence of the *intense* violence typified by the rape-strangulation in Hitchcock's *Frenzy*. If anything similar to the intensity, the heat of Hitchcock's most outrageous scene is to be found anywhere in Godard, it is in *Week End* – and Godard in *Week End*, unlike Hitchcock in *Frenzy*, almost always refuses the close up, never bringing the camera into any kind of intimate relationship with the human face. (Nor, for that matter, is there anything in Godard like the lingering, three-way kiss between Cary Grant, Ingrid Bergman, and the camera in *Notorious*.) The specific triangulation-montage effect that Hitchcock mobilizes around the murders in *Psycho* and *Frenzy* (and the "rape sequence" in the attic in *The Birds*), with its special attention to the details of the victim's face as well as to the motion of flailing limbs in empty air, is also nowhere to be found in Godard: would we attribute this to Godard's refusal to storyboard (i.e. his global reliance on *plan-séquence* construction rather than Eisensteinian intellectual

[18] This hypothetical book might center profitably on just three films: *Week End*, *Hi, Mom!*, and Bertolucci's desperate, obsessive *Partner* (1968), a film that triangulates in a dozen ways with Godard and De Palma and which, naturally, Bertolucci himself has more or less disowned as the product of a temporary mental illness. Rarely screened or discussed, Bertolucci's film is another work in the Godardian vernacular that mobilizes (however ambivalently) revolutionary violence, and it figures the bodies of women – even more than *Hi, Mom!* does – as screens upon which this violence takes a collateral toll. In regards to Oedipal narratives and their consequences, the reader will note that, unlike De Palma, Bertolucci had to assassinate Godard (in *The Conformist*) in order to free himself from his influence.

[19] Compare, for example, Richard Roud, whose only discussion of Godard's violence is to call *Week End* "gory" (Roud 1970, 139).

montage), or would we attribute this to a different relation to the subject, to a different relation to suffering – even simply *affect* – in general? When people are in pain, Godard's camera does not get very close to them; we can have a close-up of Anna Karina's face for minutes at a time as she listens to someone read poetry or as she realizes that she has been betrayed, but a close-up on her face during *physical* suffering is inconceivable within Godard's system – as would be a triangulation of the camera's gaze around her during a moment of physical crisis or danger.

When women are killed on-screen in early De Palma, from *Murder A La Mod* through to *The Fury* (with Carrie Snodgress flung in slow motion across the hood of a car – a scene that Godard dissects in *Histoire(s) du Cinéma* – or Fiona Lewis spinning in the air until she explodes in a cloud of blood[20]), are these deaths relieved of their allegorical or satiric or figural possibilities for having been presented to us through a triangulation of the gaze or through the identificatory powers of camera proximity? Are these deaths *sadistic?* We know from everyone's reading of De Sade – Sontag, Barthes, Bataille, &c. – that sadism in a certain context operates as a figure for political theorization; if De Palma is indeed sadistic, is the possibility of what Hayden White would call "tropical signification" foreclosed to him? If so, how, and by whom?

All of these questions are permutations of a central question, a dilemma at the heart of the attempt to look back at these films and this time. What needs to be indexed here – and all I can do is to open the door for some future study of the topic – is the relationship between gender and screen violence during the "revolutionary moment" of the late 1960s and early 1970s, and how this relationship changes from context to context and through time, and in response to what pressures. As Shana MacDonald points out in her discussion of Godard's *Week End* (in Russell 2010), rape – and, by extension, any violence against women – exclusively functions in a metaphorical way in a certain kind of art cinema, so that women are both reduced to their status as objects of cultural exchange and endowed with excess signification (raped women are raped nations). The sexism of the New Left has been commented upon elsewhere, as has the misogyny of Hollywood film practice at this (or any other) time. Even Godard's sexism is a familiar object of critical knowledge. But let us take a moment to consider a moment from *Forrest Gump*, a film which reviews some of these same issues and historical agents, and – more to the point – does so in an *exclusively* allegorical manner. In one scene, Forrest beats up the head of the Berkeley chapter of SDS (whom we might, or might not, understand to be Todd Gitlin) – why? Because this white radical has himself beat up Forrest's beloved Jenny. Robin Wright Penn operates in this film in much the same way that women operate in mid-period De Palma: she is a screen, and the abstraction that is projected onto her or embodied in her changes according to context. (She moves from student radicalism to cocaine to AIDS, managing in the process to embody, as

[20] … or Piper Laurie's death in *Carrie*, which is clearly punitive and highly gendered. Compare the logic of her death, though, with Žižek's discussion of the death of Gromek in *Torn Curtain*: under this logic, Piper Laurie dies in order that the audience's desire for *the bad guy to get it* may return to them in all the truth of its sadism. This, after all, is Žižek's fantasy of Hitchcock's progressive potential. See "In His Bold Gaze …" (Žižek 1992b, 222–225).

if in a logical series, nearly every cliché about the casualties of the decade available to the historical observer.) One might say that she – like Nancy Allen in *Blow Out* – is a screen upon which "violence against women" is projected; bruises appear on her in order to register abstract relations between opposed social forces.[21]

We will return to these issues – gender, violence, historical pressures, allegory and figuration – in the discussion of *Blow Out*. But what fascinates here is the kind of cinematic violence that boils up in the revolutionary moment, especially when that moment and those energies are understood in Godardian terms. In *Hi, Mom!* there is no blood, save for that coming out of the bruised heads and faces of the theater patrons at the end of the "Be Black, Baby!" segment. Neither is there the painterly wash of red that Godard uses to signify death: the blood pouring over the skinned rabbit that figures the death of the mother-in-law, or the great swathes of red in the street that, in *Week End*, signify the collapse of capitalism. And yet both these films hinge on violence; in both, there is the anticipation of a coming explosion, a wall of flames that will consume the uncommitted and level the playing field for something that we might call Utopian. And after what actually came next (the triumph of De Gaulle, Nixon's re-election, whatever one chooses), the question of violence continues to reverberate through Godard's and De Palma's work in different ways. Godard disappeared in a cloud of self-interrogation and circular, depressive anti-narratives and, after *Ici Et Ailleurs* and *Numéro Deux*, a new emphasis on the human form, in terms of sexuality if not violence. (Think of Emmanuelle Seigner trying on shirts in *Détective* or the *Dressed to Kill* reference in *Prénom: Carmen*, with two lovers struggling in the shower.) De Palma, on the other hand, would take a turn into the ghetto of "body" genres, confronting the issue of pornography with something approaching honesty, and it is De Palma, not Godard, who has consistently returned to themes that require the mobilization – and the theoretical exploration – of sexual violence. In any event, the issue of sexual violence remains unresolved in both Godard and De Palma; I can only claim that this is a *productive* instability.

Cinema of Failed Revolt

Militancy evaporates for a variety of reasons, and exhaustion is only a symptom, not a cause.

(Brownmiller 1999, 326)

The harvest is past, the summer is ended, and we are not saved.

(Jeremiah 8:20[22])

[21] Compare to Jodie Foster in *The Accused*, whose performance registers specificity rather than universality. Murray Smith, in "The Logic and Legacy of Brechtianism" (Bordwell and Carroll 1996, 139–145), turns to Foster's performance here as an example of non-Brechtian signification, and he is correct about that.

[22] Appears as the epigram to Chapter 8, "Conclusion: The Future of Socialism," in Clecak (1973, 273).

What, then, was De Palma's "primal scene," the traumatic moment that breaks his career into a "before" and an "after"? This would undoubtedly be his Warner Bros. experience. At some point in 1969, apparently before the premiere of *Hi, Mom!*, De Palma was invited to move to Los Angeles; he was to make his first major-studio film, with a real budget, a professional crew, and professional actors – namely, anti-establishment superstar Tommy Smothers, anti-establishment-It-girl-of-the-moment Katharine Ross, and über-failure Orson Welles. The script, by Jordan Crittenden, was called *Get to Know Your Rabbit*.

Warner Bros., like the other major studios in the wake of *Easy Rider*, was in the process of nearly bankrupting itself trying to appeal to the mysterious new youth audience. De Palma must have seemed a wise choice for the material; at the time he was hired, let us not forget, he was fond of making statements about the obscenity of the white middle class, and after *Easy Rider* (as Biskind explains) everyone in Hollywood was anxious to tap into a Zeitgeist that it had either dismissed (as in television's *Dragnet*) or imagined with condescension (as in Otto Preminger's *Skidoo*). Given De Palma's stated political sentiments (and the example of DeNiro in *Hi, Mom!*, reading in *The Urban Terrorist* about how to infiltrate the system), one imagines that De Palma chose to "go to Hollywood" in order to "subvert the system from within" – that is, to use the resources *of* the industry to make films *against* the industry. Perhaps De Palma even imagined that he would infiltrate the studio system and make revolutionary films within it – like a one-man sleeper cell. (Did De Palma have a private income at this time? The historical record is silent on this matter.) In any event, what is important is that De Palma was fired from the production either just before the end of shooting or shortly thereafter, and had no hand in the editing of the film;

the studio had the ending reshot and, still unsatisfied, put the completed film on the shelf, where it remained for three years. (It was finally released after *Sisters* had its festival debut in 1973.) Here is Biskind on the events:

> *Get to Know Your Rabbit* starred Tommy Smothers. It was alike in spirit to *Greetings*, another installment in the mini-cycle of dropout films that included *A Thousand Clowns* and *The Trip*, and seemed to suit De Palma's temperament. But the New Hollywood directors were not proving so easy for the studios to assimilate. Brian knew *Rabbit* wasn't working, wanted another week to shoot. Warners said, "You've had your time, forget it." De Palma wanted to innovate, use 16mm footage. Warners told him he was crazy. "We don't do things that way here."[…] "Brian De Palma was a monster," says [John] Calley. He threw him off the picture, and it was recut and released, just barely, in 1972. Says De Palma, "I always felt Warners had a certain kind of elitist arrogance to it that started with Calley and [Ted] Ashley – these guys were somewhere in the ether. They talked to Stanley Kubrick and Mike Nichols, and we were obviously not important."
>
> (Biskind 149–150)

Here is De Palma's narration of the events, from a 1975 interview with *Cinefantastique*:

CFQ:	*Warner Bros. originally planned the film as Tom Smothers's film debut?*
DE PALMA:	Yes, and that caused problems. He was not a great actor, and he had at the time some psychological problems dealing with his career. He thought the film would change his career around. When he became convinced that the film was going down, just like his career, he rode it right to the bottom. And with me on the plane.
CFQ:	*He didn't want it released at all?*
DE PALMA:	Yes. What was so lousy of him was that after promising me, siding with me on all the fights with the studio, in the end, when we wanted to reshoot some stuff, he refused. He said, "Anything you want to do, kid." He was unhappy with the film but he didn't have to lie to me. He said, "I'm going to fight for this, this is the way we're going to do it, it's a great ending, I love what you're doing with the film." Then he went in and stabbed me in the back. So the studio took it over. I will never forget talking to him on the phone and him telling me that.

(Bartholomew 29)

De Palma, by all accounts, spent the next three years in a brutal depression – a depression that might be said to resemble that which befell the New Left at about the same time. For De Palma, this series of events would prove to be pivotal: his expulsion from *Get to Know*

130

Your Rabbit is the traumatic moment at the core of De Palma's narrative, and everything that he does, every film he makes after this point – like French theory after *les événements du mai*, like the American Left after the Weathermen or Watergate – will in some way refer back to this moment as a defining failure, a primal scene that must be endlessly replayed and that forms the horizon of what it is possible to represent. It marks the line between the "before" and the "after." Like *les élections-trahisons* that split the French Left from the nation that was its putative object, it is the Great Betrayal.

Even – or especially – when viewed from a distance of thirty-five years, the first ten minutes of *Get to Know Your Rabbit* are vintage De Palma. The opening shot – Tommy Smothers, in frame left, talking with John Astin, frame right – turns out to be a split-screen, as the two characters (both corporate executives) finish their conversation and walk in opposite directions, their respective halves of the frame following them away from each other. The film thus opens on a brilliantly Godardian note: in the very first shot, the movie splits in half.

Shortly thereafter, Astin receives a telephone call from the "Project Coordinator" of "Up Against the Wall, Incorporated" (an amusing castration of Mark Rudd's taunt to Greyson Kirk, "Up Against the Wall, Motherfucker!"), who informs him that a bomb has been planted in the building; Astin, distracted by his executive time-wasting strategies, redirects the call to Smothers, his underling. Cut to Smothers' office: as his phone rings, a dreamy look appears in his eyes and a swell of choral music rises on the soundtrack; he stands up and marches out of the building in a long continuous tracking shot. He has chosen exactly this moment to drop out of the executive rat race. We return to the split-screen: Astin sitting at his chair in his office on one side, Smothers walking away from the office building on the other. A secretary runs after Smothers and repeats the message from Up Against the Wall, Incorporated: "sixty seconds and it's your corporate ass!" Smothers thanks her noncommittally and walks away; the bomb goes off.

The next shot, a long traveling shot, finds Smothers in bed with his girlfriend; he gets out of bed to answer the doorbell, and the camera tracks him through his long, mazelike apartment to the front door. In the first appearance of a stylistic trope that would reappear in *Blow Out*, *Carlito's Way* and *Snake Eyes* (not to mention *Taxi Driver*), the shot is taken from directly overhead, perpendicular to the floor – a camera angle of such brutal abstraction that it stops the movie dead. (Indeed, there is not a single identifiably De Palma gesture for the rest of the film, save for the appearance of Allen Garfield – the pornographer from *Greetings* and *Hi, Mom!* – as a boorish panty salesman.) Having "dropped out" of the rat race (and thereby having lost his girlfriend), Smothers begins taking tap-dancing-magician classes with a legendary tap-dancing magician, played (inevitably) by Orson Welles, and indeed he then *becomes* a tap-dancing magician, although not a very good one. Unfortunately, his former boss – John Astin, now out of a job – latches onto Smothers and, unbeknownst to him, begins to build a new corporation around him: a corporation designed to service corporate executives who want to drop out of the rat race and become tap-dancing magicians. This new corporation – TDM Corp., or Tap-Dancing Magician Corporation – is a success, and while Smothers is on the road in the Midwest, tap dancing and doing bad magic tricks (and

The opening shot of *Get To Know Your Rabbit.*

meeting Katharine Ross), Astin builds his former underling's new career into a multinational concern with its own office building and assembly-line production aesthetic. Here is De Palma on the film:

> My ending, that Warners would have nothing to do with, was that he tells John Astin he wants to go out on the road. And Astin says "You're going to play the big time – New York, LA, LA, Chicago…" Cut to the Johnny Carson show, and Smothers talking about how he's dropped out and his wonderful life. And there's an Abbie Hoffman type beside him who's just published *Eat the Establishment*. And he gets into a big argument with Smothers and accuses him of being a rip-off artist and that the TDM, the Tap Dancing Magician Corporation, is financed by banks and oil companies and he's just a whole new way of exploiting the counter-culture. And Smothers is hurt because he's really believed in what he's done. Astin comes on to sell TDM products, and Smothers finally realizes that he's being ripped off, being used to merchandise products. So he tells Johnny he wants to do a trick, the Great Sawing-The-Rabbit-In-Half trick. Now, on coast to coast TV, it looks like he saws the rabbit in half and fails. The rabbit is a bloody, horrible mess, and Smothers rushes off stage. The whole TDM collapses because he's done the worst thing in America you can do, he's maimed a warm furry animal on TV. He's ruined Astin again. But he is finally left to his own devices; he's free because no one wants him now. Katharine Ross comes up and says, "How could you do that? What happened?" And Smothers pulls out the rabbit and you realize it's been a trick. He has finally done a successful trick.
>
> <div align="right">(Bartholomew 30)</div>

Clearly this is De Palma's fantasy of something like "practical revolution": in this narrative, the hero successfully destroys a corporation and thereby liberates the counterculture from at least one of the forms by which it is rehabilitated and absorbed into the mainstream of capitalist production. Perhaps this is his image of what the effect of his version of *Get to Know Your Rabbit* would have been like: the film would have detonated in the minds of his audience, like the bloody rabbit on everybody's television screens, and they would have abandoned Hollywood – and perhaps even their bourgeois ideology itself – forever (at which point De Palma, presumably, would "get the girl" – whatever *that* condensation, when unpacked, might actually mean).

Now, it would be oversimplifying to suggest that Warners fired De Palma merely because of the ending. Accounts suggest that De Palma and Smothers fought on the set and that Smothers had De Palma removed, which would suggest a typical Hollywood clash of personalities and struggle for power; it is also possible – indeed, probable – that Warner Bros. was dissatisfied with the footage for other reasons. (It is hard to know what De Palma would have done differently, but as it stands, *Get to Know Your Rabbit* is a shapeless, unfunny mess.) In any event, what is fascinating is that, after firing De Palma, Warner Bros. shot a different ending in which Smothers realizes that he is powerless against the corporation, and in despair pulls one last magic trick: he literally disappears

in a puff of smoke, and the film ends. Thus at the end, the corporation is victorious, and Smothers' rebellion against it is thwarted before it is begun: he merely "drops out" in a repetition of the film's opening, inadvertently suggesting that the cycle of dropping-out and immediately finding oneself in a new cage to escape is just that, a *cycle* – perpetual and hopeless.

De Palma's own career after this point would uncannily mirror this studio-dictated ending. Since the traumatic events of 1970, De Palma had reversed his earlier faith in revolution and revolt: he now laments the 1960s as having been "sucked up" and "co-opted" by the establishment, and in interviews he invariably describes capitalism as an unstoppable monster against which it is essentially pointless to resist: "The history of radical movements in this country," De Palma told Marcia Pally in 1984, "has been that the media addresses itself to the minor issues because there's no way they can deal with the major ones" (Pally 16). "When I made *Greetings*," he said in 1980,

> I found myself on talk shows, talking about the revolution, and I realized I had become just another piece of software they could sell, like aspirin or deodorant. It didn't make any difference what I said. I was talking about the downfall of America. Who cares? In my experience, what happened to the revolution is that it got turned into a product, and that is the process of everything in America.
>
> (Vallely, in Knapp 2003, 68)

Certainly this point of view is understandable, albeit a little grandiose.[23] De Palma had done the unthinkable: he had let himself be *bought*, and once bought, he was expendable. Who had betrayed whom, exactly? Here is De Palma's description of what he learned from the experience:

> It was sort of interesting that Orson Welles was in [*Get to Know Your Rabbit*], because *there* was a man who never figured out how to make the studio system work *for* him. But part of making movies is being able to deal with that system, and the great directors have managed to deal with it, whether it's Ford or Hitchcock [...] They managed to work within the system and get their extraordinary visions *done*. You can't sort of say, "well, I'm an artist, they don't understand me" – that doesn't really make much sense. This is an *industry*, run by greedy men, and you've got to make them work *for* you. It's like – they talk about *The Magnificent Ambersons*, which is a magnificent movie, but it was destroyed. And where [are] the lost sections of *The Magnificent Ambersons*? Well, you

[23] Compare with Robert Kramer, director of *Ice* and *Milestones*, who in 1969 said of his work with the Newsreel collective: "Within the formats now popularized by the television documentary, you can lodge almost any material, no matter how implicitly explosive, with the confidence that it will neither haunt the subject population, nor push them to move – in the streets, in their communities, in their heads." (Foreman, part 2)

can sit and talk about all the reasons in the world – and I think about it *every day*, about my very little, very stupid movie, *Get to Know Your Rabbit*. But the fact is, it's *my* fault. I got maneuvered. I got outsmarted. And the same thing happened to Welles.

(Quoted in Lagier and Voslion 2003)

The appearance of Welles at this point in De Palma's story is overdetermined, to say the least. Given that the director of *Citizen Kane* (and, more to the point, *The Magnificent Ambersons*) was ubiquitous in this era, appearing in any commercial or film that was offered to him as long as it paid hard cash, it is pointless to speculate about how he himself might have experienced the shoot, or what he thought of De Palma (although De Palma has claimed that Welles was on his side, and – quite believably – that this did him no good at all). But the mere presence of Welles on a set meant that one was in the presence of a kind of sacred relic, righteous in his exile from his art, and his failure was exactly the kind of failure that De Palma probably expected to avoid. (Perhaps he regarded Welles as having been self-destructively naïve when he first went to Hollywood, although if so, he probably did not maintain this attitude toward Welles for long.) The figuration, in *Get to Know Your Rabbit*, of Welles as a kind of secret Timothy Leary for the tap-dancing-magician set might have the resonance of an in-joke – like Welles' appearance as a studio head in *The Muppet Movie* – if it were not for the fact that *Get to Know Your Rabbit* itself is, in a sense, only half there. De Palma, then, has his own *Magnificent Ambersons*; from his own standpoint, he suffers the same fate as this revered outcast – because, despite the literal presence of Welles himself, he failed (as they say) to anticipate the other guy's greed.

The moral of the story, then, is that one must work within the system – and therefore that one must, on some level, abandon one's ideals and embrace corruption. But what does that mean, operationally? After the debacle of *Get to Know Your Rabbit*, three years would pass before De Palma was able to make another film, which would turn out to be a return to independently financed and distributed cinema. It would also be, not at all by accident, the first of De Palma's Hitchcock pastiches since the apprentice-work of *Murder a la Mod*: a remake of *Psycho*, appropriately modified for this new post-future circumstance.

Why would Hitchcock appear here – at the end of a "long dark night of the soul," not only for De Palma but for all the historical agents discussed in this chapter? There is always the idea that one might turn to Hitchcock as a method of refusing to engage with social reality, as indeed Hitchcock might be said to have done throughout his American career. But like Godard in *Made in U.S.A.* (with its trenchcoat-Bogart frame wrapped around references to Dealey Plaza and the Ben Barka affair), De Palma here turns to genre in order to more properly – that is, more *popularly* – address the political. Naturally the director, in interviews, explains this choice in terms of his own technical improvement: he turned to Hitchcock in order to become a better filmmaker, to identify and correct his own deficiencies as a storyteller. At the same time, he is still thinking in Godardian terms: in a 1973 interview with Richard Rubenstein, for example, De Palma cites Brecht's theory of alienation as a source for his stylistic choices in *Sisters* (especially the television game show inside which the film

135

opens), and he specifically identifies the television coverage of Vietnam as an instance of the manipulation, by the mass media, of the voyeurism of the audience – a manipulation that De Palma understands to have a political effect, regardless of who (network television or De Palma himself) is doing the manipulating.

As should be evident from interviews across his career, De Palma is at least *capable* of abstract theorization regarding truth, truth-effects, and power. Of course there is always the argument that the generic parameters of this statement nullify any content that might normally be thought to be alien to it – that one cannot make generic form do philosophical or political work. But, given the circumstance of its creation, if one wants a definitive statement from De Palma about the impossibility of revolutionary practice and the "disappearing trick" that the establishment will always play with any threat to its coherence, one needs to look no farther than *Sisters*, which offers a step-by-step remake of *Psycho* with the notable substitution of an articulate, educated, upwardly mobile African-American man in the place of Janet Leigh, so that after the traumatic murder at the film's center, the rest of the narrative will hinge on the search for a missing and unnamed black body – a body that, in the end, continues to elude those who impotently search for it. And it is worth pointing out that De Palma's next film, *Phantom of the Paradise*, concerns an artist who unknowingly sells his soul to the devil and dies in the attempt to liberate himself from its clutches; in this scenario, the only way to defeat the Satanic force at the heart of the entertainment industry is literally to destroy it along with oneself.

Is it too much of a stretch to see *Sisters* and *Phantom of the Paradise* as twin allegories for De Palma's own experience in Hollywood? At the very least, the collapse of two registers is notable here. There is the specificity of De Palma's time at Warner Bros., in which De Palma – embodying, inconveniently, "the counterculture" – finds himself co-opted and then discarded by the corporate establishment; and there is the death of the New Left, which explodes in a townhouse in New York City at more or less the same moment and with which De Palma doubtlessly, at some level, identifies strongly (if ambivalently). For De Palma, one suspects, these two events are more or less the same; they form a single trauma to which De Palma will return – which he is doomed, in fact, to forever repeat. If we see *Sisters* and *Phantom of the Paradise* as essentially the same film – a single narrative, told from two completely different generic angles – then we would begin with the idea that both of these films are about both *Get to Know Your Rabbit* (and thereby, *avant la lettre*, about the collapse of the New Hollywood) as well as the collapse of the New Left.

First, how would we find the specificity of the *Rabbit* experience indexed in each film? Then, how would we find the narrative of the failed Left mapped onto that same narrative? In *Sisters*, the allegorical turn is obvious: Philip, the "black man" who is murdered a third of the way into the film, *is* De Palma's lost movie; at the end of the film, the dead body rests in a sofa – locked away somewhere secret (a sofa, a film vault), with only a single, silent, powerless witness to its existence. (The studio cut of *Get to Know Your Rabbit* finally appeared in a few theaters while *Sisters* was being shot.) The narrative surrounding the trajectory of this body then becomes an elaboration not of a *Psycho*-like whodunit – after all, De Palma is careful to

let us know, with a shot of two red pills tumbling down a sink drain, that Dominique and Danielle are, in some way, the same person – but of a disinterested investigative search for *proof*. No one cares about "the black guy," who after his death has no name: the cops don't believe the story or perhaps just don't care, no one comes looking for him, Danielle (conveniently) shows no remorse. Unlike Marion Crane, who has a sister and a lover, "the black guy" has no one to speak for him after his death, only a random witness, who tries to prove that the murder actually happened, but whom nobody believes anyway. Why does no one believe this witness? Because she is a Leftist.

When we play back the narrative again, we see this other frame printed neatly across the film as well: Philip, the perfectly assimilated minority, who has a good job, wears a suit and tie and talks white – that is to say, the embodiment of the Left dream of an integrated, raceless future, in which *love is color blind, man!* – dies in an explosion of violence and then disappears into a piece of furniture, and once he is gone, no one remembers him. Here, "the black guy" becomes the figure for the ideals of the Left: *Where did they go? What happened to us?* The search for proof leads nowhere: all the participants are trapped in a web of the quotidian and the accidental, and the truth simply dissipates (just as it does in the Warren Report), even as the body lies entombed in a sofa somewhere in Nova Scotia. Even more outrageously, one can play the mental game of imagining *Sisters* with the cast De Palma wanted to get but, for budgetary reasons, could not: the reporter would not have been Jennifer Salt, but Marlo Thomas, and the "black guy" would not have been Lisle Wilson, but Sidney Poitier (Rubenstein 8). Perhaps if Sidney Poitier were the one to disappear halfway through and, from that moment forward, to be referenced simply as "the black guy," and

if the film ended with Marlo Thomas shouting in frustration, "there was no body because there was no murder!", the nature of the allegory might have been clearer – and perhaps *Dressed to Kill* might, seven years later, have been understood differently.

Can we map a similar double allegory within and across *Phantom of the Paradise*? First, we find *Get to Know Your Rabbit* – the lost work of art, the stolen jewel – figured as "the Faust cantata," Winslow Leach's lost song cycle about (as he puts it) "an ancient German magician who sold his soul to the Devil." Winslow Leach does not sell his soul to the Devil; as would be appropriate in a capitalist scenario, he sells his soul to someone who has *already* sold his *own* soul to the Devil – that is, *a middleman*. In this case, the middleman is the rock entrepreneur Swan, a peerless showman who encourages the worst impulses of his audience and gleefully arranges for his new bride, Phoenix, to be assassinated on stage just for sheer entertainment value. Winslow, unfortunately, is not a showman, and has no street smarts. Instead, he is astoundingly naïve, as De Palma in 1974 might have imagined De Palma in 1970 to have been: after all, he signs the contract with Swan (in blood) *even after* his music has been stolen, his face maimed, and his voice destroyed. Unlike everybody around him, Winslow seems not to understand that integrity is a pointless exercise. Everything, all endeavor, will eventually slide into the machine of vulgarity that typifies the spectacle; Swan will eventually take his percentage, and if you sign the contract, maybe you will get your percentage of his percentage – unless, as he plans to do with Winslow's beloved Phoenix, he forces you to betray yourself before marrying you and then having you assassinated. Winslow, formerly (and still) naïve, becomes vengeful, overpowered by hate (like David Horowitz) for everything he once valued: he blows up or kills everyone who tries to play his music or sing his songs, except Phoenix, *because he is sentimental*. Once he witnesses her betrayal, Winslow hates himself and wants to die, but he cannot kill himself – he is under contract, and the contract only ends with Swan. And Swan cannot die – for he himself is under contract, and *his* contract only ends with the medium on which it is printed (i.e. two-inch analog video). If you burn the reels, maybe you can burn down the whole system – except if that happens you yourself, the artist, will die, a martyr for a cause that no one can, or will, understand or recognize. Thus the nihilistic abandon of the final sequence, in which the disfigured Winslow, fatally wounded but having successfully broken Swan's hold on this earthly plane, crawls miserably through a crowd of wildly dancing stoners and dies, still rejected, at Phoenix's feet.

This line of inquiry is probably more maudlin than De Palma himself would want, and in any event *Phantom of the Paradise* is, like *Hi, Mom!*, a comedy, not a suffering-artist tragedy like *Immortal Beloved*. (It is closer in spirit, in many ways, to the great Ken Russell musicals of the era – *Dance of the Seven Veils*, *The Music Lovers*, *The Boy Friend*, *Lisztomania*.) Let us turn to the political aspect of *Phantom*, which more or less coincides with its comedic aspect and which operates at dozens of levels – from the matching of this particular kind of songwriting to this particular film genre (like the coupling of acid rock to Expressionism) to the film's resigned disgust with the naïve attempt to maintain integrity in a world in which everything, even one's ideals, are for sale. Much of the film's political theorizing manifests

itself within the narrative in the form of film references: thus the *Manchurian Candidate* reference at the narrative's conclusion (very hip in 1974, given that Frankenheimer's film had been out of circulation for ten years and would remain so for a dozen more) couples the JFK assassination to Kent State while the orgiastic finale of Winslow's lonely death in the midst of a rock concert couples *Phantom of the Opera* to Altamont. (*Phantom of the Paradise*, given its collage structure and apocalyptic finish, is essentially *Woton's Wake*, De Palma's last student film, with a through-line and a political consciousness.) And we can see De Palma's post-*Rabbit* attitude about artists vs. the system in the grotesquely precious song that Winslow first sings for Swan at the film's opening – apparently intended to both embody and satirize the concept of artistic self-expression – which, naturally, metamorphoses into surf-rock banality with the Juicy Fruits and then goes through a series of permutations before arriving in its proper arrangement as an acid-rock funeral dirge. One can defeat one's enemies, but this will make no difference: failure and co-optation are inevitable anyway.

I propose that we can play this game with the rest of De Palma's career. With a careful glance backward to Chapter 1 and the "allegorical dimension" that (for Rothman, Jameson, and Žižek) is the mark of Hitchcock's conceptual self-reflexion, let us put forward the idea that every film that De Palma has made since *Get to Know Your Rabbit* indexes, more or less directly, this original trauma – what we might call the Rabbit–Left Betrayal – so that even films like *Wise Guys* are in some way films about the twinned monsters of global capitalism and Hollywood film practice. However, let us note that, in the wake of this betrayal, De Palma chooses to return over and over to a specific gesture – that is to say, the remaking of *Psycho* – as if it is the only proper way to express the methods by which power operates. In *Blow Out*, for example, *Psycho* appears as another film-within-the film (a gratuitous slasher flick that literalizes the feminist positioning of *Dressed to Kill* as an act of cinematic gynocide), but it also appears in *Blow Out*'s overarching narrative as a social ruse or lure, that lure being the use of "sex murder" as a cover for, and distraction from, crimes committed by the state. And *Psycho* appears, finally, as a dissonant combination of macabre comedy and super-alienated social critique, a tonal instability that marks *Psycho* as a masterpiece and *Blow Out* as illegible. Indeed, how can Film Studies approach *Blow Out*, and especially its notorious final shot, if it has not an adequate apparatus to discuss humor and, therefore, the notion of the *punch line*?[24]

In *Hi, Mom!*, De Palma (naively) theorizes that the radicalization of the voyeur is inevitable, a conclusion obviously drawn from the way that news footage from Vietnam helped to ignite a national opposition to the war. But by the time of *Sisters* and *Blow Out*, he has come to a very different conclusion: the voyeur may become radicalized, but

[24] I am not claiming that this punch line is *funny*, at least no more so than the ending of *Dr. Strangelove* – merely that, structurally speaking, the last shot functions, for the film as a whole, as the stinger at the end of an especially cruel and despairing shaggy-dog joke (structurally reverse-engineered from *Psycho*) about the three-way relationship between capitalism, gender, and narrative.

radicalization is always and only the first step on a path that leads inevitably to defeat. This is because the voyeur can never be a participant – which is precisely the reason that, as De Palma suggests, the state/culture complex finds it advantageous to keep its citizens addicted to images. In interviews, De Palma (like Gorin) has cited Godard's famous dictum that the cinema is the truth twenty-four times a second, and suggested the contrary – that the cinema can *only* be falsehood, no matter the frame rate. This is the thesis of *Blow Out* – and also the starting point for the argument about canonicity and the politics of taste that De Palma lays out in *Body Double*, as well as for his argument about the role of fantasy in wartime in *Redacted* (in which the social addiction to *images* has become an addiction to *imagemaking*).

Are we to believe, then, that "the Political" is only operative in De Palma when Hitchcock is mobilized? The answer is *no*, for what we understand as "the Political" shifts in relation to its object. We will spend more time on this subject in Chapter 3, but let us point out at this juncture that when De Palma finally "returns to Vietnam" – in the 1989 *Casualties of War* – he literally returns to the last scene of *Greetings*, in which Robert DeNiro attempts to triangulate something in between a rape and a fashion shoot using a Vietnamese woman and a documentary film crew as the props of his fantasy. All of *Casualties of War* transpires within this scene – a neat instance of conceptual kismet, given that the article upon which *Casualties of War* was based was published in the *New Yorker* over a year after *Greetings* was released.

It is no surprise, though, that when De Palma chooses to follow Coppola and Stone "back to Vietnam" – like all battlefields, The Land of Possible Oscar – he does so not through a "combat film," a noisy spectacular about war and battle, about Grand Human Themes like *man's inhumanity to man* or *the absurdity of war*, but something far more intimate: like a post-Woodstock *Paths of Glory*, *Casualties of War* is a specific, local narrative about very few characters with rape at its center, stripped of all of its metaphorical tendencies (this rape is not a *figure* for rape, *this is rape*) and framed as an *ethical* situation, a turning point, a moment of decision in which one man must take action, and fails to do so. At the same time, the main character's naivete could be characterized as a failure of film knowledge: not having seen all the Vietnam movies like *The Deer Hunter* or *Apocalypse Now* or *Platoon*, he does not realize that Our Boys Went Crazy Over There, that is that, according to a code of narrative that has something to do with American masculinity as well as something to do with audience expectations, the horrors of combat are to be attributed to the System, the "facts of war," rather than individual choices in the face of crisis. ("It's what armies *do*, man," one of the other soldiers says.) Thus in some way Private Eriksson's impossible crusade to bring the four participants in the rape to trial is a crusade against *clean institutional narratives*, like the narratives of the State as well as the narratives of Hollywood (as well as the narratives of the Left), that create legal and epistemological categories like "blame" and "responsibility" and "the individual" only to ignore those categories when it is convenient or seemingly necessary to do so. The choral upswell at the film's close – with its banal suggestion of redemption and hard-won inner peace – belies the fact that, for De Palma,

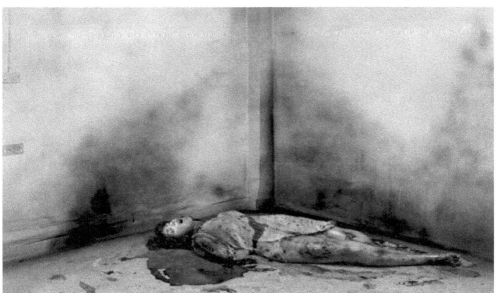

Always nameless, always dead: *Casualties of War, Redacted*

the main heritage of the 1960s is a sense of not having done enough, of having failed when the chips were down. There may be justice with effort, but we all know that the guilty will go free (and that no good deed, like Eriksson's, goes unpunished) and, in any event, there is still the body of the Vietnamese girl, rotting by the shore of the river Kwai – like the "black guy" in *Sisters*, she is always nameless, always dead.

It is with *Casualties of War* that De Palma's "turn to Hitchcock" finally makes sense as a *strategy*, for it is best understood as a remake of *Vertigo*. It, too, is a narrative of one man's failure – through indecision or handicap – to save a woman from death; the narrative

frame around the film's traumatic flashback to Vietnam – the entire film transpires within the memory of Private Eriksson as he rides the MUNI train on the day after Nixon's resignation – even allows De Palma to stage (in San Francisco!) the reappearance of the dead girl in the form of the same actress, who steps onto the train and, when stepping off, leaves *something personal* behind so that Eriksson, in his desperation to connect, can return it to her. (In a way, this is De Palma's most apologetic moment: the panties stolen by Craig Wasson in *Body Double* are returned here in the form of a scarf.) If *Obsession* represents De Palma's failure to "do" *Vertigo* – to reproduce not simply the plot mechanisms or the

The panties are returned in the form of a scarf.

look or sound of *Vertigo*, but rather the ineffable, timeless, vaguely surreal sense of tragedy that gives *Vertigo* its "masterpiece effect" – then it is *Casualties of War* that finally allows De Palma to stage a story of loss that can legitimately aspire to the high tragedy of Hitchcock's film, in which the death of a woman – again and always a *screen*, as in *Greetings* – indexes a much larger failure.

The narratives of the time we have been discussing – from Todd Gitlin and Fredric Jameson to *Bonnie and Clyde* and *Casualties of War* – are all tragic narratives. Perhaps it is inevitable that these narratives, having been composed in the shadow of perceived disappointments, end in death. And yet, as the famed "We blew it!" in *Easy Rider* and the climactic slaughter in *Bonnie and Clyde* make clear, the tragedy is – like the downfall of Macbeth – always-already foretold. The mobilization of tragedy as a dramatic form is also, as we will see in the next chapter, a matter of traumatic repetition: but this is merely another way in which Hitchcock, the great Lacanian of the cinematic enterprise, connects with these narratives. In a way, De Palma's turn to Hitchcock is simply another example of the global turn, by many of the primary agents of the Movement, toward a "Bad Master" after their crushing defeat. The 1970s was, in many ways, the decade of Bad Masters: Charles Manson, Werner Erhard, Reverend Jim Jones, and (in the case of David Horowitz) Ronald Reagan would all be examples of new sources of evil to whom many on the Left turned during the decade. (Richard Nixon, of course, was always-already the ultimate Bad Master – a shining pillar of evil, attachment to whom was simply inconceivable before his "shocking" re-election in 1972.) And *genre* was itself a sort of Bad Master: Ryan and Kellner would identify the return to genre as an incipiently reactionary – even fascist – gesture, in a rhetorical move dependent upon the idea that (for example) Robert Altman's "genre deconstructions" are inherently progressive, and this general idea – that movies that resemble older movies are implicitly of that older ideological order – informs the majority of Left writings about film throughout the 1970s and into the 1980s and beyond, when what Ryan and Kellner call "reactionary" would come to be called "postmodern." (And when the post-Mao Godard "does" genre, as in *Détective* or *Soigne Ta Droite*, the gesture is read as the hopeless, self-abnegating shrug of the disappointed progressive.)

Thus, by this logic, De Palma's turn to genre, like that of Spielberg or George Lucas, is exemplary of a shift away from the social attitudes of the "sexual revolution" generation and back toward a view of family structure and gender relations, in which transgressions – especially sexual ones – are punished in various ways, according to the demands of the genre. But the deep mistrust of family relations that typifies De Palma's output from *Sisters* to *The Black Dahlia* is surely indicative less of a conservative shift toward "the family" than a recognition – theorized out of Marcuse, or Godard, or Hitchcock, or merely personal experience – that the roots of both social and personal oppression are born in the family and, therefore, always return there.

De Palma, therefore, becomes not a "Hitchcockian" – the way that, say, M. Night Shyamalan has become "a Hitchcockian" – but, rather, takes on the *operation* of the Hitchcock machine as *un Godardiste*. De Palma's comments after the *Get to Know Your Rabbit* fiasco seem to indicate that he realized two important things: first, that he did not actually know quite as

much about filmmaking as he thought, which would explain his technological-scientific turn toward Hitchcockian grammar; and second, that if he wished to continue to work with a professional film crew in a professional environment, he could no longer simply short-circuit from point A (possession of camera and film) to point C (Godard) without going through point B (classical Hitchcockian technique). This, then, is the narrative/technical lesson of both *Sisters* and *Phantom of the Paradise*: anything that you imagine to be a purely oppositional tool – the position of newspaper reporter, a cantata of philosophical/religious songs, a Godardian tic – will, in being put to use, become technologies and therefore systems. To adopt the language of the New Left: all tools, once used, are instantly co-opted. Therefore, if one wishes to be a Godardian in Hollywood, one must adopt its technology. Or, to paraphrase Audre Lorde: the master's tools are the *only* tools that can destroy the master's house.

Why is it, then, that this "other" De Palma – not the thief and rapist evoked by Stephen Prince and *Ms. Magazine*, but the Godardian, political De Palma, the De Palma of "Be Black, Baby!" and *Redacted* – remains, to this day, more or less invisible? I propose two reasons. The first: might it be that De Palma in his specificity remains "invisible" to Film Studies precisely because, in maintaining a Godardian orientation toward the Hitchcockian object, he occupies *the exact same subject-position* as the discipline itself? The second: if Film Studies as we know it today was originally born from an *auteurist* project, a project that melted into French theory at approximately the same time as the collapse and failure of the New Hollywood, and if the discipline has recently (and not for the first time) claimed to have reinvented itself after what has been perceived as a long stretch in the wilderness, then could we not say that this desperate attempt to reinvent Film Studies is doomed to be endlessly repeated – precisely because the discipline, like De Palma, is still defined by its paradoxical sense not only that it has *failed* in some way, and not only that this failure was *inevitable*, but that the discipline *has only itself to blame*?

Chapter 3

The Personal and The Political

Blow Out was greeted by a snarling press, ready to pounce. They attacked the film's violence, the putting-one's-wife-in-lingerie routine, and, worst of all, the stealing from the Great Directors. Not even Pauline Kael's usual praise (she compared Travolta to a young Brando and called the film "hallucinatory, a great movie") could soothe Hollywood's rumpled nerves. They were convinced: Brian De Palma was *mad*. *Saturday Night Live* summarized the *Blow Out* backlash in a "commercial" for a Hitchcock-esque (De Palma-esque) film entitled *The Clams* (*The Birds*) by announcing at the close: "Once a year Brian De Palma picks the bones of a dead director and gives his wife a job." "No one would answer my phone calls after *Blow Out*," recalls De Palma. "It was a very bad time."

Bad for his marriage as well. All the negative press, according to mutual friends (Nancy Allen will not comment), helped to ruin the De Palma's marriage. A woman he dated before Allen has her own thoughts about the matter: "How would you like to be married to someone who keeps a book of Nazi atrocities next to his pillow?"

<div style="text-align: right">(Hirschberg 88–89)</div>

Bad Objects

Peter Biskind's *Easy Riders, Raging Bulls: How the Sex-Drugs-and-Rock-and-Roll Generation Saved Hollywood* is, as we have seen, symptomatic in a number of ways. From the vantage point of the late 1990s – an historical moment at which the sainted Hal Ashby was long dead, Scorsese had painfully reinvented himself, and Spielberg had finally won his Oscar – it aims to tell a certain kind of story about a well-defined group of directors, in a kind of easy-to-digest connect-the-dots between (say) Robert Philip Kolker's humanist auteurism and the type of biting industrial history typified by Jon Lewis's *Whom God Chooses to Destroy: Francis Coppola and the New Hollywood*. (Biskind's anecdotal, cumulative year-by-year form is clearly borrowed, not without good judgment, from Otto Friedrich's classic *City of Nets*.) The story it tells is unbearably sad, especially for anyone who has ever dreamed of making a film. Unsurprisingly, the dice are loaded against the filmmakers from the start, and – like the narratives discussed in the last chapter – this story ends with death, specifically that of Hal Ashby, who comes in this moment to embody a range of destroyed dreams and unfulfilled potential, sacrificed on the transnational altar that, since *Star Wars*, has defined Hollywood. The book ends with a shooting star in the night sky over Los Angeles – perhaps Ashby's ghost passing by – that, unnervingly, bears more than

a little structural resemblance to Spielberg's signature wink, an effects-generated shooting star for the viewer to wish on.

The main characters in this drama are familiar by now; indeed, the cast is canonical, and almost every character gets his (and sometimes her) moment in the spotlight – or under the microscope. There is Spielberg, and there is Scorsese, and there is Lucas, and there is Coppola; there are Altman and Penn and Ashby, all of whom are from a slightly earlier generation (a generation from which, puzzlingly, the *über*-tragic Sam Peckinpah seems to have been omitted as a name of importance). There are the screenwriters or actors – Schrader, Towne, Beatty, Milius, Nicholson – who crawled their way up the ladder to the post of director, and there are the directors – Bogdanovich, Rafelson, Friedkin – who simply flamed out and were left in the dust. (Kubrick, unseen, hovers above and behind Biskind's narrative like God above the *New Testament*.) And then there is De Palma, who, for reasons about which we have in general speculated, assumes a position of lesser importance than all of these men (and, indeed, than most of their wives and mistresses) to Biskind's narrative as a whole – even though his name is always associated with a short list of five directors (Scorsese, Spielberg, Lucas, Coppola, De Palma) who constituted what history would call, for a very specific and obvious reason, *the film-school generation*.

We should pay attention to this fact. Biskind, like many others who have written about these men, lists the pedigrees: Coppola was a UCLA grad, Lucas went to USC, Scorsese to NYU, De Palma to Columbia – this writer's own film-school alma mater. (Amazingly, Spielberg could not get into any of the Big Four and instead decided to drop out of CSU at Long Beach; he was directing television by the age of nineteen.) The aesthetic practice inculcated at the Big Four film schools in the mid-to-late 1960s was predominantly influenced by a pair of (only apparently contradictory) strands of thought: first, the old-school idea that "personal" filmmakers from Europe like Bergman, Antonioni, Fellini, et al. were the model to emulate, and, perhaps opposing that, the nascent *Cahiers*-Sarris version of authorship, which stressed Hollywood industrial filmmaking as the site of struggle, potential, and achievement. Orson Welles would be a particular point of identification for both of these aesthetics, and thus both could be said to privilege a certain Romantic myth about filmmakers and the industrial practices in which they work.

The careers of all of these directors – except for Spielberg – are clearly marked by these concepts of film history and assumptions about industrial filmmaking practice. How else would one define "limit films" such as *New York, New York* or *One from the Heart* than as the inevitable miscegenation of these two strands of thinking, the European-personal-artistic model and the Sarrisian-rebellion-against-constraints model? How else would one read the attempt – in Coppola, in Lucas – to escape the limits of the industry by setting up their own production facilities and means of distribution, or the decision – in De Palma, after *Mission to Mars* – to abandon America altogether? One sees in the work of all of these directors (again, except for Spielberg) a certain *a priori* attitude about what cinema is supposed to accomplish, and – after the Encounter with Failure – the unbearable pressure and subsequent allegorization of a certain *a posteriori* knowledge about How Hollywood Really Works.

This perhaps accounts for the appearance of the failure motif we have been discussing across the entire breadth of the production of the New Hollywood – except, yet again, for Spielberg. Like Welles, but unlike (for example) Alan Pakula or Arthur Penn, the film school generation approached the system in a certain way, with a certain set of impossible desires, and this conceptual goal – the proverbial "storming of the gates" – was, as Hayden White says of Utopian thinking in general, ultimately illusory.[1]

We have spoken of the "allegorical aspect" of De Palma's filmmaking – the extent to which each of De Palma's movies is "about Hollywood." One sees this same dimension at work in an easily recognizable way in George Lucas, of course, but it is particularly evident in Coppola: one can easily argue – and others, like Jon Lewis, have argued – that films like *Apocalypse Now*, *Rumble Fish*, *Tucker*, and even the miserable *Jack* are about Coppola's experience as a filmmaker attempting, and failing, to use the system to make his *own* movies. (Spielberg, by contrast, always lacks this allegorical dimension, since his goals and the machinery of the system are fundamentally not in conflict.) Even the film that one might say is the terminal point of Coppola's authorship – *Apocalypse Now* – is shot through with this notion of failure: from the helplessly impotent ambiguity of the film's ending to Coppola's own cameo appearance as a documentary filmmaker exhorting the troops to pretend that the camera is not there, *Apocalypse Now* achieves its "masterpiece effect" precisely through the tension between Coppola's desire (like De Palma's in *Blow Out* or Scorsese's in *The King of Comedy*) to *say it all*, to create the ultimate personal film document, and the inevitability of this failure, which – as Coppola inadvertently confirmed when he told a Cannes press conference that "this film *is* Vietnam" – maps precisely onto America's own failure of confidence in the wake of the collapse of the 1960s.

This overwhelming sense of failure is Biskind's main theme; every character is obsessed with its possibility, and Biskind strongly implies that this fear of failure is precisely the drive that created the necessary conditions for that failure. But since they – and we – operated, and continue to operate, under the *Cahiers* model of film study, we can see that there are two kinds of failure: honorable (*Pauline Kael loved my movie, but it tanked at the box office*) and dishonorable (*my film sucked*, or *they took my film away from me and recut it*, or *I never got the green light in the first place and now here I am, serving veggie burgers in the Paramount commissary*). It is understood that the artist's vision is what matters, and that the studio system in which these directors worked was, and remains, an impediment rather than a tool or a horizon of possibility. Therefore questions of failure and questions of blame are both inevitable and determinant. *Apocalypse Now* still retains its "masterpiece effect" – even now, after the disastrous intervention of the "Redux" cut that Coppola premiered at Cannes in 2001 – despite the fact that Coppola himself, more than any of the

[1] "The fact of humanity's failure everywhere to finally redeem itself from the condition of sociality argues more for the delusory nature of this desire and for an accommodation to that condition, after the manner of Freud's argument in *Civilization and Its Discontents*, rather than for continued efforts to achieve what, in the nature of things, seems impossible." In "Getting Out of History" (White 143).

other members of the "film school generation," is usually regarded as the greatest failure of the bunch. Evidence would suggest, of course, that – strictly in terms of blockbuster success and the ability to ruin one's career that accompanies it – De Palma is the greatest failure, since (as he himself has pointed out in dozens of interviews) he has never had a blockbuster success, and therefore has never been able to throw a gigantic amount of studio money into one of his "own" projects. (There is always *Mission: Impossible*, but the received wisdom assigns that film's success to the presence of Tom Cruise: it would have made a zillion dollars and spawned a franchise, it is imagined, whether it was directed by De Palma or by Stan Brakhage.) Indeed, the best indication of the real fortunes of these directors is charting those moments when they have had to hire themselves out; unlike Spielberg or Lucas or (to a lesser degree) Scorsese, both Coppola and De Palma have spent most of the last twenty-five years signing on for paycheck-generating movies that, once upon a time, neither would have ever dreamed of making.

In this regard, the easiest critical distinction to make, when dealing with De Palma, is deciding which movies are *good*, and which are *bad*. (This distinction is not so easy with Coppola, for example.) Even in the age of IMDB chatrooms and the internet-related proliferation of fan discourse – and the subsequent collapse of the film scholar's lock on evaluative authority – there is little disagreement amongst De Palma's fans about which of De Palma's films are outright failures: they are *Get to Know Your Rabbit* (1970), *Obsession* (1976), *Wise Guys* (1986), *The Bonfire of the Vanities* (1991), *Mission to Mars* (2000), and perhaps *The Black Dahlia* (2006). (Each, of course, does have its partisans.) The first thing to note about all of these projects is that De Palma, in each instance, was a director for hire; he neither originated the project nor wrote the script. This is not to say that De Palma is incapable of writing a bad movie; there are many committed De Palma fans who dislike *Snake Eyes*, for example, although in the unavailability of the film in its original form – that is, with the infamous studio-excised "tsunami ending" intact – it is difficult to make a real determination. There are also fans who automatically dismiss *The Untouchables* or *Mission: Impossible* out of hand simply because they are not "real De Palma movies," even though the latter is a spectacular technical achievement and the former a gorgeous, perfectly crafted homage to Sergio Leone and Anthony Mann[2] (and to Robert DeNiro's entire post-*Hi, Mom!* career). Essentially, as with any director who writes some of his own movies as well as directing other producers' projects, De Palma fans who have encountered auteurism in any of its varied forms (from undiluted to Ebertized) tend to divide the system they call "De Palma" into "personal" filmmaking and "commercial" filmmaking. (Witness the similar application of this mode of thinking to Coppola in the 1980s and 1990s, for example.)

The second thing to note about the string of movies mentioned earlier is that they all follow financial failures – that is, they are all "recovery projects." *Get to Know Your Rabbit* followed *Hi, Mom!*, while *Obsession* came after *Phantom of the Paradise* – clearly

[2] Mann also appears in the form of *Femme Fatale*'s supremely illogical dream structure, clearly borrowed from *Strange Impersonation* (1946).

a "personal" film for De Palma that did badly at the box office. Similarly, the unfortunate *Wise Guys* came after *Body Double* – itself the latest, at that point, in a string of financial and critical failures that followed on the heels of *Dressed to Kill* – and seems at first glance to represent a drastic retreat from the provocation of its predecessor; it is, along with *The Bonfire of the Vanities*, the least enjoyable of De Palma's films, at least partially because the genre of humor that the picture putatively represents – that is, hectic farce with simpleton protagonist(s) – would not seem suited to De Palma's operatic style or evident thematic concerns. *The Bonfire of the Vanities* followed after the monumental professional defeat of *Casualties of War*, a film which represented – after *The Untouchables*, a major box-office success – De Palma's chance to make a large-scale, Oscar-worthy personal film about America, something that would reverse the damage done to his career by the *Blow Out/Scarface/Body Double* string earlier in the decade. The public indifference to *Casualties of War* was outdone by the gleeful media-fueled rejection of *Bonfire*, which – partially due to its huge budget, bestselling source novel, and high-wattage cast – went down in the most damaging possible way to De Palma's career ("like watching a World Trade Center tower topple onto Wall Street," as Kirkus Reviews rather unfortunately put it in 1991). And *Mission to Mars* followed upon the failure of *Snake Eyes*, which was – like *Casualties of War*, like *Blow Out*, like *Phantom of the Paradise* – an attempt to "say it all," to distill a worldview into a single coherent statement. While *Mission to Mars* has its moments, this attempt to make a statement about scientific and spiritual transcendence and the insignificance of the "human scale" within the Hollywood space-thriller format was probably doomed to failure long before De Palma came aboard.

The third point to note is that each of these four failures was followed by a significant artistic (if not necessarily financial) rebound: *Carrie* followed upon *Obsession*, *The Untouchables* upon *Wise Guys*, *Raising Cain* upon *The Bonfire of the Vanities*, the French-financed meta-trifle *Femme Fatale* after *Mission to Mars*. One bounces back from failure, whether that failure be *The Bonfire of the Vanities* or the collapse of the utopian project of the New Left. However, according to the psychoanalytic paradigm, one's actions always echo or repeat the past; failure or defeat or trauma are the kinds of wounds that one reopens compulsively, either with or without strict intention. One is always theorizing one's failure, just as one is always fantasizing one's primal trauma: either one realizes it or not, but failure or trauma always constitutes a horizon, the other side of which is blank, unknowable, the object of infinite speculation. In other words: we reenact things. This is true at various levels, from the public and the seen (such as the Ant Farm's 1977 performance-art repetition of the JFK assassination at Dealey Plaza) to the personal and unseen (such as wiring a potential witness for sound transmission even though one has already caused one person's death that way). Of course one theorizes and repeats one's successes, too: think of Spielberg or Lucas. But repetition is what typifies so many things central to our narrative – the repetition of revolution, the repetition of failure, the repetition of Hitchcock – and what matters is that, when one is dealing with trauma, the *compulsion to repeat* and the *compulsion to fail* are indistinguishable.

Here, one would cite Freud's idea – first outlined in "Remembering, Repeating, and Working Through" and treated most fully in *Beyond the Pleasure Principle* – of the compulsion to repeat as a kind of unconscious ego strategy for delaying or masking repressed trauma, since American film in the period after *Star Wars* is commonly understood to be typified by a kind of intense, almost adolescent repression across several different registers, from the sexual to the political, as well as by a concomitant generic "return" which inevitably fails in its attempt to paper over or bridge this primal wound. But in order to properly address the theme of repetition in the context of De Palma, we will need another theoretical tool that allows us to mobilize a film's *entire* context, including the psychobiographical element – that is, the phantasmatic auteurist object that we might call "the life-experience of the director" – without losing an element of agency, the Sartrean *subject who chooses*, and while avoiding the intense speculative psychoanalysis that typifies texts such as Robert Samuels's *Hitchcock's Bi-Textuality* or Rothman's *The Murderous Gaze*.

There is a Lacanian idea that will be useful for placing De Palma in this regard, and as so often in Lacan, it is a process that is described in a single word, a condensation or complex pun that, in the original French, takes several homophones and homonyms and reduces their possibly arbitrary family resemblances into a single unit. In this case, the word is *père-version*, and its condensation of *père* and *version* – not to mention *perversion* – offers a spectacularly suggestive way of imagining how a certain stage in personality development (rebelling against the authority of the Father) might repeat itself in social acts (rebelling against the authority of the social Master). In this scenario, the subject in rebellion does the unthinkable: he or she destroys the rule of the Father by, paradoxically, following the Father's rules *absolutely to the letter*, by obeying the Father's minutest directions to such an absurd and literal degree that an object or result is produced that is precisely the opposite of its putative intention. This is a perverse act, and it is understood as the sign of a perverse structure: the subject calls to the Father and forces him "out into the open," that is forces him to uphold the paternal function. Without this gesture, the Father does not exist; he is called into being when the subject offers a *version* of the *père*, and the result is *perverse*: the gift of gold is a gift of shit. The subject points at the flaming wreckage and, trying not to gloat in triumph, deadpans: "but this is what you TOLD me to do!"

This scenario, to be sure, describes a *particular* kind of process. We are all familiar with it from our own childhoods, and we have encountered it in our friends and colleagues as well as in the culture we each choose to consume. In relation to De Palma, we can see it operating consistently in almost every film from *Sisters* onwards, and an argument could doubtlessly be made that even the pre-*Rabbit* De Palma was typified by exactly this kind of strategic response to institutional demands. It is in relation to three films in particular, however, that the idea of *père-version* is most fruitfully mobilized: three films that came out in a row and which appear, with the benefit of hindsight, to constitute a single continuous thought.

Here is the narrative again: in 1980, Brian De Palma released a movie called *Dressed to Kill*. Outrage, as they say, was provoked. As we have seen, the most ferocious and coherent (and political) of the attacks were clustered around two issues – De Palma's "theft" from

Hitchcock, and De Palma's pornographic animus against the female body. By the time of *Body Double* in 1984, these two issues were mutually imbricated at almost every level of discourse, so that one could not discuss one without discussing the other, but at the time of *Dressed to Kill* there was Sarris on the one hand and the National Organization of Women on the other (with Reagan on the horizon). In 1980, were feminists concerned with issues of authorship and theft, or Sarris with issues of misogyny, other than as further evidence of De Palma's capacity for callous disrespect? In any event, it is clear that De Palma paid attention to these accusations, as they reverberate through a set of films that I will call De Palma's "porn trilogy": *Blow Out* in 1981, *Scarface* in 1983, and *Body Double* in 1984. Each one of these films, I would maintain, is about its predecessor and the public reaction to it: *Blow Out* is "about" the feminist and auteurist reactions to *Dressed to Kill*, *Scarface* is "about" the critical and financial rejection of *Blow Out*, and *Body Double* is "about" the condemnation De Palma received from the public and the industry for *Scarface*. All three films are about failure, and all three films *were* failures (in terms of both box-office performance and immediate critical reception). And each of these films constitutes a kind of *père-verse* response to an imagined directive: *You want an X? I'll give you an X!* or *You want racism? I'll give you racism!* or *You want a Hitchcock ripoff? I'll give you a Hitchcock ripoff!* or *You want the truth about how the oppression of women is mobilized as a lure under the regime of image capitalism? I'll give you the truth about how the oppression of women is mobilized as a lure under the regime of image capitalism!*[3]

In the two decades since their release, *Blow Out* and *Scarface* have been recuperated as "classics" by the mainstream of film taste: *Blow Out* has its Criterion spine number and its Tarantino endorsement (even though one suspects that Tarantino has no idea what the film is really about), and then there is *Scarface*, with its extraordinary second life as a – or even *the* – foundational film text for dozens of minority cultures in the United States and abroad. (*Body Double* has not been recuperated yet, but doubtlessly its time is coming.) It will probably come as no surprise to any reader who has come this far that I will claim them to be the three central American films of the Reagan era, nor will it surprise anyone that I will claim that these films, because of the tangle of cultural forces outlined in the previous chapters, have failed to receive the kind of attention from several different discourses (popular and academic) that, properly observed, they would or could generate. As we have seen, each is best understood as a certain kind of *strategic response to institutional demands*: that is, De Palma delivers a "gift of shit" to a certain force or set of forces – however those forces are theorized, and however they are addressed. But in order to track De Palma's application of the interpersonal technology that we are calling *père-version*, we will need to turn to our own bad object: the problem of biography.

[3] "As soon as I get some dignity from *Scarface* I'm going to go out and make an X-rated suspense porn picture […] I'm sick of being censored. *Dressed to Kill* was going to get an X rating and I had to cut a lot. So if they want an X, they'll get a real X. They wanna see suspense, they wanna see terror, they wanna see SEX – I'm the person for the job" (Hirschberg, in Knapp, 90–91).

So far in our inquiry, we have tried to evade (as much as possible) what we might call "the psychobiographical impulse" – the attempt to help De Palma's movies "create meaning" for us (on behalf, of course, of others) by drawing parallels between their narrative content and the "deep" psychological content of De Palma's inner life, particularly the influence of his childhood. On the one hand, we know from Barthes and Foucault that once a text leaves the hands of its individual or collective "author," it becomes the property (so to speak) of all others who encounter it, so that any "intent" – or personal referentiality – that an author may have mobilized during production is obviated by the multiplicity of meanings the text generates in its independence. (From that moment forward, no text has an author, but every text has an author-function: that is to say, the reader produces "the author" as an effect of reading.) On the other hand, we know from psychoanalysis that an author's own ideas about his or her production are not necessarily to be trusted in the first place: the truth of a person or collective is never available to that person or collective, is indeed structurally "extimate" to his or her or its self-apprehension. But in spite of these deterrents, let us go ahead and ask the question: what would be gained by introducing a certain biographical/historical element to our thesis?

Here is that element, according to the public record.[4] De Palma (Brian Russell) was born in Newark, New Jersey, on September 11th, 1940. (The reader will note that De Palma is not, strictly speaking, a boomer.) He was the youngest of three: his oldest brother, Bruce De Palma, went on to become a notorious physicist (while in self-imposed exile in New Zealand, he invented a perpetual-energy machine), while the middle brother, Bart De Palma, became a painter. When Brian was five, his family moved to Philadelphia. His father, a surgeon, was apparently a cold and distant man with a reputation as a philanderer (he apparently had several affairs during his marriage, and after his divorce married his suture nurse); it has been reported that after he returned from his stint as a combat surgeon during World War II, Dr. De Palma began to take young Brian to work with him – the child would sit in the observation theater and watch his father operate on patients. Brian's mother, a failed opera singer, was apparently a depressive, a narcissist, a dramatic sufferer who doted on her oldest child and completely ignored young Brian. (Both parents were Italian Catholics, although Brian attended a Quaker school until he was eighteen.) Years later, after he and his wife were divorced, Dr. De Palma would apparently write a novel, the only one he ever wrote – the unpublished thriller *The Anatomist*, which concerns "a brilliant doctor who becomes a murderer to satisfy his necrophiliac sexual urges" (Salomon 41).

By the time Brian was in high school, he showed exceptional intelligence and promise in science classes (he won second place in the National Science Fair with his project, "The Application of Cybernetics to the Solution of Differential Equations," by building a computer

[4] The following paragraphs are drawn from a range of sources. Primary among them is the discussion in Julie Salomon's *The Devil's Candy* (1992, 39–44), which draws a nightmarish portrait of De Palma's childhood. There is more in Lawrence F. Knapp's interview anthology, and specks of detail in Biskind's *Easy Riders, Raging Bulls* and Susan Dworkin's *Double De Palma* (1984).

in his bedroom) – but of course his oldest brother Bruce was by all accounts even more brilliant, and Brian's parents dismissed Brian's efforts as mere showmanship. Nonetheless Brian filled his life with technology, especially recording technologies – cameras, tape recorders, and so forth. (He is said to have been caught tape-recording the activities in a girls' locker room at school.) After his mother attempted suicide during the spring break of his senior year in high school, De Palma became obsessed with the idea of capturing one of his father's infidelities on film, so that he could win his mother a divorce and gain stature in her eyes; to this end he tapped his father's phone line, climbed trees in black Ninja gear and took pictures of his father through a fourth-story office window, and – after purchasing a 22-caliber rifle, presumably in order *actually to kill his father* – finally confronted him in the hospital late one night, a camera in one hand and a knife in the other. (He found his father's suture nurse cowering in a slip.) Brian did indeed manage to win his mother a divorce, but this came at some cost: the family exploded, and it is hinted that Brian never spoke to his father again.

In 1958 De Palma enrolled at Columbia University, where he intended to major in physics and technology; however, it was that fall that Brian saw Hitchcock's *Vertigo* in its first run and abandoned science for filmmaking. It was also that fall in New York City that he got drunk one night after his girlfriend dumped him and stole someone's motorcycle; after a brief chase, he was shot in the leg by an NYC policeman and spent the night in jail, making him the only ranking American director ever to have been shot by a cop. (His mother and his eldest brother bailed him out, and he got a stern reprimand rather than a prison sentence from the judge.) Over the next few years, De Palma got involved with theater at Columbia and began experimenting with super-8 and 16mm filmmaking; his third short, *Woton's Wake*, won the 1962 Rosenthal Award from the precursor to SCMS (Pauline Kael was the chair of the jury that year). Subsequently, De Palma attended Sarah Lawrence College on a graduate writing fellowship; he made *The Wedding Party* while enrolled there in 1964. After *The Wedding Party*, De Palma spent his mid-twenties involved in the East Village beat and theater scenes; for cash, he shot various industrial films, including the aforementioned back-to-back assignments working for the National Association for the Advancement of Colored People and the United States Treasury Department.

De Palma taught at NYU in the mid-to-late 1960s (while he was editing *Greetings* in an editing stall there, Martin Scorsese was in the next stall editing *Who's That Knocking at My Door?*), and after making five feature films he left NYU for Los Angeles in 1970, where he met Steven Spielberg, Paul Schrader, John Milius, George Lucas, and all the rest of them, and where he met the doom that awaited him on *Get to Know Your Rabbit*. He and Spielberg became best friends (Biskind obliquely suggests that De Palma arranged for Spielberg to lose his virginity), and De Palma eventually became godfather to Spielberg's first son, Max; there is also the suggestion (especially in Biskind) that De Palma was also Scorsese's closest friend, and that Scorsese "dropped" De Palma once De Palma was no longer of use to him. We have already rehearsed the rest of De Palma's professional trajectory; to fill in the personal details, we note that De Palma was married and divorced three times – to actress

Nancy Allen, whom he married (in an ominous choice of locale) on the set of Spielberg's *1941*; to producer Gale Ann Hurd, formerly wedded to James Cameron; and to one Darnell Gregorio. He has two daughters.

This, then, is the sort of narrative that Biskind introduces about each of his primary characters, such as Scorsese, whose sickly childhood and shattered marriages get at least a dozen pages of coverage, or Hal Ashby, whose odyssey becomes the book's central through-line. De Palma's biography therein, by contrast, is salutary in the extreme: we know he had sex with Margot Kidder in a closet during an industry party, and we know that

> De Palma had a sarcastic wit and a positive genius for saying the wrong thing at the wrong time. He invariably antagonized people who didn't know him, but his friends were amused. He had been so traumatized by the *Get to Know Your Rabbit* debacle, it took him a while to shake the experience.
>
> (Biskind 232)

The general pitfalls of the psychobiographical impulse are obvious in *Easy Riders, Raging Bulls*, even though this impulse is not applied to De Palma (he is not important enough to psychoanalyze), and they are just as obvious in those journalistic accounts of De Palma's filmmaking (from the sympathetic, such as Julie Salomon's *The Devil's Candy*, to the hostile, such as Zina Klapper's article in *Ms. Magazine* or the passage about De Palma's divorce that heads this chapter) that *do* mobilize De Palma's biography to help "explain" his films. On the one hand, these narratives often have the effect – not unreasonably – of casting the director as a personality in the grip of his childhood, unconsciously returning to certain events (think of Hitchcock's jailhouse experience, or the Schrader brothers' psychosexually abusive upbringing) without the benefit of reflection or experience to help them understand what they are doing: thus De Palma has an "operatic" style because his mother was an opera singer, and De Palma is "cold" because his father was a surgeon. Again, this is a question of *agency*: the mobilization of the psychobiographical narrative tends to trap the director in a synchronous state of development, and the implicit Sartrean message – if it can be expressed psychoanalytically – is that the artist must, like the Lacanian analysand, *choose his trauma*. (After Nixon's re-election, this was the choice that faced an entire generation of American activists.) On the other hand, the biographical impulse tends to obscure the economic or industrial element to any of these stories: *Vertigo*, after all, did not spring undiluted out of Hitchcock's murky unconscious, but instead came through its production stamped by compromise (the primary one being the substitution of Kim Novak for Vera Miles) and by the contributions of other industry professionals at various registers (from performance and physiognomy to design and lighting to music, editing, color timing, and so on – not forgetting, of course, whatever Alma may have contributed). The important question is really this one: if introducing a certain kind of element into a piece of criticism automatically means a certain kind of strategic alliance (with feminism, with auteurism, with one theorist or another, one version of film history or another, one political orientation or another), then

should we be considering the end, or the means? What information do we require that is not available without reference to this material? What readings will become available to us, and which will become foreclosed?

By way of answer, let us first ask the traditional critical question and then see what answers pop out. To wit: can we see in De Palma's films reflections, at the narrative level, of the family situation that formed him? First, there is the extraordinary – and paradoxical – hostility to doctors and scientists that appears in various levels of intensity throughout his career. There is the surveillance-voyeurism-technology theme, which has been exhaustively analyzed – although always in terms of formal and/or paranoiac issues, and seldom to any great depth – in dozens of writings about De Palma, such as that of Laurent Bouzereau. There is the occasional direct reference to his late (and intensely envied) older brother Bruce, the crazy physicist, who had a large strawberry birthmark over his right eye (like the creepy, horny psychiatrist in *Sisters*) and who believed that Mars had once been the home of an advanced civilization (as the principals in the uncharacteristically solemn *Mission to Mars* would discover). We could also state that perhaps there is some significance – however we might define or explicate it – in the choice to set *Blow Out* in Philadelphia, where De Palma grew up, or in the choice to make *Wise Guys*, which is set at least partially amongst Italian Catholics in Newark. We might also spend some time elaborating traces of a hypothetical conflict between De Palma's Quaker schooling and his Catholic family, or indeed between those two traditions and the third tradition – science, technology – that is perhaps best represented by young Brian's time perched above his father's operating theater. This elaboration would begin with certain assumptions about *blood, the body, violence* and *death*, and how these values/ideas operate within Quaker, Catholic, and medical discourses; it would also be the simplest – if perhaps the least productive – way to compare De Palma and Scorsese, whose attitudes toward these issues could not be more different from De Palma's despite their putative ethnicity.[5] Which of these avenues of inquiry would be productive? Which would be arbitrary? Could we really tell the difference?

For the sake of the experiment, let us look to 1980. In the years since *Get to Know Your Rabbit*, De Palma had become a genre practitioner (whether by choice or necessity, it is both impossible and pointless to distinguish): thus *Sisters, Phantom of the Paradise, Obsession, Carrie*, and *The Fury*, each of which has its own position in regard to generic requirements and audience expectations, and each of which might be regarded as the product of a certain kind of experimentation with form and grammar. After *Phantom*, none of them are what Robert Kolker (for example) would call "personal" films (although it is clear that De Palma brought something more than just technique to *Carrie*). De Palma did not write *Obsession, Carrie*, or *The Fury*, although he had a hand in the final narrative construction of *Obsession* – indeed he changed that film's screenplay enough to enrage its author, Paul Schrader. And while one might say that *Carrie* and *The Fury* display their director's bleak worldview (i.e. no

[5] In fact, the proper way to approach a comparison between De Palma and Scorsese – if one were required to use biographical information as a determining *political* frame – would be at the level of *class*.

good deed goes unpunished, violence is both ghastly and funny when hyperbolized, and so on), the mere *existence* of each film, the fact that it went into production and had a successful release, might be attributable to nothing more than some producer's idea that De Palma would be a "good match for the material." Let us note in this context that a strict auteurist like Laurent Bouzereau would have to trace the development of certain "personal themes" in De Palma's work that are perhaps strictly generic gestures rather than marks of De Palma's "individuality": thus "all of De Palma's visual concepts, combined with his fascination with themes such as voyeurism, sexuality, guilt, and the double, make his work unique, and worthy of examination" (Bouzereau 15). Let us also note that, even before 1980, De Palma was an object of suspicion for several registers: even though *Sisters* had been described by feminist scholars as displaying an awareness "of the voyeuristic mechanisms of the cinema [and] analyzing the ways in which women are oppressed in patriarchal society" (Asselle and Gandhy 1982, 138), feminists were not certain what to do with the menstrual nightmares of *Carrie* and *The Fury*, and for other writers De Palma's evolving reputation as a maker of violent genre pictures was taking shape along clearly delineated lines.[6] Note, too, that the late 1970s saw the groundbreaking organized resistance to William Friedkin's disastrous *Cruising*, a group action that helped to pave the way not only for the feminist group actions against *Dressed to Kill* but also for the electrifying rhetoric, and anger, of ACT-UP.

In 1980, De Palma released two films. The first of them, the deliberately amateurish and clunky *Home Movies*, was made (in both 16mm and 35mm) at Sarah Lawrence by a crew of De Palma's students, with a budget of $400,000 subsidized by Kirk Douglas, Steven Spielberg, George Lucas, and De Palma himself, while the second, *Dressed to Kill*, was a much larger affair, with a budget of $10,000,000 and a perfection of style epitomized by Ralf Bode's creamy Panavision cinematography. If one were to look for evidence of De Palma's commitment to "personal" filmmaking, these two films would be the cornerstone of the argument; however, unlike Scorsese's critically lauded *Mean Streets* or Spielberg's enormously successful *E.T.*, De Palma's own fantasy reconstructions of his childhood milieu are simply too unappetizing for the mainstream auteurist to confront. Think of the way that *Mean Streets* is always framed: it is a portrait of an artist's community, his ethnicity, his own fears and beliefs and therefore the fears and beliefs of the world that made him (New York's Little Italy, a particular type of Catholic masculinity, street violence, sexual and familial guilt); Scorsese brings us this world because he is possessed by its terrible beauty, and the rhythms and images of that world are both Scorsese's and not Scorsese's. No auteurist castigates Scorsese for presenting human failures or human violence, and none thinks it problematic that Scorsese stylizes or hyperbolizes for cinematic effect: it is *his* imagination, and also that *of his people*. (Consider the critical fetishization of Scorsese's own fetishization of his parents as movie subjects.) Besides,

[6] For feminist positions on *Carrie*, see especially Barbara Creed (1993), whose invocation of the "monstrous-feminine" seems especially apropos to the avenging figure of Carrie White; see also Bathrick 1977, Citron 1977, Clover 1992, Coykendall 2000, Lindsey 1991, Matusa 1977. For the genre-hack tag, see especially the alternately sympathetic and contemptuous profile of De Palma in Pye and Myles, *The Movie Brats* (1979).

Scorsese aims for, and achieves, a poetic, operatic vision, a vision marked by Catholic themes of redemption and sacrifice – themes that Scorsese *feels* deeply and personally. (Thus Robert Kolker, in *A Cinema of Loneliness*, can call his Scorsese chapter "Expressions of the Streets.")

By contrast, consider the openly hostile and deliberately petty *Home Movies*, which – if approached with some knowledge of De Palma's background – might best be understood as a *truly* "personal" gesture, a gesture of communication aimed not at a film audience, not at "the public," but literally *at the artist's own family*. One might be tempted to read this gesture – surely the most unpleasant of De Palma's movies – as De Palma's attack on the very notion of "family," and if this were the case it would certainly bolster a reading of De Palma as a radical-Left artist concerned with The Collective, &c. However, *Home Movies* is not about "the family": it is specifically about the De Palma family of Philadelphia, almost to the exclusion of any "universal" application of the film's themes.[7]

We might imagine here – admittedly, with absolutely no license or position to do so – what each member of De Palma's family must have felt upon seeing it, or rather (and more precisely) what *Brian De Palma might have imagined that each member of his family would feel upon seeing it*. There is the father, the surgeon, played by Vincent Gardenia as a sexually rapacious, stupid, venal man, utterly amoral and therefore capable of any transgression against anyone; there is the mother, played by Mary Davenport (who previously appeared as the nagging mother in *Sisters* and in an uncredited role as a street interviewee in *Hi, Mom!*) – she whines, shrieks, theatrically attempts suicide every few minutes, and fawns in a barely concealed incestuous way over her eldest son. For *that* member of the family – played by Gerrit Graham (Beef in *Phantom*, the conspiracy theorist in *Greetings*) – it is clear that the most intense feelings of hatred are reserved. The eldest son, a megalomaniacal Werner-Erhard-type crazy with quasi-Nazi beliefs about the purity of the male body, has a coterie of sycophants, who follow him around and perform his bidding; at the end, he leads his groupies into a mass homosexual act, which his fiancée (a former stripper, played by Nancy Allen) accidentally witnesses. The film closes with De Palma's obvious narrative stand-in – played by Keith Gordon as an honest and smart but hopelessly inept kid, pure of heart in a family of perverts – escaping the clutches of his family by going off to college, with his brother's former fiancée in tow; meanwhile, back at home, the entire family – without young Dennis – has a collective meltdown while watching Dennis's home-movie footage of the eldest brother's abortive wedding, which unexpectedly (for the gathered family) ends with a reenactment of De Palma's own primal movie – candid footage of the father fucking his nurse. (The middle brother of the De Palma family, the painter Bart De Palma, might have felt this collective attack most keenly: in the film, the Byrd family has no middle child.)

[7] One might say that *Home Movies* represents the exact reverse of the kind of scenario outlined by Freud in "Family Romances," in which the subject (whether child or daydreamer) imagines that his family are impostors – that is that he has been *stolen* and that his "real" family are *noble* beings, such as royalty. In *Home Movies*, De Palma imagines that his "real" family are not nobility but, rather, represent the *worst* impulses that human beings are capable of producing: venal, corrupt, opaque to themselves and destructive to others. See Freud 1959.

Clearly, we are not in the realm of what most critics would define positively as "personal" filmmaking (at least not in the sense that *Vertigo* and *Shadow of a Doubt* are "personal" films, nor in the sense that *Faces* and *Husbands* are "personal" films); instead, one might say of it – as Pauline Kael says of Peckinpah's *The Killer Elite* – that this is no longer personal filmmaking, but *private* filmmaking. What *are* we to think about this fantasy? For starters, there is the film's tone: aggressively Godardian (text on the screen, 360-degree pans, the continuous use of *plan-séquence* construction) and just as aggressively juvenile (the Laurel and Hardy music, the grotesque sex jokes, the exaggerated performances, and especially the unpleasant blackface sequence in which Keith Gordon, perched in a tree in order to spy on his father, is called a "nigger" by a fat white cop). In other words, it is at once deliberately anti-naturalistic in style, perhaps in order to "throw" casual spectators out of the movie, and anti-naturalistic in tone and affect, perhaps in order to insult the film's *real* spectators – that is to say, De Palma's immediate family. In addition to the ambiguity and confusion engendered by the film's tone, there is its structure: standing over the narrative is an utterly superfluous character – a film director, The Maestro, played by Kirk Douglas – who frames the film's narrative as a flashback to his greatest failure as a director, his failed attempt to get Dennis to be more than "an extra in his own life." *Home Movies* is therefore choked by frames within frames – the film itself is presented as a filmed record of a lecture in which The Maestro shows a movie in which Dennis tries to shoot a movie about his family – and indeed the super-recursive animated credits at the film's beginning stage a series of graphic transformations along these lines: the reels of a film projector are eyes, breasts, windows, while the screen upon which the projector shines its phallic beam is a house, a window, a woman's body. Essentially, *Home Movies* combines the literal self-disclosure of Truffaut's *Les Quatre Cents Coups* with the *mise-en-abyme* of *Contempt* or *Made in U.S.A.* and the combative sensibility that one might associate with John Waters or Robert Downey Sr.

This, then, is the first of De Palma's *deliberately bad objects*: here, inside a gesture toward collectivist, low-budget, outside-the-industry filmmaking, he experiments for the first time with the production of a certain *unpleasure*. The secret of this particular kind of cinematic unpleasure is not modernist seriousness *a la* Straub or Akerman but, rather, *unfunny comedy*: like Godard's counterintuitive appropriation of certain aspects of Jerry Lewis's technique (first operationalized in *Les Carabiniers* and still primary as late as *King Lear*), De Palma keeps the theoretical viewer – that is, not you or me, but De Palma's father, his mother, his brothers, perhaps even his father's second wife – at a quasi-scientific distance from the slapstick perhaps in order to politicize the act of viewing. Thus we have the exaggerated mugging of the gathered family as they watch the film that Dennis has left for them: De Palma frames the actors together in a long shot, centered in the frame very much like a theatrical *tableau vivant*, effectively killing any impulse that any spectator might have to laugh at the "funny acting." There is not a single laugh in *Home Movies*, even though it is nominally a comedy: this is why, unlike *Obsession* (which is also devoid of laughter), *Home Movies* is one of De Palma's most serious films.

When De Palma next returned to these familial themes – in his very next film – he would reverse course in regard to his call to the audience. *Dressed to Kill* is a perfectly built machine for delivering thrills and *jouissance* to a mass audience; there is no evidence that De Palma cooked it up in order to alienate anyone – except, again, his relatives and, past that, anybody and everybody. The secret of *Dressed to Kill* is its choice to stage *Psycho* inside De Palma's own family: in the elimination of both older brothers and the substitution of a cold, unfeeling stepfather for a missing biological father ("my *real* father died in Vietnam!"), De Palma sets the stage for a lush pornographic fantasy about his relationship with his mother, who dares to transgress against the husband she despises and is instantly rewarded with gonorrhea, syphilis, and death. The son – Keith Gordon again – uses his knowledge of surveillance technology to avenge her murder, with the help of a kindly prostitute (Nancy Allen again), who has enough insight into her real-life husband's fictional avatar to murmur sympathetically, "You liked your mom a lot, didn't you?"

As we have seen, *Dressed to Kill* provoked outrage from a number of groups of people for a number of different reasons, not least among them its choice (brilliant but unfortunately timed, historically speaking) to stage *Psycho* inside *An Unmarried Woman*, featuring the

beloved star of *Police Woman* (the cover heroine of *Ms. Magazine*) as the object of a transvestite's murderous rage: the sympathetic portrayal of a housewife's gradual awakening into her own desires is, as it cruelly turns out, nothing but a lure for the viewer's sympathies, a trap set with the mechanisms of identification. When the trap is sprung, anyone who has been ensnared by the character of Kate Miller – anyone, that is, who has something invested in this fictional character's fictional arc toward fictional self-realization – experiences what we might ambiguously call a "violation" of some kind. In 1980, as De Palma may or may not have realized, that category of viewers with something invested in the idea of *a woman's journey out of servitude* would necessarily include groups like NOW and WAVAW (Women Against Violence Against Women) as well as individual feminists like Carol Clover and Linda Williams, for each and all of whom that "something invested" would be their *own* struggle as well as the struggle of *all* women to achieve their own goals in a system that is built, visibly and invisibly, upon the suppression of those goals.

No doubt the outcry against the ferocity of the film's central murder sequence would have been a dozen times more heated if scholars like Kaplan and Williams had *truly* in this instance collapsed the personal into the political: after all, one could without intense theoretical gymnastics read the film, at some level, as a fantasy about *the sex-murder of a real woman*, Brian De Palma's actual mother, Vivienne – if one chose to do so.[8] Yet this, too, is a lure (a MacGuffin?), for *Dressed to Kill*, unlike (for example) *Star 80*, is a comedy – a comedy about the reactions of the people in the audience who have fallen, and will always fall, for that lure. Our signal to this effect is the return of Mary Davenport, the mother from both *Home Movies* and *Sisters*, in her featured role as an eavesdropper to a conversation in a Manhattan restaurant: as she listens to the two principals discuss the procedural details of a sex-change operation ("and the reconstruction of an artificial vagina – a *vaginoplasty*, for those in the know!"), she becomes visibly nauseous, so much so that her white-haired companions-who-lunch stop their own conversation in order to express their alarm. The movie we are watching is that conversation; we who find it distasteful are that eavesdropper.

Given how often and how insistently De Palma includes an "audience surrogate" or "screen-audience analogue" in the narrative and/or visual fabric of his movies – that is to

[8] That *the sex-murder of real women* is the referent under contest in these discussions is highlighted by the fact that *Dressed to Kill* arrived in theaters four years after the notorious Roberta Findlay "sexploitationer" *Snuff* (1976), which – as Joan Hawkins points out in *Cutting Edge* (2000) – offered a ready-made *idée fixe* for the bourgeoning feminist movement in the United States in the form of its "documentary" onscreen murder of a real woman. Hawkins quotes Linda Williams's assertion that the murder, even after it was definitively revealed to be a hoax, continued to "haunt the imagination" (135–139), and perhaps the primal scene of the "real" murder in *Snuff* served as the grain of sand (so to speak) around which the pearl of Dworkin-MacKinnon anti-porn feminism was grown. Certainly the idea that *real blood* flows through films like *Friday the 13th* – or, indeed, *Dressed to Kill* – might owe its genesis to this clever publicity stunt. In any event, this helps to point up the differing ideas of "representation" in critical and positivist disciplines, such as Film Studies and Sociology (and the problems that might arise with the collapse of these registers that occurs in work like Ryan and Kellner's *Camera Politica*).

say, the staging of a clear relationship, within a single film frame, between the two spatial environments of a gaze and its object, a relationship that has an uncanny resemblance between the movie itself and the person watching it – it seems odd that this aspect of his habitual rhetorical address to the audience was not noticed by mainstream critics (or film scholars) nominally concerned with De Palma's contempt for his audience. Let us recall, for example, the look of nausea that crosses the face of the principal of Bates High when, in *Carrie*, he catches sight of a smear of menstrual blood on Betty Buckley's white gym shorts. In both this shot and the eavesdropping sequence in *Dressed to Kill*, both the subject and the object of the anxious gaze are together in the same frame, but visually separated from one another by the out-of-focus edge gradation of the split diopter – a primitive lens modifier that, in creating a double plane of focus rather than the more naturalistic Wellesian single-plane deep focus,[9] calls attention both to the presence of the camera as technological object and to a potential visual-metaphorical split between opposed forces arranged at the sides of the frame.[10] De Palma's use of this kind of screen–audience analogue, by its very structure, can only take place inside a single shot: it is always an effect of framing and camera technology,

[9] See Paul Ramaeker's useful "Notes on the Split-Field Diopter" (2007), which correctly identifies De Palma's debt to Gregg Toland's use of the split-gradation lens as an anti-naturalist device and discusses De Palma's use of the lens in relation to Raoul Ruiz.

[10] Consider, for example, the uses to which Raoul Ruiz puts the split diopter, which unless used very carefully is always and only a distanciation device. Ruiz heightens this effect by staging traveling shots with the diopter on the lens, which one must never do if one's intent is to maintain an illusionist style (any visual element, if it passes through the edge gradation of the diopter, will go wildly out of focus and can even suffer color distortion). When Hitchcock uses the split diopter, he is always careful to hide the edge along a visual "seam," such as a doorway or the shadowed corner of a room; De Palma, and to an even greater extent Ruiz, refuses to hide the edge – so that the image itself is split, refracted, framed by itself. This would be considered a "Godardian" use of the technology, even though, to my knowledge, Godard never used the split diopter until the 1980s (in *King Lear*). See Ramaeker (2007).

never of editing, and although the split diopter is one easy way to achieve (and highlight) the effect, De Palma also uses other tricks of camera technology to achieve it. Consider the "asylum" scene in *Dressed to Kill*, when the camera slowly zooms back to a perfectly split shot, murder on one side and crazies on the other. Thus *Dressed to Kill* is on the left; "we" are on the right. Or consider nearly any moment in *Body Double*, which seems to spend all of its energies and all of its allotted screen time in an attempt to delineate all the possible oppositions and arrangements of the subject and the object of the cinematic gaze (from the weird roundelay on the back terrace of the beach motel to the literal staging of a porn film in a tacky West Hollywood studio). Why would a director of genre pictures so insistently indicate our place, as spectators, within the diegesis, inside the frame? What would be at stake? Would this constitute *a theorizing of spectatorship*?

In this context, let us seriously consider De Palma's reputation for being "detached" or "impersonal." If *Home Movies*, thanks to its "personal" content and its "personal," handmade technique, has the force of a "personal" gesture – let us imagine that, since its familial addressee is so specific and so clear, it actually means to hurt someone (or at least to hurt someone's feelings) – then *Dressed to Kill* has the abstracted quality of a lab experiment or a thesis paper, or a high-school science project. And yet in spite of (or because of) this detached quality, this impersonality, *Dressed to Kill* was read as having murder on its mind: it not only *means* to hurt, it *actually hurts* – women, Hitchcock, the audience. Consider the fact that Hitchcock is always spoken of in God terminology (lofty, capricious, inscrutable), while Kubrick (for example) is always spoken of as cold and detached, which is to say scientific – not quite the same thing. (Hitchcock *is* God, while Kubrick "plays God.") And Godard is somewhere along this same continuum: he is a critic and a Brechtian, so his gaze is both immediate and empathetic *and* cold and heartless. De Palma is on this continuum as well, but how shall we define that position? And how shall we relate this detached quality to the political narratives we have been building around De Palma?

I want to try to get at a pair of issues that, I think, are linked to detachment, impersonality, distance. The first is the relationship between objectivity, the detached gaze – perhaps we should say objectification – and its apparent opposite, empathy. The other issue concerns modernism and its political project – that is to say, the Utopian movement toward the impossible resolution of what Žižek (after Laclau and Mouffe) would call the "bedrock antagonism."[11] These are both, in the end, problems of spectatorship, and they are engaged in certain specific ways in De Palma's cinema – and, I would argue, nowhere else in the New Hollywood. And it is this theorizing of spectatorship that, in the final analysis, makes it impossible for Film Studies to "see" De Palma, since De Palma has, with the "porn trilogy" and its mobilization of *père-version*, theorized the "redemptive" possibilities of filmmaking, and therefore of Film Studies, right out of existence.

[11] The original Laclau and Mouffe formulation (2001) – itself modeled half on Rosa Luxemburg and half on Althusser – is a fascinating attempt to take the inevitability of failure as an *a priori* for political struggle, and it is not without consequences that Žižek builds his early work on this formulation.

The Liberal Gaze

> Nobody was surprised to hear that the director of the *Scarface* remake was Brian De Palma; they were perhaps surprised to see a theme that had obsessed an entire generation of young American directors to make arguably great films like *The Godfather* and *Mean Streets* turned into pure panache and tasteless titillation.
>
> (Jaehne 49–50)

Scarface opens with ominous disco music and a montage of news footage: the Mariel boat lift. We see an American flag; we see steamers crammed to capacity with brown-skinned men and women signaling frantically for rescue; we see Castro pointing his finger during a televised speech and shouting, "We don't want them! We don't need them!" The "them" is the dregs of Havana's jails, released and tossed to the waves as a sort of extruded Yippie joke on the whole United States, and among them is Tony Montana, a fictional character in the midst of a "real" historical moment, a Cuban gangster-wannabe to whom Karen Jaehne refers in her *Cineaste* review as a "detonated capitalist without any socially redeeming values." *Scarface* itself, as Jaehne points out, also "lacks any artistically redeeming dimensions," and so it, like its protagonist, will turn out to be a sort of capitalist detonation: there will be no redemption for Tony Montana, nor will there be for Brian De Palma, because, in defacing a *beloved object* – Howard Hawks and Ben Hecht's classic *Scarface* – he has turned the quintessential American film genre, its primal myth of gangsters and gangsterism, into a silly, gratuitous horror show.

Except that *Scarface* is about anything other than Cuban gangsters. Like every movie that De Palma made after his experience with *Get to Know Your Rabbit*, *Scarface* is about Hollywood, and it is about the Left. It is easy enough to see how the film is about Hollywood: the extravagant waste of money on flamboyant idiocy, the condescension and venality of the people holding the money, the necessary corruption of any industrial practice under capitalism, the suicidal bravura of the successful *auteur-entrepreneur*. Tony rises to the top because he is the most venal, the most foolhardy, the most corrupt; he is destroyed when he tries to perform a human gesture, refusing to allow a crusading journalist to be assassinated because it would mean the deaths of an innocent woman and child. Tony, as it turns out, is sentimental – we knew this already, from his overdetermined attitude toward his family – and he is punished by the narrative for this "human" weakness. Additionally, the blizzard of cocaine that, in one way or another, consumes the entire cast had, at the moment of *Scarface*'s production, damaged or destroyed the careers of a number of De Palma's contemporaries, and indeed the empire that Tony Montana builds – and then, through arrogance and greed, destroys – resembles nothing more than American Zoetrope in the years before *Scarface* was released. In the film's final act, Tony Montana trapped behind his bank of security monitors could be Francis Ford Coppola, locked in the Zoetrope RV and directing *One from the Heart* via a remote camera feed – blitzed to oblivion, no longer a master of survival within the industry but a fully corporatized American monster, horny and delusional and

suicidally unaware of his own weaknesses. (Tony's mantra – "First you get the *money*; then you get the *power*" – could be any of Coppola's more confessional statements to the press; there is a certain naïve similarity between Tony's logic and the logic of statements like "You can't just shake your fist at the establishment and put them down for not giving you the chance. You have to beat them down and take that money from them" [quoted in Lewis, 15].) Or Tony Montana could be De Palma's former friend Martin Scorsese (at least as Peter Biskind describes him): an egotistical, hopped-up little loudmouth from the streets, firing his guns off in the air and, fired up by coke and 'ludes and whatever else, attempting to move past the limits of his ability and drowning (*New York, New York*). With their oblique modernist visions and consequent delusions of grandeur, both directors had pissed off all the wrong people, and the gigantic finale of *Scarface* – the scene of Tony's payback, with the destruction of his Olympian palace in a burst of gunfire and blood squibs and drifting smoke – resembles nothing so much as the collapse of Zoetrope after *One from the Heart* or the debacle of *New York, New York*.[12]

How, though, is *Scarface* about the Left? The surface reading of the film (which is largely influenced, as Stephen Prince inadvertently showed us in Chapter 1, by Oliver Stone's screenwriting credit) tells us that the film is somehow *critical of capitalism*, and is therefore itself Left in some way – a reading that would have been correct if Sidney Lumet had not left the project before shooting. This logic requires that we read Tony as the American Dream Gone Bad. Money and luxury corrupt Tony, because there is no spiritual core to him – just as money and luxury always corrupt, because they destroy love, and where is one to learn love in a capitalist society anyway? Thus the hinge scene of the film is Tony's speech at a fancy restaurant toward the end of the film, after Elvira walks out on him: "You need people like me," Tony tells the assembled millionaires, "so you can point your fuckin' fingers and say, 'that's the bad guy.'" Tony is evil, but he is not a hypocrite; capitalism requires hypocrisy from its participants (according to the Left, at least), but Tony sees the global hustle for what it is, and of course he is destroyed for seeing the truth. This would be the Oliver Stone moral: everyone is a pig, but Tony is honest, and thus he is the truth of our position.

Perhaps this is a legitimate way of reading the film – it is the *preferred* reading, the "intended reading" – but it is also, as they say in the trades, a *cop-out*. Let us recall that Oliver Stone's original idea was much more documentary: in addition to being a gangster film (and a remake at that), *Scarface* was to be a hard-hitting Left-wing exposé of what immigrants have to do to get by in the United States, realistic in tone and accusatory in temperament, less *The Godfather* and more a Warner Bros. "social problem" drama of the 1930s. De Palma, of course, turned it into an operatic cartoon of banality and violence, a cross between *Ludwig* and *The Wild Bunch*, something more akin to Jodorowsky or Leone than Peter Watkins – which is to say, he *pornographized* it.

[12] By contrast, the last shot of *Wise Guys* suggests the same fantasy in reverse: Joe Piscopo and Danny DeVito, perhaps figuring Spielberg and Scorsese, have successfully founded Zoetrope.

What does this pornographization entail? Bathed in major-chord Moroder disco, nauseating production design in hot acrylic colors, tanned blond women in mauve bikinis pointing their asses at the camera lens, and the spectacle of an Italian man playing a Cuban peasant in brownface (not to mention blazing gunfire and, in the film's infamous "shower scene," roaring sound effects and splattering gore), *Scarface* is unlike any previous Hollywood fantasy about the racial Other, far surpassing Hawks's already-notorious original in sheer brutality and explicitness. It stages, in a significant number of the film's individual shots, a particular kind of screen–audience analogue: at the center, we have racial difference *in extremis*, and all around this central figure, we have the visceral, visible reaction of the dominant social environment to that difference. (If one watches *Scarface* closely, one realizes that it is one of the few De Palma films in which there is nary an African-American in sight: they have been foreclosed, one assumes, in order to make the field of vision as Caucasian as possible.) It therefore pornographizes the liberal gaze itself: in mapping this double-vision of racial difference – the snarling, unsatisfied and unsatisfiable rage of the racial underclass, and the aghast politesse of the white ruling class – onto a story about the "forbidden truth of capitalism," it stages not "the truth of capitalism," but rather the truth of the quotidian interpersonal politics that keeps the post-Nixon Left in thrall to the capitalist system in the first place.

What has happened is that De Palma – like Paul Verhoeven with Joe Eszterhas' script for *Basic Instinct* – has radically inverted the presuppositions of the script without changing its positive content in the slightest. Stone's idea has been turned upside-down: once a cry (or mumble) of protest about greed and injustice, *Scarface* becomes, in De Palma's hands, a porn horror show of racial difference, something far more complicated and strange than (for example) a simple "blaxploitation" film. We might, in fact, compare it to a blaxploitation film *in blackface* – something like casting Al Jolson in *The Avenging Disco Godfather*. Consider that De Palma elicits what may be the most garishly xenophobic performance of the Reagan era from none other than Al Pacino, and at least in its historical context, Pacino's presence – with its intertextual hint of castrated or fallen liberal idealism (*Serpico*, *The Godfather*, *And Justice for All*, *Panic in Needle Park*, even *Cruising*) – guarantees that the film be read on its surface as an impossible (and typically Hollywood) invitation to "sympathize with the Other," a racist artifact about issues of race such as *Uncle Tom's Cabin*. (*This hideous criminal just* happens *to be Latino – some of my best friends are Latino!*)

On one level, this is simple Hollywood racism (never uncommon, usually ubiquitous); certainly this was the belief of the Cuban-American community, along with a majority of press critics in the United States. But given the sensitivity to issues of race – or, more precisely, the sensitivity *to sensitivity* to issues of race – that De Palma displays in *Hi, Mom!* and *Sisters* (and later in *Casualties of War*), and that neither Scorsese nor Spielberg nor Lucas nor Altman nor Coppola nor Bogdanovich nor Friedkin nor Rafelson nor Milius nor Schrader nor Beatty (until *Bulworth*) have ever manifested, perhaps we might inquire whether De Palma might be mobilizing racism – specifically, what he imagines to be *the racism of the audience* – in particular ways and for a particular purpose or set of purposes. (To cite Comolli and Narboni's classic system of ideological inscription: if the triple-edged

race parable *Imitation of Life* can be identified as a "category E" film, then why not *Scarface*?) And given the fact that (as De Palma recognizes) the bedrock antagonism in American society at any given time is not race but class, we might inquire whether the film's address to its audience – that is to say, to an imagined Left audience – might have something to do with that displacement as well.

Let us return again to the "screen–audience analogue" and its role in this particular visual regime. In *Greetings* and *Hi, Mom!*, the gesture toward the audience is literally an address to the audience: Gerrit Graham turns and delivers a monologue about the Kennedy assassination to the camera, or Robert DeNiro reads out loud from some post-Freudian book about sexuality and, at especially provocative lines, locks gazes with the camera, eyebrow raised suggestively. We recognize this to be a Godardian strategy; but we also understand that, after *Get to Know Your Rabbit*, this strategy is no longer useful for De Palma. So the address turns inward, into the diegesis, and *you*, the viewer, are figured there, *in the frame*, watching the action; this "you" inside the film watches Tony – or listens in on a conversation in a restaurant, or gazes at the stain of menstrual blood on a character's shorts – and you are inevitably disgusted by what you see. Which is not to say that the camera's gaze is no longer directly met by the gaze of a diegetic character: Winslow spins to us, the audience, after the "guilty" verdict is read and screams his innocence (the American flag towers in the background); the unfortunate Amy Irving locks gazes with the camera during most of her telekinetic moments in *The Fury* (although she is not seeing "us," but rather "it" – that is to say, the otherworldly vision supplied to her by her psychic abilities). And there is always that marvelous shot in *Raising Cain*, in which John Lithgow's horrified gaze into the lens tells us that we are now "Margo." But after the 1960s, rather than having someone address the audience directly in order to remind them that they are watching a movie, De Palma generally chooses to create a character in the film to whom the technique can point as if to say, "*this* is *you*." Thus he demonstrates for us how he expects us to react – or, as in the split-level shot in the asylum or the overheard conversation in *Dressed to Kill*, how he *wants us to think* that he expects us to react. In *Scarface*, "we" (the audience, the executives at Universal Pictures, the MPAA, the Left) are the whites around Tony: the corrupt police captain who bluntly tells Tony what percentage of the take he expects; the paternal drug lord in the white suit who tells Tony that he appreciates his style; the blond-haired-and-blue-eyed representative of the United States government (Gregg Henry, who would return the next year as the murderous-husband-in-cigar-store-Indian-makeup in *Body Double*), sneering at the Colombian reformer on the television; the crooked lawyers, the corrupt bankers, and so on – in other words, *everyone who makes money off Tony*. "We" are all the millionaire restaurant patrons that Tony drunkenly tells off – a set of characters that Pauline Kael described as "the usual Hollywood dress extras," whose "polite, aghast expressions (and anonymous, helpful buzz) give them a stiff, Pop Art stuffed-dummy look" (Kael 1985, 105), which might as well be what De Palma thinks of most Americans anyway. (We know it is what Hitchcock thought of us.) We are also Michelle Pfeiffer: once he kills our previous owner, we fuck and eventually marry Tony for the money, even though we think he is disgusting. And we are all the tanned women in bikinis who snarl "Fuck off!" to Tony as he ogles them on the beach.

"A stiff, Pop Art stuffed-dummy look".

In other words, "we" are configured as the entire range of white citizens' reactions to this outrageous cartoon of the racial Other, which means that there is no position for "us" to occupy other than hypocrisy. I would like to suggest that the importance of *Scarface* to various minority cultures in the United States, and indeed across the globe, has at least partially to do with this aspect of the film's enunciation: the protagonist and rhetorical center of *Scarface*, its dynamic point of focus, is constantly fixed in a complex of hateful, tight-lipped white gazes, against which Tony rebels and succeeds – succeeds enormously, in fact, and on his own terms. Even his death is a success: he takes out *everybody*, and only dies when *shot in the back* (the ultimate cheat, at least in the cliché "code of honor" that was the western's contribution to American screen morality).

Consider: the protagonist is palpably, from the film's first lines of dialogue, the object of white condescension, a scorn that rises off the screen like a heat wave; he repays that scorn with a mushroom cloud of invective and spittle and gunfire and blood. Thus the film has two levels of enunciation: its address to its presumably white audience stages the same sort of relationship that *Barton Fink* stages between its eponymous protagonist, a New York radical, and the figure of the "common man," Barton's ideological love-object as personified in the body of Karl "Madman" Mundt, serial killer and harbinger of apocalypse; while another audience, theoretically figured along racial lines, that already knows what it is like to be the object of the unremittingly condescending white gaze might find Tony's incandescent rebellion to be exhilarating – not a cautionary tale at all, but the hagiography of a martyr.[13] In either direction, "we" are confronted with the Real of our desire: the racial Other as a fount of obscenity, greed, incestuous lust, and an unimaginable capacity for violence, who is

[13] For a particularly sharp investigation of the gangsta "read" of *Scarface*, see Rob Prince's (unpublished) doctoral dissertation, "Say Hello to My Little Friend" (2009). On the other hand, for a sloppy and potentially racist investigation of the same topic, see Ken Tucker's *Scarface Nation* (2008).

also rhetorically figured as "the truth" of capitalism, of the American Dream Gone Bad, of what an immigrant has to do to get by in this society of *lyin', cheatin' white bastards.*

This strategy will appear again in *Body Double*, the narrative logic of which requires that the "fake" murderer – the husband in Indian drag – be racially marked, and hopefully as obtrusively as possible, so that the audience *understands* that race is being used as a lure. Let us point out in this regard that, in De Palma's original script, the character that later became known as "the Indian" was first conceptualized as "the Rastafarian," whose dreads and blackface would wash off in a swimming pool to reveal the character's true identity. As in *Hi, Mom!*, De Palma mobilizes not racism "in itself" but, rather, the ways in which *a certain audience* will approach the very *idea* of racism. Thus in a certain way the character of "the Indian," keeping its genealogy in mind, might be seen as De Palma's response to the accusations of racism that rained down on *Scarface*, which immediately preceded *Body Double* to the screen: racism is primarily *an event of the social gaze*, and that is how De Palma stages it. (One can find a particularly noxious and pointed "mobilization" of white bourgeois paranoia in the travails of the Nancy Allen character in *Dressed to Kill*.)

With this discovery – the idea that De Palma might theorize both race and class, as he theorizes both electoral and sexual politics, as an event of the gaze as a social object – we have run into the first of the issues regarding "detachment" mentioned earlier: the tension between objectification and its putative opposite, empathy, as they are imagined by the "liberal project." This is a problem of the gaze as it constructs the subject, that is to say, a certain relation of the free citizen to the object of his or her political contemplation: *I see your pain, brother or sister, and I will work for your freedom as if it is my own.* Need we point out that this kind of gaze – or its corresponding rhetoric, from primal-scene texts like those of Kerouac and Mailer to books like Barbara Ehrenreich's *Long March, Short Spring* – is usually not matched by an attendant economic selflessness? (The gaze has nothing to do with "real life" – the exact opposite of what anti-porn feminism was arguing.) It is this hypocritical gaze, this disembodied embodiment, that De Palma addresses in *Scarface*, and it is our relation to that gaze that he stages in scenes like the restaurant speech. What is the nature of that tension – in the fixing of someone, some Other, in our gaze, and either condemning them (*that homeless man is disgusting and filthy, the government should do something about this*) or empathizing with them (*that homeless man is so sad and unfortunate, the government should do something about this*)?

This is an enormous question, and – like all the best, most disturbing inquiries – it unfolds into dozens of other questions, each one demanding an inquiry in itself. To wit: is there a quasi-object, a social mechanism, that we might identify or theorize as *the liberal gaze*? How and when does it appear or become mobilized, and what does it "do"? To what would it be opposed – the fascist gaze, perhaps? Would these opposed gazes construct "good objects" and "bad objects" differently – or similarly? Would each produce different visibilities as well as different invisibilities? Are these gazes *raced*? Do they produce "real-world" effects, either at the level of the individual body or within the socius? Does each generate a discourse? Are they produced by ideology, or do they produce ideology? Naturally, some historiographic

White bourgeois paranoia in *Dressed to Kill.*

questions appear as well. Assuming that the liberal gaze and the fascist gaze do exist, would they both be byproducts of modernism? Are they, by their very nature, cinematic? If so, did they precede cinema historically, or were they produced by cinema, and if so, when – that is, before or after *The Jazz Singer*? Would these gazes be, in some sense, effects of montage, or effects of framing, or effects of sound design – or all three?

Keeping in mind that we are, after all, talking about Brian De Palma, perhaps the best way to zoom in and rack focus, so to speak, is to talk about pornography. We know that the words "pornography" and "pornographic" first attached themselves to De Palma with *Dressed to Kill*, even though De Palma first addressed pornography in *Greetings*; after the NOW intervention against *Dressed to Kill*, De Palma's next three films each generated dozens, if not hundreds, of press reviews in English that used the word "pornographic" as a pejorative, even if none of the films are sexually explicit in the literal, pubic way that we usually associate with pornography. With one eye on the previous discussion of the problem of De Palma's doubleness – the confusion over whether De Palma is "capitalist" or "anticapitalist," his presumably hypocritical appeal to both film purists and Times Square "hooligans," De Palma "the master" vs. De Palma "the moron" – let us turn to the (appropriately) double-issue *Film Comment* spread on *Body Double* and pornography, which hit the newsstands in September and November 1984.

The first of the issues – which features a leather-clad and peroxided Melanie Griffith on the cover – contains a cluster of De Palma materials: a quartet of carefully chosen excerpts from the *Body Double* script[14] (included as "a way in to the heart of the debate over pornography and violence to women" [Jacobson 1984, 9]); an article by Marcia Pally that, echoing Sarris, opens with the familiar elision "It would be easy to say Brian De Palma hates women. He goes after them in the most grisly ways" (Pally 1984, 12); and an extended and remarkably combative interview, in which Pally imagines that De Palma is going to cut her with a razor or, worse, rape her.[15] (A parenthetical aside during the interview text, during a particularly heated exchange, claims that "De Palma starts to smile – oddly, I think. Is he feeling out of control? Is he going to want to do something about it? Am I crazy to be wondering where the drill is? No, razors would be better for the office" [15].) This spread – in the same issue as an auteurist-inflected (and utterly apolitical) interview with Clint Eastwood to promote *Tightrope*, arguably a far more distressing and misogynist film than *Body Double* – positions De Palma as a reckless provocateur, heartless and egotistical; the title of the spread

[14] Let it be noted that the script, as excerpted as "evidence" in the magazine, is different in subtle but extremely important ways from the finished film: the icily parodic tone that typifies *Body Double* is not apparent from the screenplay, and the dialogue and visual directions are often completely changed in the film as it was released. The script is far more "pornographic": the masturbation scene is much more detailed, for example, and the drill-murder – while not exactly *restrained* in the film – is far more outrageous in the script. The effect on the page is far closer to Ken Russell's exactly contemporaneous *Crimes of Passion*, which beat *Body Double* at the box office on both films' opening weekend – and which, of course, is not mentioned anywhere in this issue of the magazine.

[15] For further discussion of this interview, see the last section of Chapter 3.

("*Body Double*: Porn To Kill?") reinforces the idea that De Palma is a murderer, and the shadow of Hitchcock hangs over the proceedings. (It is worth mentioning that, at the time of the spread, the editor of *Film Comment* was Richard Corliss, whose attacks on De Palma are invariably about his tendency toward cinematic shoplifting.[16])

It is clear from the interview that Pally has not yet seen the film: her opening question to De Palma is "Do you think the hardcore fucking will get you an X?" Historically speaking, De Palma has set himself up for this assumption, since *Body Double* was (according to several interviews given after the release of *Scarface* in 1983) at least partially conceived as a very public affront to the MPAA ratings board, with which De Palma had had a series of confrontations. *Body Double* was going to be, De Palma said at the time, exactly the sort of film that the MPAA mistakenly thought his other films to be – an explosion of raw sex and gratuitous violence – and would deserve its X rating.[17] Probably because of these statements, Pally believes that *Body Double* will be a work of hardcore "pornography" in literally the same way that *The Opening of Misty Beethoven* would be a work of "pornography" – that is to say, that *Body Double* is marked by the inclusion of shots of erect penises, exposed labia, penetration, &c. – and that the violence would be similarly "X"-rated, perhaps passing over from Peckinpah-esque stylization into Herschell Gordon Lewis territory. This assumption is very important, and it is also very important that it is De Palma's own (perhaps ill-advised) statements to the press that engender this assumption, for it is De Palma's intentionality that is at stake. Pally spends the entire interview attempting to get De Palma to take a singular position – either for pornography or against it, for feminism or against it, for capitalism or against it – but the (necessary) ambiguity of his position is, for Pally, almost literally unreadable. Thus the counter-transference we see in Pally's asides to the reader – "He laughs. I'm getting pissed off. He's just getting off" – which speak to the difficulty, and (for Pally) the necessity, of fixing De Palma's desire and therefore discovering his intentionality. Pally, in asides like these, rhetorically suggests a certain aggression in De Palma that would easily map onto the putative relationship between the male consumer of pornography and the "real" woman that pornography destroys – or, more dangerously, onto the relationship between pornography (understood as a species of "snuff" culture) and the would-be rapist or sex-murderer liberated by the images he imbibes. (Pally herself remained suspicious of this transposition; in her next book, *Sex and Sensibility*, she noted a lack of evidence for the cause-and-effect relationship between pornography and violence.)

[16] It is also worth mentioning that the very next issue of *Film Comment* went even further: it invited such writers as Alan Dershowitz, Dorchen Leidholdt of Women Against Pornography, Janella Miller of the Pornography Resource Center, and Al Goldstein of *Screw Magazine* to debate the issues raised by De Palma's use of "images of sexual violence." Inevitably each of the contributions (there are twelve) is primarily concerned with issues of censorship – a development that might have helped De Palma decide to make a Mafia farce his next film. "Sex and Censorship," in *Film Comment* (Vol. 20, no. 6, November-December 1984, 29–51).

[17] "If they want an X, they'll get a *real* X. They wanna see suspense, they wanna see terror, they wanna see SEX – I'm the person for the job. It's going to be unbelievable" (Hirschberg 83).

When Pally broaches "the Hitchcock question" – symptomatically, at the very end of the interview – it elicits an exchange that has come back to haunt De Palma in several ways:

PALLY:	*One last question. You've often been accused of lifting from* Hitchcock ...
DE PALMA:	Richard Corliss is a big one on that.
PALLY:	*Given all those accusations, why do you still put bathroom scenes – lifting from* Psycho, *they call it – in every one of your films, including the new one?*
DE PALMA:	I throw it right in their face. I refuse to be censored by a bunch of people who have the wrong perceptions of my movies. I should listen to those nitwit critics? I don't cater to the public, why should I cater to the critics?
PALLY:	*Do you put those scenes in as a jab?*
DE PALMA:	No. If I'm attracted to something I shouldn't refuse to use it just because Hitchcock was attracted to it too.
PALLY:	*What's the attraction of the shower scene?*
DE PALMA:	Hitchcock discovered that people feel safe in the bathroom with the door shut.
PALLY:	*Not any more ...*
DE PALMA:	It's a place that when someone comes in, you really feel violated. To me it's almost a genre convention at this point – like using violins when people look at each other or using women in situations where they are killed or sexually attacked. You know, the woman in the haunted house – I didn't invent that. Women, over the history of Western culture, seem to be a lot more vulnerable than men. It has a lot to do with their being physically less strong. They made a movie with Roy Scheider being stalked in a basement. Roy Scheider is the guy who killed Jaws. Now who is going to jump out at Roy Scheider? Obviously children in peril is also something you'd connect with, but there's something too awful about that.

<div align="right">(Pally 1984b, 17)</div>

J. Hoberman called this exchange "filled with inadvertent disclosures" (Hoberman 1991, 202–203), and indeed both participants in this conversation are served badly by their behavior in it; each claims to know the limits of the other's position, but both fail to see that they are each other's repressed truth. Specifically, what each misrecognizes here is the nature of the

other's surrender to capitalism: De Palma wants to see WAP (Women Against Pornography) take an essentially Marxist stand "against porn and General Motors simultaneously," a stand that De Palma sees to be ultimately fruitless and yet more noble and intelligent than a single-issue "reformist" campaign, while Pally wants De Palma to recognize that his choice to make these images and construct these narratives is just that, a *choice*, with real-world effects and consequences that an *honest* person would *have* to consider. Clearly, both positions are correct and incorrect at the same time: one might say that each is correct for the wrong reasons and incorrect for the right ones. In the "lifting from Hitchcock" passage quoted above, this type of misrecognition is at its highest: Pally wants De Palma to see his real motives for his own choices, his phallic aggression against women, critics, and Alfred Hitchcock himself, while De Palma wants Pally to see that aggression is precisely the point of the enterprise, since Hitchcock, not to mention film itself as a medium, is about aggression – plus, capitalism itself *is* aggression. Each wants the other to recognize something basic about history: that film exists and acquires meaning in an economic and historical continuum, or that real women exist and suffer.[18] Each has a particular fantasy about what the other is looking for: De Palma thinks Pally is proposing some kind of censorship, while Pally thinks De Palma is on the trail of revenge and money (not necessarily in that order). But each is blind to the ways in which their positions are both true even as they are mutually incompatible.

The idea that De Palma might have a "message for feminism" – a *coded* message, naturally – itself also operates as a kind of doubling. One can find this idea in several scholarly articles and other feminist writings of the era (such as Linda Williams' "When the Woman Looks" or Carol Clover's *Men, Women, and Chain Saws*), but the best example is provided by Zina Klapper, who in *Ms. Magazine* (Klapper 30) ups the rhetorical ante considerably by calling De Palma "the most vicious woman-hater in Hollywood today": "even more than Alfred Hitchcock, from whom he often lifts his plots and techniques," writes Klapper, "[De Palma] is fixated on the murder of beautiful young women." In this piece – a double review of *Body Double* and *Double De Palma*, a making-of-the-movie book by *Ms. Magazine* contributing editor Susan Dworkin – Klapper expands on the logic of the Pally interview, first moving De Palma's intentionality (and self-understanding) into a certain category, the category of the Romantic artist (with the Romantic artist's attendant blindness to social context and

[18] Carol Clover (1992, 50) cites this portion of the interview – specifically De Palma's comments about the requirements of genre convention – as proof of De Palma's true feelings about gender: "When De Palma says that feminine frailty is a predicate of the suspense genre, he proposes, in effect, that the lack of the phallus – for Lacan, the privileged signifier of the symbolic order – is itself simply horrifying, at least in the mind of the male observer." The logic of this reading is not at all clear: Clover suggests that vulnerability, both for De Palma as well as for the (again unavoidably male) audient, is the ultimate source of horror precisely to the extent that it is gendered (it is the woman's passivity that is terrifying, exactly because that passivity is experienced by the audient as the specific lack of male genitalia). And yet a glance at *Dressed to Kill* confirms its essentially surrealist model of gender and agency: consider that De Palma's original script for *Dressed to Kill* opened with a "shower scene" in which the hirsute body of a man, in fetishized close-up, is shaved of its hair and then – in an off-screen cut – castrated. Undated *Dressed to Kill* script, purchased on eBay.

political causality), and then affixing a certain conservative morality to that place of blindness. "De Palma's murders are anything but meaningless, aesthetic flashes," writes Klapper. "They are rich with cogent messages about – and expressly for – women." Citing *Body Double* as a "cautionary tale" about women's sexuality – that is to say, a message from De Palma himself to all women, warning them to *stay in their place, or else* – Klapper dismisses De Palma's standard formalist defense with the unassailable logic that "the great majority of us do not wake up screaming because we've been confronted with an unappealing formal composition." The comparison here is one of rape: the formal components of visual imagery do not inflict trauma, at least not of the sort that might leave the trauma's recipient emotionally scarred enough to return to its source, its primal scene, in nightmares. Quoting Susan Dworkin's book (itself a highly ambivalent text in regards to the relationship between De Palma and women), Klapper cites De Palma's claim that "the use of murders in movies is aesthetic stuff. Motion. Form. Shapes." "Now, surely even Brian De Palma himself does not believe this is what his movies are about," responds Klapper; after all, "De Palma knows full well that he pursues the [generic] tradition in a highly selective way, magnifying its most misogynistic elements and dropping all others."[19]

This is a powerful statement, to say the least. In accepting the idea that cinematic violence against women is to be taken literally, as *real violence* against *real women's bodies*, it makes certain assumptions and suggests several things. De Palma has an intent, and that intent is to hurt women; he wants to hurt women because he hates them – and this is an *active* hatred, in that he makes these movies because of his hatred, and, most damningly, *knows* it. Meaning: he knows that it is wrong to make these movies, and when he uses formalism as an excuse, he is lying. In order to lie, one must know the truth *as truth* and in that way *believe* it, yet *choose* to ignore it; this kind of knowledge – and by fixing his knowledge, Klapper has named his desire – is what makes De Palma not just a woman-hater but a *vicious* one, a sadist, who takes a certain perverse relation to his own enjoyment and to the enjoyment of the Other. In relation to the status of *Body Double* as an intentional message to women about their sexuality, Klapper writes that "not only the 'crime,' but the means of punishment was conspicuously chosen because of its cultural implications" – meaning that De Palma not only understands himself as someone who kills and disfigures women, but also what it means *to women* for a man to disfigure women, and he understands how this action creates, and is created, by political and social meaning – and that, in turn, he understands what feminism is trying to achieve and even believes in its truth in some way, but still chooses to kill and disfigure women. (Presumably Hitchcock, by contrast, has no

[19] Ryan and Kellner (1988) offer an interesting variant on this view of De Palma's stylization, which attempts to link this tendency to De Palma's childhood: "The fantastic, exaggerated, baroque style is thus essential to the sexist vision of the films. That style constitutes a representational performance that indicates power over the world, an ability to manipulate it at will. If the child sees himself as not cared for, he will grow up not caring about the world, converting his resentment against his abandonment into a calculating, cynical, unempathetic manipulation of that world." In "Brian De Palma and the Slash and Gash Cycles," in *Camera Politica* (190).

knowledge of feminism and is therefore blameless, even though cinematic gestures like the "rape" of Melanie Daniels in the attic in *The Birds* are neither more nor less "literal" than the punishment of women that Klapper locates in *Body Double*.) Therefore De Palma has the same relation to knowledge as that figure that Žižek, after Lacan, calls "the Supreme Evil Being": a sadist who tortures his victims on behalf of a vicious God (and who is, in Žižek's formulation, in turn acted upon by other agents on behalf of the repressive state).[20] This knowing, intentional hatred of De Palma's goes hand in hand with his status as impostor, thief, pretender to the throne of a previous Great Misogynist whose memory he defiles; for these crimes, his punishment – as Klapper hopes – should be the end of his career ("Now, with *Body Double* off to a slow start at the box office, we can only hope that De Palma will finally close up his little shop of horrors – for good.").[21]

We should be mindful here of the specific cultural moment at hand: during the period of time between *Dressed to Kill* in 1980 and *Body Double* in 1984, the anti-porn movement first gained real momentum, with its puzzling-to-this-very-day coalition of Moral Majority vultures and hard-left activist feminism. The Dworkin/MacKinnon machine, for example, first swung into action in the early 1980s, and the appearance of the Meese Commission report in 1986 was but the most *obviously* hypocritical gesture of the Reagan administration's strategic alliance with a certain brand of feminism – an alliance that produced a lot of negative publicity for feminism, a small set of restrictive public ordinances, and an enormous crisis in public support for the arts. There is no point in second-guessing the decisions made by (or imagined motivations of) past activists, no matter how sympathetic or condemnatory we may feel about those decisions or motivations – although if the "personal life" and public fantasies of prosecution of Brian De Palma can be mixed indiscriminately, as they usually are, then one might turn (as several others, including Linda Kauffmann, have already done) to Andrea Dworkin's novel *Mercy*, which far surpasses the sum of De Palma's entire output in terms of traumatic repetition and sexualized violence. Given that the Dworkin-MacKinnon conception of pornography is no longer dominant – if it ever was, statistically speaking – it would seem redundant to return to it here; after all, the (extremely brave) preparation and publication of the Linda Williams anthology *Porn Studies: A Reader* would seem to indicate that this particular "blind spot" has finally become a site of investigation. But pornography is still far from "safe territory," and – as the most volatile of the quasi-objects related to Film Studies – any object in its *field of meaning*, like debris around a black hole, is ultimately pulled in.

After the *Dressed to Kill* fiasco – and perhaps looking ahead to what those events would later help to produce, a strategic alliance between auteurism and feminism – De Palma

[20] This discussion appears at least three times in Žižek's writings, but a particularly concise example of it can be found in "In His Bold Gaze My Ruin is Writ Large" (1991, 219–223).
[21] A similar note is sounded by Ken Eisen (1984), who suggests that perhaps an end to De Palma's career would be the "dark cloud's silver lining" rather than a "tragic loss." In "The Young Misogynists of American Cinema" (an article comparing Paul Schrader, James Toback, and De Palma), 35.

makes what I will call his "porn trilogy."[22] We have looked at the way in which *Scarface* operationalizes a certain horrified gaze, the liberal gaze of appalled fascination and socially legislated empathy, and we have suggested how in that film De Palma might be said to be creating a kind of pornography for, and of, and about, that gaze. Let us now frame *Blow Out*, *Scarface*, and *Body Double* together, as a trio of narratives about that gaze – about how that gaze is manipulated (by cinema, by the media, by the government), how it is fascinated (by violence, by excess, by difference), and how, ultimately, it is structurally vacant.

The Political Invisible

Cruelty has nothing to do with some ill-defined or natural violence that might be commissioned to explain the history of mankind; cruelty is the movement of culture that is realized in bodies and inscribed on them, belaboring them. This is what cruelty means.

(Deleuze and Guattari 1983, 145)

Dressed to Kill opened in 1980. *Blow Out* appeared the next year, and I would like to suggest that the chronology is of central importance in reading the way that the film has been received. Note first that the discourse surrounding *Blow Out*, both lay and professional, has tended to position the film in two mutually exclusive ways. Here is a good example of the first:

[This is] the same Brian De Palma who wrote and directed last year's brutally misogynist *Dressed to Kill* [...] The real trouble has to do with how De Palma gets "beyond" his Freudianism, specifically his preoccupation with voyeurism. How he displays his recently emergent "maturity and humanism." And, more incidentally, how he uses artistry to obscure his less seemly designs. For *Blow Out* is a typically offensive De Palma product after all: its moral claims only make its basic immorality more devastating.

(Horning 1982, 6)

[22] Of course it would be foolish to suggest that De Palma planned these three films this way. If De Palma had been able to make the films he planned to make in this period, we would have had *Prince of the City* instead of *Blow Out*, *Act of Vengeance* (a drama about the Yablonski murders) instead of *Scarface*, and instead of *Body Double*, we would have had *Fire* (a musical about a rock star – loosely based on Jim Morrison – who fakes his own death, later made by Todd Haynes as *Velvet Goldmine*). The great challenge in writing about the history of filmmaking inside the American studio system is that, at every step, things might have gone a different way: thus we might have had *The Magnificent Ambersons*, and we also might have had – for example – De Palma's alternate Howard Hughes biopic. But then again, we could have had De Palma's *Flashdance*; thank heaven for small mercies.

Here is an effective example of the second, from the same journal (*Jump Cut*), originally submitted as a response to the previous example:

> Whatever De Palma's intent was in making *Blow Out* (he has said he wanted to portray the insanity and uncontrollability of an assassination conspiracy), the effect is to leave the audience with a strong sense of the rot and utter unredeemability of this society/system, as well as the stupidity and hypocrisy of patriotism.
>
> (Bautista 1984, 65)

So on the one hand, the film is an act of rape; on the other hand, it is a critique of patriotism. (For fans like Quentin Tarantino, it is perhaps both.) As Jacquelin Bautista notes, questions about De Palma's intent are primary, and this primacy is accompanied by an instability in the way in which De Palma is understood to understand "the political." Here are our two positions again: first, Robin Wood notes that

> *Blow Out* explicitly invites us to look for connections between its two political levels, the national and the sexual [...] The celebration of a liberty created by males, for males, at the expense of women, within a culture the film has characterized as at every level corrupt and manipulative, coincides with the death of its latest victim [... The film is] an object lesson in the cost of phallic assertion. [...] For me, no film evokes more overwhelmingly the desolation of our culture.
>
> (Wood 1986, 160–161)

And on the other hand, Michael Ryan and Douglas Kellner disagree

> with the suggestion that De Palma is a progressive filmmaker whose work reflects critically on issues of morality. While his films are critical of aspects of American society, these critiques are limited to a traditional populist suspicion of big institutions (government in *Blow Out*, corporations in *Phantom* [*of the Paradise*]). In his interviews, he does voice some of the reality of feminism, but his films speak more loudly (and perhaps more unconsciously) than his words, and they stand as symptomatic expressions of a misogyny so endemic to American culture that it passes as normal.
>
> (Ryan and Kellner, 190–191)

Note that these two positions are accompanied by a generic dilemma, and that the two ways of resolving this dilemma more or less match up with them. First, there is the idea that *Blow Out* is a sadistic porno-murder fantasy masquerading as a conspiracy thriller; then there is the reverse idea, namely that *Blow Out* is a conspiracy thriller masquerading as a sadistic porno-murder fantasy. Each position is concerned with what is determinant, either at the narrative level or at the level of De Palma's putative "intent." Is the film about sex, or politics? Is it *Friday the 13th*, or is it *The Parallax View*? Is it representative of the director's childhood castration anxieties

(and adult neuroses), or is it a conspiracy theorist's misreading of Chappaquiddick? In other words, which aspect is a *red herring*, merely serving or masking the centrality of the other?

One can see how the juxtaposition of these elements might strike a certain kind of viewer – if not most viewers – as dissonant, to say the least, and indeed *Blow Out* is a highly dissonant film: there is something opaque, even *hidden* about it. It is plagued with strange tonal shifts, narrative inconsistencies and attenuations, and conceptual gestures that look like (and could be) mistakes: much of Pino Donaggio's score, especially the thudding cop-show disco music during the chase through Liberty Day Parade; Nancy Allen's anti-sympathy-generating performance as the gum-chewing embodiment of masculinist cliché (J. Hoberman calls her a "one-woman distanciation effect"); the obvious "breakaway bottle" that gets used on the head of Dennis Franz – indeed, Dennis Franz's entire performance as well as the whole conception of his character; the set of plot mechanisms that allow for the creation of a perfectly sync-sound Zapruder film out of a copy of *Newsweek* and a quarter-inch Nagra tape; the low comedy of the screamer auditions ("Okay, switch places you scream, and you pull her hair") juxtaposed with the high tragedy of Nancy Allen's death under a sky blazing with fireworks. In many ways one is perhaps led to ask: what are we meant to take seriously? Are there any parts of this narrative that we *are not* meant to take seriously, and if so, how do we know which is which (or which is determinant)? What does "take seriously" *mean*?

In this regard, we know how Sirk is imagined to have operated: when Dorothy Malone does a mambo in a blood-red gown and knocks her father dead (in *Written on the Wind*), we know that the flamboyance of the scene – the color-coordinated excessiveness of the visuals, the overstatement of the "symbolism," the tonal contradiction between the garish party atmosphere evoked by the music and the Olympian tragedy of the oil baron's stunt-doubled fall down the wide Texas staircase – is deliberately dissonant, that Sirk "meant" it, that there is a *scientifically verifiable double level of enunciation* in the film's address to the audience. We know this partially from the text itself (we can "see it" when we see it) and partially because Sirk is on record with the statement that he hung out with and understood Brecht, and that he frequently employed what we understand to be Euripidean irony, and that, indeed, he intended certain *specific* excesses (i.e. around issues of race, class, gender) as ironic in the classical sense. What is more, this deliberate double enunciation is progressive – *politically* progressive – because, in its application of various theories of theater (Brecht, Euripides) to the processes of Hollywood generic film practice, it creates, at the moment of exhibition, the possibility of the creation of an awakened (revolutionary?) spectator – perhaps we may imagine a housewife in Kansas who, at the moment that Mahalia Jackson begins to sing "Trouble of the World" to the weeping, elegantly mixed-race congregation (in *Imitation of Life*), blinks through her own tears and suddenly understands that this is *not* a dignified death, that this whole ideological fantasy is a *blanket of lies* and, in that moment of recognition, decides to leave her husband. Unfortunately the actual, historical operation of this anti-false-consciousness mechanism on contemporary spectators is difficult to verify, and so now we have two generations of film scholars who have been trained to administer questionnaires and other sociological instruments in an attempt either to substantiate or to defeat theoretical suppositions like these.

Certifiably influenced by Brecht.

For film theory in its post-1968, *Screen*-inflected context, this subversive application of left-wing theatrical strategy, Brecht in particular, would necessarily appear in an industry that, with its repressive codes of representation, was perfectly suited for the job of putting these theories to work, that is for attempting to create, within the Hollywood machine, another machine that, like the production of schizophrenics by capitalism, could bring about the end of the entire system.[23] Of course this calculated dissonance – this *deliberate* double enunciation – cannot be attributed to just any director making any film. First, it can only appear in material that is, on the face of it, reactionary: why would we single out as progressive a film that went *the other way* – that pretended to be Left but was, in fact, Right (like, say, *Nashville* or *Blow Up*)? Second, the director must *verify* his or her intent to use generic film practice as a sort of Trojan Horse device for progressive ideas, preferably in language (and with references) that a film scholar would recognize as providing sufficient theoretical architecture to supply "political awareness." By this logic, Paul Verhoeven is excluded, simply because his confessions of double enunciation are not properly footnoted; this is how something as incendiary as *Starship Troopers* – surely the smartest, most *prescient* English-language film of

[23] De Palma – specifically the De Palma of *Hi, Mom!* – links up with *Fight Club* through Deleuze and Guattari, which in its attention to schizophrenia as the real "product" of the capitalist apparatus – its *père-version*, as it were – more or less supplies the theoretical skeleton of Fincher's film in its entirety. In fact, one might describe *Fight Club* as *Hi, Mom!* plus Bertolucci's *Partner* – an equation that encapsulates what is at once theoretically coherent and politically evasive about both *Anti-Oedipus* and Fincher's film.

the 1990s – could be misrecognized so completely, even with Verhoeven's stridently antifascist statements about the film to the press. But why is De Palma necessarily excluded from this praxis, given that he was citing Brecht in interviews as late as 1974 and, at the same time, was exploring generic territory ordinarily associated with counter-progressive impulses?

Some of the reasons are, by now, probably obvious. We have excavated how De Palma is assumed to have a "double consciousness," depthless and without capacity for self-knowledge or reflection at the same time that he is assumed to know exactly what he is doing to women and why; we see that he is detached and impersonal (Kubrickian, Enlightenment-rationalist-masculinist; mechanical, cold, and cruel), at the same time that he is sneaky, untrustworthy, evasive, a thief. We have seen how this oscillation allows De Palma to remain invisible to several different discourses across several different registers; and we have seen also how a certain process that a rhetorician might identify as "scapegoating" occurred, at a certain historical moment and at a certain level of intensity, around De Palma's films as well as the figure of his authorship. And we have seen that De Palma's paradoxical (and theorized) willingness to become – or his insistence on becoming – what his more hostile critics would accuse him of already being (another *père-version*) has tended to reinforce those attitudes. Still the question remains: what are we to take seriously? The answer: we should take seriously the *process* by which we decide what to take seriously.

For example: *Blow Out*, in another common De Palma trope, opens inside another text. Just as *Sisters* starts "inside" a candid-camera stunt (itself "inside" a game show, "Peeping Toms") or *Dressed to Kill* opens inside a character's porno-rape fantasy, *Blow Out* opens inside a teenybopper-slasher flick, *Coed Frenzy*, which, when *Blow Out* begins, has already started. Thus the impression of rudely cutting into the middle of some other film's narrative: from the silence of the opening company logo, De Palma cuts straight to the POV of a serial killer, complete with heavy breathing, ominous synthesizer score, and nervously thudding heartbeat on the soundtrack. The sound of the wind is way too loud; the sound mix is cheap and too obvious, just the type that would typify something one would catch on Cinemax at four in the morning. The camera/killer's POV lingers outside a girl's dormitory, leaning against the windows and watching the inhabitants masturbate, have sex, and disco-dance in skimpy negligees. The camera limps through a door, and maneuvers into a bathroom, where "we" catch sight of "ourselves/himself" in a mirror: a middle-aged white man in a janitor's uniform, complete with thick glasses, clutching an enormous knife in one hand. "We" turn, and there is the shower, and in it the girl. We approach with the knife, the synthesizer music swells, and the girl turns, sees us, and screams.

Perhaps even before De Palma cuts to the reverse shot, we notice that we have been literally watching a movie screen: the entire opening sequence has been *projected*, and what we see of *Coed Frenzy* in *Blow Out* has been re-filmed from the image of that projection. When the reverse shot comes – John Travolta and his boss, an exploitation-film director, in the process of creating the sound mix for what is presumably the final cut of their new movie – we are moved out of one movie and into another, out of what we thought was the grounding ontological frame of the narrative and into what we now realize is the *actual* movie, *Blow*

Out, which is – so far – clearly about *movies*. And yet the movie we have been watching is, in fact, the movie that so many critics and activists accused *Dressed to Kill* of being: it embodies – it *subjectifies* – a murderous gaze that is at once fascinated by women and enraged by them; the fantasy that sustains that gaze is hypnotized by its own perception of women's animality, by their uncontrollable sexuality, and so it stages an explicitly Hitchcockian scenario in which women can first display themselves lasciviously – for our delectation – and then be punished for their transgression. We do not get to see the shower murder in *Coed Frenzy* – the obvious inadequacy of the girl's anticipatory scream brings the cut to Travolta, laughing contemptuously – but we can be sure that, true to form, it will be an act of rape, thinly metaphorized and clearly meant to put *all* women in their place.

What is it, exactly, that we are meant to "take seriously"? From the opening sequence, *Blow Out* goes on to stage a political assassination (in the form of a car, with a shot-out back tire, flying off the road and into a body of water) and a subsequent cover-up engineered by a rogue operative – a sort of G. Gordon Liddy meets The Jackal – acting on the interests of some organization or set of interests that might or might not be part of the government of the United States. The cover-up is a retroactive one: the Liddy figure will kill the key witness, the prostitute-with-a-heart-of-gold (Nancy Allen), and "make it look like a series of sex killings in the area," so that he spends the first two-thirds of the film incomprehensibly stalking and killing random women – preparing the public (and the astute viewer) for Sally Bedina's eventual death. While the rogue operative goes about Philadelphia killing women, Travolta takes it upon himself to prove that the death of Governor McRyan was not an accident, using an actual sync-sound *movie* he has constructed out of his sound recordings and someone else's still photographs of the incident. Did I say "still photographs"? Actually, the photographer took eight or ten seconds' worth of pictures at twenty-four frames a second – that is to say, Hollywood film speed – and even more conveniently, a national news magazine *immediately prints them all*, just like the infamous *Life Magazine* spread on the Zapruder film. Travolta decides to "wire" Allen in order to protect her, but he fails: in front of a gigantic American flag, in the middle of the "Liberty Day Celebration," Sally Bedina's throat is cut by the Liddy figure and she dies, the sky overhead ablaze with fireworks, in a moment that immediately (and unpleasantly) recalls an iconic moment in *To Catch a Thief*.

Out of this "unbearably putrid representation of American social reality, with Watergate, Chappaquiddick, the Kennedy assassination, Son of Sam, and the Bicentennial all conjoined in one ultraparanoid conspiracy" is produced the film's "superbly nasty punchline" (Hoberman 1991, 204–205): Sally's dying scream, which we first heard over the appearance of the film's title ("Blow Out"), is dubbed into the murder in *Coed Frenzy*. "Now *that's* a scream!" yells the director, as Travolta, clearly in *big pain*, presses his palms into his ears to blot out the sound. Freeze-frame, fade out.

What, again, are we meant to take seriously? The *one* film opens inside *another* film, a paranoid conspiracy thriller unfolding inside a slasher flick (a pair of genres that, for many reasons, are not often mixed); we get to witness – in enough detail that we can understand the nature of the process – the sound mix to a movie being created, and later we are treated

to a lengthy overview of the sync process, by which sound and image are hooked up to one another; one character demonstrates how the movie effect of a black eye is created with makeup; one scene takes place in a film developing lab, while several other scenes take place in an exploitation producer's set of offices, with grindhouse movie posters on every wall. Elsewhere, a psycho killer – or, rather, a Black Ops specialist pretending to be a serial killer, mobilizing the "audience expectations" of the local public – rolls down a dirt hill at a construction site, tightly clinging to the ends of the piano wire he has wrapped around the neck of a woman he has yanked out of a bus line. *Murder a la Mod* plays on a television while one character is knocked out with a breakaway bottle – an illusion that could easily be reinforced with montage, but which takes place in an uncut, floating overhead shot, as if to underline its artificiality. True to generic form, the cops do not believe a word of what Travolta says, while the eager newsman seems to have stumbled in from some 1930s gumshoe fantasy like *The Bat Whispers* or *Dr. X* (and the gum-chewing Nancy Allen from an imaginary grindhouse adaptation of *Gidget*). The film's wind sounds are taken from the optical track of a 16mm print of *Blow Up*. And, like *Winter Kills* or *The Parallax View*, the whole film is in red, white, and blue.

Regarding the process by which we decide what to take seriously, how can we tell what De Palma intends, and how can we tell which meaning-effects are purely aleatory? This is especially vexing when one compares *Blow Out* to *JFK*, and Oliver Stone's desperate attempts therein to generate truth-effects: not a thing in *Blow Out* is "believable" in the slightest, and we are not talking about the kind of scrutiny of narrative logic that Hitchcock would attribute to "the Plausibles." Both films are about the Warren Report, but while Stone's film is about that volume in its specificity, De Palma dilates the Warren Commission's findings – and the modernist uncertainty of the Zapruder film – into a general principle of life under capitalism, as well as under Hollywood. (Compare *Executive Action*, which in its literal-mindedness, technical ineptitude and insultingly elocutionary conceptualization might be said to represent *conspiracy film degree zero*.) Stone – like Pakula in *The Parallax View* – believes that the truth *really is out there*, even if, for the conspiracy theorist, the price of knowledge is death. De Palma starts from the assumption that the truth *is not* really out there. From the very beginning of his career he has acted on the lesson of Antonioni's *Blow Up* – that when you think you have got proof of the structure of injustice, what you actually have is usually just static. After *JFK*, the "truth" of the conspiracy disappears in a blizzard of information noise; after Watergate, the crime itself disappears. Given these circumstances, the protagonist can only and always fail – but the failure is still his own fault. Cowardice, it is suggested, is the worst excuse. (In this regard, a psychobiographer might look at the De Palma family dynamic outlined above and surmise that there was a problem with the institution of the Phallus.)

With the twinned Watergate/JFK narratives that undergird *Blow Out*, we are in the lineage of *Greetings*, with its literal collapse of the representational dilemma of *Blow Up* into the narrative dilemma of the Zapruder film; and with the ex-cop-protects-hooker-from-lunatic narrative, we take up a whole string of generic practices, from the cold, modernist

quasi-feminism of *Klute* to De Palma's own *Dressed to Kill*. The generic requirements are all met, all across the board, and it is the dissonance between these fulfilled requirements – and between the contradictory generic material and the Godardian self-reflexivity that interrupts and frames it – that makes *Blow Out* so difficult to read, to sort into coherence. By comparison, William Richert's similar *Winter Kills* (another puzzling generic slam between the assassination-conspiracy thriller and the conceptual satire, released about a year before De Palma began production on *Blow Out*) has no Godardian element and therefore, within the logic we have been describing, has no political element either[24]: for we know from Godard (as from Lacan and Hayden White) that content is determined by form. But *Blow Out*'s self-reflexivity – that aspect of its enunciation that has a direct lineage to Brechtian thought – is what, for most commentators so far, erases its political content.

Similarly, consider *Body Double*, which concerns a cuckolded – and therefore recently homeless – Hollywood Z-list actor who, while house-sitting for a friend (himself house-sitting for an unseen millionaire) in a pointedly panoptic Beverly Hills mansion-on-a-stilt, witnesses what looks like the robbery and murder of a rich heiress by a grotesquely ugly, muscle-bound character called "the Indian"; it turns out that the key to the plot resides in a porn actress, Holly Body, who may or may not have accidentally participated in the murder. While the film contains not one gesture specifically marked as comedy, there is also not one gesture in it that can be taken seriously: its continuity is so arbitrary and its narrative so preposterous *on the face of it* that it seems disingenuous for some to have understood its deadpan tone as something like a desire to be "taken seriously," either as a New Masterpiece In The Tradition Of Hitchcock or as a cautionary tale "rich with cogent messages about – and expressly for – women" (Klapper 30). It is certainly a message to feminists (and to those auteurists with whom they have strategically aligned to "purify" Hitchcock), but what is its content? If it operates on two levels, what are those levels, and how do we distinguish them from one another? What, again, are we meant to *take seriously*?

Blow Out, as we have said, is highly dissonant; tonally, is *Body Double* any different? Whereas *Blow Out* opens and closes inside a slasher pic called *Coed Frenzy* – a film that both occults and memorializes the "reality" of gendered suffering – *Body Double* opens inside a low-budget horror film, *Vampire's Kiss*. As with *Coed Frenzy*, there is no question that we are meant even for a moment to experience *Vampire's Kiss* in itself, "as a movie" – or, rather, that we are meant for a moment to experience it as anything *other than* a movie: that process that one might theorize as the "spectatorial movement towards identification" is thwarted before it can even get started by the blatant, even insistent artificiality of the

[24] And there is also *The Conversation*, an obvious progenitor to *Blow Out*. De Palma is on record with his dislike of Coppola's film (especially the way Coppola "cheats" with the double reading of the line, *"he'd kill us if he had the chance"*), and *Blow Out* is as much as reply to Coppola as it is to Andrew Sarris or NOW. But if we draw a line through these three roles – from David Hemmings to Gene Hackman to John Travolta, three techno-voyeurs who are wrapped up in a homicide and fail in their duty – we see how De Palma's version of this narrative is the most conceptually astute: it is not a modernist parable, but a joke with a punch line, and the joke is not about *alienation* or *privacy*, but about *genre*.

What are we meant to take seriously?

graveyard set, the cheap attempt at "creepy music," the loud howling of wolves in the background, and finally the descent "into" the earth of the graveyard to discover, lying in a coffin, which appears to us in cross-section, a blond vampire in a studded leather suit. The camera draws close, and then with a burst of climactic music, the vampire sits up and looks directly into the camera, snarling. He continues to snarl until we realize that he is frozen in terror. The actor is claustrophobic, and the camera pressing into his space is freaking him out. From off-screen comes the voice of Dennis Franz, a frustrated film director: "Action, Jake! *Action!*"

Less than a minute later, a cut will take us from the interior of the Los Angeles film set where *Vampire's Kiss* is being filmed to the exterior parking lot – or, more exactly, to a view of a theatrical flat on casters, painted with a desert scene, that first fills the frame and then rolls away from us, pushed toward an unknown destination by two Hollywood stagehands. This is where the film's title appears – *Body Double*, in both white block lettering and "creepy" blood-drip lettering over it – so that, as the film's title is on screen, a *mise-en-abyme* gag is going on in the background. From this moment forward, this is De Palma's basic strategy throughout the entire film: highly artificial situations and locations are presented to us, then "rolled away" in one form or another, as if to suggest to the viewer that there is nothing in this text that cannot be imagined as a purely contingent theatrical performance or a cinematic sleight-of-hand. *Body Double* could not be more Brechtian (as De Palma understands Brecht, anyway); it is as self-referential, narratively self-abnegating, and anti-pleasure-producing as a studio-financed film in the Reagan era could possibly be and still get a green light.

Rolling away the image.

It is worth taking a moment to catalog a few of the film's more outrageous moments of artificiality and its use of other types of purely visual distanciation devices. (A full list of the film's formal gags would fill a book; it seems as if there is one in every shot – like the bodybuilder suggestively feeding his girlfriend a hot dog during the opening credits, or the Lichtenstein prints that frame Craig Wasson's head in another shot.) There is the liberal use of back projection for driving scenes, even when it is unnecessary, and sometimes De Palma cuts from "real" driving shots (i.e. truck in traffic, camera on truck, truck towing car, actor in car) to back-projected shots *in the same scene* – surely a more convincing example of a deliberate technological mistake (a strategic tackiness, to paraphrase Robin Wood) than, for example, the accident-on-horseback sequence in *Marnie*. (Laura Mulvey [2007] terms this kind of aesthetic "the clumsy sublime.") There is the grotesque recreation of the famed 360-degree kiss in *Vertigo*, in which Craig Wasson and Deborah Shelton engage in highly theatrical heavy petting ("No!... Yes!") while standing on a turntable in front of a back projection of the location; it does not take a trained eye to see that the turntable and the background are turning at radically different speeds. This is not romantic verisimilitude that De Palma is trying to achieve; it appears, rather, to be a deliberate vulgarization. At another point, not long after the film's spectacularly offensive murder-by-drill, the film stops dead for what appears to be a Frankie Goes to Hollywood video – complete with Holly Johnson, in silk ascot and white gloves, looking directly into the lens as he mouths along with the gibberish opening of the blowjob anthem "Relax" – which turns out to narratively represent *another* film, specifically a porn film called *Body Talk*, into which our protagonist, an actor, has without warning stepped in full costume.[25] (He appears to have been costumed in an L.A. porn film's idea of what a stuffy film academic would wear to a departmental cocktail party: owlish tortoiseshell glasses, argyle sweater-vest, pleated slacks.) *Body Talk* itself is about as reflexive as it could possibly get: as the camera cranes down a staircase to follow a Gloria Swanson double, another camera crew enters the frame; at one particularly outrageous moment, De Palma recreates the famous "flower shop" shot in *Vertigo* – with male protagonist, screen right, ogling a woman seen in the mirror on the back of the door, screen left – and Godardizes it by having the door swing closed, revealing the camera crew in the mirror. As Craig Wasson "goes over there" so that Melanie Griffith can "show him how hot," their clothes-on sex act (and the Frankie Goes to Hollywood song) is abruptly – and insultingly – interrupted by a return to the 360-degree-beach-kiss shot and Pino Donaggio's shrill, insistently "romantic" score; at the cut, Wasson looks up from Deborah Shelton for a moment with a Three Stooges look of surprise on his face – exactly like, but exactly unlike, Jimmy Stewart looking up from Kim Novak in confusion and terror as the hotel room around him transforms into the courtyard of San Juan Bautista.

[25] As a structural gesture, the "Relax" video is comparable to the "Memo from Turner" sequence in Roeg's *Performance* – except that the Jagger song, experienced as the protagonist's drug vision, serves to culminate the film's trajectory, whereas the Frankie Goes to Hollywood song explodes the film that contains it.

On one level, this is a demonstration of how a monolithically voyeuristic male desire is said to operate: one woman is interchangeable for another; the scene of the private fantasy is always hyperbolized and therefore, when literally realized, utterly absurd; the woman is always shuddering with delight at the man's slightest touch in a fulfillment of a ubiquitous conception of phallic agency. On another level, this is a demonstration of the essentially cinematic nature of fantasy – or would that be the essentially phantasmatic nature of cinema? The Hitchcock reference, vulgarized as it is, still constitutes a gesture toward an original, *Vertigo*, which itself is read as a demonstration of how a monolithically voyeuristic male desire is said to operate – and, more often than not at this point, as a demonstration of the imbrication of the cinematic and the phantasmatic. On a third level, this is addressed to the ideal spectator in his or her utter imbecility: *you are a fucking idiot, and here is the kind of filmmaking you deserve.* This gesture is repeated at the film's climax, in which our protagonist, who happens to be severely claustrophobic (as the villain helpfully points out again), is trapped at the bottom of a freshly dug grave: during the Obligatory Expository Unmotivated Villainous Rant Ending (or OEUVRE), a carefully designed combination of zooming-and-tracking camera movement and *trompe-l'oeil* set design turns the five-foot-deep grave into a fifty-foot-deep sinkhole with reflective tarpaulin overhead. The villain tells our hero that he can have another take, and suddenly we are returned to the set of *Vampire's Kiss*, where its director – Dennis Franz, of course – threateningly tells our hero that this is his last chance. (Craig Wasson repeats this scene in the dusty leather jacket and dirty pants from the other diegetic-ontological frame, the framing film's climax, rather than the gold-hair-and-black-leather getup of the vampire film.) When Wasson jumps back into the coffin and *Body Double* proper starts back up, the climax is severely – even comically – attenuated: the unmasked white villain and his marauding white dog are abruptly hurled into the cascading city reservoir system behind them, and as Craig Wasson peers over the lip of the aeration channel to see where they went, Melanie Griffith pops up beside him and shrieks, "What are you *doing*?"

We have spoken in several instances about the De Palma strategy of staging, within the frame, a situation that mirrors the relationship between the screen and the audience; this strategy replaces the Godardian strategies that include direct address to the camera, Raoul Coutard and his camera onscreen, and so forth. Neither *Blow Out* nor *Body Double* has anything as openly anti-illusionistic as the sequences in *Week End* in which representatives of France's working class eat sandwiches and stare into the lens while an off-screen voice reads out loud from revolutionary literature, nor is either film continually interrupted by text (such as the film's title appearing on the screen every few minutes and sometimes six or eight times in a single minute, as in *Week End*). The Godardian strategies that *Blow Out* and *Body Double* do employ are self-evident; but these openly Godardian tics are matched and abutted by De Palma's technologization (or Hitchcockization) of Brecht: that is to say, that moment we call the screen–audience analogue occurs repeatedly in *Blow Out* and in a near-hysterical, screamingly insistent way in *Body Double* – especially in the film's extravagantly reflexive denouement, which stages Craig Wasson's speech to Melanie Griffith as she sits in the grave ("Are you gonna stay in there the rest of your life?") as a plea from the film to the spectator,

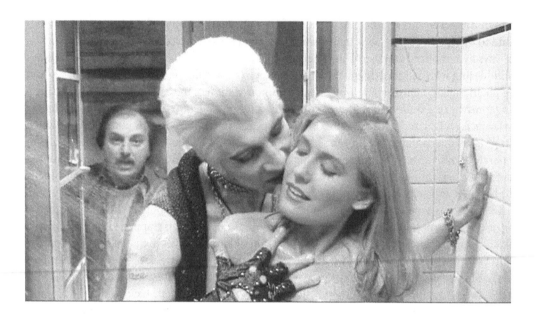

who refuses to get out of his or her theater seat and recognize that *this is the movies*.[26] Melanie refuses to stand up (only her head and shoulders are visible, like a movie-theater patron in a film) and we fade to black – only to be confronted by a cut to a vampire bat on a string, bouncing up and down in front of the camera. The final sequence of *Body Double* – over which the end credits roll – returns us to *Vampire's Kiss*, and the last of De Palma's "shower scenes": Craig Wasson rises up into frame in full studded-leather-and-Melanie-Griffith-hair drag and makes out threateningly with a stereotypically "cute" blonde co-ed in a shower, and as he is about to bite into her neck, Dennis Franz appears in the window and shouts, "Cut!"

We do not, however, cut: the camera keeps running as the woman is replaced with another actress, the most literal "body double" in the film, who has much larger breasts (or so we assume – we do not see the original actress' breasts). This process takes quite a while and involves several off-screen stagehands; there is enough time, for example, for the new actress (who has red hair, a Bronx accent, and a wad of chewing gum in her mouth) to warn Wasson that "my breasts are very tender – I'm having my period." Finally the camera is lowered so that her breasts fill the screen, and we move back into the ontological frame of *Vampire's Kiss*, with the effect of montage visibly creating an illusory continuity between two actresses – two fragmented parts, as Mulvey would say, of the ideal female body – as Pino Donaggio's cliché horror-movie score resumes on the soundtrack and the anticipatory moans of one actress help to join her head with another woman's body. The film's last shot

[26] I suggested earlier that the screen–audience analogue moment in the insane asylum in *Dressed to Kill* puts the movie on the left and us, the audience, on the right; in this shot in *Body Double*, let me suggest that Film Studies is on the left, and Brian De Palma is on the right.

begins with the sound of the vampire crunching into the co-ed's neck; the image that fades to black under the credits – De Palma's last word on the subject, as it were – is of blood pouring down the body double's breasts as the credits roll over them.

Even with this cataloging of anti-naturalistic effects across both films (which could go on for another dozen pages), we have still failed to address the central issue with both *Blow Out* and *Body Double*: how to resolve them – especially *Blow Out* – into coherent, readable theses. It is plain that most critics and scholars who confront these films assume that they are littered with poor aesthetic choices and pervasive illogic – precisely like *The Birds* or *Marnie*. But this *Verfremdungseffekt* is not necessarily dependent on intentionality for its efficacy of operation – and in any event, I would think we have done enough to demonstrate that De Palma's films are, each and every one, the end result of a process of abstract theorization, a process that combines *a certain political consciousness* and *a certain history of politically charged experiences* with a certain *scientific approach to problem solving* and a certain constitutional *detachment* or *alienation* from what we might call "the human scale" of bourgeois, liberal thinking, including certain dominant conceptions *of blood, fear, the body*, and *death* – and that this alienation expresses itself structurally as both *humor* and *hyperbole*.

Does this theorization guarantee coherence? It certainly guarantees abstraction. But I would like to suggest that one can, and must, read each film as De Palma's double response to the culture's *return of his letter* – that is to say, that *Blow Out* (for example) is something like Paul Willemen's "Letter to John," a theoretical reply to a theoretical argument on a difficult or dangerous topic such as pornography, at the same time that it is a *père-verse* gesture, an impudent and catastrophic literalization of the commands of authority. In this way, *Blow Out* is literally *about* the responses – critical, activist, feminist, academic – to *Dressed to Kill*. We have seen how *Dressed to Kill* "addressed" the struggles of women (the imperative to connect with one's own authentic desire, for example) by personalizing Kate Miller before her demise; combined with the Hitchcockian gesture – that is the theorization of *Psycho* as a complex structural machine, ready and available for co-optation – this transgression against feminism brought *Dressed to Kill* and its director a notoriety that De Palma evidently found bewildering. (It is clear that he continues to find it bewildering to this day.) In retrospect, it was perhaps only to be expected that De Palma would choose to address both of these discourses at the same time: in other words, that he would theorize film genre and feminist politics as different sides of the same dilemma.

The question of surface and depth – which is a lure, the sex or the politics? – is *itself* a lure. It is a lure as surely as the murders of young blond women that the Black Ops agent commits are a lure: they divert the public gaze from the issue at hand, which is the hand of the State in the death of Governor George McRyan, but then again they *are* sex-murders, functionally speaking – that is to say, as murders they are motivated symbolically, if not pathologically, by sex. The question of motivation is a Moebius strip: there is nothing but surface, and any question of causality leads you back where you started – that is to say, nowhere. In this way the popular (generic) notions of *sex crime* and *capitalist exploitation* are hopelessly blurred.

Blow Out is most Hitchcockian in the way it uses all of these narratives in their historical resonance – the stalkings and killings of random blond women, the assassination, the tapes, the photographs, Manny Karp, Liberty Day, and so on – to keep the audience from knowing where they are actually going to go, just as

> the first part of the story was a red herring – that was deliberate, you see, to distract the audience's attention in order to heighten the murder. We purposely made that beginning on the long side, with the bit about the theft and her escape, in order to get the audience absorbed with the question of whether she would or would not be caught [...] You turn the viewer in one direction and then another; you keep him as far as possible from what's actually going to happen.
>
> (Hitchcock, quoted in Truffaut 1985, 269)

– which is to say, that all of *Blow Out* is a machine built to deliver a single punch line: the joining of Sally Bedina's dying scream to the body of an about-to-be-slaughtered co-ed, one "true" scream (the scream of *actual fear*) replacing the "fake" scream and giving it "truth." But in this process the *real* "truth" of Sally's death is successfully erased; even though our protagonist manages to kill the Black Ops agent, he is too late to save the girl – like Pvt. Eriksson in *Casualties of War* or Jake Scully in *Body Double*, he *fails*, as a De Palma protagonist must generally do. (The erasure motif is central: in a barely metaphorical way, *Blow Out* entirely transpires within the eighteen minutes that it took for Nixon to wipe a particular stretch of tape.) And so Sally – the final proof, the last evidence that the death of McRyan was an assassination – becomes a statistic, the last victim of the Liberty Bell Strangler, and her dying scream ends up in a slasher movie – adding that touch of verisimilitude, that hidden connection to an actual referent (the real suffering of real women) that exploitation film, to be effective, requires. What matters here is that, far from being a symptom or even a cause of masculine rapaciousness, *Coed Frenzy* – the movie that is, unknown to everyone but our protagonist, a snuff film – turns out to be essential evidence; without it, there would be *no evidence of sexual oppression at all*, since the entire culture is built to cover over the fact of power relations, to exclude *cruelty* from the possible – an idea that exactly mirrors canonical feminist arguments about the forced invisibility of sexual violence. And the public event that the good citizens of Philadelphia understand as the "random sex killings" of the Liberty Bell Strangler is similar to *Coed Frenzy* in precisely and only one way: they both appear to be pathological in origin, but each really has only one function – to divert attention from the crimes of the State. De Palma's choice to drain the assassination itself of all "specific" political content (i.e. what *party* does McRyan belong to? which *side* wants him killed?) removes all the distractions that that specificity would produce, so that the State expands in all directions: even if Burke is a "rogue operative," so that the Conspiracy is born through accident and accretion, he is still the State; Left or Right, liberal or conservative, it makes no difference – the State acts upon each of us, and because we do not care, we submit.

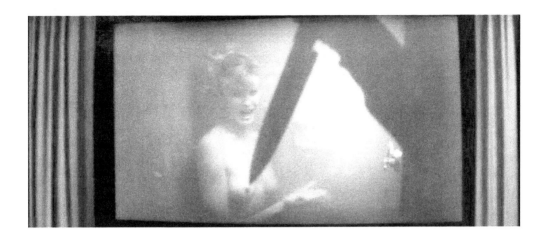

The film that Jack Terry produces in *Blow Out* – the impossible Zapruder film that "proves" beyond a reasonable doubt that McRyan's death was not an accident, that it was an *authored* act – operates like a scientific experiment in that it recreates an impossible vantage point of witnessing, a perfect seeing presence that stands in for all of us; it embodies "the truth that we hold to be self-evident," a truth that is supposed to hold democracy together. And yet whereas someone like Godard, perhaps because of the influence of Jean Rouch and Andre Bazin, understands film to be truth at twenty-four times a second, De Palma – as he himself is so fond of pointing out – understands film to be a technology of untruth; the camera *lies* twenty-four times a second. If *Gone with the Wind* (or, *pace* Godard, any Marxist-Leninst film distributed in a million prints) is a lie, then the Zapruder film is a lie; and if the Zapruder film is a lie, then pornography is a lie. It offers no more "truth" of a crime than the Zapruder film; Sally Bedina's dying scream is exactly like the tennis ball that David Hemmings catches at the conclusion of *Blow Up* – there's "something there" exactly insofar as the protagonist makes the gesture of catching it. (Like a constellation in the night sky, its existence is merely a trick of perspective.) What we have instead – in both *Blow Out* and the Zapruder-esque film that Jack Terry creates inside *Blow Out*, in both the Zapruder film itself and in pornography, in *Halloween* as well as Bonnie Klein's *Not a Love Story* – is a set of practices, a sequence of productions and stagings and acts, the movement of labor, work, capital – and then consumption and reception, interpretation and disavowal, and so on. This is how *Blow Out* offers a clearly articulated and fully theorized position on pornography. As a missive it is almost certainly addressed to the organizers of the NOW/WAP boycott; he was to repeat the central thesis, three years later, to Marcia Pally in their *Film Comment* interview, and while one may fundamentally disagree with the presuppositions of his argument, there is no doubt that he has a coherent logic and articulates a position, a position that one can find operating at the structural level – as in a thesis play – in *Blow Out*:

DE PALMA:	The history of radical movements in this country has been that the media addresses itself to the minor issues because there's no way they can deal with the major ones. If people are worried about aggression, then we shouldn't live in a capitalist society. Capitalism is based on aggression, and violence against women has to do with aggression. That aggression is fanned constantly.
PALLY:	*The anti-porn people think pornographic [video] cassettes and cable and magazines and your movies are all dangerous.*
DE PALMA:	Then we get into where you draw the line and the effects of drawing that line. Cigarettes are death and we still sell them. If you can't prevent me from smoking cigarettes then you can't prevent me from buying porn. People have a choice; nobody has to walk into my movies. Why not have an endemic boycott of films they don't like?
PALLY:	*Do you think they'd be successful?*
DE PALMA:	If they got enough support they could, probably... if that's the way society is going to go then I'll have to stop making movies. But to me that's like the revolution of the Sixties – trying to create a revolution in a society that doesn't really want a revolution. I don't think too many people want to burn down the banks; they have car payments and mortgages. Profit has become the moral justification for selling cigarettes. If you say that capitalism is the best system and free choice is necessary, you're going to have to accept that cigarettes and porn are going to exist. They make a profit, and people have the choice to buy them.
	[...]
PALLY:	*Are women affected by the profit motive?*
DE PALMA:	Of course. I think it's behind a lot of the women's movement. Women want a piece of the pie too – and why should they be deprived of what we've had?
PALLY:	*Do you think women are aggressive?*
DE PALMA:	Sure. They're being affected by the same system that men have been. If you want to change all of society you have to protest porn and General Motors simultaneously. I want to see WAP take that position.

PALLY: *I think a lot of them would.*

DE PALMA: Then they have to start trying to get legislation against both
 industries, and they will get nowhere. So they focus on porn. They
 get a lot of attention because the media loves to put anti-porn stuff
 on the air. You get the jollies of porn and you get to feel righteous
 at the same time. And you get to sell General Motors too. You can
 go live in places in this country where the profit motive is not so
 important. I'm sure I can go out and live in Maine and get a job
 in a mill and earn $200 a week – or maybe a month – and I'd be
 totally unaffected by the profit motive of this country. But if you're
 going to live in one of the power capitals…

PALLY: *Unless they closed the mill.*

DE PALMA: Then you'd have to go someplace else. But don't come to Manhattan
 and talk about pornography – it's ludicrous.

 (Pally 1984b, 15–17)

While his conclusions and rhetoric might be glib, even adolescent, this passage represents
the clearest statement of De Palma's politics: he sees this collapse, of the Utopian social
project into what he might identify as "single-issue politics," as the terminal point of the
radical impulse. *Sisters* clearly displays De Palma's at least nominal sympathy for "feminism"
as he understood it in 1972 and 1973; he identified with it precisely insofar as he could
map his *own* loss onto *its* loss, his failure onto its failure – exactly because feminism was
part of the 1960s, a strand of the great web that included civil rights activism and the
anti-war movement, and this singularity facilitated the ease with which it could be used
as a metaphor. But the movement lost, as all "radical movements in this country" do, as
De Palma did, as Godard did, as Welles did. Thus, when *Dressed to Kill* – which is as close
to a gesture of what Hitchcock would call "pure cinema" as De Palma had ever attempted,
and until *Femme Fatale* would ever attempt, to essay – is released, the feminist response to
the death of Angie Dickinson will represent, for De Palma, a prime example of "missing the
point." (A certain kind of feminism will accuse De Palma of exactly the same mistake, with
just as uncomplicated a claim to truth.) When Sally Bedina is killed, it is a horrible tragedy;
suffering is *non est disputandum*. But (as in *Redacted*) images can be used to make anyone
believe anything; the death-by-rape-by-electric-drill of Gloria Revelle in *Body Double* – with
its outrageous intimations of phallic monstrosity and way-past-overt, specifically *political*
provocation – represents the culmination of this logic, in which there is no longer a "real
person" to engage with as an object of empathy. (Deborah Shelton was doubtlessly cast for
her Nagel-print artificiality; she is a "real woman" the way that *All My Children* is "real
life.") Over a decade later, when De Palma returns to the themes of imagemaking-as-lies and
femininity-as-lure in *Snake Eyes*, he will provide a literal eye floating over the field of battle –
a television camera nestled in a huge, Magritte-like eyeball balloon – which, when it offers

up its "truth," does no more to help provide justice for the murdered Cabinet official than does the loathsome protagonist's conspiracy theorizing. Instead, as Thomas Y. Levin points out, De Palma "exposes a certain regime of narrative cinema as fundamentally complicit with certain aspects of the visual economy of surveillance" (Levin 2002, 589) – the key word here being *economy*, that which constitutes a system of exchange value and which thereby motivates every person invested in this system to maintain and protect it, even – perhaps especially – those persons who imagine themselves to be combatants against it. At the end – in *Phantom of the Paradise*, in *Blow Out*, in *Snake Eyes*, even in *The Black Dahlia* – the conspiracy is broken and the villain destroyed, but no one cares, just as in *Casualties of War* no one cares about the dead Vietnamese girl, and just as in *Sisters* no one cares about the dead "black guy," and no one cared about *Get to Know Your Rabbit*. *I failed to stop the murder and save my movie*, says the De Palma protagonist, and *no one cares, not even my parents*.

This is why almost every single De Palma film that we would mark as "personal" ends with the protagonist in defeat, or else no better off than he was at the film's opening: in the end, there is nothing but the knowledge that one could have done better, but did not – and that, regardless of one's success or failure in producing justice, the spectator will also fail. Therefore that which is truly political is, in effect, *invisible*, since political imagery is always a distraction from what one is not supposed, and does not *really* want, to see. And so one is led to ask: how, after the colossal spectatorial failures of Vietnam and JFK and Kent State and Watergate et al., can De Palma possibly care about entertaining "us"? By the time of *Femme Fatale* (2002) – which stages a fantasy of De Palma's rebirth by imagining what it would be like if he could wake up again in 1970 not yet having said "yes" to *Get to Know Your Rabbit* – De Palma is beginning to make films composed entirely of subtext. After this point, there is no longer any attempt in his "personal" filmmaking to make any sense, to ensure that his message to the Other is legible past the barest gestures toward generic form, since time and again it has been proved that "we" – the industry, the public, the Left, feminism, the Warren Commission, De Palma's parents, Martin Scorsese – are incapable of reading that message (on those few occasions when we actually try). Think of *Redacted*, De Palma's latest film at this writing: given the preposterous circumstance of America's entry into this latest overseas war, De Palma returns immediately to *Casualties of War*, transposing its narrative into the new language of YouTube in much the way that the American soldiers in Fallujah transposed the original Vietnam rape-murder reported by Daniel Lang in 1969 to the new digital battleground of the Middle East. *Redacted* is – to employ an overused phrase – a true "howl of rage," perhaps the bitterest and most sarcastic film that De Palma has ever made; it is suffused with a simple, uncompromising, hopeless anger that recalls (for example) the solo records of John Lennon.[27] In his interviews promoting the film, De Palma was clearly infuriated, both by the governmental idiocy that would allow Vietnam to occur all over again *and* by the cultural idiocy that made proto-fascists such as Bill O'Reilly suggest that De Palma

[27] See the forum on *Redacted* conducted by The San Francisco Brian De Palma Theory Collective (www.panix.com/~mito/sf-bdp-tc/redacted/).

was guilty of treason for making *Redacted*. In nearly every one of these interviews, De Palma literally says that *he made the movie to stop the war* – a huge gesture, in spirit not unlike the attempt to levitate the Pentagon or to stop the war in Vietnam by occupying a campus building. And yet he knows in advance that no one will care, that no one will even bother to read his film in any terms other than their own preconceptions about Brian De Palma; therefore he explodes the narrative into a thousand pieces, encourages his cast to perform exactly as if they are high-schoolers (or very young American soldiers) displaying themselves on YouTube,[28] makes explicit references to a dozen movies (from *The Wild Bunch* to *The Untouchables*), and ends the film with a horrifying montage of atrocity photographs from the front lines in Iraq – a gesture that resembles the "Be Black, Baby!" sequence in its structural deployment of extreme spectatorial unpleasure. This is how De Palma might be said to have a purely *negative* politics, as Adorno might be said to have had; and there is no place, in Film Studies as we understand it, for a conceptualization of what that might mean.

To be sure, we are here faced with a redefinition of the traditional division between "personal" and "commercial," if indeed there can be said, in the world of professional filmmaking, to be *any* division between these registers. We might suggest that De Palma, since *Mission: Impossible*, has occupied the position that Pauline Kael claimed for Sam Peckinpah in the mid-1970s: in 1976, she wrote that Peckinpah's "new film, *The Killer Elite*, is set so far inside his fantasy-morality world that it goes beyond personal filmmaking into private filmmaking [...] There's no way to make sense of what has been going on in Peckinpah's recent films if one looks only at their surface stories" (1980, 112–115). After a certain point, Peckinpah, like De Palma and Coppola, only made movies about making movies in Hollywood, and this is what gives these directors' work their allegorical dimension: even their crappiest films (*Convoy*, *Wise Guys*) index a private morality shaped, largely, by indignities and betrayals they suffered at the hands of a specific set of Hollywood corporate decision-makers. There is also, with these directors, the extraordinarily complicated issue of violence and gender: but let us say that Peckinpah did not usually give women any dialogue at all. Might we compare these directors' work as a way of beginning to index how *cruelty* operates as a political metaphor?

Peckinpah, of course, died relatively young, and never learned how – as De Palma said of Orson Welles – to make the greedy men work *for* him. He left behind a row of sad, ugly movies, most of which were taken away and forcibly co-authored by others. Here is Kael again:

> Peckinpah likes to say that he's a good whore who goes where he's kicked. The truth is he's a very bad whore: he can't turn out a routine piece of craftsmanship – he can't use his skills to improve somebody else's conception. That's why he has always had trouble. And trouble, plus that most difficult to define of all gifts – a film sense – is the basis of his legend.
>
> (112)

[28] For those who are bewildered by the performances in *Redacted*, *Cahiers du Cinéma* has put together an invaluable guide to the original YouTube videos that De Palma used as reference material: see www.cahiersducinema.com/Redacted-A-Geneaology.html.

The spectator will always fail.

"I failed, sir ... to stop them."

The return of the prostitution metaphor here is not accidental. De Palma is still making movies, which means at some level that he, unlike Peckinpah, *is* a "good whore": more so than Coppola, he can work within the system, which means "using his skills to improve somebody else's conception," and this in turn means that he knows how to make the greedy men work *for* him. But if this metaphor operates in De Palma's consciousness – the prostitution metaphor, that is – it likely matches Godard's construction of it, in which prostitution is a point at which dozens of global discourses and practices meet, and none of them can operate there without the others: gender, economy, integrity, public space vs. private space, performance, technique, generic form, and even signification itself are all at work around prostitution, both as metaphor and as fact. It is the dominant metaphor in the thought of the Left at a certain point in the Vietnam era; this is partially how the bodies of women can become, in De Palma as well as Coppola and Lucas et al., mere screens. Objectification, ultimately, merely *is*. When Ving Rhames delivers his chilling monologue about his youthful experience in a whites-only hospital (in *Casualties of War*), he and Michael J. Fox represent two authorial positions: that of De Palma himself circa 1969, and De Palma himself circa 1973. One of them is telling the other *not to try*; the other tries anyway. What can we expect from justice? What can we expect from ourselves and from others, in relation to being, as Rhames puts it, "on the side of righteousness"? What we can expect, says De Palma, is to be bought. Even the Left – even feminism – has its price.

Thus the prostitution metaphor and the theme of failure are intertwined and global, just as much for De Palma as it is for Godard (and for Peckinpah as well). In the end, the social process that we call reification is merely one way of abstracting the notion of prostitution into a term that recognizes depersonalization as an instantaneous process, and perhaps it is not too outrageous to suggest that, for De Palma in particular, the tendency to allegorize Hollywood practice is at once a way of theorizing reification and acceding to, or choosing

to own, one's failure. That is the price of living in capitalism, for if one is not engaged in a real effort to destroy that system – or even, perhaps especially, if one *is* – then one accedes to it, and that is the truth regardless of what one tells oneself about one's politics and one's commitment. One sells and one is sold. To paraphrase Brecht[29]:

> Every morning, to earn his bread,
> Brian De Palma goes to the market
> Where lies are bought.
> Full of hope,
> He mingles among the vendors.

[29] Cf. the poem "Hollywood," in *Bertolt Brecht: Poems 1913–1956* (1987, 382).

Conclusion

Norman Bates and His Doubles

Literature is either the essential or nothing. I believe that the Evil – an acute form of Evil – that it expresses has a sovereign value for us. But this concept does not exclude morality; rather, it demands a *hypermorality*. Literature is not innocent. It is guilty and should admit itself so. Action alone has its rights, its prerogatives.

– Georges Bataille (1973, ix)

I would like to end by talking about two books – two manifestos, one might say – both of which were published in the 1990s, and both of which were controversial to a quite unprecedented extent. Each was immediately framed as a public threat and violently excluded, and yet each was barely read and certainly almost never discussed in its specificity. And each was the object of a huge outpouring of interpretive discourse, discourse that invariably missed its object as surely and as thoroughly as Columbus missed India.

Let us start with the first. Here is a representative section – representative not in the *statistical* sense but in the sense of correctly representing the *public perception* of the text. By way of setup, let us say that the narrator is, at this point, describing his experience of himself as a colonial mentality. The scene involves two prostitutes. Naturally, we are in the first person:

I awaken only when one of them touches my wrist accidentally. My eyes open and I warn them not to touch the Rolex, which I've kept on during this entire time. They lie quietly on either side of me, sometimes touching my chest, once in a while running their hands over the muscles in my abdomen. A half hour later I'm hard again. I stand up and walk over to the armoire, where, next to the nail gun, rests a sharpened coat hanger, a rusty butter knife, matches from the Gotham Bar and Grill and a half-smoked cigar; and turning around, naked, my erection jutting out in front of me, I hold these items out and explain in a hoarse whisper, "We're not through yet ..." An hour later I will impatiently lead them to the door, both of them dressed and sobbing, bleeding but well paid. Tomorrow Sabrina will have a limp. Christie will probably have a terrible black eye and deep scratches across her buttocks caused by the coat hanger. Bloodstained Kleenex will lie crumpled by the side of the bed along with an empty carton of Italian seasoning I picked up at Dean & Deluca.

(Ellis 176)

This is, unmistakably, the world of Bret Easton Ellis's notorious *American Psycho*, a novel described as "a monstrous book" (Norman Mailer, quoted in Plagens 58) or "a kind of advertising for violence against women – and one thing we know about advertising is that it works" (Dwyer 1991, 55).[1] If there is an analogue in recent American literature to the sort of automatic invisibility-through-hypervisibility that De Palma triggered in the early 1980s, it is this novel, which prompted one of the most extraordinary displays of media hand-wringing and corporate disavowal in the entire post-Vietnam era. There is no need to rehearse the history of the book's reception, but let us note a few common themes in the way the book was generally discussed upon its first appearance. There is the idea that the book is merely an act of pornography, a solicitation to violence against women, an expression of hatred for them; there is also the idea that the book is satirical, that it expresses the viewpoint of a character (a murderous Wall Street executive) whom the book (the author? the reader?) views negatively – but the book is *bad* satire, incompetent and badly written, and that the main character is too shallow to be a real person:

> Bret Easton Ellis would presumably argue that *American Psycho*, being a satire on the Reagan era, need not be overly literal. But having chosen to write his book in an ultra-naturalistic style, Ellis is stuck with the conventions of naturalism, which include a certain amount of surface plausibility, of which *American Psycho* has none whatsoever.
>
> (Teachout 1991, 45 – 46)

What is more, the book is to be understood as a social problem, a product not just of one man's sickness (Bret Easton Ellis's sickness, that is) but of a social sickness: *National Review* links the book (through Ellis's time at Bennington) to "the modish brand of academic nihilism that goes by the name of 'deconstruction,'" while Vintage Books president Sonny Mehta said of it, "one may not necessarily like the book, but it does reflect something of our times" (quoted in *Newsweek* November 26, 1990, 85). More to the point, the defenders of the book were said to

> invoke what might be called the Masters and Johnson law: better to know these things than not to know them, and fiction is our best probe into the dark side of the human condition. Although the novel will not likely cause any real deaths (unless chanting Giorgio Armani can kill), it does up the ante.
>
> (Plagens 1991, 58)

At the time of the book's release, there were no truly positive reviews; even the sympathetic reviews – those that understood the novel to be *satirical*, if not necessarily *good* – defensively positioned themselves against "real" violence, as if there were no way to like the book or to discuss it in depth without contamination by its more dangerous aspects.

[1] Quoted by Dwyer, but uttered by a Canadian anthropologist who, according to the article, had not read the book.

I have brought *American Psycho* into the discussion for several reasons – some of which are probably already obvious – but the most important of these is doubtlessly Pat Bateman's taste in film.

> "I like the part in *Body Double* where the woman… gets drilled by the… power driller in the movie… the best," I say, almost gasping. It seems very hot in the video store right now all of a sudden and after murmuring "oh my god" under my breath I place my gloved hand on the counter to settle it from shaking. "And the blood starts pouring out of the ceiling." I take a deep breath and while I'm saying this my head starts nodding of its own accord and I keep swallowing, thinking *I have to see her shoes*, and as inconspicuously as possible I try to peer over the counter to check out what kind of shoes she's wearing, but maddeningly they're only sneakers – *not* K-Swiss, *not* Tretorn, *not* Adidas, *not* Reebok, just cheap ones.
>
> (Ellis 113)

Body Double is Pat Bateman's favorite movie: he has rented it thirty-seven times – so many times that the clerk has a "horrified reaction" upon seeing him in line at the register with the video again. Pat Bateman is the film's ideal audience. But which *Body Double* has he seen? Is it *Body Double*, by Brian De Palma, or is it "*Body Double*" by "Brian De Palma," the antifeminist fantasy-object – the image-text that *forces* men to rape, a fantasy object that we might call "the Pornograph" – that nearly sent a generation of American men into a frenzy of rape and power drilling? Pat Bateman is the perfect spectator for *Body Double*, as not only does he love the movie, he watches it over and over. Why? Because he, too, just like "Brian De Palma," is compelled to murder women, heartlessly but with *special enjoyment*, on behalf of men everywhere. Pat Bateman is Mulvey's (or Dworkin's) perfect male spectator, but with a difference: he is sadistic and voyeuristic and everything else in between – but, rather than these processes being unconscious, they are primary and conscious for Bateman. He has some understanding of his own sickness as a product of social processes, which gives him, much like Zina Klapper's idea of De Palma (or Martin Amis's), a kind of impossible double consciousness:

> there is an idea of a Patrick Bateman, some kind of abstraction, but there is no real me, only an entity, something illusory, and though I can hide my cold gaze and you can shake my hand and feel flesh gripping yours and maybe you can even sense our lifestyles are probably comparable: I simply am not there. It is hard for me to make sense on any given level. Myself is fabricated, an aberration. I am a noncontingent human being. My personality is sketchy and unformed, my heartlessness goes deep and is persistent. My conscience, my pity, my hopes disappeared a long time ago (probably at Harvard) if they ever did exist. There are no more barriers to cross. All I have in common with the uncontrollable and the insane, the vicious and the evil, all the mayhem I have caused and my utter indifference toward it, I have now surpassed. I still, though, hold on to one

single bleak truth: no one is safe, nothing is redeemed. Yet I am blameless. Each model of human behavior must be assumed to have some validity. Is evil something you are? Or is it something you do? My pain is constant and sharp and I do not hope for a better world for anyone. In fact I want my pain to be inflicted on others. I want no one to escape. But even after admitting this – and I have, countless times, in just about every act I've committed – and coming face-to-face with these truths, there is no catharsis. I gain no deeper knowledge about myself, no new understanding can be extracted from the telling. There has been no reason for me to tell you any of this. This confession has meant nothing…

I'm asking Jean, "How many people in this world are like me?"

She pauses, carefully answers. "I don't… think anyone?" She's guessing.

"Let me rephrase the ques – Wait, how does my hair look?" I ask, interrupting myself.

(Ellis 377)

Patrick, as a character – and the word "character" is exactly the problem – has no problem theorizing his behavior; he understands himself as a byproduct of a larger structure and sees his actions as his own and as nobody's. This recalls the scene in *Schindler's List* with the Nazi commandant trying to decide, out loud, whether or not to seduce his lust-object, a Jewish girl – a scene which, as Žižek points out,

presents a (psychologically) impossible position of enunciation of its subject: it expresses his split attitude towards the terrified Jewish girl as *his direct psychological self-experience.* The only way to express this split correctly would have been to stage the scene in a Brechtian way, with the actor playing the Nazi villain directly addressing the public: "I, the commander of the concentration camp, find this girl sexually very attractive; I can do whatever I want with my prisoners, so I can rape her with impunity. However, I am also imbued with the racist ideology which tells me that Jews are filthy and unworthy of my attention. So I do not know how to decide."

(Žižek 2001, 70)

Žižek reads this scene as an example of the "falsity" of *Schindler's List,* and then turns to Hannah Arendt and her "banality of evil" thesis in order to show how this potentially Brechtian moment is nullified by Spielberg's choice to stage the scene as psychological realism. And yet this is what Bret Ellis does in *American Psycho,* to the reverse effect: the entire novel is staged as a character's direct self-experience, and the effect is finally Brechtian: as the "grounding" of the character's verisimilitude begins to fracture and evaporate, the reader finally has nothing but his or her own reading. By the time Bateman is buying Dove bars with bones in them and, at a possibly redemptive and tender moment with a woman, having a hallucinatory moment of empathy with a starving child in Africa, the character has completely disintegrated. Which is not to say that he has "gone insane." Patrick Bateman, after all, is not there.

Conclusion

The conversation follows its own rolling accord – no real structure or topic or internal logic or feeling: except, of course, for its own hidden, conspiratorial one. Just words, and like in a movie, but one that has been transcribed improperly, most of it overlaps. I'm having a sort of hard time paying attention because my automated teller has started speaking to me, sometimes actually leaving weird messages on the screen, in green lettering, like "Cause A Terrible Scene At Sotheby's" or "Kill The President" or "Feed Me A Stray Cat," and I was freaked out by the park bench that followed me for six blocks last Monday evening and it too spoke to me. Disintegration – I'm taking it in stride. Yet the only question I can muster up at first and add to the conversation is a worried "I'm not going anywhere if we don't have a reservation someplace, so do we have a reservation someplace or not?" I notice that we're all drinking dry beers. Am I the only one who notices this? I'm also wearing mock-tortoiseshell glasses that are nonprescription.

(Ellis 395–396)

This would on some level be a "satire of consumerism," but the more one examines this idea, the more it disintegrates. The depth of the misunderstanding of Ellis' novel is symptomatized in the replacement, in Mary Harron's sympathetic but ultimately misguided film version, of *Body Double* with Tobe Hooper's *The Texas Chainsaw Massacre*. Hooper's film is complicated, but it can be convincingly placed in a Left paranoid lineage that would include *The Parallax View* and *Easy Rider*. *Body Double*, however, cannot. *Body Double* is Hitchcock; it is Godard reading Hitchcock; it is De Palma reading Godard reading Hitchcock; it is De Palma reading *Ms. Magazine* reading De Palma reading Godard reading Hitchcock. Like *American Psycho*, it is recursive at every level; there is no solid surface to step down to.

In this way *American Psycho* teaches you to read, just as *Body Double* teaches you to watch: rhetorically, Ellis sets two traps for the reader and waits for you to fall in. The first, as we have seen, is that *American Psycho* is a vile work of antifeminist pornography, a grotesquely cynical attack on the very people who happen to be at the mercy of a patriarchal "information capitalism." The second is that *American Psycho* is a "satire," somehow exposing the way in which those "in power" relate through that same "information capitalism" to those whom they oppress (i.e. through a cinematic projection of phantasmatic masculine agency). These two positions are set out for the reader by the novel itself; they are indicated for you; they are *lures*. The real point of the novel – the grandiose, adolescent heart of its logic – is that if you fall into either of those two traps, *then the book is about you*. Brian De Palma plays precisely the same game with *Blow Out*, *Scarface*, and *Body Double*; he anticipates two subject positions, two ways of "not getting it," and – since he is, after all, a *film* director – stages them for you, right in the middle of the frame.

Pat Bateman is over-involved, passionate, murderous; he is also cold, detached, impersonal. He is merely the embodiment of the contradictions of capitalism; he is singular, insane, incoherent. He is all surface and no depth; he is no surface and all depth. He is double; he is *Body Double*. In other words, he is De Palma – or, rather, he is "De Palma." I am not suggesting that Bret Easton Ellis, in *American Psycho*, wrote a novel about Brian De Palma;

209

I am suggesting that Bret Easton Ellis, in *American Psycho*, put *Body Double* to work because he understood, in some way that he might or might not have been able to articulate to a professional Brechtian's satisfaction, that the notion of this film, "Body Double," was akin to the notion of this character, "Pat Bateman." If Pat Bateman is the fictional person whom *Body Double* could turn into a murderer and rapist, then his coherence as a character necessarily rests in the fact that he is simultaneously closed and open, opaque to himself and completely available to himself, blameless and guilty, a recognizable social type and a cartoon of difference, the typical white devil and an utterly atypical, *sui generis* one.

The doubleness – or duplicity – of *American Psycho* (and of the character at its center) is, in the end, both a cause and an effect. In the various public reactions to the book, the division between what is political and what is not depends, like *Body Double* itself, on which version of the trap the reader has fallen into. The book, like Pat Bateman, is either a subject of politics or an object of politics: the "satirical" gesture, if present, would mean that the book is a political intervention, and the lack of it would mean that the book requires a political intervention. We can see the lingering influence of the Dworkin-MacKinnon argument not only in *American Psycho* itself, but also in the rhetoric of those reviewers who condemned the book without reading it (or, worse, having just skimmed it instead of reading it, word for word, to the end – which is what *American Psycho* requires). I myself am still unsure whether *American Psycho* is the best novel of its decade, or the worst; perhaps this is because, like *Body Double*, it forecloses all evaluative criticism.

I mentioned that we would close with two books; having just inquired about the *murderous effects of reading*, let us turn to the second. It, too, is a work of fiction in a certain way; it, too, is perhaps pointless, perhaps pornographic, certainly repetitive and difficult to read for a number of reasons. It, too, concerns a psychotic – a psychotic with whom we may or may not be expected to identify. Here is a representative section – again, not "representative" in the *statistical* sense, but in the sense of correctly representing the *public perception* of the text:

173. If the machines are permitted to make all their own decisions, we can't make any conjectures as to the results, because it is impossible to guess how such machines might behave. We only point out that the fate of the human race would be at the mercy of the machines. It might be argued that the human race would never be foolish enough to hand over all the power to the machines. But we are suggesting neither that the human race would voluntarily turn power over to the machines nor that the machines would willfully seize power. What we do suggest is that the human race might easily permit itself to drift into a position of such dependence on the machines that it would have no practical choice but to accept all of the machines' decisions. As society and the problems that face it become more and more complex and machines become more and more intelligent, people will let machines make more of their decisions for them, simply because machine-made decisions will bring better results than man-made ones. Eventually a stage may be reached at which the decisions necessary to keep the system running will be so complex that

human beings will be incapable of making them intelligently. At that stage the machines will be in effective control. People won't be able to just turn the machines off, because they will be so dependent on them that turning them off would amount to suicide.

(Kaczynski 1995)

We are, unmistakably, in the world of the Unabomber, who billed himself at the time of the publication of this text as a militant organization called "F.C." but who turned out, once apprehended, not to be a collective at all, but to be a bearded former academic named Theodore Kaczynski. Kaczynski, let us remember, was a reader: and while the Manifesto does not do much in the way of proper academic citations, it is clearly a gathering together – and *theorizing* – of written sources, from Marx to Marcuse, Fanon to the "Port Huron Statement." And yet it is a book bathed in blood. Here, finally, is someone – as all too many have suggested – who was made to kill by reading.

Since *Industrial Society and Its Consequences* is a narration given in the first-person-plural of a fictional character (the militant organization called F.C.), let us say that it is *a novel by Theodore Kaczynski*, just as *American Psycho* is a novel by Bret Easton Ellis. (It just so happens that, like Anne Perry, one of these novelists actually *is* a murderer.) Further, let us say that they are both modernist novels, in the lineage of Robbe-Grillet or Robert Coover: that is to say, they are primarily concerned with problems of form; politics are subsumed into their structure. *American Psycho* is a novel about a person who may or may not be a murderer, while *Industrial Society and Its Consequences* is about a murderer who may or may not be a person. F.C., like Pat Bateman, has a consciousness about itself as a structural byproduct of a much larger system; it – they? – explains its actions in terms of desired results and is able to articulate its own constitutive contradictions. To its detriment, the Kaczynski novel is structurally equivalent to one of *American Psycho*'s music-criticism chapters –

Take the lyrics to "Land Of Confusion," in which a singer addresses the problem of abusive political authority. This is laid down with a groove funkier and blacker than anything Prince or Michael Jackson – or any other black artist of recent years, for that matter – has come up with.

(Ellis 136)

– if it stood alone, without the pornography-of-the-quotidian that would give it context: essentially a ponderously serious, densely theorized argument supporting an untenable position, *Industrial Society and Its Consequences* only gains its meaning by the murders and violence that surround it, just as Pat Bateman's unmotivated excursuses on pop music resonate the way they do because their author may or may not have killed dozens of people. (And it underscores the fact that having an education – i.e. having been taught how to build a college-level logical argument in correct sentences, and how to use examples to support your position – does not automatically keep a person from being able to commit murder.)

There is no need to say very much about Kaczynski, or his interlocutors, although it is notable that a certain kind of post-Left commentator (Alston Chase, David Gelernter) automatically, when addressing the Unabomber, finds his topic dilating uncontrollably. Therefore, for Gelernter, "from my point of view the twentieth century is the crime scene," because

> in the late 1960's (though the roots admittedly reach back earlier), a group of intellectuals entered the freightyard control room and toyed like children with the switches, resetting them for fun – unaware of what they were doing, except making trouble; then the excitement wore off and they slunk away. The trains started to collide before they had even gone, and are still smashing up. This is no issue of Left against Right, it goes deeper, as I will explain – and, yes, it was all a long time ago, but things that are quickly smashed can take a long time to fix. The blast that injured me was a reenactment of a far bigger one a generation earlier, which destroyed something basic in society that has yet to be repaired.
>
> (Gelernter 1997, 3)

Kaczynski himself disappears from the book, replaced by a diminutive figure Gelernter calls "Hut Man"; Hut Man is petty, an idiot, a reactor, a buoy adrift in a sea of disastrous social causes, a product of the decline of social responsibility in the wake of the 1960s; he is also pure evil. *It is society's fault that it is this man's fault*, Gelernter essentially claims. (This is of a piece with Gelernter's desperate invocation of the "Grosse Fugue" as the highest expression of man's potential.) Alston Chase, in his similarly confused half-right, half-left investigation of the Unabomber, lays the blame at the foot of the CIA, Harvard University, the sexual revolution, the media, and the Left; one can sense Chase's frustration at how much larger the problem is than a single man, whom he still insistently – and, again, like Gelernter – refers to as "evil." Kaczynski is therefore "the dark side in all of us" (Chase 128), but the problem is larger: the problem is *modernity* –

> a flawed conception of reason created the culture of despair, which in turn transformed our time into an age of ideologies, and these ideologies are now killing us. By politicizing everything, we leave ourselves no sanctuary.
>
> (Chase 370)

What Gelernter and Chase correctly see – although they misunderstand what it means – is that Kaczynski is, indeed, the logical extension of the New Left *qua* baby boomer leisure activity. That is to say, his thinking is irrevocably utopian, and he theorizes his acts as steps toward the anti-productive revolution, which – apart from the extreme Luddite conjugation of Kaczynski's position – is more or less the theoretical event upon which the eschatology of groups like the Weathermen, or filmmakers like the Brian De Palma of *Hi, Mom!*, depended: what is a handful of deaths by terrorist bombings compared to the rivers

of blood that run through the Pentagon (or through Wall Street)? Like the murder that comes around to haunt Rupert Caddell in *Rope*, the mailbombs and manifesto – that is to say, the *production* – of the Unabomber represent the letter of the New Left returning in its true, inverted form. Of course if we take the rhetoric of the Left seriously, even the anti-globalism Left protesting the WTO, then everything the Unabomber says and believes is right, and although his actions – like the bombings we see in *The Battle of Algiers* – result in the deaths of innocent people, they are attacks on the power structure and are therefore justified. But naturally, no one on the Left (except the more hardcore environmentalists) can say this. Instead they are silent, because *these are not their ideas anymore*; like Jimmy Stewart's crazed homosexual students, Kaczynski is a madman – worse, he is *evil* – and in taking the word of the Left literally, he has perverted our noble ideals, thereby returning our letter in its pure, inverted form.

Kaczynski – or "Hut Man," or "F.C." – is uncomfortably double, like Pat Bateman; he has agency and yet is merely a product of a process; he is heartless, and yet he cares too much; he is insane, and yet he theorizes, and his theorizing resembles our own; he is "correct," and yet he is utterly wrong. What is striking in this context is that Pat Bateman and "F.C." are both fictional characters, who are not well drawn enough to be plausible to the average reader, and yet convince themselves of their own veracity; and because of this (deliberate in Ellis, accidental in Kaczynski) *instability in the first person* as regards this violence, each of these authors becomes also the author of the murders: one "falls through" Pat Bateman and lands on Bret Easton Ellis, just as one "falls through" the fiction of a terrorist collective called "F.C." and lands on Ted Kaczynski – or, to make the point, just as one "falls through" Tony Montana or Dr. Elliott and lands on Brian De Palma.

Pat Bateman, F.C., and Tony Montana are each the embodiment – the paradoxical, schizophrenic embodiment – of a different truth about America at a specific time, and each of the authors of these fictional characters have found themselves "owning" the acts of violence attributed to these characters. And each, because of certain blind spots in certain discourses, is therefore, in himself, invisible. In the end, this is a question about the representation of violence, and about the interpretation of that representation, and about how that representation and its interpretation are, and are not, "political acts" as the Left understands them. Apropos of this bad object, Ted Kaczynksi, and his movement toward actual murder, let us recall what the French post-Left philosopher Alain Finkielkraut said of the Nazis, that they "were, in effect, not brutes, but theorists" (Finkielkraut 1992, 30). Certainly this is exceptionally felicitous academic overphrasing: what Finkielkraut *literally* says here is that the actual real-world effect of the Nazi violence was not in fact *real*, but *theoretical*. But what Finkielkraut, speaking from the right wing of official western scholarship, *means* to say of the Nazi violence – and, it seems to me, this mirrors what nearly everyone in the left wing of the academic discourse says about Kaczynksi, or Bret Easton Ellis, or Brian De Palma, or anti-globalization protesters, or the Weathermen – is that, while one is under obligation to emphasize that it is *impossible to empathize* with these bad objects, the crux of this impossibility is not, as one might think, hinged upon the character of their acts,

but rather upon the *factitiousness of their actions*. (One sees a similar logic on the Right when abortion-clinic bombings and Timothy McVeigh are the topics of conversation.) In other words, the fact that these agents *acted at all* is alien to the practitioners of professional humanities discourse on both sides of the political spectrum. What is the affective legacy of the 1960s for the discipline of Film Studies, after all, but the baby boomers' narcissistic self-fulfilling prophecy that *failure is inevitable*?

Whether or not it is true, that idea – and the struggle to force the discipline to "come to terms with it" – remains the central, unspoken issue in Film Studies, a discipline which, perhaps more than any other discipline in the humanities, came into being under the shadow of the failure of the 1960s. In all disciplines, generations come and go, students following teachers and scholars begetting scholars; does not each generation leave its own thumbprint across the consciousness of the next? Perhaps the idea that the 1960s failed is mistaken, and the shadow of this disappointment equally illusory; perhaps it is not – I certainly cannot offer an answer. But even if it is "merely" anecdotal, the idea is ubiquitous; and while its main adherents will inevitably make way for another generation, the idea, doubtlessly, will remain behind. Further, it is symptomatic of this idea's influence that De Palma, being the director whose films connect Hitchcock *qua* object with Godard *qua* subject, would remain largely untheorized by the discipline, even now. De Palma's invisibility is, no doubt, largely influenced by mundane taste politics ("I just don't think he's a good director") – but then again, is there any aspect of Film Studies that is not? Do our politics influence our taste, and vice versa? Does individual – or institutional – taste influence the limits of what can and cannot be considered to be a fit object of historical inquiry? Does our sense of what is and is not historically possible influence how we situate our object of study?

The Bataille quote that opens this conclusion is particularly apropos to these questions. Film – since film is literature – is not innocent. Neither is Film Studies. The question of "action" – which we might translate, given the *Cahiers* model under which we labor, as "practice" (as opposed to "theory") – is crucial, and it is particularly important now, all over the world and at this particular historical moment. The question for Film Studies, in regard to the balance of theory and practice, is not whether anyone who practices film scholarship should be making movies instead – although there is no denying that it would be a good idea to make every film student, especially graduate students, learn how movies are actually made. (Many of the perceived problems in the discipline would be solved if all of its participants had real first-hand knowledge of the nuts and bolts of the medium.) The questions, rather, are these: Why does the discipline of Film Studies still exhibit *neuroses of inadequacy*? How else is the discipline marked by *generational* aspirations and limitations? What is the *lost object* that Film Studies cannot recover? I am not suggesting that the only route into this inquiry is De Palma, although I hope that I have demonstrated that there is much in his work that the discipline should recognize. I am suggesting, however, that if we still want to "reinvent Film Studies," we might want to consider what we do in light of the various narratives I have tried to assemble here – narratives of failure and impossibility, narratives that have their own histories and their own ways of appearing, whether we recognize it or not, as allegory.

THE END

Reference List and Bibliography

Allen, Richard and S. Ishii Gonzalès, eds. (1999) *Alfred Hitchcock: Centenary Essays*. London: BFI.

Amata, Carrie (1981) "Travolta and De Palma discuss *Blow Out*," in *Films and Filming*; reprinted in Lawrence Knapp, ed. (2003) *Brian De Palma: Interviews*. Jackson: University of Mississippi Press.

American Film Institute Seminar Series (1977) "Brian De Palma: An American Film Institute Seminar on His Work Held April 4, 1973." Glen Rock, NJ: Microfilming Corporation of America.

Amis, Martin (1984) "Brian De Palma: The Movie Brute"; reprinted in *The Moronic Inferno*. New York: Viking, 1987.

Andrew, Dudley (2009) "The Core and the Flow of Film Studies," in *Critical Inquiry* (35:4).

Ashbrook, John (2000) *The Pocket Essential Brian De Palma*. Herts: Pocket Essentials.

Asselle, Giovanna and Behroze Gandhy (1982) "Dressed to Kill: A Discussion," in *Screen* (23:3–4).

Atack, Margaret (2000) *May 68 in French Fiction and Film: Rethinking Society, Rethinking Representation*. London: Oxford University Press.

Auster, Al and Leonard Quart (1984) "American Cinema of the Sixties", in *Cineaste* (13:4).

Ayers, Bill (2003) *Fugitive Days*. New York: Penguin Books.

Babington, Bruce (1983) "Twice a victim: *Carrie* Meets the BFI," in *Screen* (24:3).

Baritz, Loren, ed. (1971) *The American Left: Radical Political Thought in the Twentieth Century*. New York: Basic Books.

Bartholamew, David (1975) "De Palma of the Paradise," in *Cinefantastique* (4:2); reprinted in Lawrence Knapp, ed. (2003) *Brian De Palma: Interviews*. Jackson: University of Mississippi Press.

Bataille, Georges (1973) *Literature and Evil*. New York: Marion Boyars.

Bathrick, Serafina Kent (1977) "Ragtime: The Horror of Growing Up Female," in *Jump Cut* 14.

Bautista, Jacquelin (1984) "Intent and Effect in *Blow Out*," in *Jump Cut* 29.

Bellour, Raymond (2000) *The Analysis of Film*. Bloomington: Indiana University Press.

Bergstrom, Janet (1979) "Enunciation and Sexual Difference," in *Camera Obscura* (1–2).

Berkowitz, Edward D. (2006) *Something Happened: A Political and Cultural Overview of the Seventies*. New York: Columbia University Press.

Biskind, Peter (1998) *Easy Riders, Raging Bulls: How the Sex, Drugs, and Rock-and-Roll Generation Saved Hollywood*. New York: Simon and Schuster.

Black, Joel (1991) *The Aesthetics of Murder: A Study in Romantic Literature and Contemporary Culture*. Baltimore: Johns Hopkins University Press.

Bliss, Michael (1983) *Brian De Palma*. Metuchen, NJ: Scarecrow Press.

Bonitzer, Pascal (1992) "Hitchcockian Suspense," in Slavoj Žižek, ed. *Everything You Ever Wanted to Know about Lacan (But Were Afraid to Ask Hitchcock)*. New York: Verso.

Bordwell, David (1989) *Making Meaning: Inference and Rhetoric in the Interpretation of Cinema*. Cambridge: Harvard University Press.

Bordwell, David and Noël Carroll, eds. (1996) *Post-Theory: Reconstructing Film Studies*. Madison: University of Wisconsin Press.

Bouzereau, Laurent (1988) *The De Palma Cut: The Films of America's Most Controversial Director*. New York: Dembner.

Braudy, Leo (1986) "The Sacraments of Genre: Coppola, De Palma, Scorsese," in Film Quarterly (39:3).

Brecht, Bertolt (1997) "Hollywood," in *Poems 1913–1956*. New York: Routledge.

Brody, Richard (2008) *Everything Is Cinema: The Working Life of Jean-Luc Godard*. New York: Metropolitan Books.

Brown, Royal S., ed. (1972) *Focus on Godard*. Englewood Cliffs, NJ: Prentice-Hall.

Brownmiller, Susan (1999) *In Our Time: Memoir of a Revolution*. New York: Delta.

Calvert, Greg and Carol Neiman (1971) *A Disrupted History: The New Left and the New Capitalism*. New York: Random House.

Carroll, Peter N. (1990) *It Seemed Like Nothing Happened: America in the 1970's*. New Brunswick: Rutgers University Press.

Chase, Alston (2003) *Harvard and the Unabomber: The Education of an American Terrorist*. New York: Norton.

Chepesiuk, Ron (1995) *Sixties Radicals, Then and Now*. Jefferson, NC: McFarland and Company.

Chion, Michael (1999) *The Voice in Cinema*. New York: Columbia University Press.

Citron, Michelle (1977) "*Carrie* Meets *Marathon Man*," in *Jump Cut* 14.

Citron, Michelle et al. (1978) "Women and Film: A Discussion of Feminist Aesthetics," in *New German Critique* 13.

Clecak, Peter (1973) *Radical Paradoxes: Dilemmas of the American Left 1945–1970*. New York: Harper and Row.

Clover, Carol (1992) *Men Women and Chain Saws*. Princeton: Princeton University Press.

Coates, Paul (1985) *The Story of the Lost Reflection: The Alienation of the Image in Western and Polish Cinema*. London: Verso.

Comolli, Jean-Louis and Jean Narboni (1969) "Cinema/Ideology/Criticism," in *Cahiers du Cinéma*; reprinted in Nick Browne, ed. (1990) *Cahiers du Cinéma 1969–1972: The Politics of Representation*. Cambridge: Harvard University Press.

Conrad, Tony (2000) *The Hitchcock Murders*. London: Faber and Faber.

Corliss, Richard (1981) "Bad Crash," in *Time Magazine* (July 27, 1981).

Coykendall, Abigail Lynn (2000) "Bodies Cinematic, Bodies Politic: The 'Male' Gaze and the 'Female' Gothic in De Palma's *Carrie*," in *Journal of Narrative Theory* (30:3).

Cusset, François (2008) *French Theory*. Minneapolis: University of Minnesota Press.

Cvetkovich, Ann (1991) "Postmodern *Vertigo*: The Sexual Politics of Allusion in Brian De Palma's *Body Double*," in Raubicheck and Srebnick, eds., *Hitchcock's Rereleased Films*. Detroit: Wayne State University Press.

Davis, Francis (2002) *Afterglow: A Last Conversation with Pauline Kael.* Cambridge: Da Capo Press.

Dean, Tim (2008) "The Frozen Countenance of the Perversions," in *Parallax* (14:2).

De Lauretis, Teresa (1982) *Alice Doesn't: Feminism, Semiotics, Cinema.* Bloomington: Indiana University Press.

Deleuze, Gilles and Felix Guattari (1983) *Anti-Oedipus: Capitalism and Schizophrenia.* Minneapolis: University of Minnesota Press.

DeMause, Lloyd (1982) *Foundations of Psychohistory.* New York: Creative Roots/Institute for Psychohistory.

Denby, David (1980) "*Dressed to Kill*," in *New York Magazine* (July 28, 1980).

Denby, David et al. (1984) "Pornography: Love or Death?" in *Film Comment* (20:6).

De Palma, Brian (1987) "Brian De Palma's Guilty Pleasures," in *Film Comment* (23:3).

Deutelbaum, Marshall and Leland Poague, eds. (1986) *A Hitchcock Reader.* Ames: Iowa University State Press.

Dhairyman, Şagri (1992) "Between Hysteria and Death: Exploring Spaces for Feminine Subjectivity in de Palma's *The Sisters* [sic] and *Body Double*," in *The New Orleans Review* (19:3–4).

Diggins, John Patrick (1992) *The Rise and Fall of the American Left*, revised edition. New York: W.W. Norton and Co.

Doane, Mary Ann (1981) "Woman's Stake: Filming the Female Body," in *October* (17).

Douchet, Jean (1960) "Hitch and His Public," in *Cahiers du Cinéma* (113); reprinted in Marshall Deutelbaum and Leland Poague, eds. (1986). Ames: Iowa State University Press.

Dumas, Chris (2011) "The Žižekian Thing: A Disciplinary Blind Spot," in *Critical Inquiry* (37:2).

Dumas, Chris (2012) "Cinema of Failed Revolt: Brian De Palma and the Death(s) of the Left," in *Cinema Journal* (51:3).

Durgnat, Raymond (1998) *The Strange Case of Alfred Hitchcock.* Cambridge: MIT Press.

Durgnat, Raymond (2002) *A Long Hard Look at Psycho.* Berkeley: University of California Press.

Dworkin, Andrea (1989) *Pornography: Men Possessing Women.* New York: Dutton.

Dworkin, Andrea (1993) *Mercy: A Novel.* New York: Four Walls Eight Windows.

Dworkin, Susan (1984) *Double De Palma: A Film Study with Brian De Palma.* New York: Newmarket Press.

Dwyer, Victor (1991) "Literary Firestorm," in *Maclean's* (April 1, 1991).

Dyer, Richard (2007) *Pastiche.* New York: Routledge.

Ehrenreich, Barbara and John Ehrenreich (1969) *Long March, Short Spring: The Student Uprising at Home and Abroad.* New York: Monthly Review Press.

Eisen, Ken (1984) "The Young Misogynists of American Cinema," in *Cineaste* (13:3).

Ellis, Bret Easton (1991) *American Psycho.* New York: Vintage.

Elmer, Jonathan (1995) *Reading at the Social Limit.* Stanford: Stanford University Press.

F.C. (1995) Industrial Society and Its Consequences, aka "The Unabomber Manifesto," in *The New York Times* (September 19, 1995).

Feldenstein, Richard, Bruce Fink, and Maire Jaanus, eds. (1996) *Reading Seminars I and II: Lacan's Return to Freud.* Albany: State University of New York Press.

Felman, Shoshanna (1987) *Jacques Lacan and the Adventure of Insight*. Cambridge: Harvard University Press.

Fink, Bruce (1995) *The Lacanian Subject: Between Language and Jouissance*. Princeton, NJ: Princeton University Press.

Fink, Bruce (1997) *A Clinical Introduction to Lacanian Psychoanalysis: Theory and Technique*. Cambridge: Harvard University Press.

Finkielkraut, Alain (1992) *Remembering in Vain: The Klaus Barbie Trial and Crimes Against Humanity*. New York: Columbia University Press.

Fonda, Jane (2006) *My Life So Far*. New York: Random House.

Foreman, Donal (2008) "The Filmmaker-Activist and the Collective: Robert Kramer and Jean- Luc Godard." www.donalforeman.com.

Fraser, Ronald, et al. (1988) *1968: A Student Generation in Revolt*. London: Chatto and Windus.

Freud, Sigmund (1959) *Group Psychology and the Analysis of the Ego*. New York: Norton Library.

Freud, Sigmund (1959) "Family Romances," in *Collected Papers Vol. 5*. New York: Basic Books.

Freud, Sigmund (1960) *Jokes and Their Relation to the Unconscious*. New York: W. W. Norton.

Freud, Sigmund (1961) *Civilization and Its Discontents*. New York: W. W. Norton.

Freud, Sigmund (1989) *Beyond the Pleasure Principle*. New York: W. W. Norton.

Frum, David (2000) *How We Got Here: The 70's*. New York: Basic Books.

Gallop, Jane (1985) *Reading Lacan*. Ithaca: Cornell University Press.

Gallop, Jane (1992) *Around 1981: Academic Feminist Literary Theory*. New York: Routledge.

Galloway, Alexander R. (2006) "Origins of the First-Person Shooter," in *Gaming: Essays on Algorithmic Culture*. Minneapolis: University of Minnesota.

Gay, Peter (1985) *Freud for Historians*. New York: Oxford University Press.

Gelernter, David (1997) *Drawing Life: Surviving the Unabomber*. New York: Free Press.

Gelmis, Joseph (1970) *The Film Director as Superstar*. New York: Doubleday.

Gerard, Fabian S., T. Jefferson Kline, and Bruce Sklarew, eds. (2000) *Bernardo Bertolucci: Interviews*. Jackson: University Press of Mississippi.

Gibley, Ryan (2003) *It Don't Worry Me: The Revolutionary American Films of the Seventies*. New York: Faber and Faber.

Gitlin, Todd (1988) *The Sixties: Years of Hope, Days of Rage*. New York: Bantam Books.

Godard, Jean-Luc (1987) "ABCD ... JLG," in *Le Nouvel Observateur* (1206: December 12–24, 1987, 50–52).

Goetsch, Paul (1997) "Atrocities in Vietnam War Movies: The Direction of Sympathies in *Casualties of War*," in Wolfgang Gortschacher, ed., *Modern War on Stage and Screen*. Lewiston, NY: Edwin Mellin Press.

Gottlieb, Sidney and Christopher Brookhouse, eds. (1998) *Framing Hitchcock: Selected Essays from The Hitchcock Annual*. Detroit: Wayne State University Press.

Grieveson, Lee and Haidee Watson, eds. (2008) *Inventing Film Studies*. Durham: Duke University Press.

Greven, David (2009) "Misfortune and Men's Eyes: Voyeurism, Sorrow, and the Homosocial in Three Early Brian De Palma Films," in *Genders: An Online Journal* (49).

Harris, David (1970) *Goliath*. New York: Avon.

Haskell, Molly (1974) *From Reverence to Rape: The Treatment of Women in the Movies*. New York: New English Library.

Hawkins, Joan (2000) *Cutting Edge: Art-Horror and the Horrific Avant-Garde*. Minneapolis: University of Minnesota Press.

Hennelly, Jr., Mark M. (1990) "Scary Movies: American Horrors and *Body Double*," in *Journal of Evolutionary Psychology* (11:3–4).

Hirsch, Foster (1981) *Film Noir: The Dark Side of the Screen*. New York: Da Capo Press.

Hirschberg, Lynn (1984) "Brian De Palma's Death Wish," in *Esquire*; reprinted in Lawrence Knapp, ed. (2003) *Brian De Palma: Interviews*. Jackson: University of Mississippi Press.

Hoberman, J. (1980) "Dazzling," in *The Village Voice* (July 23–29, 1980).

Hoberman, J. (1991) *Vulgar Modernism: Writing on Movies and Other Media*. Philadelphia: Temple University Press.

Hoberman, J. (2003) *The Dream Life*. New York: New Press.

Hoesterey, Ingeborg (2001) *Pastiche: Cultural Memory in Art, Film, Literature*. Bloomington: Indiana University Press.

Horning, Beth (1982) "*Blow Out*: Fake Humanism," in *Jump Cut* (?7).

Howowitz, David (1998) *Radical Son*. New York: Touchstone.

Jacobson, Harlan (1984) "Brian's Body," in *Film Comment* (20:5).

Jaehne, Karen (1983) "*Scarface*," in *Cineaste*.

Jameson, Fredric (1990) *Signatures of the Visible*. New York: Routledge.

Jameson, Fredric (1991) *Postmodernism or, the Cultural Logic of Late Capitalism*. Durham: Duke University Press.

Jameson, Fredric (1992) *The Geopolitical Aesthetic*. Bloomington: Indiana University Press.

Johal, Kalwant S. (2009) "The Battle over the Kent State Shootings and the Monopoly of Memorialization." Unpublished doctoral manuscript, University of Akron.

Kael, Pauline (1965) *I Lost It at the Movies*. New York: Little, Brown and Co.

Kael, Pauline (1968) *Kiss Kiss Bang Bang*. New York: Little, Brown and Co.

Kael, Pauline (1970) *Going Steady*. New York: Little, Brown and Co.

Kael, Pauline (1973) *Deeper Into Movies*. New York: Little, Brown and Co.

Kael, Pauline (1976) *Reeling*. New York: Little, Brown and Co.

Kael, Pauline (1980) *When the Lights Go Down*. New York: Holt, Rinehart and Winston.

Kael, Pauline (1984) *Taking It All In*. New York: Holt, Rinehart and Winston.

Kael, Pauline (1985) *State of the Art*. New York: Dutton.

Kael, Pauline (1989) *Hooked*. New York: Dutton.

Kael, Pauline (1991) *Movie Love*. New York: Plume.

Kaplan, E. Ann (1982) "Movies and the Women's Movement," in *Socialist Review* (12:6).

Kaplan, E. Ann (1983) *Women and Film: Both Sides of the Camera*. New York: Methuen.

Kaplan, E. Ann, ed. (2000) *Oxford Readings in Feminism: Feminism and Film*. Oxford: Oxford University Press.

Kapsis, Robert (1990) *Hitchcock: The Making of a Reputation*. Chicago: University of Chicago Press.

Kaufman, Anthony (2007) "Brian De Palma Explains Himself," in *The Village Voice* (October 2, 2007).

Kellner, Douglas (1991) "The 1980s: Film, Politics, and Ideology: Reflections on Hollywood Film in the Age of Reagan," in *Velvet Light Trap* (27).

Kendrick, James (2009a) *Hollywood Bloodshed: Violence in 1980's American Cinema*. Carbondale: Southern Illinois University Press.

Kendrick, James (2009b) *Film Violence: History, Ideology, Genre*. New York: Wallflower Press.

Killen, Andreas (2006) *1973 Nervous Breakdown*. New York: Bloomsbury.

Klapper, Zina (1985) "The Latest in De Palma's Shop of Horrors … and a Book about the Drill, the Dog, the Man," in *Ms. Magazine* (January 1985).

Knapp, Lawrence F. ed. (2003) *Brian De Palma: Interviews*. Jackson: University Press Of Mississippi.

Koch, Gertrud (2009) "Carnivore or Chameleon: The Fate of Cinema Studies," in *Critical Inquiry* (35:4).

Kolker, Robert Philip (2004) *Alfred Hitchcock's Psycho: A Casebook*. New York: Oxford University Press.

Kolker, Robert Philip (1985) *Bernardo Bertolucci*. New York: Oxford University Press.

Kolker, Robert Philip (1998) *A Cinema of Loneliness: Second Edition*. New York: Oxford University Press.

Kosselleck, Reinhart (2002) *The Practice of Conceptual History: Timing History, Spacing Concepts*. Stanford: Stanford University Press.

Kuhn, Annette (1985) *The Power of the Image: Essays on Representation and Sexuality*. New York: Routledge.

Lacan, Jacques (1958) "The Seminar of Jacques Lacan, Book V: The Formations of the Unconscious, 1957–1958." Unpublished translation by Cormac Gallagher.

Lacan, Jacques (1981) *The Seminar of Jacques Lacan, Book XI: The Four Fundamental Concepts of Psychoanalysis*. New York: W.W. Norton.

Lacan, Jacques (1988) *The Seminar of Jacques Lacan, Book I: Freud's Papers on Technique, 1953–1954*. New York: W. W. Norton.

Lacan, Jacques (1988b) *The Seminar of Jacques Lacan, Book II: The Ego in Freud's Theory and in the Technique of Psychoanalysis*. New York: Norton.

Laclau, Ernesto and Chantal Mouffe (2001) *Hegemony and Socialist Strategy: Towards a Radical Democratic Politics, Second Edition*. New York: Verso.

Lagier, Luc and Amaury Voslion (2003) "De Palma: Les Anneés 60," a video included on *Brian De Palma: Les Anneés 60* (French DVD).

Laplanche, J. and J-B. Pontalis (1973) *The Language of Psycho-Analysis*. New York: W. W. Norton.

Laplanche, Jean (1976) *Life and Death in Psychoanalysis*. Baltimore: Johns Hopkins University Press.

Lasch, Christopher (1969) *The Agony of the American Left*. New York: Alfred A. Knopf.

Latour, Bruno (1987) *Science in Action*. Cambridge: Harvard University Press.

LaValley, Albert J. (1972) *Focus on Hitchcock*. Englewood Cliffs: Prentice-Hall.

Leary, Timothy (1976) "How Our Paranoias are Hyped for Fame and Profit," in *The National Review* (April 16, 1976).

Leitch, Thomas (2006) "How to Steal from Hitchcock," in David Boyd and R. Barton Palmer, eds., *After Hitchcock: Influence, Imitation, and Intertextuality*. Austin: University of Texas Press.

Levin, Thomas Y. (2002) "Rhetoric of the Temporal Index: Surveillant Narration and the Cinema of 'Real Time,'" in Thomas Y. Levin, Ursula Frohne, and Peter Weibel, eds., *CTRL[SPACE]: Rhetorics of Surveillance from Bentham to Big Brother*. Karlsruhe, Germany: ZKM Center for Art and Media.

Lewis, Jon (1995) *Whom God Wishes To Destroy …: Francis Coppola and the New Hollywood*. Durham: Duke University Press.

Librach, Ronald (1998) "Sex, Lies, and Audiotape: Politics and Heuristics in *Dressed to Kill* and *Blow Out*," in *Film/Literature Quarterly* (26:3).

Lindsay, Shelley Stamp (1991) "Horror, Femininity, and Carrie's Monstrous Puberty," in *Journal of Film and Video* (43:4).

Loshitsky, Yosefa (1995) *The Radical Faces of Godard and Bertolucci*. Detroit: Wayne State University Press.

Lott, Eric (1998) "Boomer Liberalism," in *Transition* (78).

MacBean, James Roy (1975) *Film and Revolution*. Bloomington: Indiana University Press.

MacCabe, Colin (2004) *Godard: Portrait of the Artist at Seventy*. New York: Farrar, Strauss, Giroux.

MacDonald, Shana (2010) "Materiality and Metaphor: Rape in Anne Claire Poirier's *Mourir à Tue-Tête* and Jean-Luc Godard's *Weekend*," in Dominique Russell, ed., *Rape in Art Cinema*. New York: Continuum.

MacKinnon, Catherine A. (1993) *Only Words*. Cambridge: Harvard University Press.

MacKinnon, Kenneth (1990) *Misogyny in the Movies: The De Palma Question*. Cranbury, NJ: Associated University Presses.

Mahoney, John M. (1991) "Voluntary Control of Male Sexual Arousal," in *Archives of Sexual Behavior* (20:1).

Mamber, Stephen (1991) "In Search of Radical Metacinema," in Andrew S. Horton, ed., *Comedy/Cinema/Theory*. Berkeley: University of California Press.

Marcuse, Herbert (1991) *One-Dimensional Man*. Boston: Beacon Press.

Matusa, Paula (1977) "Corruption and Catastrophe: Brian De Palma's *Carrie*," in *Film Quarterly* (31:1).

McGilligan, Patrick (2003) *Alfred Hitchcock: A Life in Darkness and Light*. New York: Regan Books.

Modleski, Tania (1982) "Ou en est la theorie feministe?", in *CinemAction* (20).

Modleski, Tania (1988) *The Women Who Knew Too Much*. New York: Routledge.

Mulhall, Stephen (2006) "The Impersonation of Personality: Film as Philosophy in *Mission: Impossible*," in Smith, Murray and Thomas Wartenberg, eds., *Thinking Through Cinema*. Oxford: Blackwell.

Mulvey, Laura (2004) "Looking at the Past from the Present: Rethinking Feminist Film Theory of the 1970s," in *Signs* (30:1).

Mulvey, Laura (2007) "A Clumsy Sublime," in *Film Quarterly* (60:3).

Mulvey, Laura (2009) *Visual and Other Pleasures*. New York: Palgrave Macmillan.

Muse, Eben J. (1992) "The Land of Nam: Romance and Persecution in Brian De Palma's *Casualties of War*," in *Film/Literature Quarterly* (20:3).

Naremore, James (1973) *Filmguide to Psycho*. Bloomington: Indiana University Press.

Naremore, James (2002) "Remaking *Psycho*," in Sidney Gottlieb and Christopher Brookhouse, eds., *Framing Hitchcock: Selected Essays from the Hitchcock Annual*. Detroit: Wayne State University Press.

O'Hara, John (1934) *Appointment in Samarra*. New York: Harcourt Brace and Co.

Pally, Marcia (1984) "Brian De Palma interviewed by Marcia Pally," in *Film Comment* (20:5).

Peretz, Eval (2006) *Becoming Visionary: Brian De Palma's Cinematic Education of the Senses*. Stanford: Stanford University Press.

Plagens, Peter (1991) "Confessions of a Serial Killer," in *Newsweek* (March 4, 1991).

Polan, Dana (2007) *Scenes of Instruction: The Beginnings of the U.S. Study of Film*. Berkeley: University of California Press.

Prince, Rob (2009) "Say Hello to My Little Friend: De Palma's *Scarface*, Cinema Spectatorship, and the Hip Hop Gangsta as Urban Superhero." Unpublished doctoral manuscript, Bowling Green State University.

Prince, Stephen (1998) *Savage Cinema: Sam Peckinpah and the Rise of Ultraviolent Movies*. Austin: University of Texas Press.

Prince, Stephen (2000) *A New Pot of Gold*. New York: Charles Scribner's Sons.

Prince, Stephen, ed. (2000b) *Screening Violence*. New Brunswick: Rutgers University Press.

Provencher, Ken (2008) "*Redacted*'s Double Vision," in *Film Quarterly* (62:1).

Pye, Michael and Linda Myles (1979) *The Movie Brats: How the Film Generation Took Over Hollywood*. New York: Holt, Rinehart and Winston.

Ramaeker, Paul (2007) "Notes on the Split-Field Diopter," in *Film History: An International Journal* (19:2).

Raubicheck, Walter and Walter Srebnick, eds. (1991) *Hitchcock's Rereleased Films: From Rope to Vertigo*. Detroit: Wayne State University Press.

Rebello, Stephen (1990) *Alfred Hitchcock and the Making of Psycho*. New York: Dembner Books.

Rorty, Richard (1992) "The Feminist Saving Remnant," in *New Leader* (75:7).

Rosenbaum, Jonathan (2002) "Master Thief," in *The Chicago Reader* (November 2, 2002).

Rothman, William (1982) *Hitchcock: The Murderous Gaze*. Cambridge: Harvard University Press.

Roud, Richard (1970) *Godard: Second Revised Edition*. Bloomington: Indiana University Press.

Rubenstein, Richard (1973) "The Making of *Sisters*: An Interview with Director Brian De Palma," in *Filmmakers Newsletter* (September 1973); reprinted in Lawrence Knapp, ed. (2003) *Brian De Palma: Interviews*. Jackson: University of Mississippi Press.

Rubin, Jerry (1970) *Do It: Scenarios of the Revolution*. New York: Simon and Schuster.

Rubin, Jerry (1976) *Growing (Up) at 37*. New York: Warner Books.

Rudd, Mark (2009) *Underground: My Life with SDS and the Weathermen*. New York: William Morrow.

Ryan, Michael and Douglas Kellner (1988) *Camera Politica*. Bloomington: Indiana University Press.

Salomon, Julie (1992) *The Devil's Candy: The Bonfire of the Vanities Goes to Hollywood*. New York: Delta.

Sarris, Andrew (1960) "Movie Journal: *Psycho*," in *The Village Voice* (August 11, 1960).

Sarris, Andrew (1963) "Notes on the Auteur Theory in 1962," in *Film Culture* (Winter 1962–1963).

Sarris, Andrew (1976) "Is *Obsession* an Imitation of *Vertigo*?" in *The Village Voice* (August 30, 1976).

Sarris, Andrew (1978) *Politics and Cinema*. New York: Columbia University Press.

Sarris, Andrew (1980a) "Sarris Vs. Kael: The Queen Bee of Film Criticism," in *The Village Voice* (July 2, 1980).

Sarris, Andrew (1980b) "Derivative," in *The Village Voice* (July 23, 1980).

Sarris, Andrew (1980c) "Dreck to Kill," in *The Village Voice* (September 17, 1980).

Sarris, Andrew (1983) "The Critical Anatomy of Alfred Hitchcock," in *The Village Voice* (October 18, 1983).

Schreyer, Roberta (1997) "Will the Reel Woman in *Body Double* Please Stand Up?" in Christine Moneera Laennec, ed., *Bodily Discussions: Genders, Representations, Technologies*. Albany: State University of New York Press.

Schulman, Bruce J. (2001) *The Seventies*. New York: Da Capo Press.

Scott, A. O. (2006) "Say 'Brian De Palma.' Let the Fighting Start," in *The New York Times* (September 7, 2006).

Shor, Frances (1995) "Father Knows Beast: Patriarchal Rage and the Horror of Personality Film," in *The Journal of Criminal Justice and Popular Culture*, 1995 (3:3).

Silverman, Kaja (1983) *The Subject of Semiotics*. New York: Oxford University Press.

Silverman, Kaja and Harun Farocki (1998) *Speaking about Godard*. New York: NYU Press.

Skerry, Philip J. (2009) *Psycho in the Shower: The History of Cinema's Most Famous Scene*. New York: Continuum.

Smith, Joseph W., III. (2009) *The Psycho File: A Comprehensive Guide to Hitchcock's Classic Shocker*. Jefferson, NC: McFarland and Company.

Smith, Julian. (1975) *Looking Away: Hollywood and Vietnam*. New York: Scribner.

Sontag, Susan (1983) *Sontag: A Reader*. New York: Vintage.

Spear, Bruce (1992) "Political Morality and Historical Understanding in *Casualties of War*," in *Film/Literature Quarterly* (20:3).

Spoto, Donald (1983) *The Dark Side of Genius: The Life of Alfred Hitchcock*. New York: Little-Brown.

Starr, Peter (1995) *Logics of Failed Revolt: French Theory After May '68*. Stanford: Stanford University Press.

Steiner, Wendy (1982) "Brian De Palma's Romances," in *Michigan Quarterly Review* (21:3).

Stengel, Wayne (1985) "Brian De Palma's *Body Double* and the Shadow of Alfred Hitchcock," in *The New Orleans Review* (Fall 1985).

Stengel, Wayne (1987) "Voyeurism as Crime," in *The New Orleans Review* (Fall 1987).

Straw, Mark (2007) "The Guilt Zone: Trauma, Masochism and the Ethics of Spectatorship in Brian De Palma's *Redacted*," in *Continuum* (24:1, 91–105).

Teachout, Terry (1991) "Applied Deconstruction," in *The National Review* (June 24, 1991).

Thompson, Hunter S (1971) *Fear and Loathing in Las Vegas: A Savage Journey to the Heart of the American Dream*. New York: Popular Library.

Thomson, David (2004) *The New Biographical Dictionary of Film*. New York: Alfred A. Knopf.

Thomson, David (2009) *The Moment of Psycho: How Alfred Hitchcock Taught America to Love Murder*. New York: Basic Books.

Truffaut, Francis (1985) *Hitchcock/Truffaut*. New York: Touchstone.

Tucker, Ken (2008) *Scarface Nation: The Ultimate Gangster Movie and How It Changed America*. New York: St. Martin's Press.

Unger, Irwin (1974) *The Movement: A History of the American New Left 1959–1972*. New York: Dodd, Mead and Co.

Waller, Gregory, ed. (1987) *American Horrors: Essays on the Modern American Horror Film*. Urbana: University of Illinois Press.

Welsch, Tricia (1997) "At Work in the Genre Laboratory: Brian De Palma's *Scarface*," in *Journal of Film and Video* (49:1–2).

White, Armond (1991) "Brian De Palma: Political Filmmaker," in *Film Comment* (27:3).

White, Hayden (1987) *The Content of the Form: Narrative Discourse and Historical Representation*. Baltimore: Johns Hopkins University Press.

Willemen, Paul (1971) "Distanciation and Douglas Sirk," in *Screen* (12:2).

Williams, Linda (1989) *Hard Core: Power, Pleasure, and the "Frenzy of the Visible."* Berkeley: University of California Press.

Williams, Linda and Christine Gledhill, eds. (2000) *Reinventing Film Studies*. New York: Oxford University Press.

Williams, Linda (1992) "When The Woman Looks," in Mast, Cohen, and Braudy, eds., *Film Theory and Criticism*, Fourth Edition. New York: Oxford University Press.

Williams, Linda, ed. (2004) *Porn Studies: A Reader*. Durham: Duke University Press.

Wolin, Richard (2010) *The Wind from the East: French Intellectuals, the Cultural Revolution, and the Legacy of the 1960's*. Princeton: Princeton University Press.

Wollen, Peter (1982) *Readings and Writings: Semiotic Counter-Strategies*. London: Verso.

Wood, Robert E. (1986) "You've Got to Act: Escaping the Gaze in De Palma's *Body Double*," in *Studies in the Humanities* (13:1).

Wood, Robin (1986) *Hollywood from Vietnam to Reagan*. New York: Columbia University Press.

Wood, Robin (1989) *Hitchcock's Films Revisited*. New York: Columbia University Press.

Wood, Robin (1998) *Sexual Politics and Narrative Film*. New York: Columbia University Press.

Žižek, Slavoj (1989) *The Sublime Object of Ideology*. New York: Verso.

Žižek, Slavoj (1992a). *Enjoy Your Symptom: Jacques Lacan in Hollywood and Out*. New York: Routledge.

Žižek, Slavoj (1992b) *Everything You Always Wanted to Know about Lacan (But Were Afraid to Ask Hitchcock)*. New York: Verso.

Žižek, Slavoj (1994) *Looking Awry*. Boston: MIT Press.

Žižek, Slavoj (2001) *Did Somebody Say Totalitarianism?* New York: Verso.

Index of Film Titles and Selected Proper Names

1941 (Spielberg), 156
2001: A Space Odyssey (Kubrick), 103
39 Steps, The (Hitchcock), 71

Accused, The (Kaplan), 128n
Act of Vengeance (De Palma, unmade),
 178n
Akerman, Chantal, 9, 160
Ali, Muhammad, 124
Alice Doesn't Live Here Anymore (Scorsese), 59
All About Eve (Mankiewicz), 36
All My Children (television series), 195
All That Heaven Allows (Sirk), 14
Allen, Nancy, 15, 128, 156, 159, 161, 170,
 180, 183
Alphaville (Godard), 125
Althusser, Louis, 87, 89, 92, 100, 102, 164n
Altman, Robert, 49, 96, 143, 148, 167
American Psycho (Harron), 209
Amis, Martin, 40–42, 207
And Justice For All (Jewison), 167
Antonioni, Michelanelo, 23, 78n, 116,
 125, 148
Apocalypse Now (Coppola), 140, 149–150
Arendt, Hannah, 208
Argento, Dario, 110
Armani, Giorgio, 206
Ashby, Hal, 96, 147–148, 156
Astin, John, 131–133
Avenging Disco Godfather (Wagoner), 167
L'Avventura (Antonioni), 78n
Ayers, Bill, 94–95

Band of Outsiders (Godard), 101
Bardot, Brigitte, 126
Barka, Ben 135

Barnes, Clive 122
Bartel, Paul, 107n, 111
Barthes, Roland, 91, 92, 100, 127
Barton Fink (Coen), 169
Basic Instinct (Verhoeven), 64, 167
Bass, Saul, 56
Bat Whispers, the (West), 184
Bataille, Georges, 38, 127, 205, 214
Battle of Algiers, the (Pontecorvo), 213
Battleship Potemkin (Eisenstein), 23
Baudrillard, Jean, 40
Bauer, Steven, 70
Bazin, Andre, 193
Beatty, Warren, 148, 167
Before the Revolution
 (Bertolucci), 116
Belle de Jour (Buñuel), 48
Bellour, Raymond, 31, 53–55, 71, 75
Bergman, Ingmar 9n, 65, 81n, 148
Bergman, Ingrid, 126
Bergstrom, Janet 32
Berkeley, Busby 23–24
Bertolucci, Bernardo, 99, 116, 126n, 181n
Birds, the (Hitchcock), 29, 35, 46, 65, 78n,
 126, 147, 177, 191
Biskind, Peter, 95–97, 118, 129, 130,
 147–150, 154n, 155–156, 166
Black Dahlia, the (De Palma), 7n, 110, 143,
 150, 196
Blackmail (Hitchcock), 71
Blade Runner (Scott) 81n
Bliss, Michael, 9
Blow Out (De Palma), 8, 9, 23, 25, 55, 63,
 78, 81, 107, 110, 116–117, 120, 128,
 131, 139–140, 147, 149, 151, 153, 157,
 178–201, 209

Blow Up (Antonioni), 114–117, 121, 181, 184, 185n, 193
Blue Velvet (Lynch), 42
Bode, Ralf, 158
Body Double (De Palma), 8, 9, 10, 13, 14, 25, 33, 39, 40, 43, 44, 48, 55, 59, 60–64, 76, 78–80, 105, 107, 109–110, 120, 121, 140, 142, 151, 153, 164, 168, 170, 172–178, 185–192, 207, 209
Bogart, Humphrey 104, 135
Bogdanovich, Peter, 9, 148, 167
Bonfire of the Vanities, the (De Palma), 9, 23, 124, 150–151
Bonitzer, Pascal, 71
Bonnie and Clyde (Penn), 48, 95, 143
Bordwell, David, 3, 4, 29, 88, 89, 102, 128n
Borges, Jorge Luis, 105
Born on the Fourth of July (Stone), 43
Bouzereau, Laurent, 9, 157–158
Boy Friend, the (Russell), 138
Brakhage, Stan, 150
Brando, Marlon, 147
Brazil (Gilliam), 81n
Breathless (Godard), 88, 98, 108, 109
Brecht, Bertholt, 4, 67, 87, 88, 101, 104, 108, 128n, 135–136, 164, 168, 180–182, 186, 189, 201, 208
Bresson, Robert, 9, 12n
Bride Wore Black, the (Truffaut), 56n
Bridge That Gap (De Palma), 109
British Sounds (Godard/Roger), 99
Brody, Richard, 104
Brownmiller, Susan, 128
Buckley, Betty, 163
Bulworth (Beatty), 167
Buñuel, Luis, 35, 63, 107, 111, 114
Burton, Richard 105
Burum, Stephen 105, 106

C.K., Louis, 107
Cabinet of Dr. Caligari, the (Wiene), 21
Calley, John 130
Cameron, James 156

Carabiniers, les (Godard), 160
Carlito's Way (De Palma), 12, 15, 131
Carpenter, John, 44
Carrie (De Palma), 7, 11, 15, 41, 42, 48, 54, 55, 78, 90, 117, 151, 157–158, 163
Carroll, Noël 3, 88, 89, 128n
Carson, Johnny, 133
Cassavetes, John, 86n, 102
Castro, Fidel, 165
Casualties of War (De Palma), 8, 11, 36, 43–44, 59, 78, 140–143, 151, 167, 192, 196, 200
Cavell, Stanley, 9
Céline et Julie vont on bateau (Rivette), 23
Chabrol, Claude, 28, 35, 36, 77, 86
Chaplin, Charlie, 9n, 65
Chase, the (Penn), 125
Chase, Alston, 212–213
Guevara, Che, 121
Chinoise, la (Godard), 89, 99, 108, 120, 122, 125
Citizen Kane (Welles), 21, 109, 135
Citron, Michelle, 32, 158n
Cixous, Hélène, 92
Clarke, Shirley, 86n
Clecak, Peter, 94
Clinton, William Jefferson, 12, 33n
Clover, Carol, 11, 158n, 162, 175
Cohn-Bendit, Dany (aka Dany le Rouge), 99
Comolli, Jean-Louis, 167
Conformist, the (Bertolucci), 126n
Conrad, Peter, 26, 28n, 125
Contempt (Godard), 126, 159
Conversation, the (Coppola), 101, 185n
Convoy (Peckinpah), 197
Coppola, Francis Ford, 96, 97, 140, 147–150, 165–167, 185n, 197, 200
Corliss, Richard, 173, 174
Coutard, Raoul, 105, 106, 126, 189
Coover, Robert, 211
Creed, Barbara, 11, 158n
Crimes of Passion (Russell), 172m
Crimes of the Future (Cronenberg), 110

Crittenden, Jordan, 129
Cronenberg, David, 110
Cruise, Tom, 150
Cruising (Friedkin), 158, 167
Crumb, Robert, 95
Cusset, François, 95
Cvetkovich, Ann, 21, 33–34

Dance of the Seven Veils (Russell), 138
Darc, Mireille, 126
Davenport, Mary 122, 159, 162
David Holzman's Diary (McBride), 85–86,
 87, 117
Davidovich, Lolita, 70
Day, Doris, 118n
Dead of Night (Cavalcanti *et alia*), 35
Dead Ringers (Cronenberg), 110
Dean, Tim, 39n
Debs, Eugene V., 93
Deer Hunter, the (Cimino), 140
De Gaulle, Charles, 91, 128
Deleuze & Guattari, 178, 181n
Demy, Jacques, 86
Denby, David, 35
DeNiro, Robert, 109, 112, 117, 120–125, 129,
 150, 168
De Palma, Bart (brother), 154, 159
De Palma, Brian: shot by a cop, 155;
 great director or not, 9n; jammed
 disrespectfully into Brecht poem, 201
De Palma, Bruce (brother), 157
De Palma, Vivienne (mother), 162
Dershowitz, Alan, 173n
Détective (Godard), 128, 143
Deux ou Trois Choses que Je Sais d'Elle
 (Godard), 125
Devil and Daniel Webster, the (Dieterle), 21
DeVito, Danny, 166n
Dial "M" for Murder (Hitchcock), 61, 70–71
Dickinson, Angie, 36–38, 45, 48, 55, 63
Diggins, John Patrick, 92–93
Dionysus in '69 (De Palma), 9, 109,
 117–120, 124

Discreet Charm of the Bourgeoisie, the
 (Buñuel), 23, 48
Disney, Walt, 104
Diva (Beineix), 99
Doane, Mary Ann, 32
Dolce Vita, la (Fellini), 109
Donaggio, Pino, 55, 180, 188, 190
Donahue, Phil, 53
Double Indemnity (Wilder), 33
Douchet, Jean, 27, 36, 76, 77
Douglas, Kirk, 158, 160
Downey, Robert Sr., 160
Dr. Strangelove (Kubrick), 139n
Dr. X (Curtiz), 184
Dragnet (television series), 129
Dressed to Kill (De Palma), 7, 12, 13,
 23, 33, 36, 38–39, 44, 47, 48–57,
 59–60, 64, 78, 90, 110, 128n, 139,
 151, 152–153, 158, 161–164, 168,
 172, 175n, 177, 178, 182, 185, 190n,
 191, 195
Dreyer, Carl Theodor, 9
Dudley, Andrew, 3, 4, 88
Durning, Charles, 120
Dworkin, Andrea, 177, 207, 210
Dworkin, Susan, 154n, 175–176
Dylan, Bob, 73, 99n
Dziga Vertov Group, 88, 89, 98, 99

Easy Rider (Hopper), 8, 95, 101, 111, 117,
 129, 143, 209
Ebert, Roger, 5, 7n, 44, 150
Echoes of Silence (Goldman) 35
L'Eclisse (Antonioni), 56
Edelman, Lee, 77
Ehrenreich, Barbara, 170
Eisen, Ken, 177n
Eisenstein, Sergei, 4, 126
Ellis, Bret Easton, 205–214
Elmer, Jonathan, 25n
Erhard, Werner, 143, 159
Eszterhas, Joe, 167
Euripedes, 117, 180

Executive Action (Miller), 184
Exorcist II: The Heretic, the (Boorman), 105

Faces (Cassavetes), 160
Fanon, Frantz, 211
Farocki, Harun, 101
Fassbinder, Rainer Werner, 107
Feiffer, Jules, 94
Fellini, Federico, 148
Femme est une Femme, une (Godard), 98,
 109, 116, 125
Femme Fatale (De Palma), 15, 78, 150n, 151,
 195, 196
Femme Mariée, une (Godard) 108, 125
Fight Club (Fincher), 181n
Film Socialisme (Godard), 100
Fincher, David, 181n
Findlay, Roberta, 162n
Fink, Bruce, 39n
Finkelkraut, Alain, 92, 213–214
Finley, William, 15, 110, 118
Flicker, Ted, 95n
Fonda, Jane, 94
Fonda, Peter, 96
Ford, John, 125, 134
Foreign Correspondent (Hitchcock), 23,
 61, 72
Forrest Gump (Zemeckis), 127–128
Foster, Jodie, 128n
Fox, Michael J., 200
Frankie Goes to Hollywood, 45–46, 188
Franz, Dennis, 15, 52, 180, 186, 189–190
Frenzy (Hitchcock), 44n, 51, 126
Freud, Sigmund, 76n, 152, 159n, 168, 178
Friday the 13th (Cunningham), 45, 162n, 179
Friedkin, William, 96, 148, 158, 167
Friedrich, Otto, 147
Fuller, Samuel, 23, 107, 125
Fury, the (De Palma), 9, 35, 86n, 90, 127,
 157–158, 168

Gallop, Jane, 32n
Gandhi, Mahatma, 94

Gardenia, Vincent, 159
Garfield, Allan, 120, 121, 131
Garland, Judy, 21
Gavin, John, 53
Gelernter, David, 212–213
Gelmis, Joseph, 12, 87n, 108
Get to Know Your Rabbit (De Palma),
 129–135, 136, 139, 143, 150, 152, 155,
 157, 165, 168, 196
Gidget (Wendkos), 184
Gilda (Vidor), 89
Gimme Shelter (Maysles), 95
Gitlin, Todd, 93, 94, 97, 127, 143
Gledhill, Christine, 3
Godard, Jean-Luc, 8, 14, 23, 35, 36, 57, 59,
 63, 83–144, 160, 164, 185, 189, 193,
 195, 200, 209, 214
Godfather, the (Coppola), 96, 165, 166, 167
Goldstein, Al, 173n
Gone with the Wind (Fleming), 99, 193
Gordon, Keith, 60, 159–161
Gorin, Jean-Pierre, 88, 98n, 100, 105, 140
Graham, Gerrit, 21, 114–115, 116, 121, 122,
 124, 159, 168
Grant, Cary, 126
Greetings (De Palma), 12, 35, 67, 78, 87, 101,
 108, 110, 111–117, 120, 121, 131, 134,
 140, 143, 155, 159, 168, 172, 184
Gregorio, Darnell, 156
Grieveson, Lee, 3, 31
Griffith, D.W., 23
Griffith, Melanie, 62, 89–90, 172, 188,
 189, 190

Hackman, Gene, 185n
Halloween (Carpenter), 44, 193
Harron, Mary, 209
Harvey, David, 23
Haskell, Molly, 31
Hawkins, Joan, 107n, 162n
Hawks, Howard, 7, 165, 167
Haynes, Jonathan, 30n, 89, 105n
Haynes, Todd, 5, 107, 178n

H.E.A.L.T.H. (Altman), 96
Heath, Stephen, 31
Heaven's Gate (Cimino), 96
Hecht, Ben, 165
Hemmings, David, 185n, 193
Henri-Levi, Bernard, 92
Henry, Gregg, 15, 168
Herrmann, Bernard, 21, 56n, 58
Herzog, Werner, 65
Hi, Mom! (De Palma), 9, 107, 108, 110,
 120–125, 128, 129, 131, 138, 139, 150,
 167, 168, 170, 181n, 213
Hill, Jack, 33
Hirsch, Foster, 28–29
Hirschberg, Lynn, 147, 153n, 173n
Histoire(s) du Cinéma (Godard), 100,
 105, 127
Hitchcock, Alfred, 8, 9, 14, 19–82, 87, 88,
 89n, 100, 102–103, 112, 125, 126,
 127n, 134–136, 143, 151, 155, 156,
 163n, 164, 168, 174–177, 185, 189,
 191, 192, 209, 214
Hoberman, J., 34, 61n, 100, 112n, 174,
 180, 183
Hoffmann, Abbie, 133
Home Movies (De Palma), 55, 78, 110, 158,
 159–160, 162
Hooper, Tobe, 209
Hopper, Dennis, 96
Horowitz, David, 94, 97, 138, 143
Hostel 2 (Roth), 12
Howard, Ron, 124
Hudson, Rock, 118n
Hughes, Howard, 178n
Hunchback of Notre Dame, the (Dieterle), 21
Hurd, Gale Ann, 156
Husbands (Cassavetes), 160

Ice (Kramer), 134n
Ici et Ailleurs (Godard *et alia*), 99, 128
Imitation of Life (Sirk), 168, 180
Immortal Beloved (Rose), 138
Irving, Amy, 168

Jack (Coppola), 149
Jackson, Mahalia, 180
Jackson, Michael, 211
Jaehne, Karen, 165
Jagger, Mick, 188n
Jameson, Fredric, 23, 74, 81, 93, 139, 143
Jaws (Spielberg), 174
Jazz Singer, the (Crosland), 172
JFK (Stone), 184
Jodorowsky, Alejandro, 166
Johnny Guitar (Ray), 105
Johnson, Lyndon Baines, 8, 112
Johnson, Holly, 188
Jolson, Al, 167
Jones, Reverend Jim, 143
Jules et Jim (Truffaut), 109

Kaczynski, Ted, 211–213
Kael, Pauline, 7n, 26, 34–40, 45, 52, 86,
 89, 107, 112, 147, 149, 155, 160, 168,
 197–200
Kaleidoscope (Hitchcock), 63
Kapsis, Robert, 29, 34
Karina, Anna, 86, 98, 125–127
Kauffmann, Linda, 177
Kellner, Douglas, 125, 143, 162n, 176n, 179
Kennedy, Robert F., 94
Kennedy, John F., 82, 112, 114–117, 118n,
 119, 121, 139, 151, 168, 183, 184, 196
Kerouac, Jack, 170
Kiarostami, Abbas, 9
Kidder, Margot, 156
Killer Elite, the (Peckinpah), 160, 197
King Lear (Godard), 100, 160, 163n
King, Dr. Martin Luther, 94
King of Comedy, the (Scorsese), 149
Kirk, Greyson, 131
Klapper, Zina, 156, 175–177, 185, 207
Klein, Bonnie, 193
Kline, Franz, 34
Klute (Pakula), 185
Knocked Up (Apatow), 12
Koch, Gertrud, 3

Kolker, Robert Philip, 26, 42, 147, 157, 159
Kosselleck, Reinhart, 13, 90
Kracauer, Siegfried, 4
Kramer, Robert, 134n
Kramer, Stanley, 42
Kristeva, Julia, 92
Kubrick, Stanley, 15, 87, 103, 107, 130, 148, 164, 182

LaBianca, Rosemary, 95
Lacan, Jacques, 28, 30, 32, 39, 61, 71, 74, 75, 76n, 89, 91, 92, 103, 143, 152, 156, 175n, 177, 185
Laclau, Ernesto, 42, 164
Ladies Man, the (Lewis), 65
Lady Vanishes, the (Hitchcock), 61
Lang, Daniel, 196
Langlois, Henri, 89
Last Action Hero, the (McTiernan), 63
Last Tango in Paris (Bertolucci), 23
Latour, Bruno, 5
Laurie, Piper, 127n
LaValley, Al, 31
Leary, Timothy, 135
Lehman, Ernest, 73n
Leigh, Janet, 27, 38, 45, 53, 58
Leitch, Thomas, 26, 47
Lennon, John, 196
Leone, Sergio, 150, 166
Lesage, Julia, 32
Lester, Richard, 23, 101.
Levin, Thomas Y., 196
Lewis, Fiona, 127
Lewis, Herschell Gordon, 173
Lewis, Jerry, 65, 67, 98, 104, 160
Lewis, Jon, 147, 149
Lichtenstein, Roy, 34, 188
Liddy, G. Gordon, 183
Lisztomania (Russell), 107, 138
Lithgow, John, 15, 63, 67, 70, 168,
Lodger, the (Hitchcock), 110
Lorde, Audre, 144
Lost in Space (Hopkins), 33n

Lucas, George, 96, 101, 143, 148, 150, 151, 158, 167, 200
Ludlam, Charles, 21
Ludwig (Visconti), 166
Lumet, Sidney, 166
Luxemburg, Rosa, 164n
Lynch, David, 42
Lyotard, Jean-François, 23

MacBean, James Roy, 101, 104
MacCabe, Colin, 98, 99
MacDonald, Shana, 127
MacKinnon, Catherine, 177, 210
MacKinnon, Kenneth, 7n, 10, 11, 33
Made in USA (Godard), 105, 135, 160
Magnificent Ambersons, the (Welles), 134–135, 178n
Mailer, Norman, 170, 206
Malone, Dorothy, 180
Man Who Knew Too Much, the (Hitchcock), 33, 61, 77
Manchurian Candidate, the (Frankenheimer), 139
Maniac (Lustig), 44
Mann, Anthony, 15, 150
Manson, Charles, 143
Mao, Zedong (Chairman), 87, 98, 99, 100, 101, 102, 108, 143
Marcuse, Herbert, 143, 211
Marnie (Hitchcock), 23, 56, 61, 67, 71, 73, 188, 191
Marx, Karl, 87, 104, 211
Masculine-Feminine (Godard), 98, 108, 120
Matrix, the (Wachowski), 81n
Maugham, W. Somerset, 82n
Maysles brothers, 23, 59, 86n
McBride, Jim, 87
McCabe and Mrs. Miller (Altman), 49, 58
McChesney, Robert, 40
McVeigh, Timothy, 214
Mean Streets (Scorsese), 158, 165
Menand, Louis, 99
Miles, Vera, 53, 156

Milestones (Kramer), 134n
Milius, John, 96, 148, 155, 167
Miller, D.A., 31
Miller, Janella, 173n
Minnelli, Vincente, 12n
Mission: Impossible (De Palma), 23, 150
Mission to Mars (De Palma), 148, 150, 151, 157
Mizoguchi, Kenji, 9n
Model Shop (Demy), 23
Modleski, Tonia, 25, 30, 32, 46
Monet, Claude, 121
Moon is Blue, the (Preminger), 53
Moroder, Giorgio, 167
Morrison, Jim, 178n
Mouffe, Chantal, 42, 164
Mozart, Wolfgang Amadeus, 100
Mulvey, Laura, 5, 14, 27, 28, 29, 31–32, 89, 97, 104n, 188, 190, 207
Muppet Movie, the (Frawley), 135
Murder a la Mod (De Palma), 22, 108, 109, 110–111, 114, 127, 135, 184
Murnau, F.W., 9
Music Lovers, the (Russell), 138
Narboni, Jean, 167
Naremore, James, 26, 31, 167
Nashville (Altman), 181
New York New York (Scorsese), 96, 148, 166
Newsreel Collective, 88, 134n
Nichols, Mike, 130
Nicholson, Jack, 148
Night Games (Penn), 125
Nixon, Richard M., 95, 128, 142, 143, 156, 167
North by Northwest (Hitchcock), 56, 61
Not a Love Story (Klein), 193
Notorious (Hitchcock), 71, 126
Nouvelle Vague (Godard), 103
Novak, Kim, 55, 62, 64–65, 156, 188
Nuit Américaine, la (Truffaut), 23
Numéro Deux (Godard), 99, 128

O'Hara, John, 82n
O'Reilly, Bill, 5, 196–197
Obama, Barack, 82
Obsession (De Palma), 23, 48, 49, 58–59, 64, 142–143, 150, 157, 160
Once Upon a Time in America (Leone), 23
One from the Heart (Coppola), 148, 165
Opening of Misty Beethoven, the (Metzger), 173
Ophüls, Max, 87
Oudart, Jean-Pierre, 29n

Pacino, Al, 15, 167
Pakula, Alan J. 149, 184
Palance, Jack, 126
Pally, Marcia, 134, 172–175, 193–195
Panic in Needle Park, the (Schatzberg), 167
Parallax View, the (Pakula), 179, 184, 209
Partner (Bertolucci), 126n, 181n
Party Girl (Ray), 23
Passion (Godard), 100, 103
Paths of Glory (Kubrick), 140
Peckinpah, Sam, 15, 23, 44n, 56, 148, 160, 173, 197–201
Peeping Tom (Powell), 44
Penn, Arthur, 125, 148, 149
Penn, Sean, 15
Pennebaker, D.A., 23, 86n
Peretz, Eyal, 9, 12n
Performance (Roeg), 188n
Perry, Anne, 211
Pfeiffer, Michelle, 15, 168
Phantom of the Opera, the (Julian), 21, 109
Phantom of the Paradise (De Palma), 8, 21–23, 35, 67, 110, 121, 136–139, 144, 150–151, 157, 159, 168, 179, 196
Pierrot le Fou (Godard), 87, 125
Piscopoe, Joe, 166n
Platoon (Stone), 43, 44n, 140
Poe, Edgar Allen, 25n
Poitier, Sidney, 137–138
Polanski, Roman, 15, 23, 35, 51, 87
Police Woman (television series), 162

Pootie Tang (C.K.), 107
Powell and Pressburger, 65n
Powell, Michael, 44, 63
Pravda (Godard/Gorin), 99
Preminger, Otto, 61, 95n, 129
Prenom: Carmen (Godard), 98n, 105, 128
President's Analyst, the (Flicker), 95n
Prince, 211
Prince, Rob, 169n
Prince, Stephen, 42–46, 63, 144, 166
Psycho (Hitchcock), 22, 23, 26–28, 34, 35,
 38, 39, 40, 42, 44, 45, 48–57, 58, 61, 70,
 73, 75, 82, 110, 126, 135–138, 139, 161,
 174, 191
Psycho (Van Sant), 59

Quatre Cents Coups, les (Truffaut), 160

Radosh, Ron, 94
Raemaker, Paul, 11n, 163n
Rafelson, Bob, 148, 167
Raging Bull (Scorsese), 102
Raising Cain (De Palma), 25, 48, 52, 54, 55,
 56, 63–64, 76, 111, 151, 168
Rashomon (Kurosawa), 110
Ray, Nicholas, 23, 108
Ray, Robert, 3
Reagan, Ronald, 3, 7, 8, 12, 13, 61, 94, 97,
 143, 153, 167, 177, 186
Rear Window (Hitchcock), 21, 39, 40, 43, 48,
 61, 63, 70, 75, 76, 77, 78, 121
Rebecca (Hitchcock), 61
Rebello, Stephen, 35n
Red Shoes, the (Powell and Pressburger), 21,
 65n, 109
Redacted (De Palma), 5–6, 8, 12, 15, 67n,
 82n, 110, 140, 195, 196–197
Règle de Jeu, la (Renoir), 107
Rehak, Bob, 96n
Renoir, Jean, 9, 41, 56n, 107
Resnais, Alain, 86, 102
Responsive Eye, the (De Palma), 109
Reville, Alma, 156

Rhames, Ving, 200
Rich, B. Ruby, 32
Richert, William, 185
Riefenstahl, Leni, 6, 7
Rififi (Dassin), 23
Rio Bravo (Hawks), 89
Rivette, Jacques, 86, 103
Robbe-Grillet, Alain, 211
Robot Monster (Tucker), 107n
Rocky Horror Picture Show, the
 (Sharman), 23
Roeg, Nicolas, 188n
Rohmer, Eric, 28, 35, 36, 39, 77, 103
Rope (Hitchcock), 31, 38, 61, 213
Rose, Jacqueline, 32
Ross, Katharine, 129, 133
Rothman, William, 14, 25, 27, 28, 30, 32, 65,
 67, 75, 110, 139, 152
Rouch, Jean, 193
Roud, Richard, 126n
Rowbotham, Sheila, 99
Rubenstein, Richard, 135
Rubin, Jerry, 94
Rudd, Mark, 94, 131
Ruiz, Raoul, 64, 163n
Rumble Fish (Coppola), 149
Russell, Ken, 51, 107, 138, 172n
Ryan, Michael, 125, 143, 162n, 176n, 179

Sabotage (Hitchcock), 39, 56, 76
Saboteur (Hitchcock), 76
Sade, Marquis de, 127
Salomon, Julie, 154n, 156
Salt, Jennifer, 137
Samuels, Robert, 152
Sarris, Andrew, 28n, 33, 34–40, 50, 58, 59, 61,
 109, 148, 153, 172, 185n
Sartre, Jean-Paul, 87, 152, 156
Sauve Qui Peut (La Vie) (Godard), 99, 100
Scarface (De Palma), 7, 8, 12, 23, 42, 43, 45,
 52, 63, 107, 120, 151, 153, 165–170,
 173, 178, 209
Scarface (Hawks), 7, 165

Schechner, Richard, 117

Scheider, Roy, 174

Schindler's List (Spielberg), 67n, 208

Schlesinger, John, 101

Schrader, Leonard, 156

Schrader, Paul, 58, 96, 102, 148, 155, 157,
167, 177n

Schwarzenegger, Arnold, 63

Schygulla, Hanna, 103

Sconce, Jeffrey, 107n

Scorsese, Martin, 35, 40, 41–42, 61, 96,
101–102, 109, 118n, 147, 148, 149, 150,
155, 156, 157n, 158–159, 166, 167, 196

Scott, A.O., 7n

Searchers, the (Ford), 34

Secret Cinema, the (Bartel), 111

Seigner, Emmanuelle, 128

Serpico (Lumet), 167

Seventh Seal, the (Bergman), 109

Shadow of a Doubt (Hitchcock), 46, 160

Shakespeare, William, 72

Shaviro, Steven, 104, 105

Shaw, Fiona, 15

Shelton, Deborah, 45, 188, 195

*Show Me a Strong Town and I'll Show You a
Strong Bank* (De Palma), 109

Shyamalan, M. Night, 143

Sidney, Sylvia, 76

Silverman, Kaja, 29n, 191

Sirk, Douglas, 21, 87, 104, 107, 180

Sisters (De Palma), 10, 22, 25, 48, 57–58, 59,
64, 76, 110, 117, 122, 135–138, 139,
141, 143, 144, 152, 157, 158, 162, 167,
182, 195

Skidoo (Preminger), 95n, 129

Smith, Julian, 112n

Smothers, Tommy, 129–135

Snake Eyes (De Palma), 25, 78, 110, 116, 131,
150, 151, 195–196

Snodgress, Carrie, 127

Snuff (Findlay), 162n

Soigne ta Droite (Godard), 101, 143

Sokal, Alan, 3

Sontag, Susan, 103–104, 126, 127

Spider Baby (Hill), 33

Spielberg, Max, 155

Spielberg, Steven, 40, 41–42, 67n, 96, 101,
108, 143, 147–148, 149, 150, 151, 155,
156, 158, 166n, 167, 208

Spoto, Donald, 45

Stage Fright (Hitchcock), 76, 77

Stalin, Josef, 92

Stam, Robert, 105

Star 80 (Fosse), 162

Star is Born, a (Cukor), 21

Star Wars (Lucas), 97, 101, 147, 152

Starr, Peter, 91–92, 97

Starship Troopers (Verhoeven), 181–182

Sterritt, David, 104

Stewart, Jimmy, 62, 64, 77–78, 188

Stone, Oliver, 43–44, 116, 140, 166, 167, 184

Strange Hostel of Forbidden Pleasures
(Motta), 107n

Strange Impersonation (Mann), 150n

Strangers on a Train (Hitchcock), 61

Straub, Jean-Marie and Danièle Huillet, 160

Sunset Boulevard (Wilder), 105

Susann, Jacqueline, 21

Swanson, Gloria, 188

Talk Radio (Stone), 43

Tarantino, Quentin, 11, 105, 153, 179

Tarkovsky, Andrei, 81n

Tashlin, Frank, 21, 98n

Tate, Sharon, 95

Taxi Driver (Scorsese), 42, 101, 121, 131

Taylor, Anna Maria, 32

Tetzlaff, Ted, 77

Texas Chain Saw Massacre, the (Hooper),
29n, 209

Thin Man, the (Van Dyke), 105

Thomas, Marlo, 137–138

Thompson, Hunter S., 95, 97

Thomson, David, 6–7, 34, 44n, 118

Thousand Clowns, a (Coe), 130

Three Men and a Cradle (Serreau), 99

To Catch a Thief (Hitchcock), 23, 183

Toback, James, 177n
Toland, Gregg, 163n
Torn Curtain (Hitchcock), 127n
Touch of Evil (Welles), 21
Tout Va Bien (Godard/Gorin), 99
Towne, Robert, 148
Travolta, John, 147, 182–183, 184, 185n
Treasure Island, 64
Trip, the (Corman), 130
Truffaut, François, 30, 31, 36, 56n, 86, 89,
 103, 109, 112, 192
Truman Show, the (Weir), 111
Tucker (Coppola), 149
Tucker, Ken, 169n
Tuotti, Joseph, 124
Turning Point, the (Ross), 55

Unger, Irwin, 93
Unmarried Woman, an (Mazursky), 59, 161
Untouchables, the (De Palma), 15, 42, 52, 150,
 151, 197

Van Sant, Gus, 59
Varda, Agnès, 86
Velvet Goldmine (Haynes), 178n
Verhoeven, Paul, 64, 167, 181–182
Vertigo (Hitchcock), 23, 29, 34, 35, 42, 43,
 45, 55, 58, 61, 63, 70, 103, 141–143,
 155, 156, 160, 188, 189
Videodrome (Cronenberg), 110
Visconti, Luchino, 102
Vivre sa Vie (Godard), 109, 125–126
Vladimir et Rosa (Godard/Gorin), 98,
 104, 107
Vreeland, Diana, 70

Wadleigh, David, 118n
Wasson, Craig, 62, 89–89, 188, 189, 190
Wasson, Haidee, 3, 31
Waters, John, 114n, 160
Watkins, Peter, 166
Weathermen, the, 93–94, 98, 125, 131, 213

Wedding Party, the (De Palma), 108, 109–110,
 112, 114, 155
Week End (Godard), 86, 88, 98, 100, 108, 114,
 120, 122, 125, 126, 127, 128, 189
Welles, Orson, 9n, 23, 35, 129, 131, 134–135,
 148, 149, 163, 195, 197
West, Nathanael, 62
White, Armond, 11
White, Hayden, 17, 40n, 90, 127, 149, 185
Who's That Knocking at my Door?
 (Scorsese), 155
Wild Bunch, the (Peckinpah), 23, 166, 197
Wilder, Billy, 33
Willemen, Paul, 104n, 191
Williams, Linda, 3, 105, 162, 175, 177
Wilson, Lisle, 137
Window, the (Tetzlaff), 77
Winter Kills (Richert), 184, 185
Wise Guys (De Palma), 9, 139, 150, 151, 157,
 166n, 197
Wollen, Peter, 31, 100–101
Wood, Ed, 104
Wood, Robert E., 9n
Wood, Robin, 7n, 10–11, 25, 28, 30, 36, 39,
 42, 58, 90, 97, 103, 179, 188
Woodstock (Wadleigh), 118
Woton's Wake (De Palma), 108, 109, 139, 155
Wright Penn, Robin, 127–128

X, Malcolm, 94, 112, 121

Yablonski, Joseph, 178n
Young and Innocent (Hitchcock), 61

Zabriskie Point (Antonioni), 23, 56
Zapruder, Abraham, 116, 180, 183, 184, 193
Zazie dans la Métro (Malle), 23, 109
Žižek, Slavoj, 4, 14, 27, 28, 30, 32, 33n, 39,
 54, 55, 61, 63, 71–82, 127n, 139, 164,
 177, 208
Zsigmond, Vilmos, 49, 58